G000039359

Durkheim, the Durkheimians, and the Arts

Durkheim, the Durkheimians, and the Arts

Edited by
Alexander Riley
W.S.F. Pickering
and
William Watts Miller

berghahn
NEW YORK · OXFORD
www.berghahnbooks.com

Durkheim Press / Berghahn Books

Published in 2013 by
Berghahn Books
www.berghahnbooks.com

© 2013 Durkheim Press

All rights reserved. Except for the quotation of short passages
for the purposes of criticism and review, no part of this book
may be reproduced in any form or by any means, electronic or
mechanical, including photocopying, recording, or any information
storage and retrieval system now known or to be invented,
without written permission of the publisher.

Library of Congress Cataloging-in-Publication Data

Durkheim, the Durkheimians, and the arts / edited by Alexander Riley, W.S.F.
Pickering, William Watts Miller.
 p. cm.
 ISBN 978-0-85745-917-6 (hardback: alk. paper) -- ISBN 978-0-85745-918-3
 (ebook) 1. Art--Social aspects. 2. Durkheim, Émile, 1858-1917. I. Riley, Alexander.
II. Pickering, W. S. F. III. Miller, William Watts.

N72.S6D786 2013
306.4'7--dc23

2012033462

British Library Cataloguing in Publication Data

A catalogue record for this book is available from the British Library

Printed in the United States on acid-free paper

ISBN 978-0-85745-917-6 (hardback)
ISBN 978-0-85745-918-3 (institutional ebook)

In memory of Philippe Besnard,
almost certainly the only great Durkheimian sociologist
to have jammed with Bud Powell at the Blue Note…

Contents

Illustrations

Introduction to *Durkheim, the Durkheimians, and the Arts*

Alexander Riley

Not least of the accomplishments of the sociology of art is the fact that the world of literary and art criticism has been influenced, albeit sometimes only indirectly and without proper acknowledgement of sources, for at least a half century now by a vision of the human world that can reasonably be classified as sociological. Most of those who make their professional living talking about works of art now consider it more or less an imperative to at least make mention of the fact that the artist is a human being occupying a particular position in a social world, with a particular history informed by that position, and a view of the world that at least in some vague and imprecise ways is affected by the inevitable sociality of the artist's life and experience. To be sure, in some of these circles one still encounters the vocabulary of mysterious, inexplicable individual creativity, but the virus of the sociological vision has fairly well infected art criticism and history, ultimately to the detriment of explanations of artistic work as the singular genius of the isolated, usually tormented, and emotionally unique figure on whose saintly head is placed a laurel reading "Artist." Sociology can and should be proud of this influence.

Nonetheless, it remains the case that within the ranks of sociologists, and, it seems, especially English-speaking ones, art remains an object only rarely considered, and, when it is, the analysis is frequently inadequate, if not embarrassing. Contemporary sociologists are not typically knowledgeable about art nor are they generally significantly intellectually or personally drawn to it. A colleague in the humanities once told me, with a sly grin, that if one wishes to despair of the victory of philistinism in the contemporary world, one need not even ask the man in the street what he thinks about art: just talk to the sociologists. Insulting literary stereotypes of sociologists as dull-minded statisticians without even the slightest sensitivity to the aesthetic are commonplace, and it is only with

the aid of densely-tinted glasses that one can deny the actual existence of significant numbers of sociologists who neatly fit the literary stereotypes. It is highly recommended that those who believe such accusations baseless should not set foot in an American sociology department lest they come face to face with the proof at the first or second office they pass.

Whence this state of affairs? Some of the explanation might reside in the inevitable reality that a discipline dominated in much of the English-speaking world by positivism and hyperspecialization tends to recruit individuals who are not centrally motivated by humanistic approaches to the study of society and the wide cultural literacy that is their prerequisite. The lab-coat envy of much of American sociology helps produce a state of affairs in which the model type presented to young graduate students is not a scholar well-read in the classics and generally informed about Western cultural history, but one who reads everything in some narrowly defined subfield in the discipline and comparatively little about anything else. Some basic, and true, sociological insights into the nature of cultural production are also distorted and simplified in many sociological circles into an ossified framework for denunciation of all cultural work and workers that would dare to invoke value distinctions. Howard Becker's (Becker 1982; Faulkner and Becker 2009) penetrating insights into the study of art using basically the same sociology-of-work tools that can be used to study the activity and products of automobile mechanics or short-order cooks must be taken seriously by any sociology of art worth its salt, but Becker never intended to suggest that artworks were in every important way indistinguishable from a 1989 Ford Mustang with a cracked head cylinder or a plate of onion rings. While the belief that the distinction of cultural objects and activities into categories of "high" and "low" should be interrogated critically certainly has some laudable intellectual and moral motivations, it is not self-evident that any such distinctions can only be the product of the illegitimate imposition of the cultural values of elites. Nor is it true that knowledge of the social processes that inform the classing and hierarchical ranking of aesthetic work should necessarily lead one to suspicion or even rejection of art as merely another ideological brick in the edifice of class domination. Pierre Bourdieu, who is incorrectly taken by some of his readers as an iconic figure in the movement to dismantle any possibility of distinguishing aesthetic works of high quality from those of lesser quality, actually believed quite firmly that a principle by which one could and should distinguish important works does exist. This is craft, *askesis*, "effort, exercise, suffering" (Bourdieu and Wacquant 1992:87); Delacroix's *La Mort de Sardanapale* or Cezanne's *Le Panier de pommes* are the products of more time and effort than is the case of an issue of *The Amazing Spider-Man* or even more pretentious contemporary graphic novels, and Beethoven labored significantly more intensely over the *Eroica* than Lady Gaga did over her latest album, and these

distinctions can be seen and appreciated in the products themselves by readers who have put in the difficult ascetic work in learning the conventions required for approaching these works. Bourdieu points specifically to the effort of the reader, viewer, or listener as the key to understanding why his vision of the sociology of culture does not require the adoption of an aesthetic relativism: "Thus if we can say that avant-garde paintings are superior to the lithographs of the suburban shopping malls, it is because the latter are a product without history . . . whereas the former are accessible only on condition of mastering the relatively cumulative history of previous artistic production . . . It is in this sense that we can say that 'high' art is more universal" (ibid.). If too few sociologists recognize what Bourdieu's actual position here was, it is perhaps not only because they have read him with insufficient care but also because they have invested the entirety of their professional identities in the patently absurd idea that any and all attempts to make decisions based on categories of distinction are offensive by definition.

Lest readers take the present writer for an idiosyncratic curmudgeon, let me hasten to note that it is not merely my opinion that contemporary sociology has, by and large, failed to take the task of the intellectual analysis of art seriously enough. Two others whose stride far exceeds my own arrived at the same conclusion, and expressed it still more caustically. One of the most penetrating observers of the social life of art, Cesar Graña, once described the failings of sociology, specifically in its American incarnation, with respect to the study of art in a footnote that I cannot resist citing at length:

> None of the "classic" figures of American Sociology have addressed themselves to aesthetic questions. And it is typical for widely read classroom primers . . . to spend several hundred pages on every aspect of the "value system," including religious behavior and educational institutions, without once mentioning art or literature. Such indifference (or distrust) can be explained in part by the professional history of sociology in the United States. In Europe, until quite recently, sociologists dwelled within the traditional company of the man of letters . . . and sociology itself could be regarded as a widening, through new visions, of the historical, philosophical, artistic, and literary scholarship in which these men had been bred. The spirit of American sociology, on the other hand, possibly because its beginnings were so largely tied to the field of "social problems," has been "secular," brisk, immediate, unapologetically factual, devoted to the exhaustive accounting of human relations and every conceivable or at least describable aspect of the social environment . . . A discipline which claims to provide a systematic accounting of human culture cannot ignore as much as it has what in the eyes of tradition, if nothing else, are regarded as the articulate monuments of that culture. (Graña 1971:65–66)

Another astute and respected cultural theorist, Jean Duvignaud, described the sociology of art as "entangled in the wrong kind

of problems." Why and how? Again, let us give him some space to eloquently speak for himself:

> The most obvious reason for this is that those studying the subject are totally ignorant of the problems associated with artistic creation in all its manifestations, and more important, are unaware of the kind of experience which artistic creation involves [he specifically attacks Charles Lalo ("who established the practical and theoretical relations between art and social life") and Pitirim Sorokin here] . . . Not being artists, not even amateurs, it is hardly surprising that they discuss works of art with the incompetence of philistines and remain victims of the prejudices implanted by their teachers. Their understanding of artistic creativity is limited to an academic viewpoint, prisoners as they are of an outdated ideal of "the beautiful" . . . they are incapable of properly understanding the enduring creative force of imaginary experience . . . In most cases, they have been concerned to isolate artistic expression to a milieu or else to study the environment of art (the public, the indirect but so-called "positive" influences), as if this could possibly lead to any serious understanding of the exact nature of artistic creation! (Duvignaud 1972[1967]:35–36)

A serious challenge to these charges is difficult to imagine. Sociology and art have not spoken well to, or of, one another over the years, and sociological efforts to speak of art have frequently fallen into banality, and worse. Yet, however abject the failings of later generations, one cannot avoid recognizing that there were adept and profound efforts among those giants of European social philosophy who invented the intellectual perspective on the world that came to be called "sociology" in the generation framing the turn of nineteenth century into the twentieth to inspect art from this new intellectual perspective. The Germans in this generation reflected particularly deeply on art and aesthetics as social ideas and practices. One need only point to Weber's lengthy manuscript on rationalization in music (Weber 1969), or Simmel's essays on Rembrandt, Goethe, and the philosophy of art (Simmel 2005[1916] and 1906), or his considerable attention to aesthetic matters elsewhere in the bulk of his work, for example, in his consideration of the philosophical perspectives of Nietzsche and Schopenhauer (Simmel 1991[1907]), both centrally and even obsessively focused on aesthetic and artistic matters. And though Marx himself did not systematically take on aesthetic and artistic questions, the burgeoning body of work in the Marxist sociology of art that emerged after his death, culminating in the writing on this topic of twentieth-century disciples of the caliber of Lukacs (e.g., 1971[1920]), certainly did.

Among the French sociological founders too, there was some important engagement with art. Durkheim's main competitor in his lifetime for the title of inventor of French sociology, Gabriel Tarde, discussed art at some length in his *The Laws of Imitation* (1900), which should be

better known by English-speaking sociologists. Even August Comte, who began as a staunch opponent of art and literary influences (in the *Cours de philosophie positive*), had turned by the end of his life to writing a *Synthése subjective* wherein he argued that a proper sociology must turn to purely poetic means to express its highest laws (1975, 2000).

But what of the founder of the first and strongest French school of sociology, Durkheim, and the school he created? What, if anything, did they contribute in the way of a sociological understanding of art? And in what other ways might Durkheimian thought be brought to bear on consideration of the aesthetic and the artistic? Is it even perhaps possible to conceive of Durkheimian sociology itself, in at least some of its incarnations, as an essentially aesthetic, artistic endeavor?

Here, the prelude ends, and we turn steadfastly to the volume now before you. The claim I make to you, which can only be insufficiently defended in this introduction, as the true proof to sustain it must reside in the exacting and detailed arguments to follow in the subsequent chapters, is that, the "common understanding" of the Durkheimian tradition's failure to address art in any substantive way notwithstanding, it is precisely in the Durkheimian tradition, in its varied incarnations over the years, that we find one of the most compelling intersections between sociological thought and art to date.

As several contributors to this volume make clear, there is considerable evidence of Durkheim's neglect of the question of art, along with looming intellectual and historical explanations for it. The very first chapter of his first major work, the study of the division of labor in society, contains a statement about art that places it in a clearly inferior position relative to science: ". . . art . . . is a luxury and an acquirement which it is perhaps lovely to possess, but which is not obligatory . . . [It] responds to our need of pursuing an activity without end, for the pleasure of the pursuit . . . [whereas] . . . science . . . presents a moral character . . . we do not have to be artists, but everyone is now forced not to be ignorant" (1933[1893]:51, 52). An important fact about art that combined with Durkheim's central intellectual interests and contributed to his broad suspicion of art has to do with the profound differences between primitive art and art in the modern world. In the primitive world, art (or, rather, the activity to which we apply that name, as primitives certainly did not have such a concept) represents the beliefs and values of an entire society, in a relatively unproblematic way related to the deep unity of thought in such societies, and these beliefs are directly joined to practical action in the form of rituals and ceremonies seen as crucial to the very life of the society, while in modernity art has become a realm of representations produced and consumed only by a small minority, and a deviant, rebellious, individualist minority at that, and these beliefs no longer have any tangible connection to collective ritual and

action except perhaps on the rare occasions of the emergence of coherent and cohesive artistic movements such as Parisian Surrealism of the early twentieth century. Perhaps if in modernity one could hope to find an art that recaptured the ethos of the whole people and was morally centered in the life of the community, Durkheim might have treated it with more explicit attention, and earlier, than he did. It is precisely insofar as art leads not to integration and social solidarity, which were guiding principles in his life and thought, but to alienation and individualism that Durkheim was something less than an obvious partisan of this variety of human action.

That said, though, it would still be a grave mistake to presume that Durkheim and the tradition in social thought bearing his name present nothing in the way of a consideration of the place of art in the human world. Even in the seeming silences of the master, there are backhanded statements about the value (or lack thereof) of the artist and his work. And there are more than just these telling silences, especially once we enlarge our frame of vision to include not only the founder of the school, but also the several colleagues who proved invaluable in that founding, and the later writers who invoked the legacy of this thought with more or less interest in faithful translation, in the process of producing their own reflections on the social world.

It must also be said that the possibility of finding an approach to art in Durkheimian thought, while ultimately defensible only by reference to the work they produced, has something important to do with the intellectual context in which we are today reading and making sense of Durkheimian thought. It is not too much to say that this volume only became imaginable in roughly the last two decades or so, for reasons having to do with recent developments in the state of sociology in both the English- and French-speaking worlds. Without doubt, one of the leading factors involved in the movement to reconsider how the Durkheimian tradition of thought might shed light on artistic production and phenomena is the rise of "the cultural turn" in the social sciences. Cultural sociology, which is to be distinguished from the sociology of culture, wherein culture attains no intellectual significance or causal power of any greater quantity than any other item that might be inserted at the end of the phrase, "the sociology of" (Alexander 2003), has been reminding the discipline for several decades now that Durkheim's final work, the one that has the strongest claim to represent the fruit of his most mature intellectual effort, is not *Suicide* or the *Division of Labor*, which still receive the lion's share of the attention in the orthodoxy of the discipline, but rather *The Elementary Forms of Religious Life*. This is a sprawling book of tremendous ambition, in which Durkheim aims to respond to some of the very biggest of the big questions: What are the roots of religious belief? What is the future of religion? How are science and religion related as forms of knowledge? Somewhat hidden among these questions is another, less frequently

noted but certainly equally important: *How is art as a knowledge system related to religion and ultimately to deeper processes of social organization and the production of meaning?*

As is suggested by a number of the contributors to this book, the third, fourth, and fifth chapters (on "The Positive Cult" in the form of mimetic and representative rites, and "Piacular Rites and the Ambiguity of the Notion of the Sacred") of the third book (on "The Principal Ritual Attitudes") of Durkheim's masterwork are where much of the obvious action is to be found in the exegetical effort to find a theory of art in his writing. In the mimetic rites discussed in chapter 3, Durkheim gives what might be read, perhaps only a bit too simplistically, as an account of the origin of much of the performative arts. As Australian totemic groups imitate the totem in, for example, leaping like kangaroos or emerging from a chrysalis like a witchetty grub, they perhaps provide us with a precursor to the theater and dance. The representative or commemorative rites described in the following chapter reveal still stronger roots to the birth of the arts; unlike in the mimetic rites, here the performative, aesthetic element is foregrounded. Durkheim recounts Spencer and Gillen's summary of the Intichiuma of the Black Snake in vivid detail as an "histoire mythique" (1991[1912]:623) of the ancestors of the Warramunga tribe. In this chapter, Durkheim does not leave the connection between primitive religious rite and nascent art to inference:

> It is well known that the games and the principal forms of art seem to have been born in religion and that they long maintained their religious character. We can see why: while pursuing other goals directly, the cult has at the same time been a form of recreation. Religion has not played this role by chance or a happy coincidence but as a result of its inherent logic. Indeed, as I have shown, although religious thought is something other than a system of fictions, the realities to which it corresponds can gain religious expression only if imagination transfigures them. Great is the distance between society, as it is objectively, and the sacred things that represent it symbolically. The impressions really felt by men—the raw material for this construction—had to be interpreted, elaborated, and transformed to the point of becoming unrecognizable. So the world of religious things is partly an imaginary world (albeit only in its outward form) and, for this reason, one that lends itself more readily to the free creations of the mind. Moreover, because the intellectual forces that serve in making it are intense and tumultuous, the mere task of expressing the real with the help of proper symbols is insufficient to occupy them. A surplus remains generally available that seeks to busy itself with supplementary and superfluous works of luxury—that is, with works of art. (Durkheim 1995[1912]:385)

If religious rite and the genesis and nature of art are closely intertwined, then certainly we are not out of the realm of plausibility in considering a massive tome on the nature of the former as a text that might have something important to tell us about the latter as well.

So Durkheim was certainly a sociologist of art, at least in the limited sense that he had things to say about its origins and its position in contemporary European society. Some have considered him also an artist in his own right. In Robert Nisbet's *Sociology as an Art Form*, an effort is made to cast sociological thought in its nineteenth-century roots as an essentially artistic endeavor, insofar as it relies on imagination for its conceptual creative work, produces landscapes (the masses, the metropolis) and portraits (the worker, the bourgeois, the intellectual) in its account of social reality, and manifests itself in its different incarnations quite in the manner of musical compositions, that is, as variations on a few standard themes (order, change, progress).[1] To be sure, Weber, Marx, Tocqueville, and even Auguste Comte are given more attention by Nisbet than Durkheim, but the latter too is presented as an artist at bottom, working toward theoretical discovery without prescriptive rules but only imaginative insight at his disposal, painting complex and aesthetically intriguing tableaux of the new industrial order of Western capitalism, and composing intellectual symphonies on the development and contour of organic solidarity, anomie, and collective effervescence.

Yet Nisbet's effort to understand the artistic dimensions of Durkheim's work remains limited because he does not pursue any concentrated sociology of knowledge or social history of intellectuals and intellectual movements to give his characterizations empirical teeth. Edward Tiryakian, on the other hand, does, and his work on this theme therefore extends to a greater depth. In a revised version of an essay originally published in 1979 that is well known to students of Durkheimian thought (it is subjected to a critical reading by Marcel Fournier in the present volume), Tiryakian posits a "notable affinity between avant-garde art and the Durkheimian School" (2009:153). Both Durkheimian social theory and Impressionist painting "were contrary to what one could call 'the natural attitude,' as Husserl put it" (ibid.:158). Both purported to use rational methodologies and concepts (the social fact and pointillism, respectively) in order to represent aspects of reality that underlay the surface and were of much greater import in determining human action and possibility. In a later essay (which, like the 1979 essay, was revised and presented in his 2009 book), Tiryakian compares Durkheim and the Durkheimians to Picasso and the Cubists in their mobilizations of primitivism in order to reflect on realities of modernity: "By drawing on the primitive as an ingress on the modern, *The Elementary Forms* opened up in advance of its times the 'cultural turn' in sociology. It qualifies Durkheim as a creative avant-garde artist" (ibid.:186). There is even some stirring historical speculation on the fact that Stravinsky's *Rite of Spring* had its scandalous début in Paris in May of 1913, almost exactly a year after the publication of *The Elementary Forms*, and on the points of commonality of the two works: "I would suggest ... an enhanced reading anew of *The Elementary Forms* might profitably be done listening

to Stravinsky's score and imaging [sic] the performance of Nijinsky and his troupe" (ibid.:182).

Tiryakian does not stop at the argument that Durkheimian sociology constitutes an endeavor to describe reality that shared characteristics with artistic movements of the day. He also points to what we should recognize as at least the fragile beginnings of an effort in the first series of *L'Année sociologique* to produce a characteristically Durkheimian view on "sociologie esthétique." Here, we begin to move beyond Durkheim himself to consider the Durkheimian *tradition*, and the argument that Durkheimian concepts provide handy tools for the analysis of artistic production gains considerable strength as we widen our lens to consider those who worked with Durkheim during his lifetime to build French sociology and others who were deeply influenced by the school in subsequent generations.

There is a range of positions on the substance of Durkheim's thought on art and the applicability of his more general cultural theory to the understanding of artistic production and meaning, and the first section of this book endeavors to capture something of this range.

William Watts Miller has been carefully reading and rereading *The Elementary Forms* for many years, and his chapter in our book is an interpretive gem. Watts Miller reads Durkheim's argument in his great final book as, at least in part, an effort to theorize art as a kind of *Gesamtkunstwerk* or, literally, total artwork. But this is not Richard Wagner's synthesis of the fragmented arts into one unified theatrico–musical spectacle so much as it is an attempt to whittle the core of all art down to a process of production of collective energy and power. Following on ground previously carved out by Tiryakian (1981), who compared *The Elementary Forms* in structure and rhetorical force to the Book of Revelations in the Old Testament, Watts Miller describes how Durkheim's work not only analyzes the work of art in its aesthetic totality, but is itself also just such a work. Art-objects, he argues, are always parts of art-events, and art-events can be fruitfully understood in the terms Durkheim uses to describe the "tumult" of collective effervescence. Watts Miller's chapter constitutes a concerted effort to read all art as inevitably collective and therefore to present a critique of most orthodox theories of "high" art.

W.S.F. Pickering offers something of a counterpoint to this argument. In Pickering's account, we find much to illustrate Durkheim's antagonism to art. Drawing strongly from Durkheim's course on moral education, which was given regularly between 1889 and 1912, he reveals a stark contrast between Durkheim's moral seriousness, rooted in the deeply Jewish call to embrace reality, and hedonistic Bohemianism, in Durkheim's time illustrated by Impressionism's escape from reality into the imaginative. So strong is Pickering's argument here that one might well finish the chapter with serious doubts as to the necessity, or even the possibility, of

a book on Durkheimianism and art, although he does allude to the existence of others in the *Année* school (including Mauss, Hubert, and Lalo) who did not precisely share Durkheim's views on this matter. But could it perhaps be that Durkheim rejects art not because of art per se but because of the pressing need in his day to establish the scientific credentials of the new way of seeing things that was sociology? Philosophy, from which Durkheim desired to separate the new discipline, was marked by spiritualist, literary style and pretention, and one of the most basic ways of creating sociology's own intellectual space was to build up its scientific pretentions in opposition to the literary and artistic worlds. As Jean-Louis Fabiani argues, the model of the scientific ascetic fit Durkheim's personality snugly. But despite this, Fabiani demonstrates, there is conceptual advance to be had in utilizing Durkheim's sociological ideas to understand artistic phenomenon such as the two major French festivals that take place every year at Cannes and Avignon.

Armed with an impressive textual set of armaments, Pierre-Michel Menger takes a more radical stance. He undertakes the primary exegetical work toward the establishment of a connection that is explored in a number of the chapters in the second section of the book. The problem of excess, a term of great significance in the work of a lineage in French social thought stretching from Georges Bataille to Jacques Derrida, is demonstrated to be at the very heart of Durkheim's position on art. Menger culls material from a wide range of Durkheim's work, from *Suicide*, where the "excess [that] haunts individual behavior" is the engine behind many suicidal impulses, to the 1911 essay on "Value Judgments and Judgments of Reality," where he finds Durkheim articulating startling thoughts on the "free, spontaneous . . . [and] utterly unnecessary sacrifices" that are constituted by virtuous acts. In a move of considerable exegetical daring and brilliance, Menger finds in Durkheim an effort to treat art as a "supplement" in just the complex sense in which Derrida famously uses the term. It is both something in excess of what is needed and something that fills a lack. Supplementarity, or "the development of an initial state [that] both degrades that state and provides the principle that will compensate for and correct the degradation," is ultimately the key to understanding Durkheim's view here.

Donald Nielsen describes Durkheim's attempt to construct a narrative to explain the causes and effects of excessive individualism as comparable to the literary effort to do the same in the novels of Fyodor Dostoevsky. In this chapter, instead of an exegetical approach to the explication of what Durkheim said about art, the reader will find a stimulating display of some of the ways in which Durkheim can be considered an intellectual fellow traveler of the social novelists of the European nineteenth century. Dostoevsky and Durkheim created works in which egoism produces nihilism and anomie respectively, with a heightened propensity to suicide as a corollary effect. Nielsen also looks at the discussions of socialism as a

solution to the problem of social disintegration and fragmentation in the two writers, and again finds remarkable points of similarity. The upshot is a spur to us to read other literary works in this way. Whether Durkheim was or was not a social thinker interested in art, he clearly was one who trod the same research ground of the realist novelists of his century.

We begin the journey away from Durkheim himself to a consideration of the *Durkheimians* with the chapter by Marcel Fournier. Here we find a meticulous description of the Sociology of Aesthetics (*sociologie ésthetique*) section of the *Année sociologique*, which, though it was not considered by Durkheim as of primary importance in the new discipline, certainly did attract intellectual energy from within the developing Durkheimian school and touch on intriguing questions. Fournier shows that the foundation of a Durkheimian sociology of art can be exhumed from the small rubric of *sociologie ésthetique*, quoting, among others, Henri Hubert's description of literature as a social institution. Michèle Richman then provides a masterful examination of the great array and number of sources in Marcel Mauss's work wherein the aesthetic is at issue in order to reveal his complicated position on the topic. Things such as artworks, Mauss told his students, are no more divided than is a living being, and we are beings who constitute wholes, collectively and individually. Richman looks with piercing exactitude at the chapter on aesthetics in Mauss's *Manuel d'ethnographie* for the most compelling elements of her effort to reinterpret the meaning of his work. The *Manuel* attacks many of the distinctions and categories considered basic to our Western way of looking at things. Art, for the West, is distinct from technology and from "mere" cosmetic body work, but Mauss argues they must all be reconnected as cultural artifacts. Richman reveals that Mauss's guidebook for ethnographers endeavored to teach them, quite appropriately, that these distinctions mean nothing empirically; they are only applied by specific cultures, and they certainly cannot determine the work of the social theorist. Sociology and anthropology are necessarily aesthetic, literary projects. Mauss's frequent use of personal anecdotes and experiences to illustrate cultural facts, as in his discussion of the use of spades in the trench warfare of the Great War in which he himself was a combatant, is indicative of his refusal of some of the categories the Western mind takes as essential to the production of good social science. The revolution of Mauss's work, Richman argues, involves the fundamental remaking of our understanding of the social world.

Sarah Daynes explores a facet of the post-Durkheim Durkheimian work on art too little known in the English-speaking world: Maurice Halbwachs's sociology of music. Halbwachs is celebrated for his work on collective memory, but the essay on the collective memory of musicians, which is the focal point of Daynes's chapter, is much less widely read. Much of the theoretical action in Halbwachs's essay has to do with his effort to define *how* music can mean, i.e., its nature as a communicative

system. He privileges the idea of music as a rational, structural language driven by a semiotic system in which individual elements (tones, chords, rhythms) stand in a structured relation with certain meaningful units, and communication depends on the participants in a musical conversation (audiences as well as performers) having attained a formal competence in the system. Music can communicate, to those who know the language at least, even when it is not performed but exists only as a score. The assumed model is the Western high art music tradition. Daynes briefly invokes the powerful criticism made of Halbwachs's view of musical communication by Alfred Schutz, whose concept of "making music together" pointed to the experiential, lived social exchange of musicians in which music communicates outside the formal text of music, i.e., in the gestures and signs the musicians give one another during the performance. She also pits one Halbwachs (he of the work on the social frameworks of memory) against another (the author of the musical essay), demonstrating that the earlier Halbwachs pointed to the ways in which participation in a shared social life and trajectory enabled a common set of memories. Through a close reading of the world of group improvisation in Kansas City jazz of the 1930s, Daynes shows that the early Halbwachs actually provides a good working theory for understanding how this jazz world produced meaningful communication in the absence of musical scores, indeed, in the absence of the semiotic competence in the language that the Halbwachs of the musical essay posits as a requirement for musical communication.

From Mauss and Halbwachs, both of whom worked personally with Durkheim on the *Année sociologique* team, we move to a subsequent generation of thinkers who came of age after Durkheim's death but imbibed the teachings of the great master and injected their meanings into their own discussions of art. Claude Lévi-Strauss explicitly invoked a Durkheimian predecessor, Mauss, as one of the originators of the structuralist thinking of which Lévi-Strauss was one of the major proponents in the mid twentieth century. Nonetheless, Lévi-Strauss's relationship to Durkheimian thought is generally thought of as complex, close on some points and distant on others. Stephan Moebius and Frithjof Nungesser make the case that some of Lévi-Strauss's work before his "discovery" of the structuralist method reveals him already thinking in Durkheimian terms. In attempting to understand the meanings of Brazilian masks and other facial markings, he rejects an approach that would reduce this material culture to a question of aesthetics and instead looks to Durkheim and Mauss on classification to show that this primitive art is a site wherein "religious, legal, moral, political, and aesthetic intersect inseparably." Art is, per Lévi-Strauss, a Maussean social fact.

The final three chapters of the book (my own on Michel Leiris and two on Georges Bataille by Romi Mukherjee and Claudine Frank) are illustrations of how broad "Durkheimian thought" had become in France by the Second World War. Unlike any of the other Durkheimian

thinkers examined in the earlier chapters, Leiris and Bataille had their feet solidly planted as producers in both social theoretical/ethnographic and artistic worlds. Leiris studied with Mauss, was handpicked by him and Marcel Griaule as the official field note taker of the famed Dakar–Djibouti expedition of 1931–33, and published a number of ethnographic research monographs on African and Caribbean societies. Bataille was closely intellectually associated with Leiris, Roger Caillois (a student of the mythologist Georges Dumézil, himself Mauss's student), and Alfred Métraux, an ethnologist who studied under Mauss. Both men were at one time part of the fascinating band of writers, poets, painters, filmmakers, and musicians loosely organized around André Breton in Parisian Surrealism. I argue that the writerly trajectory of Leiris, from at least the mid- to late 1930s until the end of his life in 1990, was determined by his encounter with the Durkheimian concept of the sacred and the way it shaped his personal inquiries into the nature of writing, biography, and the Other. From his ethnographic and philosophical study of the *corrida* to his autobiographical *chef d'oeuvre*, *La Règle du jeu*, one of his central concerns was an inquiry into the deepest meaning of artworks in modernity, and he consistently carried out this study from a framework that can fairly be classified as Durkheimian; indeed, to call him the only Durkheimian poet would not be an offense to the meaning of either term or his work.

Frank and Mukherjee present complementary but quite different perspectives on Bataille's view of art and the way in which the influence Durkheimian categories had on him affected it. Mukherjee's reading of Bataille on art finds him looking on in horror at the thing and seeking to annihilate it through a cultivation of dark eros, which is the core of the human experience distorted in bourgeois societies into the thing known as "art." Though Bataille perhaps begins with an absorption of some of the key Durkheimian materials regarding sacrifice, myth, and the sacred, Mukherjee argues that in the end he moves completely beyond the Durkheimian opposition of sacred and profane into a new binary system opposing the everyday world in which art and politics take place to the purely mythical world of ecstasy "glimpsed in the metaphor of lovers." Bataille also surpasses, in Mukherjee's reading, Durkheim's framing of effervescence, which closes it within the boundaries of the needs of productive society and refuses it any justification in its own terms. The Bataillean end of erotic unity cannot be collapsed into Durkheimian solidarity, as it points to something imaginary and infinitely darker. Frank brings new material to the discussion of Bataille's perspective on art and his relationship to the renegade Durkheimian perspective on the transgressive sacred (described in Riley 2010). She has obtained access to materials produced by two artist participants in the Bataille-organized secret society Acéphale and uses these new data to show how and what Bataille appropriated from artistic traditions and frames in his effort to

create a politico–aesthetic counter-movement to fascism that nonetheless drew from some of the same sources. The figure of Acteon, the hero who represents tragic eroticism in the fate he suffered for having witnessed the goddess Diana naked in her bath, looms large in the Acéphale myth, and he is opposed by Bataille to the Christian mythic figure of Parsifal in the Wagnerian imagination. The deeply anti-Wagnerian aesthetic of Bataille's efforts in the "lunatic knighthood" of Acéphale is at the core of the chapter, and Frank provides a wealth of detail regarding the particular figures and symbols picked from their mythologies of origin and inserted into Acéphale's transgressive, erotic, anti-ascetic, and anti-idealist aesthetics.

From Durkheim to Bataille may seem quite a long journey, with relatively little of the original substance left at its end, but the one point is not so distant from the other. A profound consensus holds together these two ends of a familial approach to art: their mutual insistence on theorizing the role of art in human experience with respect to myth, the sacred, ritual, and collective effervescence, and their thorough rejection of considerations of art that would remain in the rarefied atmosphere of the aesthetic and ignore the moral ground below. Every thinker examined in this book is resolute about seeing art as a human project inextricably tied to the most basic human business of distinguishing moral values. Contemporary art critics experience an involuntary twinge when they hear such things, accustomed as they are to seeing right-wing opponents of art attack it on these grounds, but they would do well to pick up any of these Durkheimian thinkers in order to open their eyes to the moral basis of their own objections to the conservative critics. Art is always about sacredness in its two binary incarnations, and by implication as well (if not more practically) about the profane. It matters relatively little that Leiris, Bataille and some other later Durkheimian thinkers[2] position themselves as partisans on the side of the sacred in art, the impure, from which Durkheim preferred to maintain a guarded distance. That they all recognize the same field of play makes them members of the same family.

Notes

1. The themes are basically a larger group of his unit-ideas from *The Sociological Tradition*, written a decade earlier than *Sociology as an Art Form*.
2. We might well have included a chapter on Roger Caillois in this volume.

References

Alexander, Jeffrey. 2003. *The Meanings of Social Life: A Cultural Sociology*. New York: Oxford University Press.
Becker, Howard. 1982. *Art Worlds*. Berkeley: University of California Press.

Bourdieu, Pierre, and Loïc Wacquant. 1992. *An Introduction to Reflexive Sociology*. Chicago: University of Chicago Press.

Comte, Auguste. 1975. *Cours de philosophie positive*. Edited by Michel Serres, François Dagonet, Allal Sinaceur, and Jean-Paul Enthoven. Paris: Hermann.

———. 2000. *Synthèse subjective, ou Système universel des conceptions propres à l'état normal de l'humanité*. Paris: Fayard.

Durkheim, Émile. 1964[1893]. *The Division of Labor in Society*. Trans. George Simpson. New York: Free Press.

———. 1995[1912]. *The Elementary Forms of Religious Life*. Trans. Karen E. Fields. New York: Free Press.

Duvignaud, Jean. 1972[1967]. *The Sociology of Art*. Trans. Timothy Wilson. New York: Harper & Row.

Faulkner, Robert, and Howard Becker. 2009. *"Do You Know?": The Jazz Repertoire in Action*. Chicago: University of Chicago Press.

Graña, Cesar. 1971. "French Impressionism as an Urban Art Form." In *Fact and Symbol: Essays in the Sociology of Art and Literature*. Cesar Graña. New York: Oxford University Press, 65–94.

Lukacs, Georg. 1971[1920]. *The Theory of the Novel*. Cambridge, MA: MIT Press.

Nisbet, Robert. 1976. *Sociology as an Art Form*. New York: Oxford University Press.

Riley, Alexander. 2010. *Godless Intellectuals: The Intellectual Pursuit of the Sacred Reinvented*. New York: Berghahn Books.

Simmel, Georg. 1906. *Kant und Goethe*. Berlin: Marquardt.

———. 1991[1907]. *Schopenhauer and Nietzsche*. Champaign: University of Illinois Press.

———. 2005[1916]. *Rembrandt: An Essay in the Philosophy of Art*. London: Routledge.

Tiryakian, Edward. 1981. "Durkheim's 'Elementary Forms' as 'Revelation.'" In *The Future of the Sociological Classics*. Ed. Buford Rhea. Boston: Allen and Unwin, 114–35.

———. 2009. *For Durkheim: Essays in Historical and Cultural Sociology*. Burlington, VT: Ashgate.

Weber, Max. 1969. *The Rational and Social Foundations of Music*. Carbondale: Southern Illinois University Press.

Chapter 1

Total Aesthetics
Art and *The Elemental Forms*

William Watts Miller

Introduction

The Elemental Forms includes a sketch of a general theory of art, which is part of its core worldview, and which lays the basis of what might be discussed as "a total aesthetics." One of the problems in bringing this out is the need to understand the work's overall structure, which in turn has origins in the story of the work itself and why and how it was created. In brief, it has roots in an intellectual crisis in which Durkheim's old theories were undermined by a pioneering ethnography of Australia by Baldwin Spencer and Francis Gillen (1899). In forcing him to rethink things, it sparked off a creative process in which various developing ideas gradually came together in a new sociological landscape. It took him over five years to produce a draft of the eventual work, in a lecture-course of 1906–1907.[1] It then took around another five years to produce a final manuscript, completed in 1911 and published in 1912.[2]

The draft and the eventual work come with the same basic overall structure and centerpiece. This includes the crucial idea, not just of two worlds, but two times of the profane and the sacred: ordinary times of the workaday and routine, and special times of effervescence and of rites of communion at the heart of socioreligious life. However, a key difference is that while the draft merely repeats Durkheim's long-running view of religion as an expression of society, in the work, in contrast, the energies that create the sacred simultaneously create the social. So although the sacred still helps to express the social, it is because it is involved in creating and constructing it.

Another key difference is that the draft comes without an account of art. Like the idea of effervescent energies simultaneously creating the sacred and the social, the account of art was generated in the process of

writing up a manuscript. But without changing the draft's basic plan, it was inserted and woven into the expanded material of what became book three's account of rites. So in a way this has an unfortunate consequence. The issue of art is already implicit in all the core theoretical business of the work's centerpiece, in what became book two. It is nonetheless without an explicit, integrated summary statement of how the energies of effervescence, at once helping to create the sacred and the social, mobilize a combination of assembly, symbolism and art. On the one hand, it is something that only gradually emerges in the work's unfolding overall argument. On the other, it is clear this is how Durkheim in the end decided to structure what became his unfolding overall argument. Accordingly, to return to the initial point, there is no quick access to the role of art in *The Elemental Forms*. Or at least it has seemed to me necessary to go backwards and forwards between different parts of the work, in an effort to investigate what is going on it.[3]

Toward a total aesthetics

Art has at least three meanings in Durkheim's writings. In the subsidiary thesis for his doctorate, for example, art is about practical action in a contrast with science, and in talk, for instance, of the art of politics versus a science and theory of politics. In his main thesis on the division of labor, art is about a surplus over and beyond imperative needs, in a contrast with "life in earnest"—*la vie sérieuse*—to do with these needs. In *The Elemental Forms*, art reconnects with life in earnest thanks to its roots in religion, and also reconnects with ordinary usage to cover music, song, dance, drama, etc. As will be seen, it still involves his abstract theoretical senses of art as practical action and as pure surplus. But a reason for talking about his "total aesthetics" is that it is anchored in art as music, hymn, chant, song, dance, story, drama, mime, costume, face-masks, face paintings, hairstyles, necklaces, earrings, armbands, codpieces, tattoos, drawings, carvings, murals, icons, altars, drinking vessels, feasts, festivals, raves, the atmospherics of a whole theatrical *mise-en-scène*.

The power of a whole fusion of art forms

In exploring art in *The Elemental Forms*, I will start with the aspect that first struck me, and that first suggested the idea of a total aesthetics. It is how the work is not just concerned with a particular art, such as painting, on its own. Again and again it emphasizes the power of a whole fusion of art forms, combined together in a great collective event.

An example comes at a crucial stage in the unfolding overall argument. It is no aesthetic accident that the physical center and midway point of

600 or so pages of text is also the work's intellectual center and turning point. This is the discussion of the energies of times of collective effervescence in book two chapter 7—revealing them as the key to society, the sacred, symbolism, collective representations, "god," the very idea of a power at work in things. These are quite extraordinary energies, arising in the world of sensate experience, but creating an altogether different realm of the mind and of the communication of thoughts and emotions. They are also quite extraordinary in their intensity, involving the total bodily and mental highs of a "surexcitation de toute la vie physique et mentale" (1912a:310).[4]

An obvious question is what helps to generate this state of uplift. The answer includes sex (309), drink (324) and other "stimulants" (547), but also and not least the excitement of coming together in assembly itself (308). Yet how are individuals able to communicate their new inner mental states and energies to one another? Accordingly, the more complex as well as more fundamental question is what can create uplift and also "concretely represent this internal transformation" (312). Durkheim's explicit concern at this point is with the simultaneously creative–communicative power of the symbol. But his discussion implicitly also involves the power of art, above all, the power of a whole fusion of art forms.

This includes dance, song and music at their most elemental and as a combination of "wild movements, cries, sheer howls, deafening noises of every kind" (309). It includes face paintings and bodily decorations of every kind (312). It includes, tattooed on people or carved on things, emblematic designs in every form (316). It includes processions, and all sorts of enactments of mythic scenes and dramas (310–12). It includes, not least, an event's entire atmospherics, as when held "at night, among shadows pierced here and there by the light of fires" (310). Nor is it just about a combination of art forms on a particular occasion. It is especially about their extraordinary impact in the enactment day after day, week after week, of a whole interlinked series of events (313).

The work's centerpiece on effervescence thus helps to prepare the way for book three's account of the interlinked rites of religion, but also its account of art itself. The book starts with a chapter on rites of the negative cult. It is to lead on, however, to a set of chapters on rites of the positive cult. So again it is no aesthetic accident that these chapters are located at the center of this book, and are about rites located at the heart of religion. At the same time they involve another lesson on the need to grasp the work as an unfolding totality. It is all very well to quote the overture in book one that plays up the negative character of the sacred, as a realm "set apart and forbidden" (65), as long as it is also noticed how it holds fire on times of exuberant effervescence. These are saved for the *pièce de résistance* in book two, revealing them as times of the positive warmth and communion at the heart of religion, as well as social life. There is then

both a restatement and a new development of all this in book three—an opening concern with rites ring-fencing the sacred with negative barriers, a core concern with rites breaking through these barriers to create intense positive feelings of communion, and, to complete the picture, a chapter on rites embodying the ambivalence of the sacred's negative–positive sides. But the message driven home in the final part of this final chapter of the work's final book is that religion is first and foremost a realm of communion and of the individual's uplift to a higher life (592). It is then re-emphasized in the work's conclusion that "a faith is above all warmth, life, enthusiasm, a heightening of all mental activity and the individual's uplift beyond himself" (607).

In my view, book three's core elemental rites of religion are sacrifice, prayer and sacred drama. But Durkheim himself discusses them as sacrifice, the mimetic rite, and the representative or commemorative rite. In any case, it is to lead up to the last of these as the most significant. It is sacred drama that is understood by the faithful themselves in essentially social and moral terms, which is why it has "exceptional importance" (541). Moreover, it is the chapter on this key rite that he selects as the location for his account of art.

Yet instead of just seizing on it straightaway, it is again imperative to understand it through what comes before, not least in the immediately preceding chapter on what I believe is prayer and he calls mimetic rites. As he explains at the start, these are rites that in various concrete ways act out and mime an object of concern, such as an animal species and its renewal and regeneration (501). He then builds up his own quite graphic picture of how, for example, they imitate the movements of the kangaroo, the flight of winged ants, the noise of the bat, the cry of the eagle, the croaking of the frog, the hissing of the snake (504). Indeed, as he says, these acts of imitation involve an ability and skill— *habileté*—that is "quite remarkable" (507). So an obvious point is that his discussion of mime is about something that must in some way involve art. It is possible to compile a by now familiar list of art forms that include— along with mimetic actions— costumes, images, dramatized narrative, dance, song, a mantra-like chant repeated again and again (501–8). These could be seen as helping to constitute mime as a complex art form in its own right, even if each is also an element of other art forms or a complex art form itself. But as his argument develops, and though mime remains a central case, it turns out that what matters is a powerful concrete way to fix the mind on an object of concern, "to say the thing wished to happen, to call up and evoke it" (512). So this is why he might actually be talking about prayer. He certainly alludes to a form of prayer—often called the petitionary prayer—when he talks about a rite where the faithful together address "a request to their gods for an outcome that is their ardent desire" (513). He insists it must still draw on the power of concrete symbols. For these are how people can focus on a hope, and can together "concentrate

on it the force of their attention and will" (512). So do we not get, here, to fundamentals of prayer? Whether in a call to god, or in a repetition again and again of mantra-like chants, or in the imagery of the mimetic rite, prayer is action that concentrates thought on key concerns. At the same time, prayer is action that creates hope in the very process of expressing it. And it is through a concrete symbolism mobilizing a concrete aesthetics that prayer has this power, and is at its core, whatever its individualized forms, an act of communion.

Yet his chapter on this religious rite never explicitly mentions prayer. Moreover, it ends with a section, not on creativity and art, but causality and science. Why? Part of the answer is a need, in arranging all the work's material, to save up art for the chapter on sacred drama and its very special significance. But in looking for a slot for science, why choose the "remarkable" artistry of the mimetic rite?

Perhaps the great unfolding theme of *The Elemental Forms* is the theme of power. Its centerpiece unveils the extraordinary elemental energies of times of effervescence as a key, not just to society and not just to "god," but to the very idea of a power that is active in things, and ends with a section on this basic concept or category of thought. In turn, almost every chapter that follows has a section on a particular aspect of the general theme. A neat contrast, then, is if— just before the chapter linking religion with the power and creativity of art—another links it with ideas of power and causation in science. Yet how is the candidate for this the mimetic rite?

All its skill, imagery and evocativeness is art. But it is art shot through with belief in cosmic forces operating according to fundamental principles, and with belief in the rite's "physical effectiveness" as a way of activating these forces to bring about a cosmic event. The hissing, slithering, writhing in the representation of the snake activates the reproduction of the snake, etc. So it is because this highlights the issue of magic that may be why Durkheim sidelines prayer. He very much wants to attack views that root religion in magic and bogus science. On the contrary, it is through the idea of a force at work in things that religion generates both magic and science (516–18). Nor is the idea a mere piece of abstract intellectualism. It is embedded in the concreteness and totality of social life. As in the mimetic rite—with its simultaneous expression, communication and creation of hope—religion is about moral effectiveness, not just physical effectiveness. Indeed, it is part of his argument that "the rite's moral effectiveness, which is real, has driven belief in its physical effectiveness, which is imaginary" (513). It is even more his argument that such beliefs endure because they are bound up with the rite's action as a whole, and do not just stand or fall on their own (513–16).

This has far-reaching implications for science, but also for art. It is how, as in the mimetic rite, art is not just frameworked as Art—an essentially modern social category—but is part of a whole fusion of symbols, practices, concerns, and moral and cosmic beliefs.

It is also how sacred drama, though again not just frameworked as Art, is still special. Thus Durkheim himself sees a weakness in his attempt to understand religious rites through their social moral meaning. It is as if it is an understanding confined to the sociologist, a secret hidden from the faithful themselves, and covered over, as in sacrifice and the mimetic rite, by belief in religious action's physical effectiveness (529). This is why he is so interested in sacred drama and gives it pride of place in his account of religious rites. It is where religion's social meaning emerges in people's own self-understanding and their concern to "maintain the community's moral identity" (530).

However, it is possible to draw on his account to put things differently. All religious rites involve belief in some vast power, and the great religious rites of sacrifice, prayer and sacred drama are all rites of communion both with one another and with this power, as a power at work not just in the cosmos, but in our own lives. Thus the point about sacrifice and prayer cannot just be that they press automatic buttons to cause a desired physical event, but that they involve various ways to invoke a vast power to act in our lives to help with various physical, moral, social or spiritual concerns. So, if sacrifice and prayer have a hidden Durkheimian meaning veiled from the faithful by their beliefs, it is less thanks to the physical effectiveness he regards as imaginary than to the god he regards as imaginary. It is the same with sacred drama, which is also shot through with belief in god. Yet it is still special. It could be seen as an essentially existential rite, reflecting on the human condition. Its form of communion with one another and with a vast power is less a way to make particular practical appeals to do with particular practical concerns, more a way to think about and explore a whole human–divine relationship. And it is a rite of communion that does this through its enactment, in sacred drama, of sacred myth.

Durkheim's chapter title refers to "representative or commemorative" rites. Yet his actual discussion again and again stresses they are not just a representation, but a "dramatic representation" (531–43). And what they dramatize is not just an existing society itself, but its "mythology," a shared set of stories and beliefs that are "how the society represents man and the world" (536). The dramatization of myth is how the rites are also commemorative. Their whole point is "to stir up certain ideas and emotions, to bind the present with the past and the individual with the collectivity" (541). However, commemoration of an ancestral past is only one of the elements of a rite binding "the individual with the collectivity." It is a mistake to seize on the work's interest in collective memory as if this is all there is to collective myth. Myth is not simply a story and remembrance of times gone by, but a story and vision of times to come. It is a narrative that joins different times, through ideas reaching across the whole of time. The very idea of "ancestors" is about a past containing the seeds of a future, and links the present generation of individuals with

one another in a sense of a continuing moral community that embraces the dead, the living and the not yet born. It is through such ideas that a society constructs a whole grand narrative, but also a whole concrete way in which "the society represents man and the world" and in which myth is "an ethic and cosmology at the same time as a history" (536).

This connects with the work's conclusion, which pictures how modern society could also have its own flourishing rites of commemoration, then at once sees obstacles in a contemporary moral "mediocrity" and lack of idealism (610). It is all very well to have commemorations of the past, except if they are divorced from any real moral vision in the present. A basic underlying point is about the solidarity of memory and hope. At the same time it is about their interlinkage within the concrete stories, symbols, practices and beliefs as well as abstract ideas that are all part of a living faith's living mythology. But it is especially about the solidarity of memory and hope through enactment of myth as drama.

It almost goes without saying that the power of drama is the power of a combination of art forms fused together in a "total" art form in itself. Durkheim's account involves the total aesthetics of two types of sacred drama. In one, the rite has a fixed location, enacts a story's episodes on a more or less "conventional stage," and pictures its scenes with the aid of symbols and images forming an elemental "theatrical set" (533). In the other, the faithful go off together on "pious pilgrimages" and travel from sacred place to sacred place to enact, *in situ*, a sacred narrative's events (534). Both cases bring out the power of drama to make myth come to life, but also to keep it alive, in continuing new enactments. Durkheim himself is then concerned with how the rite's revitalization of myth is at the same time "to revitalize the most essential elements of the *conscience collective*" (536). But there is another aspect to his account of sacred drama and the various ways it is staged and performed. A common approach to myth is just to analyze the structure and content of its stories, as though they have life as a disembodied "text." Yet even if myth has some such ethereal existence in the human mind, it is not how it grips the human imagination. Myth, as a living force, cannot be understood in abstraction from the actual social and aesthetic forms that create and re-create it through the generations. So his account is important in helping to drive this home but also, in the process, opens up questions about his focus on drama. Once we get away from myth as a mere spectral "text" and ask what keeps it alive, a basic answer is collective oral storytelling. It is in itself a sort of ritual enactment of myth. It can take place again and again, on more or less any occasion and in even the smallest group. And so it is a key to how myth lives on during ordinary times. Yet this is also how it is a way to appreciate the quite extraordinary resources and energies going into a great collective event, and the impact of drama's total aesthetics.

But there is something perhaps even more fundamental. Oral storytelling is, on its own, an important genre of art as living performative

art. At the same time it is in combination with other things an essential element of sacred drama itself. Either way, it helps to bring out how a Durkheimian approach to aesthetics is especially concerned with art as living performative art and as an event. An implication is that, far from just identifying art with "art-objects" such as paintings, it is always a good idea to ask: how are "art-objects" part of "art-events"?

It is possible to come up with at least three main answers to this question in *The Elemental Forms*, starting with ways in which art-objects are an integral part of the total aesthetics of great collective occasions. An obvious case in book three is how paintings and other images help to form the "theatrical set" of one type of sacred drama. A more theoretically central case takes us back to book two and its concern with objects in the form of sacred totemic emblems. Durkheim emphasizes the emblem as a concrete symbol of an identity, and that the totemic sacred thing *par excellence* is not an actual creature, such as the eagle, but its representation in paintings, drawings, carvings and schematic designs (177–80, 294, 315–17). Moreover, "these paintings and designs are at the same time aesthetic in character, and a first form of art" (180). So a general point is how the emblem is an art-object with a key role in sacred ritual times. A particular example involves its engraving an instrument with a key role in sacred ritual music, the bull-roarer (309, 315–16). It is not just music, but music performed on special iconic art-objects that contributes to the power of a great collective occasion.

Another type of case is to do with bodily art. Hairstyles, face paintings, rings, tattoos, codpieces and so on are in no way mere art-objects. All bodily art is first and foremost performative art, intimately bound up with its impact in action and helping to create the individual as an art-event. But it is also, through a particular overall ensemble of costume, cosmetics and finery, a creation of the individual as a total art-event, a bodily aesthetics that is in turn part of the power of a Durkheimian collective event.

This leads on to a third case, to do with his interest in the collective emblem's engraving on the individual as a tattoo (163–67, 315–16, 332–33). It is not only because the tattoo is such a dramatic sign of group membership; it is also because it is so permanent, acting both as a lifelong commitment to an identity and as a lifelong reminder of it. His underlying argument is about a need for objects with enduring aesthetic–symbolic power as enduring reminders of events in our lives. But his explicit concern is with objects empowered by events of special sacred times, sustaining memory of them in ordinary mundane times (330–31).

So is there a gap in his account? The main way in which book two's momentous foundational times are recalled and relived is through book three's periodic ritual times. Next in line, he relies on recall of both sorts of events through objects, although these include bodily art and are not simply paintings, carvings etc. But it is possible to find counterparts of his great religious rites in humbler, ordinary practices—sacred drama in

storytelling, the "mimetic" rite in quite simple actions of hoping, sacrifice in an everyday solidarity of meal sharing and gift giving. That is, the social world operates through forms of everyday symbolic action that are also bound up, as in the story, the get-well card, the meal, the gift or bodily art itself, with forms of everyday aesthetic action. In turn, and as in the modern sacred space of the living room, it involves whole particular combinations of objects and activities in a sort of total aesthetics of ordinary life.

Even so, *The Elemental Forms* is centrally about the importance of special times of assembly, and a Durkheimian total aesthetics is centrally about a fusion of the energies of assembly, symbolism and art. Accordingly, a way to proceed is to work through their interrelation, starting with assembly and art.

An intrinsic link between the aesthetic and the social

In the centerpiece's scenes of effervescence, assembly is in itself an "exceptionally powerful stimulant." Everybody's physical closeness to one another helps to generate "a sort of electricity" and individuals open themselves out to a communication of feelings in which these spread, heighten, amplify, reverberate and "echo and re-echo one another" (308). What this means, and as becomes clear as the discussion proceeds, is that the power of assembly is an integral element of the power of art as real live performative art. They are two aspects of the same dynamic, inextricably bound up with one another in generating a whole creative aesthetic atmospherics—in a gospel session, a jazz club, a dance hall, a rave, a pop festival, grand opera, the circus, the theater. Put another way, real live performative art is also interactive participatory art. So a basic point is that in living performative art there is an intrinsic link between the aesthetic and the social. In fact, there is a union of aesthetic and social form.

This contrasts with the idea that aesthetics is altogether autonomous. The idea is common to the sort of sociology of art that deals only with external data, and the sort of philosophy that looks down on sociological concerns as inessential. Indeed, there seems a link between this philosophy of art and other attitudes: an unexamined preoccupation with painting, a cult of the genius of the individual artist and the taste of the onlooking expert, a dogma that the only real art is "high" art. Yet even a philosopher should at least ask how art-objects are part of art-events. But in any case, the art of "high" culture very much includes collective performative art, hence art as an event. And here it is always a collective achievement, not least in its dependence on some sort of interaction with the audience for a creative energy in the performance itself. So there is still a basic intrinsic link between the aesthetic and the social.

However, the range of cases raises important questions about the interactiveness of different kinds of participation, about the relationship in live art between organization and spontaneity, and about varieties of effervescence. The most obvious kind of participation is when everyone in the assembly is directly and fully involved in its activity. For example, everyone at a gospel session joins in the singing, swaying, clapping, dancing and creation of a collective "high." It is possible to come up with other cases, such as the rave, in looking for modern equivalents of scenes "of the wildest excitement" in Durkheim's Australia (311). But this also takes us to how there is at least an elemental order in all the singing, swaying and deafening noises of every kind that help to generate effervescence. It is in making the point that he writes: "le tumulte réglé reste du tumulte"—or, to try to get across this cool laconic take on frenzy: an organized rave is still a rave (309).

So let us now ask about cases of a division into "performers" and the rest. Again it is often obvious that these other members of the assembly are active participants. In the case of pop concerts and festivals it is even odd to call them "the audience"— as if, without joining in, they quietly listen to the music. It is also odd to call them "the spectators"—as if, without joining in, they passively watch the jumping, the whirling, the erotically clad, pierced, ringed, tattooed bodies, the flashing lights and whole electric *mise-en-scène* of the pop act. Nor is it hard to come up with other cases in which organized effervescence is still effervescence, complete with specialist performers, an order in their art, and rules of how to participate. It is just that in a whole range of settings—a jazz club, a country and western festival, stand-up comedy, satire, cabaret, the circus—genteel restraint is very much *not* the norm. Excited involvement is what is required. It is a way in which organized spontaneity is still spontaneity. This is not just in a need for at least some preparation and planning. It is to do with events that draw on a basic cultural model of how to go about things, but, as in a jazz session, organized round expectations of creative interaction, improvisation and spontaneity.

What is then to be made of the genteel restraint, less than obvious involvement and even organized anti-effervescence, at work in modern "high" culture? It is possible to see this as yet another form of modern alienation, killing off live art by creating "the audience" and destroying active participation. But it is also possible to see it as still having roots in Durkheim's Australia, since it still involves an interaction between artists and audience that generates a whole creative atmospherics. In fact, there are many ways in which both groups are soon aware whether or not this dynamic is taking place. Even so, the argument cannot get very far unless we can come up with other varieties of effervescence besides Durkheimian "tumult."

"Tumult" might fit the sheer wild dionysian energy of the pulsating music, frenzied dance and erotic scenes of a work that was premiered

the year after *The Elemental Forms* and that generated a riot among the audience: Stravinsky's *Rite of Spring*. But it just does not fit in with the restrained force of his ballet, *Apollo*. Nor does it fit in with the power of his sacred mythic opera, *Oedipus Rex*, and how it combines the dionysian and the apollonian as part of a complex range of ideas and emotions. But Durkheim's own account of art, when we get to book three, also emphasizes its power to arouse a whole range of ideas and emotions (542–44). So there is a need to ask what, in his centerpiece on effervescence, might combine with art to do this, yet without always stirring up dionysian tumult. The key, then, is how assembly can generate quite different "highs" in its power to get across, amplify, reverberate, echo and re-echo any idea or emotion. So it is not really very paradoxical if it stirs up "highs" delighting in restraint. In all live art, and in all its dionysian and apollonian aspects, a "high" is still a "high." At the same time, to repeat another quite basic point, in all live art organized spontaneity is still spontaneity. Thus if we again take performances of works "by Stravinsky," they are created through the organization *and* spontaneity of an artistic division of labor, just as they are also created through the collective discipline of aesthetic forms *and* the spark of individuals. But in the end they are created in performance itself, in an interaction that can work through a variety of styles of participation to generate uplift.

Durkheimian total aesthetics is accordingly a way to insist on a fundamental unity throughout all live art, whether against a snobbery dismissing popular culture or a reverse snobbery rejecting high art. Or again, even if the storytelling and live arts of ordinary times seldom generate "tumult," they are not only interactive and participatory but have their own forms of organized spontaneity, all of which are ways to connect times of everyday social groupings with times of assembly. In sum, the fundamental unity is how, in an intrinsic link between aesthetic and social forms, and whether in storytelling, sacred drama, a jazz session or grand opera, the power of live art is the power of collective, participatory, performative art.

Practical and pure aesthetics

Yet is it possible to go from live art to find a unity in the whole of art? In effect, the question involves switching focus from art and assembly to art and symbolism, and at the same time takes us to Durkheim's account of art itself.

It is essential to approach it through what comes just before. This is his account of sacred drama. It is especially about art as social symbolism, which I shall discuss as practical aesthetics. It is only after driving home the rite's symbolism that he then proceeds to drive home how things always go beyond this in energies of art as sheer creative surplus, which I

shall discuss as pure aesthetics. So a danger of taking the section on art on its own is to see art only in terms of pure aesthetics, even though he says, in the section itself, that there is always a mix of "two elements" (548). And it is clear from the chapter as a whole that his two elements involve the symbolism versus surplus of what I call practical versus pure aesthetics. The upshot, then, is that a fundamental unity across the whole of art is how in different ways it always combines practical aesthetic power and pure aesthetic energy.

Thus he goes on from sacred drama to compare three types of great collective occasion: the religious rite, the popular festival and the game. But it is to insist they always combine two basic elements of life. One is about the social, moral and religious forces at work in life in earnest, or, as he says, *la vie sérieuse* (548). The other is about enjoyment, recreation, a free-play of ideas and actions, and a transgression of ordinary norms (542–48). But at bottom it is a sheer creative energy, which goes far beyond any symbolism of life for real, to generate what he accordingly calls a *surplus* (545). It is this sheer creative surplus that he considers the essence of art. So looking at art one way, as something going beyond *la vie sérieuse*, he says it is "superfluous" and "a luxury" (545). But looking at art another way, as itself a basic element of existence, he says it is "a necessity" (546). At the same time these two aspects are part of an overall argument that reconnects art with, and roots it back in, *la vie sérieuse*. It turns out that art is not just a necessary moment of escape from life in earnest. It is also interwoven with life in earnest, as in the core case of the religious rite in which, "art is not a mere external adornment," "the cult in itself incorporates an aesthetics," and "there is a poetry inherent in all religion" (546). Moreover, the fundamental reason has to do with how and why art goes beyond any role as a symbolism of *la vie sérieuse* even while rooted in it. The extraordinary energies that break through the world of mere empirical experience, to create a realm of symbolism, representation and society, sweep on in the very process to create a pure aesthetic surplus. So, as Durkheim insists, even the most solemn religious rites are not all meaningfulness, but come with an element of sheer *jouissance* (pleasure), while even the festival and the game are not all playfulness, but come with an element of sacred symbolism. His whole discussion of art then concludes with how the difference between the various cases "is, at bottom, the different proportion in which these two elements are combined" (548).

In going on to develop all this, let us start with practical aesthetics. It could cover how art ornaments the utilitarian. But in a Durkheimian context it is above all to do with how art empowers the symbolic. Thus there are two very basic points implied in his remark: "there is a poetry inherent in all religion." One is that anything that is a center of symbolic meaning and energy is also a center of aesthetic action and energy. The other is that the symbolism gets an essential power from the art, which is "not a mere external adornment." This is fundamentally thanks to the

energies of assembly, symbolism and art at work together, and so we need to grasp what his centerpiece on effervescence says on symbolism (329–31).

Here, Durkheim's concern is with society as a realm of communication, created and re-created in times of assembly. And once again he invokes its extraordinary collective energies. These can overcome the barriers between individual internal states, to form the collective representations that make possible the communication of ideas and emotions, so also making possible society itself. But it is not through a sudden springing up of abstract concepts on their own. It is through shared meanings around particular actions or objects, which can then go on to work as symbols of more abstract collective representations. And his key case is how an emblem acts as a concrete material symbol of an idea of a group. The emblem is not just a "convenient way" to express a sense of identity that already exists. On the contrary, the emblem "helps to create this senti-ment; it is itself a constitutive element of it" (329). And so it is not just that symbols help to create ideas that can then exist on their own. On the contrary, symbols remain a constitutive element in the life and career of more abstract collective ideas, continuing to inject a definite meaning into them "because they have helped to form them" (330). Indeed, he attacks the idea of pure abstract ideas. Concrete material symbols are not mere "artificial devices" and are not just "sorts of labels added on, for easier management, to already fully-formed representations." On the contrary, "they are an integral part of them" (331).

Thus a radical implication of his account is that it is impossible to get very far in thinking about god or society thanks merely to an abstract theology or an abstract sociology, stripped of all the resources of a whole concrete symbolism. Another implication is that this symbolism is not just a function of an already existing society. On the contrary, it is society that is created and re-created, constituted and reconstituted through the power of symbolism. It is certainly true that in Durkheim's view symbol-ism helps to express the social world. It is false that this is all there is to his view. Symbols help to express the ideas and emotions making up social life, for the very good reason that they help to create, construct and empower them. As he summarizes his argument: "social life, in all its aspects and in all moments of its history, is made possible only thanks to a vast symbolism" (331).

Or, as we can now add, social life is made possible only thanks to a vast symbolism and aesthetics. Durkheim himself had already noted, in the key case of the emblem, how it comes complete with paintings, drawings, carvings etc. that are "at the same time aesthetic in character, and a first form of art" (180), and then goes on to insist, in book three, that "there is a poetry inherent in all religion" (546). Or, to generalize, where there is symbolism there is also art. But it is only if we grasp the radicalism of book two's account of the symbol that we can fully appreciate book three's chapter on sacred drama and grasp the importance of a practical

aesthetics in which symbolism gets an altogether essential power from art. It is part of a campaign against just seeing the symbol as expressive, when instead it helps to create and constitute a social world. But it is also part of an attack on the sort of intellectualism that dissolves life in a bath of abstract ideas. It is instead the particularity, concreteness and power of art as symbolism that is an indispensable way—as in the paradigmatic case of sacred drama—to think about great issues to do with god, society and the human condition.

In a way, though, Durkheim becomes even more radical. In pushing the necessity of art, he does not push it as the necessity of practical aesthetics, but above all as the necessity of pure aesthetics and a free creative "surplus." It is possible to identify two forms of this surplus in his account, as well as to argue for a third. They could be discussed as the sensuous, the imaginative and the poetic.

The sensuous is about relish in a creativity of experiences that need not signify anything in particular. Whatever the underlying meaning of acrobatics, atonal music, abstract paintings or new cuisine, there is a level of a more or less symbol-free enjoyment of bodily movements, sounds, colours, shapes, textures, tastes, smells. Thus his account of art warns against seeing signs everywhere, not least in the case of religion: "A recipe for error, in trying to understand the rites, is to believe in having to assign every action an exact purpose and definite rationale . . . Some have no purpose . . . [and] there are scenes of jumping, whirling, dancing, shouting, singing, without it always being possible to give a meaning to this agitation" (545).

The imaginative, in contrast, is about relish in a creativity of meanings or at any rate an appearance of meaning. It is just that it takes us beyond belief and *la vie sérieuse* to tales of a world of legend, fiction and fantasy, not least tales of monsters and the macabre (543). But in general it involves what he calls "free creations of the mind" (545). And taking his two forms of pure aesthetic surplus together, they are about enjoyment in the creativity of what he calls "free combinations of thought and action" (545–46).

It is not hard to see a fusion of these elements in the poetry inherent in all religion. There is a relish in the power and sensuousness of its sounds, rhymes, rhythms, forms, textures, even "colours." At the same time there is an enjoyment of the power and imaginativeness of its metaphors, similes, hyperboles etc., the scenes conjured up, the characters and stories brought to life. It is just that it is impossible that all this pure aesthetic energy starts only where an underlying sacred symbolism stops. Put another way, it is impossible to translate poetry into prose without a loss of both power and meaning. So there is need to inject into his account a third form of surplus, which, generalizing from his example of poetry, could be called the poetic. It is about a pure aesthetic relish in the very skill of the ways of creating, constructing and communicating a social, sacred symbolism. Like his

other forms of surplus, it involves a sheer enjoyment, a *jouissance*. It goes beyond a genteel, tasteful appreciation of how a drama enacts the fate of Oedipus, say, or the story of Our Lord's Agony and Crucifixion. There is a need to recognize, in such cases, an intense yet ambivalent emotionality in their aesthetics. They can stir up outrage or ridicule when the art is not good enough and fails the symbolism, yet also a sense of transgression if, in detachment from the overall power of a drama of the Crucifixion, there is just a focus on its art as art. To bring out these tensions in a union of sacred symbolism and the poetic, it is perhaps best to stick with a Durkheimian marriage of *la vie sérieuse* and *jouissance*.

But there is a further problem raised by Durkheim's concern with the pure aesthetics of art as art. Most or all of the examples in *The Elemental Forms* are embedded in religious life. Few if any of its cases of art seem frameworked as Art. On the one hand, then, it could be argued that in a Durkheimian approach there is no such thing as a pure work of art. Like the sacred, after all, meaning can in principle transfer on to anything, even the most uncompromisingly abstract modernist painting. On the other, this runs into the Durkheimian objection that it is not a good idea to go around looking for meaning all the time, and in every branch and thicket of forests of symbols. Similarly, it is always possible to put a work of art to mundane use. Again, though, is this a good idea? Art, as well as offering escape from the meaningful, gives relief from the workaday and utilitarian (546). So it misses the point to insist that nothing is in essence a pure work of art. What matters is to explore actual ways in which there are moments of enjoyment of art as art, which could include how there are some things enjoyed, in practice, as pure works of art. In effect, this takes us to the dynamics of an overall set of relationships to do both with ways of focusing on a work, and with ways of framing and contextualizing it. Part of the story, then, is how there are conventions governing these. Part of the story, also, is how there are switches across conventional boundaries, in what can amount to acts of transgression. Perhaps, for example, it is only occasionally that there is any particular concentrated aesthetic focus on a painting of the *Mona Lisa* on a living-room wall. Perhaps, even when it is noticed, it is usually in moments that survey it as part of the general total aesthetics of a modern sacred space. Yet all the time the *Mona Lisa* on the wall is viewed, somehow, as a pure "work of art," while the carpet, despite its nice pattern of sunflowers, is not. And the *Mona Lisa* remains framed as this, even if a rebel in the family gives it a beard and moustache, or puts it to use as a toilet seat. The transgressive symbolism would stop having impact if the work stopped having meaning as an icon of art. No doubt this is a tame affair compared with the transgression, especially of sexual norms, that Durkheim associates with all the energy of great collective sacred times (309), and with the carnivalesque atmosphere of the festival (547). But a tame transgression is still a transgression. It is also a route to explore a number of ways of crossing conventional

boundaries, and how these organize art. Indeed, it is possible to identify four "ideal-types" of transgression, to do with two pairs of opposite cases.

There is the aestheticism of pure pleasure in the art as art of a drama of the Crucifixion. But there is also the intellectualism of going on about the underlying meaning of acrobatics. So in one kind of case, *jouissance* transgresses seriousness. In the other, seriousness transgresses *jouissance*. And in this pair of cases the basic transgression of "normal" attitudes is about switching focus. In the next pair of cases it involves switching context. The *Mona Lisa of the Living Room* is taken down from the site of its annunciation as art and debunked in the toilet. Or a urinal is moved from the ambivalent sacred–profane underworld of the lavatory—which is not just utilitarian—and taken upstairs to the purer realm of the Salon of Art. Even so, is the recontextualization a way to debunk the salon? Or is the effect to upgrade the urinal, and refocus on it as art?

Marcel Duchamp began his series of "ready-mades"—a year after *The Elemental Forms*—with a bicycle wheel mounted on a kitchen stool, continuing with a bottle rack and a urinal, first exhibited in 1917. But as he is supposed to have said much later: "I threw the bottle rack and the urinal in their faces as a challenge and now they admire them for their aesthetic beauty."[5] And it may be that they started out as anti-Art—in a campaign against a whole modern category—then quickly transformed into "transgressive" art. Yet they have long since become a more or less established part of "normal" art, like so many other once avant-garde works, such as Stravinsky's *Rite of Spring* or Duchamp's own now iconic image of the *Mona Lisa* with a beard and moustache. But this is also to say that all these works combine with one another to shake up and reframe the social category of "art," in the very process that absorbs them into it. The significance of this process is not that, in crossing particular boundaries or challenging particular conventional attitudes, it sweeps away all boundaries and all conventions whatsoever. The interaction between norms and their transgression is a basic source of creative collective energy in art, and of ways to combine practical aesthetic symbolism with pure aesthetic *jouissance*.

Indeed, despite a continuing enjoyment of the old traditional game of hunt the meaning, an underlying social–sacred symbolism at stake in each successive new wave of avant-garde art is not to do with any particular meaning at all. Instead, it is how they play around with the modern social–sacred category of Art itself. Even so, is it possible to connect all the different manifestations of traditional as well as modern art in some sort of universal criterion of aesthetics?

A universal criterion of aesthetics?

It might seem clear enough that the sketch of a general theory of art in *The Elemental Forms* involves a basic criterion of aesthetics. It is just that

it is not beauty, which is never even mentioned. It is about power and energy.

This ties up with various key aspects of total aesthetics: the power of a fusion of art forms, the power of art in an intrinsic link with assembly, the power of art as practical aesthetic symbolism and its energy as pure aesthetic surplus. At the same time it connects the art of the normal and the transgressive, of ordinary and special times, of popular and high culture, of the event and the object. In sum, it brings together and can help to make sense of a vast diverse range of cases. Sometimes it might seem obvious that they involve, like the *Mona Lisa* without a beard and moustache, an aesthetic of beauty. Often, it is not. Instead, it is a basic power and energy in whatever form that unites the wildness of the dionysian, the force of the austere, the grip of tragic drama, the cruelty of satire, the explosiveness of farce, the *frisson* of tales of horror, the monstrous and the macabre.

So what should now be done is to look for counterexamples, and a way to begin is with a distinction between foreground and background art. The job of foreground art is to absorb attention, through its power and energy. The job of background art is not to absorb attention, thanks to a lack of power and energy. Or rather, it is how this contributes to the impact of a totality. Tinkly baroque table-music is an essential part of the total aesthetics of the glittering chandeliers, sumptuous food, perfumed bodies, painted faces and powdered wigs of an old regime court banquet. But at the same time it raises an issue of style, in particular the style of a general atmospherics and whole ensemble. One extreme could be called cornucopianism. It fills every part of an environment with items each of which can be foreground art and a focus of interest on their own, and it is this clamour and competition for attention that generates the overall, even engulfing effect. Another extreme could be called minimalism. It clears an environment of anything with an interest of its own, so that everything imposes a concentration on the ensemble itself. Both styles obliterate, in their own fashion, a distinction and interaction between foreground items and background art. In practice, and in between these two ideal-typical extremes, a perennial aesthetic issue is the balance of power between foreground and background within a totality.

This includes issues arising from modern switches of the environment of traditional art. In at least some cases, it can wipe out the impact of foreground art, as with the removal of a painting of the *Madonna* from a church's altarpiece, to become merely one *Madonna* among many in a long endless line in a museum. There is almost no need to give them each a beard and moustache, since the basic work of subversion has been accomplished already. Or again in at least some cases, another way to sap aesthetic energy is by changing the environment of background art. A basic pattern of court table-music during the old regime was to herald the royal entrance with a dramatic fanfare of drums and trumpets, soon settling down to repetitive tinkliness for the rest of the meal. It is one

thing, then, if a modern concert includes the fanfare in its programme. It is another if, in the interests of authenticity, it consists almost entirely of background baroque. This is a recipe for the atmospherics, neither of a banquet nor a concert, but a museum lecture.

Essentially similar points could be made in returning to modern art itself. It is possible to become absorbed in the energy of a painting that consists only of an expanse of white, even or especially if it is an expanse of intense sheer white, without any tonal or textural variation whatever. It is another matter if it is merely one of many such paintings, lined along an art exhibition's walls. Or a sort of degree-zero concert might offer a programme of pieces that play nothing at all. Yet even in actual cases, where only a single piece plays nothing, how can it absorb attention and have aesthetic power?

A basic part of any answer is the sheer *jouissance* of playing around with conventional understandings of the category of Art, pushing things to the limit and out-minimalizing minimalism with a "music of silence." This in turn acts as a reminder that all art is created and enjoyed within a wider cultural environment of other works, key exemplars, general ideas and assumptions, etc. But there is a quite specific reason why it is not just thanks to its own aesthetic power that a "music of silence" might command an audience's attention. It is also thanks to the modern genteel rule of disciplined focus on the orchestra and their music-making. A "music of silence" is highly conventional in how, to work, it depends on this norm. But it is also highly transgressive in what it does with it. The focus on an orchestra that plays nothing at all bounces right back on to the audience themselves. And it is not simply to encourage them to create, through their own movements and sounds, the textured silence of a new music. The piece's dramatic switch of focus emphasizes the presence and participation in live art of an audience, a participation that is essential for the energy of the art itself.

A general lesson of all this is that an approach to aesthetics should help with strange cases. Complaints that it is too broad and hazy are simplistic and sterile. To do its job, it must look beyond the straitjacket of taken-for-granted boundaries and let in unusual things. An example, in Durkheim's own account, is how his realm of aesthetics links art and the game (546). Again it is unfruitful to insist on a fundamental divide between these. It is better to ask how the game is itself a form of art—above all, like sacred drama, collective participatory performative art.

But there is now a need to switch from the strategy of exploring concrete cases to consider, if only for a dialectical moment and although they never decisively settle anything, more abstract issues. In particular, what might make power and energy an *aesthetic* power and energy?

A basic key in Durkheim's account is that art is about "free," "creative" energies of a "surplus." This could be taken further, to link it with his dualism of human nature and to suggest something like an aesthetic circle

in which art transcends the dualism, but in the very way it remains rooted in it. Art is a realm of human freedom and creativity that transcends both the physical and the social worlds, but in the very way it remains rooted in them. A distinction could be made between the "sensate" and the "sensuous," to help with bringing this out in the case of the physical world. An essential form of a Durkheimian pure aesthetic surplus involves a sheer enjoyment in playing around with the material "sensate" world of sounds, colours, shapes, jumps and whirls. But it is through a creativity that transforms and transfigures it into an aesthetic "sensuous" world of sounds, colours, shapes, jumps and whirls. Art is a realm of human freedom precisely because it is a way of transcending the physical world, even while remaining bound up with this in the very effort to play around with it.

Another essential form of Durkheimian pure aesthetic surplus involves a sheer enjoyment in playing around with meanings in imaginative "free creations of the mind." At the same time there is a need to bring in something like the poetic, to understand how, as in his paradigmatic case of sacred drama, pure and practical aesthetic elements are fused with one another at the heart of *la vie sérieuse*. Yet like the sacred as god, the sacred as poetry is still about a realm of creativity that sweeps beyond the social world, precisely in the way it remains bound up with this in the transformative, transfigurative energies of a surplus.

In sum, this is clearly not to see art as a realm of human freedom and creativity thanks to an absence of any rules, conventions and categories or a lack of any anchorage in a social milieu. On the contrary, these are essential ingredients of creativity itself, even or especially in modern art's playing around with the modern social category, Art. All the same—and although much might be said for latching on to different various forms of a creative energy, including beauty but not merely beauty—it is possible to get only so far in searches for an abstract universal formula and criterion of aesthetics. It is necessary to get on with explorations of more concrete issues, through a strategy concerned with paradigmatic cases. Thus a way to identify and tackle an issue that arises nowadays, but that lies sleeping in *The Elemental Forms*, is to widen out its exemplar of sacred drama to a more general concern with "sacred art." This is in the sense that, whether associated with the secular or the religious, or with everyday or special times, or with folk or high culture, central cases of art are constituted by "sacred art" in the energies of a live event and as collective, participatory, performative art.

Repro art

The modern world involves forms of communication that go far beyond anything in Durkheim's Australia. They also go far beyond anything

in Durkheim's own time and the unique but crackly recording of him reading extracts from a 1911 conference paper.[6] Yet this only helps to underline the importance of asking about an issue that arises from his work, although never explicitly addressed in it. What is the fate of live, participatory "sacred art," in an ever-accelerating development of "repro art"?

Repro art is the art made possible by modern mass reproductive techniques. It includes new genres of art, which could accordingly be called "neo-repro" art. A paradigmatic eighteenth- and nineteenth-century case is the rise of the novel, while a paradigmatic twentieth-century case is the rise of the film. It also includes mass reproductions of copies of musical performances, paintings and so on, which could accordingly be called "re-repro" art.

Thus although mass reproducibility is a hallmark of all repro art, it comes with key differences. Reading the millionth imprint of a novel is to read the novel itself, while watching the millionth screening of a film is to watch the film itself. Even hearing the umpteenth rendering of a piece of music might be in a way to hear the music itself. At least some sort of reproducibility of the piece is involved in all the many variations between live as well as recorded performances. This contrasts with an inherent irreproducibility that a modern "cult of the original" attributes to the paintings or other objects of what could be discussed as iconic art. It is necessary to go and view the actual "original" painting to view the painting itself. Seeing a state of the art reproduction is not good enough, since it is not to be in the very presence of the icon itself. Yet it still offers a mass access to the work, which is indeed what helps to make it iconic. So it is still part of a development that, through the creation of new genres and reproduction of traditional forms, entails far-reaching changes in the role of art in society. In a word, repro art makes art available and accessible as never before.

A downside

Yet all this choice, availability and access, often at the press of a button, comes at a price. Its mechanized, individualized technology eliminates the creative energies of spontaneity, interaction and involvement that are essential elements of art as a live collective event. So a worry is if repro art, even while helping to give birth to iconic art, is at the same time the gravedigger of sacred art.

The novel has become a modern hallowed site of Literature, and its very discussion as repro art might seem sacrilegious. Yet in contrast with traditional collective oral storytelling, it generates an individualized, atomized, mass readership, without any close, direct and meaningful interaction either with one another or with the author. Indeed, it is a key

site of a modern Dictatorship of the Author. True, there is the reader's personal response, along with collective debate, and changing collective currents of fashionability and evaluation. There is nonetheless a brute fact about the text, as laid down in the printed page and reproduced in the first as well as the millionth copy. It simply does not allow for all the interactive participatory energies that go into a collectively told story and that spontaneously vary and re-vary things from one telling to another.

This is why hearing the umpteenth rendering of a piece of music is only in a way to hear the music itself. As with the story, an integral part of the music itself is that each collective realization spontaneously changes it. So a curious consequence of the nature of sacred art is that in a way no one listens to the story itself, or hears the music itself, or sees the play itself. These are the ever inaccessible and ever incomplete totalities of all past, present and future creatively variable performances. It could be argued that a similar curious consequence applies both to repro art and iconic art. In a way no one reads the novel itself, or watches the film itself, or views the actual original painting itself. These involve the totalities of all individual responses to, collective debates about, and changing historical interpretations of the works. Even so, it is important to cut through such philosophical puzzles to identify basic sociological differences between what is going on in live as against mechanized art.

The cinema is a less dramatic case of these differences, in that it developed as a collective occasion and gathering, far from tending to dissolve this. It was a key twentieth-century form of collective ritual in individual lives and generated its own collective electricity, as a place to meet up, eat, drink, smoke, chat, have discreet sex, see the news, glimpse the stars, as well as watch a film. Yet whatever the interactive hubbub going on within the cinema itself, the film cuts off audience and performers from each other. Although leaving the assembly free to express their feelings, it leaves them with no actual, immediate power of input into events on the screen. And thanks to TV, DVD, etc., it is inherently vulnerable to the same mass technological processes of individualistic consumption as literature. As a way to watch films, the cinema's heyday is over. Or in running through some of the main twentieth-century forms of theater—a town's local rep, the summer seaside variety show, the circus, the music hall—this, too, can sound like one of history's casualty lists. Cinema and the theater survive. It is just that they might seem as marginalized as each other, in an advanced age of atomistic de-participatory repro art.

On the other hand . . .

Repro art is still art. There is no doubt a need to stress issues of form, and how an entire medium might be inherently atomistic. There is often blindness to this, in a preoccupation with issues of content. It is nonetheless

misguided just to criticize repro art thanks to its form, regardless of any content. In particular, tension between form and content might be seen as one of the sources of creativity throughout art. Just as it can be a thought-provoking experience to watch, collectively, a drama about an individual's struggle against engulfing social pressures, it is not necessarily a route to false consciousness to watch, alone, a TV soap imagining community, or to read, in isolation, a novel about solidarity. In general, the rise of genres such as the novel and the film might be seen as involving channels of creative energies that develop, through use of a new technical medium, a protean aesthetic power of their own.

But this gets only so far in responding to a worry that is not at bottom about the status, as art, of forms of repro art. It is if they are on the way to becoming hegemonic, in a marginalization of forms of sacred art as a live collective event. There are various ways of addressing this concern and looking for patterns, not of an emerging dominance, but of mutual stimulation and interaction. One strategy is to explore the interrelation between literature, film and theater as a modern classic trio of the arts. Another is to compare as well as contrast the cases of music and painting.

Thus a basic point, here, is again how mass reproduction makes available as never before a vast diverse range of music and painting. Another basic point, in turn, is how it can stimulate interest in going to hear live musical performances, or in going to see the original paintings themselves—in visits to the museum as a shrine of art, or to the special blockbuster exhibition as a carnival of art. However, there is a fundamental problem with iconic art. It is the ambivalent status of a treasury of artefacts as objects belonging to a common cultural heritage but also as objects of private ownership. This generates disputes over how museums come to possess which particular bits of whose cultural heritage, and over restitution to rightful claimants. But it is also why so much iconic art disappears into a private world away from public view, or even into bank vaults away from anyone's view. These problems are to some extent created by repro art itself, and the interest and value it invests in iconic art. So in sum, the interaction of repro and iconic art is bound up with the idea of a treasury of artefacts for show in museums and exhibitions as part of a public culture. Yet it is at the same time bound up with major issues and obstacles in the achievement of this culture.

Although a treasury of artefacts can include objects such as a piece of music's original score, it is without raising the same problems for a public culture of music's actual performances. These events can be held anywhere whatever the location of an original score, if, indeed, any such thing exists. It is in any case simplistic just to equate a score with a work, or to see it as a set of instructions comprehensively dictating how the music is to be played. It is merely a basic guiding model, to be fleshed out in the different detailed renderings of actual performances—in a studio, a recording of a live performance, a live performance itself, but also in an

interaction between these forms of enactment. Interaction between the live and the reproduced has nowadays become an essential part of music as a flourishing public culture, and can work in various ways. One is how it influences the repertoire of what is played, as well as styles, approaches and interpretations. Another, bound up with this, is how it feeds into knowledge of particular musical genres, musical pieces, groups, individual artists or composers. The main way, again bound up with all this, is how it stimulates interest in live music itself and going to hear, absorb and participate in it in the atmospherics of a collective occasion and event. Moreover, there is a special type of event that stands out, not only in music but across the arts and modern culture as a whole.

The festival

In Durkheim's Australia, the year divides into two different periods. In one, everybody separates to get on with a mundane, essentially individualistic existence. In the other, everybody assembles in a series of non-stop rituals that can last for weeks or months, and in which "there are veritable orgies of collective and religious life." It is then just added, a bit dryly, that in modern social worlds the two forms of duration follow at closer intervals and without the same contrasts: "the more societies develop, the less they seem to tolerate any too great an interruption" (500).

Yet what can instead seem to have happened nowadays is a change in the social calendar in which, far from simply alternating with one another, ordinary and special times go on simultaneously and in parallel. Just as ordinary routine times go on throughout the year, special times of all sorts of festivals also go on, non-stop, throughout the year.

Thus even or especially in the challenge of trying to understand the many different things it might involve, the whole phenomenon of the festival emerges as a key modern site of Durkheimian enquiry about art, culture and society. This is because it emerges as a hard-core case of a collective art-event, which is not merely difficult but pointless to replace with a reproduction of the event, and yet which has a flourishing role in contemporary life.

Indeed, it is thanks to its importance as a time of collective energies that the festival is a way to highlight a crucial Durkheimian argument about the individual and to the effect that the collective is always individualized through each person's own understandings and perspectives (382, 605, 622). So it is not exactly unDurkheimian to insist that if art generates uplift it is not least through its impact in individual lives, in varieties of aesthetic experience. It is just that it is never simply individual. Deeply personal responses, to this or that work or aspect of a work, draw on the power and resources of art as an irreducibly collective creation, showcased in events such as the festival.

The art of *The Elemental Forms*

Perhaps enough has now been said to suggest that *The Elemental Forms* comes with an approach to art that has considerable interest and importance, and that lays the basis of what might be best described as a total aesthetics. At the same time it is of interest to explore how this work *on* art is also a work *of* art, and a start might be made with some comparisons.

Like a work of music, it introduces various themes that it then goes on to expand, interweave, reformulate and complicate in the movements of a developing whole. This is just a very basic characteristic of its way of arguing. It nonetheless means that a recipe for error is to pick out bits of text without concern with their context, and as if the work is written analytically, in separate individual atomistic units of argument. Instead, it is written dialectically as an unfolding whole.

Like a work of literature, it is heavily reliant on a thick-textured description of things. It is committed to digging around in the complexity of the particular and the concrete, in a search for an underlying logic and a basis of more abstract claims. So another recipe for error is to see the essence of the work in its abstract claims. This is like seeing the essence of a novel in a synopsis, and disregarding the whole texture and detail of the novel itself.

Or again, and like any work of art, it involves a distinctive style. All the same, these are no more than comparisons. What Durkheim intended was a work, not of art, but science. Yet this is why it runs into a quite specific problem, to do with linguistic register.

It is a work of science that is first and foremost a work on the sacred. But, for example, a way to kill off a sense of the sacred is to write about it in the manner of a work of economics and accounting. An aesthetic imperative of *The Elemental Forms* is to write in a register appropriate both to its genre as a work of science and its topic as a work on the sacred.

This is easier said than done. But it is helped by the work's whole concern with a world of "energies," "forces," "powers," and accordingly with a discourse that spans religion and science; indeed, an explicit claim is about the religious origins of scientific notions of an energy or power. It is also a way to understand how, in the work's thick-textured description of things and effort to create in the reader's imagination a real sense of a realm of the sacred, there are so many passages that are like literature, in effect *are* literature. Again it is no aesthetic accident that some of the most important examples come in the centerpiece's account of effervescence.

Although Durkheim, in retheorizing, transforms Spencer and Gillen's Australia, his description of scenes of effervescence is quite faithful to their description of scenes of the wildest excitement. But he also injects it with aesthetic touches of his own. Their description of one of these scenes concludes:

The fires died down, and for a short time there was silence. Very soon, however, the whole camp was astir. (Spencer and Gillen 1904:238)

His corresponding description concludes:

The fires died down, and there was a profound silence. (Durkheim 1912a:311)

It is obvious that the change in some way transfigures the original account. Yet even if literally false, isn't it artistically true? Does it not help to capture the whole atmospherics and sense of drama, in the rite's creation of a sense of the sacred?

In any case, and as in general with other examples, it is through the use of quite simple language rather than anything especially ornate. Thus in going through the overall text, it is possible to compile a long list of its use of different patterns and figures of speech—antithesis, chiasmus, irony, laconicism, hyperbole, metaphor, synecdoche, enumeration, amplification, repetition, and so on. Once more, however, actual instances of these are generally quite simple, and in some cases their use is rare, although in other cases they turn up again and again. But a basic point is that they are part of how, in the work itself, as in religion, art is not a mere external adornment. They are essential for a number of jobs: stirring up interest, awakening imagination, conveying an idea of things, marking importance, driving home themes, disturbing assumptions and opening out questions. Together, their most fundamental job of all is to empower the work and give it a force that—not least in science—arises from the way in which argument and the art of argument are bound up with one another.

In turn, this is bound up with grumbles about Durkheim's rhetoric. So it is important to ask which views of science might underlie such complaints. There is the ideal of science *au naturel*, as a sort of bare, naked, transparent discourse, even though the very notion of transparence has ineliminable metaphorical, symbolic–aesthetic roots. There is also the ideal of science as a discourse of analytical reason and atomistic units of argument that always mean the same, even if rearranged at random or at any rate independently of any original contextual roots. But both ideals are about science as a uniquely privileged form of discourse and the vehicle of access to the truth. Whatever position might be taken on all the issues this raises, or in exploring Durkheim's own stance on them, a more limited point here is the need to get away from sweeping invocations of science to condemn rhetoric. Any scientific account is embedded in some or other kind of rhetoric, or, it could be said, a practical aesthetics. The question is which kind, and again, in the case of *The Elemental Forms*, how its aspirations to science come with aesthetic concerns in writing about uplift to the sacred.

A further complication is that, inasmuch as the work is art, it is not sacred art but repro art, and indeed in an early modern technological

form. Spencer and Gillen helped to pioneer the use of photography and film in what is nowadays known as visual anthropology, and often fall back, in their printed texts, in saying that the scenes they witnessed are impossible to convey adequately in words. In contrast, Durkheim relies solely on the power of the printed word to draw readers closer in the imagination to a faraway land of the sacred, but also, in the process, to disturb assumptions of an individualism entrenched in modern culture, and to open out issues about the modern world itself. Durkheimian "Australia" is not just Australia. It is a realm of elemental forces at work, throughout history, in creating and re-creating social life and a source of its renewal, in a modern crisis, through the idealism and energy of another explosive moment of effervescence.

The notion of effervescence is central to the message of *The Elemental Forms*. But it is also central to how, drawing on Durkheim's own views, the work can be seen as simultaneously science and art thanks to energies generating some sort of surplus. It is the notion itself that can be seen as part of an effervescence of ideas in which the work sweeps beyond routine academic caution, in energies of a creative intellectual surplus. "Effervescence" so excites Durkheim that it becomes a key to all kinds of things, not just society and religion, but art, symbolism, conceptual thought and science. It is no doubt necessary to put each of his arguments about effervescence to the test of routine academic critique. The trouble is not just if this loses sight of the creativity of a whole dynamic interplay of ideas; it is if it loses sight of the need for creativity itself, and how deconstruction and critique are only moments of a larger process in which science, like art, depends on adventures of the mind.

Thus one of the great themes developed in the work culminates in the conclusion. It is how both science and religion break with empirical experience, how both belong to the realm of speculative and conceptual thought, and how both are concerned to understand the world through a search beyond an outward surface of things for an underlying logic of "internal relations between them" (613). Seen one way, science is a power to understand the world through a methodical, disciplined investigation of these relations. Seen another way, science has this power thanks to a radical creativity of ideas. It is all very well, in the case of *The Elemental Forms*, to acknowledge the power of its "insights" in assisting with lines of investigation. It is difficult to conceive of an *Elemental Forms* that keeps this power, but leaves out the ferment of ideas that helped to create it. This, in the end, is the Durkheimian key to it as art, but also to the creative process in general, through the idea of a synergy of forces that lift up into a surplus. In other words, a lesson of Durkheim's account of this process is that where there is synergy there is surplus. Yet if he is on to something here, in the cases of art, religion, and social and moral life itself, why should it not also apply to science?

The issue of creativity in science is so important to Durkheim that it helps to conclude the work and leads on, in the final pages, to an inspiring vision of sociology. True, it is not to suggest that it might come with an imaginative surplus. Instead, it is to stress what it might achieve through the synergy or, as he says, "synthesis," of a whole dynamic interaction of ideas and consciousnesses (637). But the work's own arguments make it hard to see how there can be all this synergy without surplus, and if, a hundred years on, the work continues to spark off ideas, it is not least thanks to a creativity that is an essential basis of both art and science.

Notes

1. See Durkheim (1907f). The significance of the lectures, as an initial draft of the work, was suggested by W.S.F. Pickering (1984:79).
2. The story of the work's creation and of Durkheim's re-imagination of Spencer and Gillen's Australia is explored in detail elsewhere (Watts Miller 2012).
3. This essay is a corrected, revised, and hopefully also clarified version of an earlier article (Watts Miller 2004). In the process it owes a general debt, in various particular ways, to contributors of other essays in the present collection.
4. Unless stated otherwise, all subsequent page references are to Durkheim 1912a.
5. Quoted as if in a "letter of 10 November 1962" from Duchamp to the surrealist Hans Richter (1965:207–8). It may have been as a joke in which they agreed on the "letter," complete with a precise but bogus date, as an impressive academic documentation of a chat between them. See Tomkins (1996:414–15).
6. See Durkheim (1996); the original, rediscovered by Jennifer Mergy, was recorded in 1913 and was of an extract from 1911b.

References

Durkheim, Émile. 1907f. "La religion: Origines." In 1975, vol. 2:65–122.
———. 1911b. "Jugements de valeur et jugements de réalité." *Revue de métaphysique et de morale,* 19:437–53.
———. 1912a. *Les formes élémentaires de la vie religieuse: le système totémique en Australie.* Paris: Alcan.
———. 1975. *Textes,* 3 vols., ed. Victor Karady. Paris: Minuit.
———. 1996. "Des jugements de valeur", Université de Paris-Archives de la parole, at Le corpus sonore: http://gallicadossiers.bnf.fr/ArchivesParoles
Pickering, W.S.F. 1984. *Durkheim's Sociology of Religion: Themes and Theories.* London: Routledge & Kegan Paul.
Richter, Hans. 1965. *Dada: Art and Anti-Art.* London: Thames & Hudson.
Spencer, Baldwin, and F.J. Gillen. 1899. *The Native Tribes of Central Australia.* London: Macmillan.
———. 1904. *The Northern Tribes of Central Australia.* London: Macmillan.
Tomkins, C. 1996. *Duchamp: A Biography.* New York: Henry Holt & Co.
Watts Miller, W. 2004. "Total Aesthetics: Art and *The Elemental Forms.*" *Durkheimian Studies,* 10:88–118.
———. 2012. *A Durkheimian Quest: Solidarity and the Sacred.* New York and Oxford: Berghahn Books.

Chapter 2

Durkheim, the Arts, and the Moral Sword[1]

W.S.F. Pickering

Introduction

On May 1, 1889 the Universal Exhibition was opened in Paris. As the greatest exhibition of its kind, it revealed extraordinary sights and sounds in the capital of the artistic world. The Exhibition made its mark on young aspiring artists whether they were composers, playwrights, painters or poets. The capital was dominated by the so-called Impressionists, Symbolists, and neo-Realists. They included such painters as Seurat, Van Gogh, Lautrec, and artists associated with Manet and Monet. The leading playwrights were the Goncourts, Poe, and Zola; the most famous of the poets was Mallarmé; and among a host of composers the best known were Fauré, Debussy, Ravel, and Saint-Saëns. Further, success was to be found in engineering. Le Tour Eiffel was opened at the time of the Exhibition and was the highest structure in Europe. It epitomized France's prowess in the sciences as well as in the arts. Here was no sentimental looking back to the past but the creation of new forms, new expressions, new representations, new experiments, new inventions. Those involved in this artistic and scientific explosion were not only French. Such was the prestige and creativity of French artists that artists from around the world flocked to Paris, as in an earlier period in time, Italy had acted as a magnet drawing artists from other countries who wished to develop their creative potentialities.

For Paris and for France these were mind-blowing times. They reached back to the 1850s and extended to the terrible turning point—the slaughter of the Great War. Such was the supremacy of France in the world of the arts.

Early Durkheimian publications relating to the aesthetic

An intellectual could not live in Paris at the time and be unaware of the city's preeminence in the artistic world. However, Durkheim, concerned with a "scientific" study of social phenomena, appeared to be ambivalent, if not hostile to what was going on in the artistic world around him.

His great creation, the journal *L'Année sociologique*, saw the light of day in 1898 during the period of *la belle époque*. After twelve volumes it ceased publication, symbolically in 1913 as the Great War was about to erupt, though later it continued for a while under the editorship of Marcel Mauss. Books and articles devoted to aesthetics were indeed reviewed in most volumes, but nearly always on the final pages. In 1979 Edward Tiryakian analyzed the contents of the section, called *Sociologie esthétique* or just *Esthétique* (Tiryakian 1979). The section was always a small one, on average about seven pages for each of the ten years in which such reviews appeared. The first two issues of the journal did not contain such a section. Henri Hubert was an editor for every year in which there was a section on the subject. Parodi wrote two reviews and Durkheim one. Tiryakian suggested that it was an area where young contributors were tried out but where senior members also lent a hand. The key contributor was Hubert himself. Art could be a useful component in analyzing elements of feeling and affection in representations. But when all is said and done, it was a weakness of the *Année sociologique* that it did not give attention to the arts which were so flourishing in Paris at the time. Sadly, one might say, Hubert seems to have lost interest in the subject. The contribution of the *Année sociologique* group to the study of the arts was, to say the least, meager, especially if one considers the work of Simmel and Max Weber on the subject (Zolberg 1990, particularly p. 38).

In what follows, an attempt is made to account for this limited consideration of art in the dominant school of French sociologists of the day. One inevitably starts with the work of the master himself.

In his last and greatest work, *Les Formes élémentaires de la vie religieuse*, published in 1912, Durkheim emphasized that religion is the source of all social institutions and learning; he had considered this to be so earlier in his work. In terms of academic subjects it gave rise to philosophy and science. Art also stemmed from religion (Durkheim 1912:544; 1915[1912]:381; Pickering 1984:264ff.).[2] In his study of representative rites of the Arunta, he saw art and play as very much integral parts of their religion—secondary but nevertheless integral and necessary. However, beyond that study, in no place do we find Durkheim examining art with the same "scientific" thoroughness he used in considering religion or suicide. As will be observed later, however, he did refer to art and its associated activities in various contexts. It might be argued that a lack of time and occasion prevented a more thorough treatment of art—he could not deal with everything! But there were other, more positive reasons

why he appeared to distance himself from a systematic study of art, especially modern art. These are to be gleaned in *L'Éducation morale* (1925). His treatment of art here deserves special attention.

The lectures on moral education were published posthumously in 1925. They were given to would-be primary-school teachers and were repeated over many years. The first course was in 1889 in Bordeaux. It ought not to be overlooked that that was the year of the Universal Exhibition. The lectures contain attitudes towards art, which, to say the least, are surprising. Durkheim was no artist and therefore had no practical advice to offer to students. What he did was almost the reverse! The book is more about morality than techniques of teaching. This is evident in his severe warning against giving a prominent place to the arts in the school curriculum, when he refers to the dangers of the "Aesthetic culture." The main points can be summarized as follows.[3] Art fails to bring people face to face with reality. It is concerned not so much with the facts of lifephysical, moral, socialas with the imagination. Indeed, it is the imagination that is the operative faculty of the arts.

1. Since art is based on imagination, it is not proscribed by boundaries. It is allowed full range of expression. The imagination assumes, if one may use a modern expression, that everything is up for grabs. In this respect it is an undisciplined exercise without boundaries or controls, mental, moral, or social. The artist works intuitively since he (or she) is freed from conventional rules (see also Durkheim 1955:29–32; 1983[1955]:2–4).
2. In the light of the lack of constraint, art is not concerned with historical background or with scientific theories. Its aim therefore is not to make a contribution to knowledge. According to Durkheim, the best way to achieve knowledge is along the path of the scientific method.
3. Since the mental processes of the arts are not concerned with truth as rationally ascertained, they are akin to religious devotion or to sacrifice. Hence they ultimately rest on emotional drives within the individual.
4. Morality can only have a negative or secondary role in exciting the imagination. A morality falsely based on the imagination does not inculcate moral habits or a sense of duty: indeed, it is no morality.
5. Art turns people away from themselves and therefore makes them forget the reality of life. It is like a game which is escapist in nature and from nature.
6. Without raising the details of Durkheim's concept of the sacred, it is legitimate to state that Durkheim feared that art, when it is removed from the control of religion as it is in modern Western society, either disregards or threatens what is sacred in society (see Pickering 1984: ch. 7). The sacred in Durkheim's eyes is at the basis of society. Clearly when Durkheim was lecturing to would-be teachers he had in mind

not the art of a bygone age, when it was subject to religious boundaries, but the secular art of his day.

Hegel made the observation that before the Reformation, religious ideas were generally conveyed through art rather than the reading of the Bible. Doubtless this close link between religion and art would have had the support of Durkheim. Art was involved in and transmitted the sacred.

What kind of art?

Before an evaluation is made to Durkheim's position a prior question needs to be raised. What kind of art did he have in mind as he lectured and wrote so unfavorably on the subject? He referred to "art" (*l'art*) and never (so far as I know) to "the arts." He posits no precise definition of art. In the lectures on moral education, he said that what he meant by art was *les beaux arts* and literature (1925:306; 1961[1925]:267). As just noted, this seems to make sense of much that he wrote on the subject. But there are some places in *L'Éducation morale* where he includes games along with art, when he talks about recreation (see below). Generally speaking, what he had in mind when he used the word art seems to be the plastic arts: the visual arts, painting and sculpture, together with literature.

His attack on the arts was not, according to the evidence, an attack on one particular art form. Nor is it to be found in the content of any of the arts. Rather, it was on the overall exercise of "doing" art. In the modern era the arts lacked any external control, other than that contained in the physical objects themselves. This meant that, at least, they had no purpose that related them to the good of society other than that contained in the physical objects themselves. An uncontrolled imagination was one in which morality had no place.

Was Durkheim opposed to the arts of his day because so much art was associated with the *salon*? In the only place (so far as I am aware) where Durkheim refers to the *salon,* he does so as an example of an intermediate group between the state and the family/individual. In his early days he held that such intermediary groups were necessary for the well-being of society (1902[1893]:11ff.; 1933[1893]:10ff.). But in *L'Éducation morale* he was more specific and praised Germany for such group activity, and criticized French society for a lack of it. And in referring to *salon* life, he wrote:

> The only social relations for which we show any inclination are those sufficiently external so that we commit only the most superficial part of ourselves. That is why *salon* life has taken on such importance and attains such a great development in this country. It is because it is a way of satisfying to some extentor rather a way of pretending to satisfy—that need of sociability, which, in spite of everything still survives in us. Need we demonstrate how illusory that satisfaction is, since that form of life in common is only

a game without any connection with the serious aspects of life (*l'existence sérieuse*)? (1925:198–99; 1961[1925]:198–99, 234–35)

So it was that the *salon* fulfilled a social need but at the same time the quality of its own social life was quite inadequate. Why? One could well assert that it was elitist and removed from democratic ideals. In Toqueville's time, in France and elsewhere in Europe, the best products of the arts were to be found in the hands of patrons who constituted an élite (Zolberg 1990:35). But that issue for Durkheim was not as important as that which centered on the subject matter and the nature of the social life of the *salons*. People in these groups were not concerned with matters that were vital to the well-being of society. What went on in the *salons* had no connection with *l'existence sérieuse*. Was there not a preciousness, an exclusiveness with hedonistic overtones, to be found in their midst? Certainly, such a setting for the arts was not universally admired at the time, either by artists or the public at large.

Impressionism gave rise to a strong moral reaction. This was clearly apparent when Gustave Caillebotte, the great collector of Impressionist paintings bequeathed sixty-five of them in his will to the State. He died in 1893 and Renoir, who was named executor, was vilified in *Le Temps* as a "veritable malefactor who had misled the youth of art" (quoted in Gaunt 1970:54). If the government agreed to accept "such filth," the aged diehard of the *salons*, Leon Gerome, argued, it would proclaim moral degeneration. He begged the President of the French Republic not to open any exhibition related to Caillebotte (ibid.). In the end the State accepted only half the collection. It would seem apparent here that there were those who argued that moral degeneration was not in the *salon* itself but among the Impressionists. Is this not a case of the pot calling the kettle black?

Searching for an explanation: an initial approach

Thus far we have described Durkheim's attitude to art and the aesthetic. It is startling that Durkheim, who helped to create a new human science, which in many ways was associated with the notions of the social and of personal freedom, autonomy, and democracy, should have taken the negative stance he did. How can such an unexpected attitude be explained? Needless to say there are many possible answers. Some might turn immediately to Durkheim's Jewish background and see in it a link with his attitude to art. This touches on a difficult subject and is riddled with methodological problems and hazards.

All too often it has been said that the greatest gift of Judaism to human civilization has been in the domain of morals and the moral life rather than in the world of the arts. There is indeed a vein in Jewish thought which holds that certain aspects of the plastic arts stand in opposition to

basic religious doctrines. Such products contain dangers that give rise to idolatry (Kochan 1997:110ff.). Pictures, but especially statues of human beings are to be condemned. This taboo can readily be extended to the arts in general, save music. Thus, the work of the Jewish artist, Camille Pissarro (1830–1903), greatly disturbed the Jews of France, not least because of his anti-Jewish outlook. In the nineteenth century, art developed among Jews in France via Jewish immigrants from Russia. One such person was Marc Chagall (1887–1985), who, although he had his Jewish critics, made windows for Jewish religious buildings as well as for Roman Catholic cathedrals.

But if one hazards the assumption that it was the plastic arts to which Durkheim was opposed, we might ask one or two further questions. Was Impressionism, the focal point of Parisian art in his day, the hidden object of his attack? It seems generally agreed, as has been noted, that the Impressionists were often disliked because of their gaiety, lightheartedness, and lack of moral rectitude. This last point would certainly have been contemptible in Durkheim's eyes, for it was morality that was his passion. That the Impressionists idolized the culture of the streets would not in itself upset Durkheim: here at least was part of social reality. It was the disregard of Jewish morality and a radical way of life that alienated middle-class Jews.

Certain strands in Jewish thought can be correlated with Durkheim's own attitudes towards the arts. Mention might be made of one in particular. It is the call, indeed the command to Jews, to embrace reality. The imaginary world devalues the real world. Heaven as a place of bliss, even of physical fulfillment, viewed as a compensation for suffering in this world, is an escape from reality and therefore is deprecated by Jews (Kochan 1997:112). By glorifying nature, the Romantics were taking a myopic world view, for it could easily lead to nihilism. The "thisness" of the world must never be forgotten. After all, part of the attack by Marx on Christianity was centered on the notion of heaven projected as an imaginative and blissful compensation for sufferings in this world.

Let us put another possible explanation on the table. What of Durkheim as a person? What of his own psychological dispositions? Recollections of the magisterial figure of Durkheim by the family and by his colleagues, repeatedly speak of his serious demeanor. He had few jokes and funny stories to tell, in contrast to his nephew, Marcel Mauss (Pickering 1999). He embraced life in all its earnestness, centered on *la vie sérieuse* (see below). He worked extremely hard, to the point of a near nervous breakdown, first when he was in Bordeaux and again during the 1914–18 War (Durkheim 1999:502–4; Pickering 2008). Admittedly he regularly took holidays both abroad, in the various resorts in France, and in the family home of Épinal, but, from what evidence we have, he spent much of that time working. Not for nothing has he been likened to a stern, puritanical figure. And Puritans, we may recall, were not known only for their strict

moral code, but also for their opposition to many of the arts. Hubert Bourgin has written that when he was invited to see Durkheim in his study, he found it "vast and simple, lacking any adornment or evidence of artistic preoccupations" (in Lukes 1973:367).

But, as is commonly known, Durkheim was a devoted family man, very fond of his children, especially André who was killed in the First World War, and whose death some have seen as hastening his own death (Pickering 2008). He was delighted with his grandson, Claude, about whom he wrote often to Marcel Mauss (Durkheim 1999:520, 524). His wife, Louise, did the proofreading of the *Année sociologique* and helped him copy manuscripts. There is a family story that Louise was forbidden to play the piano after she was married, although she much enjoyed playing. Only after Durkheim had died did she resume this activity.

These considerations can be said to have some bearing when trying to account for Durkheim's attitude to the arts, but in themselves they are not convincing. They do not take into account Durkheim's moral approach to art. His writings have to be explored further.

La vie sérieuse and *la vie légère*

We raise a theme we have considered elsewhere (for example, see Pickering 1984:ch. 19). In his very first book, his doctoral thesis of 1893, he referred to *la vie sérieuse* (1902[1893]:219; 1933[1893]:240). The phrase is translated meagerly by George Simpson in 1933 as "serious life" and in a later and better translation by W.D. Halls as the "serious business of life" (1984[1893]:185). No matter the causes, life for Durkheim was a "serious business"—a reality—that every human being must come to terms with. He also saw life as a struggle (1969[1938]:252; 1977[1938]:218, a fundamental idea he adhered to all his life without any change or modification (see Pickering 1984:32ff.). It was a given fact of life, empirically gleaned and not supported by argument.[4]

Nevertheless, this did not mean that life was a monotonous drudgery. Work is or should be tempered with recreation. Thus he wrote: "We cannot work all the time. We cannot always make that effort . . . Relaxation must succeed effort, and activity must sometimes take the form of play" (1925:313; 1961[1925]:273). Here was an intuitive or common-sense "natural law." However, the cycle was not as simple as that! Certain kinds of recreation must be condemned, for example, those that are coarse or brutal. And, by contrast, those near to moral impulses are to be upheld and praised (ibid.). Leisure activities must be limited and approached carefully. No matter what they are, they are tangential to work, which is at the heart of everyday life. Work coupled with moral rectitude is the center of *la vie sérieuse*. The lighter side of life, which includes the arts and leisure activities, constituted what we might call *la vie légère*. This was not

a term used by him but it creates a useful dichotomy, and dichotomies are at the heart of Durkheim's thought (see Pickering 1984:352ff.).

So it is that Durkheim contrasts morality with art, as when he writes: "we might say that art is a game. Morality, on the contrary, is *la vie sérieuse*" (1925:313; 1961[1925]:273). He goes on to define *la vie sérieuse* as "the most serious part of real living" (ibid.). But it is a somewhat unequal dichotomy, for as we have noted, man must have leisure, he must "use it worthily, as morally as possible" (ibid.). Why? Because "in itself leisure is always dangerous" (ibid.:314, 274). The dichotomy is thus not a static one but also implies interaction. Human beings are to embrace both elements but also to see that in practice a dialectical relation exists between the two. There thus must be balance between *la vie légère* and *la vie sérieuse* and like all such equations the problem is to get the right balance. On this depends the "health" of a society. As he said earlier and elsewhere: "The need of playing, acting without an end and for the pleasure of acting, cannot be developed beyond a certain point without depriving oneself of *la vie sérieuse*" (1902[1893]:219; 1933[1893]:240). Durkheim's fear was that "too great an artistic sensibility is a sickly phenomenon which cannot become general without danger to society . . . [Art] is a luxury and an adornment which is perhaps fine to possess, but no one is compelled to acquire it; what is superfluous cannot be imposed on people" (ibid.:17, 51).

Durkheim repeated himself later—"all art is a luxury"—and went on to add, "aesthetic activity is not subordinated to any useful end: it is released for the sole pleasure of the release" (1953[1911]:85). Durkheim criticized art because, practical though it is, and this is commendable, it is without theory (1956[1922]:69–70, 101). There may be reflection, but reflection is not a necessary element of art (ibid.). Since *la vie sérieuse* has as its base the moral, and since the moral does not exist in art, art is to be "dumped" into *la vie légère*. The following words confirm this: "Any culture which is exclusively or essentially aesthetic contains within itself a germ of immorality or an inferior morality" (1969[1938]:240; 1977[1938]:207). This is from lectures, entitled *L'Évolution pédogogique en France,* he reluctantly had to give in Paris to students graduating from the Ecole Normale Supérieure in 1904–1905. Here Durkheim was referring to the art of the Renaissance which one might see as having some kind of a parallel with *la belle époque*. He attacked the Jesuits for following the culture of their day and for elevating the subject of rhetoric. A student's education was thus finished when he had mastered the subject (ibid.:11–12, 5). Intellectuals in eighteenth-century Britain accorded a high place to oratory and rhetoric. For Durkheim, rhetoric is in the same category as art.

The formula, "art for art's sake," must have been anathema to him. One product of *la belle époque* which would have nauseated him, if he had ever read it, was Octave Mirbeau's *Le Jardin des supplices*, published in 1898 in Paris. But if he were obviously opposed to the cliché, "art for art's sake," then he was as much opposed to a similar one, "knowledge for its own

sake" (ibid.:252, 218). Over the heads of artists, and the purely academic, stood higher ideals.

The limited contribution of the arts to society

One ideal of the Enlightenment was to give a full place to *la morale* in the affairs of mankind. It was a morality based on tolerance and not on religious dogma. Under the umbrella of the moral, art should be so molded as to improve society, and in the case of literature, plays and operas, good must be seen to triumph over evil. For Durkheim there can be nothing higher than the moral order (see Allcock 1983:37). This meant, as with most so-called rationalists, that morality replaces religion. Such a transformation is not only an ideal, but is a social fact. Traditional religions are on the way out. And what stands in their stead? A system of liberal, humanistic ethics. Durkheim preferred to call it the cult of humanity.

Yet, at the same time, there existed contrary forces. Political and social life in France was seen by him to be in a somewhat precarious state—indeed throughout Europe people were living in dangerous times. In certain quarters there was found to be a rejection of moral precepts and of identity with, and loyalty to, the nation. It constituted *le malaise social,* which if unchecked would lead to social chaos, even to revolution. This Durkheim feared, despite his support for the 1789 revolution. Given the seriousness of the situation, he asserted that the arts did not contribute anything towards the reduction of *le malaise social.* They offered no healing medicine, overt or covert, for society's discontents. Indeed, they made matters worse rather than better. The best way, in his eyes, to ameliorate the miseries of the human condition was through the development of science (1969[1938]:256; 1977[1938]:222). One feels that, for Durkheim, if science did not achieve this, it was not worth studying, because knowledge for its own sake is of no value (ibid.:252, 218).

In his various sets of lectures on education it might be argued that Durkheim was little more than a stooge for the Third Republic and its policy. Of course it is true that what Durkheim wrote and taught was in line with the government policy, but what he did was done with great personal conviction and he was no lackey. One issue to be considered is government policy in the matter of education—policy that sprang from the disastrous war of 1870. The failure of France, it was argued, was due to a great weakness of the French educational system that had not been modified in the early nineteenth century. In the French system, literature and philosophy remained dominant and the sciences were badly overlooked. There is no evidence that Durkheim subscribed directly to this argument, but there is no doubt whatsoever that the lectures he gave to teachers could be seen as a response to it, and his praise of science

was clearly in line with government thinking. He placed his criticisms of art, however, in a much wider context than that of the 1870 war. One wonders how far the government would have undergirded his attack on contemporary art.

Epistemology and art

So Durkheim uses the common dichotomy of contrasting art with science. The assumption he makes is that the two are legitimately comparable. The dichotomy is powerfully drawn in an article that he wrote at the turn of the century, wherein he writes: "The fact is that art, even methodical and reflective art is one thing: science another. Science studies facts just to know them, indifferent to the applications to which the ideas can be put. Art, on the contrary, deals with them only to know what can be done with them, for what useful ends they can be employed" (1973[1900]:4).

Here we come face to face with Durkheim's rationalism. As with rationalists in general his ultimate faith was in reason's ability to save mankind from ignorance and suffering. It was not the rationalism of Descartes, however, but a rationalism that fully takes science into account. His critical rationalism was derived from Renouvier. Everything had to be made subservient to the quest for knowledge and truth. But that said, Durkheim allied such knowledge with application. That the findings of science would be beneficial to society, Durkheim held to be axiomatic.

The issue of practice

Although Durkheim claimed his work was scientific, he held that knowledge for its own sake is, as we have said, of little value. Knowledge should be utilitarian, giving rise to some kind of action, particularly in the realm of morals. He wrote: "Ethics . . . operate in the realm of action, which either get to grips with real objects or else loses itself in the void. To act morally is to do good to creatures of flesh and blood, to change some feature of reality" (1969[1938]:240; 1977[1938]:207). The same can be said for the natural sciences: they are to be applied in and for society. Here are parallels with Kant, whose arguments concerning pure and practical reason find very rough equivalents in what Durkheim had to say about science and morality. For Durkheim, sociology—the science of social phenomena—could point to the ways in which society can be changed and improved. On such assumptions it is at least legitimate for him to evaluate the moral effect of art on society. Durkheim, who admired Kant and Rousseau, had one trait in common with them: an innate suspicion of that

form of morality derived from a society in which education was based essentially on aesthetic ideals. He was prone to prefer the moral ideals of simpler, "uneducated" peoples (see Jones 1990:76ff.). The modern artist tended to withdraw himself from reality, so Durkheim wrote: "In order to experience the need to change it [society], to transform it and to improve it, it is necessary not to abstract oneself from it; one must rather stay with it and love it despite its ugliness, its pettiness and its meanness. One must not avert one's gaze from it in order to contemplate an imaginary world, but on the contrary keep one's gaze directed steadily towards it" (1969[1938]:240; 1977[1938]:207). Was Durkheim thinking only of certain kinds of artists when he wrote this? Or of artists in general? And in his day?

Against Durkheim's specific arguments

Intellectuals in contemporary democratic societies might argue against Durkheim's anti-art, pro-science stand for the following reasons:

1. Art objects, paintings for example, or musical scores, are not without boundaries. They are not just products of the unbridled imagination. They come from a historical context; they have built on what others created. They continue with these boundaries and move their products a little further from where they originated. If their representations are too radical, too far removed from the starting point, they are rejected by society.
2. In every representation is to be found the notion of likeness or some link with reality (Hacking 1983:139). At the heart of Durkheim's sociology was the study of collective representations, and these are connected with reality in various ways and to varying degrees (see Pickering 2000b).
3. Durkheim agreed that representations were subject to change through the impact of social forces (see Pickering 2000a:16ff.). Certainly in France in the period under discussion, new artistic representations were emerging—for example Impressionism in the pictorial arts and in music, although whether Impressionism is a valid name for a wide movement is debatable.
4. Scientists do not set out to confront or challenge the arts; both science and the arts aim to know what is "true" and keep to their own spheres of truth. The assumption must be that truth is multifaceted. Representations are for particular purposes, both in science and the arts. In the sciences representations tend to be rigid and specialized, in the arts they are more open and flexible. Thus, in comparing the arts and the sciences, the issues are more complex than those Durkheim asserted.

The legitimacy of the sociology of art

One does not need to stress Durkheim's denigration of art, which we assume was viewed in the modern mode and found in his lectures on education, without at the same time stating that within the *Année sociologique* group he took what appears to be a somewhat singular position. His colleagues did not identify themselves openly with their master on the issue. For example, Mauss throughout his life was a firm supporter of the sociology of art and regretted that it had not been better developed in the *Année sociologique* (Mauss 1927:115–16; Fournier 1987:2–4). This regrettable fact was attributable in part to the "hazards" of publication. Mauss was fond of Wagner, it is said, and he wrote a very short, appreciative piece on Picasso (Mauss 1930). Mauss also gave considerable attention to *esthétique* in his *Manuel d'ethnographie,* which were lectures he gave to anthropologists at the Collége de France (Mauss 1947). The issue of the sociology of art raises very pertinently the issue of how far individual members of the *équipe* of Durkheim disagreed with their leader on certain positions of the founder's sociology. It is quite apparent that there were differences in outlook, but they were seldom expressed in open conflict. (Further attention to Mauss is given in subsequent chapters of this book.)

Charles Lalo, at the margin of the *Année sociologique* circle, wrote on the sociology of the arts. His first book on the subject appeared in 1908 when he wrote about musical aesthetics and he continued writing until the end of World War II (see Lalo 1908 and 1947). In 1922 he published a book, *L'Art et la morale*. His opening thesis was expressed in some words from La Fontaine, "The good is rarely a companion of the beautiful" (1922:3). The notion of an ambiguous relation continues throughout the book, which is mainly historical in approach. In the end he optimistically adopts the notion of a synthesis. That Durkheim is never mentioned, even when he writes about those who are on the side of morality as against the arts, may at first sight seem extraordinary. Did Lalo know Durkheim's position? Probably not, because he would not have known of Durkheim's lectures on education. *L'Éducation morale* was not published until three years after Lalo's book. Had he consulted Fauconnet or Mauss he might have been surprised!

If one looks further afield than the Durkheimians, one might recall the pioneering book, *L'Art au point du vue sociologique* by J.-M. Guyau, published posthumously in 1889—once again the year of the Universal Exhibition. This genius, as he was often called, had written widely on aesthetics previously. Further, it should be realized that Guyau had exerted some influence on the thought of Durkheim in the 1880s (Durkheim 1887). But Guyau was a philosophical idealist, a position hardly in keeping with Durkheim's position of critical rationalism. What Guyau emphasized was the social component of all art. He was convinced that art would take over the social functions of dying traditional religions.

Concluding remarks

So how are we to judge Durkheim, the sociologist, who writes in an anti-art mode? Durkheim's stance raises two issues. He readily entered into the age-long controversy that stretches back in Western philosophy as far as the time of Plato: —the moral versus the aesthetic. It has continually reasserted itself, not least in Kant, to whom Durkheim so often refers, and later in Kierkegaard.[5] Outside the realm of philosophers, the issue appeared in several forms, as in the Iconoclastic controversy of the eighth century and at the Reformation. In one way it can be said that Durkheim offered a sociological solution as he tried to solve the classical epistemological problem in *Les Formes élémentaires* (1912). He speaks as the sociologist who comes down on the side of the moralist on pragmatic grounds in deciding from "scientific" evidence what is good for the health of a society. His solution raises as many questions as it answers and the debate between the moral and the aesthetical is by no means foreclosed.

Let me end by referring to some words of the Oxford scholar, Sir Isaiah Berlin. In one basic respect, and perhaps only in one, he was like Durkheim. In the matter of human affairs both men held that rationality was supreme. Judgments extend beyond "scientific facts." Berlin wrote: "On the moral association of ideas, on such basic concepts as those of the past, future, things, persons, causal sequence, logical relations—a closely woven network of categories and concepts—human rationality, perhaps even sanity, in practice depends. Departure from these, as attempted, for example, by surrealist painters and poets, or aleatory composers, may be interesting, but it is deliberately counter-rational" (Berlin 1980:153).

Notes

1. This is a revised edition of an article of the same name that appeared in *Durkheimian Studies/Etudes Durkheimiennes*, n.s. 2000, vol. 6: 43–60. I am very grateful to Jonathan Fish for his constructive and critical comments of this edition.
2. Durkheim uses the word art in another sense when he refers to the art of teaching and compares it with the science or theory of teaching (see, for example, Durkheim 1925:314; 1961[1925]:274; Pickering 1979:105). For the purposes of this chapter such a meaning is disregarded.
3. That part of *L'Éducation morale* on which these points are based is chapter 18, entitled "La Culture esthétique. L'enseignement historique." Some of the ideas are also found in other books, such as *L'Evolution pédagogique en France* (1938) and *Pragmatisme et sociologie* (1955).
4. Durkheim was not out on a limb in being dedicated to *la vie sérieuse*. One example is that of the ex-seminarian, who became a well known professor of Hebrew, Ernest Renan (1823–92). He wrote in his *Souvenirs d'enfance et de jeunesse* that his early teachers taught him to love truth, respect reason and the serious side of life (Renan 1935[1883]:110). Through them he learned a firm morality which was always at hand to help him face the trials of life. "The superficiality (*légèreté*) of Paris life only polished this jewel of morality without modifying it" (ibid.). For Renan it was impossible to lead a satisfactory life or career, unless it was focused on matters relating to the soul, and for such a career he

wished to have no salary. Here speaks a young man full of ideals. But it is to be noted that both Durkheim and Renan were wedded to the idea of *la vie sérieuse* as a fundamental ideal (see Peyre 1960:28ff.). One might add that in the long run Durkheim was more dedicated to the ideal than Renan who, when he became a highly successful academic, was also accused by some of becoming a dilettante. That criticism could never be made of the "puritanical" Durkheim. Indeed, Durkheim disliked Renan (ibid.; and see Durkheim 1925:253; 1961[1925]:221).

5. There are some interesting parallels to be seen between Durkheim and Soren Kierkegaard, philosopher and theologian, and a father of modern existentialism. Kierkegaard was born in 1813 in Copenhagen and died in 1855, shortly before Durkheim was born. It is doubtful if Durkheim had heard of Kierkegaard, although he was read by French philosophers in the 1920s. He and Durkheim, however, were close with regard to the aesthetic/moral dichotomy, and also on another issue, namely socialization. But on the other hand, on basic issues they were poles apart: the one, the religious individualist and the other the sociologist, often falsely charged with determinism.

 Kierkegaard wrote of the stages through which human beings may pass. These have nothing to do with historical evolution. The first or primary stage is the aesthetic (see Thomte 1949). It is based on immediacy, on the erotic; it is hedonistic, void of meaning. It shows a dislike of the common, the ordinary tasks of life. It escapes from reality and eventually becomes a state of despair. This estimate is encapsulated in the German romanticism of the late eighteenth century, where the ultimate response is despair.

 The next stage is the ethical, which offers meaning and purpose and which transcends the aesthetic. Of course, for Kierkegaard, but not for Durkheim, the ethical is ultimately internal and subjective. And again, not for Durkheim, there exists a third stage, the religious, which once more is subjective.

 The two thinkers travel different paths but their starting point is not dissimilar: it is an attack on the aesthetic. Another parallel is revealing. Both wrote at the time when in their respective countries the arts had reached a high point. Kierkegaard lived in the *belle époque* in Denmark, the so-called Golden Age (Kirmmse 1990). Success inevitably brings its critics! Even today in the Western world, which boasts of its many freedoms, the controversy over art versus morals is by no means foreclosed. It persists in many forms. For example, it is to be seen in the moral behavior, frequently condemned, of Eric Gill who sculptured the famous stations of the cross in London's Roman Catholic Westminster cathedral. A public demand for their removal arose when his extraordinary sex life was revealed in a biography. In a similar way one may point to the continuing Jewish condemnation of Wagner's music in Israel. Of the content of art itself one recalls the political (and moral?) control that was exerted in the former Soviet Union. Writers and musicians in this country found their works of art condemned because, it is said, they challenged the Marxist-Communist ideology.

 The age-long debate can also be expressed in terms of the sacred values of a society. What is sacred must not be profaned. The question rises: Is no value or ideal to be protected? Is there nothing in society that is held to be sacred? Nothing is protected, everything is mocked (Pickering 1990). Of course, protection means taboos or laws of blasphemy, which a modern, open society tends to reject. Perhaps only human rights can claim the status of the sacred on anything like a personal basis. But what of the presence now in Europe of many millions of Muslims, who have a very strong and protective sense of the sacred?

References

Allcock, J. 1983. "Editorial introduction to the English translation of *Pragmatisme et sociologie*."

Berlin, I. 1980. *Personal Impressions*. Oxford: Oxford University Press.

Comte, A. 1865[1848]. *A General View of Positivism*. Trans. J.H. Bridges. London: Trübner.

Durkheim, E. 1887. Review. "Guyau, L'Irréligion de l'avenir." *Revue philosophique*, 23:299–311.

———. 1890. "Les Principes de 1789 et la sociologie." *Revue internationale del'enseignement*, 19:450–56.

———. 1902[1893]. *De la division de travail social: Etude sur l'organisation des société supérieures*. Paris: Alcan.

———. 1912. *Les formes élémentaires de la vie religieuse. Le système totémique en Australie*. Paris: Alcan.

———. 1915[1912]. *The Elementary Forms of the Religious Life. A Study in Religious Sociology*. J.W. Swain. London: Allen and Unwin. New York: Macmillan.

———. 1925. *L'Education morale*. Int. P. Fauconnet. Paris: Alcan.

———. 1933[1893]. *The Division of Labor in Society*. G. Simpson. New York: Macmillan.

———. 1953[1911]. "Value Judgments and Judgments of Reality." Pp. 80–97 in *Sociology and Philosophy*. Trans. D. F. Pocock. New York: Free Press.

———. 1955. *Pragmatisme et sociologie*. Paris: Vrin.

———. 1956[1922] *Education and Sociology*. S.D. Fox. Chicago: Free Press.

———. 1961[1925]. *Moral Education: A Study in the Theory and Application of the Sociology of Education*. E.K. Wilson and H. Schnurer, ed. and int. E.K. Wilson. New York: Free Press.

———. 1969[1938]. *L'Evolution pédagogique en France*. Int. M. Halbwachs. Paris: Presses Universitaires de France.

———. 1973[1900]. "Sociology in France in the Nineteenth Century." Pp. 3–24 in *Émile Durkheim on Morality and Society*. Ed. R.N. Bellah. Chicago and London: University of Chicago Press.

———. 1977[1938] *The Evolution of Educational Thought*. P. Collins. London and Boston: Routledge and Kegan Paul.

———. 1983[1955] by J.C. Whitehouse. *Pragmatism and Sociology*. Ed. and int. J.B. Allcock. Cambridge: Cambridge University Press.

———. 1984[1893]. *The Division of Labour in Society*. W.D. Halls, int. L. Coser. London and Basingstoke: Macmillan.

———. 1995[1912]. *The Elementary Forms of Religious Life*. Trans. and int. K.E. Fields. New York: Free Press.

———. 1999. *Émile Durkheim. Lettres à Marcel Mauss*. Ed. P. Besnard and M. Fournier. Paris: Press Universitaires de France.

———. (with others). 1918. *La Vie universitaire à Paris*. Paris: Colin.

Fournier, M. 1987. "L'Année sociologique et l'art." *Etudes durkheimiennes* 112:1–10.

Gaunt, W. 1970. *The Impressionists*. London: Thames and Hudson.

Guyau, J.-M. 1889. *L'Art au point de vue sociologique*. Paris: Alcan.

Hacking, I. 1983. *Representing and Interviewing: Introductory Topics in the Philosophy of Natural Science*. Cambridge: Cambridge University Press.

Jones, R.A. 1990. "Religion and Realism: Some Reflections on Durkheim's *L'Evolution pédagogique en France*." *Archives de sciences sociales des Religions*, 69:69–89.

Kirmmse, B. 1990. *Kierkegaard in Golden Age Denmark*. Bloomington, Indiana: Indiana University Press.

Kochan, L. 1997. *Beyond the Graven Image*. London: Macmillan.

Lalo, C. 1908. *Esquisse d'une esthétique musicale*. Paris: Alcan.

———. 1922. *L'Art et la morale*. Paris: Alcan.

———. 1927. *Notions d'Esthétique*. Paris: Alcan.

———. 1947. *Les grands Evasions estheiques*. Paris: Vrin.

Lukes, S. 1973. *Émile Durkheim. His Life and Work: A Historical and Critical Study*. London: Allen Lane. Further edition in 1982.

Mauss, M. 1927. "Divisions et proportions des divisions de la sociologie." *L'Année sociologique*, n.s. 2: 98–176.

———. 1930. "Hommage à Picasso." *Documents* 2, 3:177.

———. 1947. *Manuel d'ethnographie*. Paris: Payot.

———. 2008[1947]. *Manual of Ethnography*. D. Lussier, int. N.J. Allen. New York and Oxford: Durkheim Press/Berghahn Books.

Peyre, H. 1960. "Durkheim: the man, his time and his intellectual background." In *Émile Durkheim 1858–1917*. Ed. K.H. Wolff . Columbus, Ohio: Ohio State University Press.

Pickering, W.S.F. 1984. *Durkheim's Sociology of Religion: Themes and Theories*. London: Routledge and Kegan Paul.

———. 1990. "The Eternality of the Sacred. Durkheim's Error?" *Archives de sciences sociales des religions* 69:91–106.

———. 1999. "Mauss's Jewish Background: A Biographical Essay." In *Marcel Mauss: A Centenary Tribute*. Eds. W. James and N. J. Allen. New York and Oxford: Berghahn Books.

———. 2000a. "Representations as Understood by Durkheim." In *Durkheim and Representations*. Ed. W.S.F. Pickering. London and New York: Routledge.

———. 2000b. "What do representations represent?" In *Durkheim and Representations*. Ed. W.S.F. Pickering. London and New York: Routledge.

———. 2008. "Reflections on the Death of Émile Durkheim". In *Suffering and Evil. The Durkheimian Legacy*. Ed. W.S.F. Pickering and M. Rosati. New York and Oxford: Durkheim Press/Berghahn Books.

Pickering, W.S.F. (ed.). 1979. *Durkheim: Essays on Morals and Education*. London: Routledge and Kegan Paul.

Pickering, W.S.F. and M. Rosatti (eds.). 2008. *Suffering and Evil. The Durkheimian Legacy*. New York and Oxford: Durkheim Press/Berghahn Books.

Renan, E. 1935[1883]. *Souvenirs d'enfance et la jeunesse*. Paris: Culman-Levy.

Thomte, R. 1949. *Kierkegaard's Philosophy of Religion*. Princeton: Princeton University Press.

Tiryakian, E. 1979. "L'Ecole durkheimienne à la recherche de la société perdue: la sociologie naisssante et son milieu culturel." *Cahiers internationaux de sociologie* 66: 4–11.

Zolberg, V. 1990. *Constructing a Sociology of the Arts*. Cambridge: Cambridge University Press.

Chapter 3

Durkheim and Festivals
Art, Effervescence, and Institutions

Jean-Louis Fabiani

Durkheim's aesthetics: a neglected argument?

For quite some time now, Durkheimian sociology has been viewed as paying scant attention to art.[1] Indeed, one can imagine that Durkheim was too busy establishing the fundaments of his discipline to indulge in the more recreational aspects of social life. Sociologists build theories and consider serious topics (for example, capital, division of labor, rationality, and so on) and do not give overtime to what is happening after the working day. If we look at indexes and textbooks, this lack of interest is obvious. The upgrading of culture as a central feature of sociological investigation is a rather recent phenomenon (Alexander 2003; Fabiani 1993). In many ways this has to do with the emergence of cultural industries that forced sociologists to analyze, first in a very critical manner, social changes brought about by the mass consumption of symbolic commodities. Today the sociology of art and culture has moved from the periphery to the center. In France in particular, these topics have been taken up so as to renew theories and build intellectual reputations. Durkheim, of course, never planned to draw up any sociological aesthetics, as was indeed attempted by Bourdieu in *Distinction* (Bourdieu 1979). Although from today's perspective Bourdieu's book may be considered as a partial failure, one cannot deny the panache and inventiveness it involved, largely based as it was on the recognition of the high sociological significance of cultural and artistic matters. Bourdieu's interest in art and literature was central from the very beginning of his career, and one of his first attempts to define the concept of field (*champ*) appeared in a paper devoted to literature (Bourdieu 1967). Things are obviously very different with Durkheim. When Werner Gephart tried to assess the importance of artistic and cultural issues in Durkheim's works, he started

from a widely shared viewpoint: "A sociological aesthetic was unthinkable to Durkheim" (Gephart 2000:86). This is true. There is no room in Durkheim's theoretical world for an autonomous study of aesthetic phenomena as such. One might even rephrase Gephart by saying that a sociological aesthetic was never even imagined by Durkheim, since the author of *The Elementary Forms of Religious Life* never ceased to think about art, convinced as he was of its anthropological centrality while still being conscious of its potential dangers.

Things become more complicated if we take a closer look at the theoretical constructs worked out by Durkheim. Since the mid 1990s, authors as varied as William S. Pickering, Willie Watts Miller, Werner Gephart and Pierre-Michel Menger have shown that art is a key to understanding Durkheim's work, and especially his later studies. This has to do with the renewal of Durkheimian scholarship in recent years. In the 1970s and 1980s it remained focused on historical issues as the sources of Durkheimian thought, tracing its development and changes across time. The investigations were helped along by the use of epistolary sources to solve certain enigmas. But in the last ten years, it seems there has been a growing interest among scholars in at least the partial use of Durkheimian tools for contemporary research. This is particularly the case with Watts Miller's essay on total aesthetics (Watts Miller 2004; a revised version of this essay appears in the present volume) which asserts that effervescence is the entryway into aesthetics and also "a way into a grasp of creative process, through the idea of a whole synergy of forces that lift up into a surplus" (ibid.:115) Here is the boldest attempt yet to consider Durkheim not only as historical figure of first magnitude, but also as a trove of fresh resources for our sociological investigations. Such a path had been already followed by Erving Goffman (Goffman 1967) and more recently by Randall Collins (Collins 2004). The notion of ritual is central to the process, and many issues have been raised by the decontextualized uses of the word, as it has been freed from its original anthropological matrix. If we call something a social ritual that is not regarded as ritual by the agents themselves, then do we not weaken and make useless the very notion itself? Are we not led down the garden path of free association? My contribution to the ongoing debate is based on empirical studies of two major French cultural festivals, Avignon and Cannes. Using quantitative data analysis and ethnographic methods, my research colleagues and I tried to offer a more precise understanding of what audiences really do in such festive settings (Ethis 2002; Fabiani 2003a). In the present chapter I should like to analyze the heuristic uses of notions such as ritual, energy, emotion, and assess the validity of what might be called, grossly, a Durkheim-inspired approach. In doing so, it will be possible, to show the fecundity, ambivalence, and shortcomings of Durkheim's own conceptualization.

There have been considerable changes in the way we regard Durkheim's theoretical proposals as they appeared in his 1912 masterpiece.

Steven Lukes's intellectual biography of Durkheim, which played a major role in reassessing Durkheim's sociological and philosophical centrality, paid little attention to the status of art in *The Elementary Forms* (Lukes 1973). There is only one reference to the issue (ibid.:469–70), which is not considered deserving of any further investigation. Although Lukes stresses rightly the point, he just mentions it and goes on with the book presentation: "In a striking passage interpreting these ceremonies, Durkheim discussed the 'recreative and aesthetic element' of religion, comparing the rites to 'dramatic representations,' and relating them to 'games and the principal forms of art.' Interestingly (and none of his interpreters or critics have noticed this), he seems to have seen the expressive aspect of religion as a by-product of its cognitive role" (ibid.).

Lukes is the first to recognize the importance of the aesthetic element in Durkheim's theory of religion, but he thinks that this element should not be exaggerated. Durkheim is rather vague about how much of the aesthetic element is to be found in religious ceremonies. Such a question is obviously central in determining the nature and location of the recreational or dramatic features in religious life, be they elementary or not. Such a question is also extremely relevant for contemporary research on theater, music hall and dance, which have drawn extensively on metaphorical uses of religion to account for the relationship between the performers and the audience. Are artistic forms weakened, or in fact enhanced, remnants of archaic religious forms? A reflection based on Durkheim's conceptualization would be very helpful in clarifying this ongoing and admittedly tedious discussion.

By stressing the relationship between emotion and cognition, Durkheim has in some ways been very bold in elaborating new clues to understand how aesthetic elements factor into religious and social life. Ann Warfield Rawls has recently drawn attention to the importance of emotions in Durkheim's theory (Rawls 2004). It is a central concern, something that might well have been unthinkable in the early days of Durkheimian scholarship. But Durkheim did not do much to help his own case, as he never fully recognized the importance of aesthetic elements in symbolic and religious life.

Art and aesthetics: present and hidden

If sociologists have not taken up the topic of art in Durkheim's works, they have good reasons for it. He was very ambivalent about the status which should be afforded to art in contemporary society, and he was not prepared to clearly identify the aesthetic factor in religious life. That would have been very un-Durkheimian: as Willie Watts Miller (2004) has shown Durkheim did not believe that aesthetics is autonomous. What does "effervescence" mean then, according to Watts Miller?

> What this means—and becomes clear as the discussion proceeds—is that the power of assembly is an integral element of the power of art as real performative art. They are two aspects of a same dynamic, inextricably bound up with one another in generating a whole creative aesthetic atmospherics—in a gospel session, a jazz club, a dance hall, a rave, a pop festival, grand opera, the circus, the theater . . . Put another way, in real live performative art there is an intrinsic link between the aesthetic and the social. In fact, there is a union of aesthetic and social form. (Ibid.:96)

I shall discuss later whether it is legitimate to extend Durkheim's conception of primitive religion to all sorts of contemporary cultural forms. For now, what is at stake is precisely teasing out the aesthetic elements in the various manifestations of social life. This is exactly the thing which Durkheim asserts for the elementary forms of religious life, but nowhere in his work is there any hint that an art world could exist in a modern society where there is a complex division of labor.

This has to do mainly with the reluctance shown by Durkheim in acknowledging the social centrality of artistic and literary life. Here the great sociologist is highly ambivalent about art and literature. We know that Durkheim had received a humanistic education, mainly at the Ecole normale supérieure, and this education was a major formative influence in his thinking. Wolf Lepenies has shown the importance of literary references in Durkheim's typology of suicide (Lepenies 1988), but most of the time, the author of *The Division of Social Labor* is too busy exhibiting his scientific attitude to acknowledge the effects of his scholarly *habitus* in his ways of analyzing social facts. Durkheim created a tradition which would be followed by quite a few French academics, including Althusser and Bourdieu: in order to be a member of good standing of the scientific world, sociologists had to break away from all that might be labeled literary or aesthetic. Such an "epistemological break," to use Bachelard's phrase (Bachelard 1938) was a necessity establishing the specificity of social science, or, even more broadly, of the academic approach to the world. In an essay dedicated to "The Principles of 1789 and sociology" (Durkheim 1890:38), this sociological pioneer warned that a "purely aesthetic culture does not place the mind in sufficiently direct contact with reality to enable it to create an adequate representation of it." In other words, an aesthetic representation of the world does not allow us to grasp the depth of human history and the weight of our social bequest. Durkheim's uneasiness with literature can be explained in the same light: literature does not grant us real access to the organic dimension of society. It leaves us on the surface of things, unaware of history and social constraints. In today's terms we might say that art and literature lead us to treat society as a text, thus blurring our objective view of society, which is the only ground available for any truly scientific sociology. Thus sociology as well as philosophy must avoid all the literary traps involved in the use of vernacular language, and the risk inhering of common-sense interpretations.

Of course such a rigid stance on Durkheim's part had to do with the historical conditions pertaining to France of the early Third Republic. The newly restructured Sorbonne was still in its fragile infancy and was the subject of harsh attacks from conservative literati. As a symbolic figure of the New Sorbonne, Durkheim felt compelled to constantly underscore the demarcation line between art and science, literature and sociology. As was the case with many other university professors at the turn of the century, Durkheim fought against what he called "anarchic dilettantism," an ever present risk for all those committed to understanding the social world. Art and aesthetics were perceived as threats to social scientists, who were to be on their guard against those attitudes and styles which characterized a merely aesthetic perspective. Such a stance may appear a bit strange to sociologists today, as we have since grown to integrating hermeneutics into our methodological toolkit, and perhaps even stranger in view of the fact that our scholarly culture is far less humanistic than was Durkheim's. Epistemological break with traditional humanistic visions was so vivid and sharp because the new sociologists, who were mostly philosophers by training, were still very close to the spiritualist way of thinking, which in his opinion gave undue weight to introspection and literary style in social thought. That would be the first explanation for Durkheim's constant avoidance of aesthetic discussions and warnings about the harmful identification of society as an aesthetic world (Fabiani 2003b).

A nice explanation, but far from being the only one. When he describes the risks pertaining to aesthetic perspectives in sociology, Durkheim is very explicit. But he is less clear in trying to assert the place of art in society. Of course, art is not the most suitable topic when one is trying to create the building blocks for an objective science. Art deals mainly with subjectivity; it appears to be loosely organized in some ways (and might even be mistaken for a pathological state of society), and very often in modern times it stresses the rights of the individual to set himself against society. We all know that Durkheim was deadly serious, that he was what today would be described as a workaholic, and that he was not the most playful individual. "Il faut ce qu'il faut"; "Mettons nous au travail." Let us work as much as we can: this is not a slogan particularly suited for the study of recreation. Durkheim wrote during the French Golden Age of café-concerts and music halls, but none of this appears in his work, almost as if to treat of such things would be to threaten the very foundations of sociology. He may have been witness to some "effervescence" in the Parisian cabarets of the time, but if so there is no record of it. As I have already noted, art is not a serious preoccupation of founding fathers, and culture was not yet a relevant topic. "Art" appeared only in the third volume of the *Année sociologique* and was accorded secondary treatment at that. Nobody would have put art at the center of their social investigation in the late nineteenth century, although art and literature were

undergoing great transformations and witnessing radical innovations. Those explanations are mostly circumstantial; they belong to social and intellectual history. In some ways, they remain superficial.

Is it possible to go further and attain to a theoretical perspective regarding Durkheim's relationship to art? P.-M. Menger has suggested that art raises enormous problems for sociology as conceived by Durkheim because it reveals all the interpretive uncertainties that are the price to pay for a scientific sociology (Menger 2000; a revised version of this article appears in the present volume). Menger even talks of the aporetic status of art in Durkheim's work. Menger's analysis is rather convincing if we consider the fact that the author of *The Elementary Forms* failed to give any coherent account of what art in society is. He bases his argument on the contradiction, which is present in all art forms, between individual expression and collective reception. How can something which is ordinarily predicated on hyper-individuality be acknowledged as a universal form? But as of late, artistic activity has emerged as a means of releasing oneself from social routines, and becoming strongly integrated into community and its institutions. This apparent anomaly is the source of endless cultural conflict. How can an individual or even a small group pretend to express collective feelings? But it may be an anachronism to explain Durkheim's discomfort with aesthetics by means of this paradox. It is true that Durkheim is ill at ease, especially in *The Division of Social Labor*, with the outcomes of aesthetic activities. Drawing on Kant's conceptualization of art, he defines art as finality without an end, and creation as an activity with no specific regulation. This involves of course a playful and unproductive dimension, which may ultimately produce unwanted feelings or actions. Art belongs to a set of actions which are defined as unnecessary and maladjusted to any "vital end" as well as being a luxury (Durkheim 1893). This includes all gratuitous acts, such as heroism, altruism, sanctity, and artistic sponsoring. Durkheim does not believe that there might be a rational explanation for disinterestedness or pure and free activity. Such actions are permitted by the remaining energies; Durkheim uses this term quite a bit when it comes to recreational activities at the end of the working day: "After we have constrained a part of our physical and intellectual energy to fulfill our daily task, we wish for this energy to be given free play ('la bride sur le cou'), to spend it for the sheer pleasure of spending it, although it is to no specific purpose or in the service of any designated goal. Herein lies the essential delight in play, whose aesthetic pleasure is only an upgraded form. Art leads us beyond rules" (ibid.).

Durkheim was never really explicit about this issue. On the one hand, the leisure activities are necessary, since they appear to momentarily relieve social constraints and burn off excess energy. On the other hand, Durkheim has grievances against excessive playfulness: "All aesthetic activity is healthy only if it is moderate. A too strong artistic sensitivity is an unhealthy phenomenon which cannot be generalized with harm

being done to society" (ibid.). In fact, so as to understand that notion of excessive energy, we must turn to Durkheim's description of primitive religion. About the religious world, he says: "Also, since the intellectual forces which serve to make it are intense and tumultuous, the unique task of expressing the real with the aid of appropriate symbols is not enough to occupy them. A surplus generally remains available which seems to employ itself in supplementary and superfluous works of luxury, that is to say, in works of art" (Durkheim 1912:545).[2]

The word "surplus" appears here, although it is not clearly defined by the author. He presents an array of concepts like "surplus," "excess," "supplementary," and "free play," which indicate that psychic life and imagination are not simply adjusted to their functions. It is important to note that such an excess of play is already at work in primitive religion: observing and deciphering rites can be a misleading and disappointing operation. Many gestures in rites have simply no function at all. They seem meaningless with regard to the functions that the rites perform, but religion cannot be efficient if its rites are reduced solely to their functions. Religion would not be itself, Durkheim says, if it granted no space to art. Art in religion is not an ornament or a package, but a necessity. Werner Gephart remarks that: "[t]here is an autonomous aesthetic moment inherent to rituals and cults, based on the functional parenthood between religion and the arts. Far away from any utilitarian purpose, religion and the arts leave behind the world of everyday life in order to elope to another reality, where the power of imagination has place enough to unfold. That capacity of imagination (*Einbildungskraft*) is not a simple side effect of the religious world but the very core of religion itself" (Gephart 2000:87). So a contradiction remains: Durkheim warns us that the status of art in primitive religion should not be overrated, but that is still a necessary element for religion. A rite is not a game; it is serious. But it is more than serious: its performance has to be playful and pleasurable.

Does this mean that art for art's sake is not a serious endeavor? Durkheim is ambiguous on this point. In some ways, excess is always excessive and surplus is potentially harmful, even in religion. It was in *The Elementary Forms* that transgression of the rules was first presented as an important element in lay-popular fêtes, but in a footnote Durkheim notes that we find the same transgression in religious ceremonies, particularly with regard to the rule of exogamy. These transgressions have no proper ritual meaning. They do not fit into the model; they are in excess since they seem to express a "simple discharge of activities" (Durkheim 1912:548). But local interpretations of such transgressions are somewhat different. With very little additional comment, Durkheim writes that the indigenous peoples think that if the sexual transgression is not performed, then the ceremony will fail. The whole anthropological construction is ambivalent with regard to the value and function of surplus and transgression. It seems that to reinforce the collective rules, they must be violated in some

parts in certain ways as to ensure the ceremony's success. But the breaking of the rules is never a component part of the rite, as anthropologists would reconstruct it; rather, it is a mere energetic discharge, superfluous but necessary, not to the rite itself, but to its effective performance. There exists a lag here between the rite and its effectuation. There exists also a parallel between the man in a complex society who at day's end amuses himself to no functional purpose and the primitive group that performs rites to which they add non-functional elements. Both of these entail a discharge, a quantity of energy in excess, which sometimes appear to be in infinite supply. This discharge is simultaneously necessary to social life and somewhat harmful to it. The notions of effervescence, tumult and intensity, which characterize those intellectual and psychic forces at work in primitive religion, are never absolutely clear. In some ways they have to be contained by external elements and Durkheim evokes the pressure exerted by these tangible realities on the imagination, which can merely regulate this apparently limitless flow of energy. The same would apply to modern man, who might easily succumb to the temptation of ceaseless play, if the reality principle did not return him to the performance of his social duties. Of course, such can also be explained by the dual nature of man and the conflict that takes place within him between an inexhaustible capacity to desire and the constraints of social life. But the relationship between those two natures remains a mystery in many ways.

Critics have often remarked that the very notion of effervescence has been at the core of innumerable misunderstandings and confusions. Although Durkheim had harshly criticized crowd psychology and theories of imitation, it seems that he was still prone to employ such theories in his later work. One is familiar with Evans-Pritchard's criticism on that topic. He thought that the analysis of the ritual side of Australian totemism was "the more obscure part of Durkheim's thesis, and also the most unconvincing part of it" (Evans-Pritchard 1965). Pascal Michon goes yet further by claiming that Durkheim's description of effervescent mental states in primitive religion is based upon notions of imitation and influence, developed by Le Bon in his crowd psychology as well as by the early Tarde, both of whom were his archenemies. Michon asserts that Durkheim adopted their anthropological dualism (Michon 2005). The primitive man "runs helter-skelter like a lunatic" (Durkheim 1912:208); he forgets himself just as does the ordinary man in Le Bon's modern crowd. Effervescence is an expression of "natural violence" and Durkheim is unable to explain this excitation in any other terms; his analysis suffers from the fact that the effervescence seems to have a circular logic, i.e., it helps create rites which in their turn produce a genuine effervescence. Nature and society are obscurely intertwined, and Durkheim's anthropological ambition gives way to a sort of prescriptive emotional mixture. This has been often noted, and as a result *The Elementary Forms* has not infrequently been co-opted for anti-rational uses. The ambivalent status

of art in Durkheim is a case in point. Gratuitous activities may be seen as a kind of residual element of natural man's unlimited desires, but they are also necessary to further psychic development. They must be regulated by economic necessity and the social principle of reality, while simultaneously remaining at the core of psychic and collective development. As Durkheim put it, regulated tumult is still tumult (ibid.:309). His thoughts on these issues are themselves tumultuous and somewhat obscure. He fails to provide us with a theory of excess, simply because it would threaten his rational theoretical construct. *The Elementary Forms of Religious Life*, itself a superb artwork and an inspirational masterpiece as Watts Miller remarks, is very difficult to use in any socio-anthropological analysis.

Exporting Durkheim

Should we stop at this point and consider Durkheim's anthropology of religion as a mere historical curiosity? It would indeed be tempting to do so if we consider all the criticisms regarding Durkheim's treatment of anthropological information and its dual theory of the human condition. But in spite of all its shortcomings, it is worth noting that *The Elementary Forms* is the first attempt in history to account for public representation in society in sociological terms as it is expressed in the comparison between rite and drama. Of course, Durkheim's observations are piecemeal and flawed by the rhetoric of effervescence and turbulence, a style not really mastered by this hyper-rational sociologist. But because they do in fact exist, they should be evaluated within the framework of contemporary analyses of cultural life.

Erving Goffman played a major role in drawing from Durkheim key elements for his conceptualization of international ritual. As Randall Collins puts it, "Goffman's Durkheimianism is one constant point of anchorage; everything he does remains consistent with this position, and indeed elaborates it, and throughout his career he rejected interpretations that stressed his supposed similarities to symbolic interaction, ethnomethodology, and Machiavellian conflict theory" (Collins 2004:22). First off, Goffman sundered ritual from religion, and enhanced its performative dimension, which was one element among others in Durkheim's construction, albeit clearly not the leading one. He also developed a lay concept of ritual, which is no longer referred to as religious sacredness, but still implicitly draws a boundary line between the profane and the sacred. Everyday life is seen as full of procedures that constitute micro-sacralizations through their delineation of borders between proper and improper attitudes. Hence, Goffman does not consider ritual in its anthropological definition as an essential part of the structure of society (ritual in this sense is also a means to social totality, which reflects a macro-functioning view of

society). Instead he hopes for a more elementary form of ritual which lies in micro-situations, in unexceptional settings, and lacking the intensity and the effervescence that characterize the ritual fitted for an anthropological perspective. Thus did Goffman broaden the scope of the ritual from exceptional religious settings to the minutiae of everyday life, and in fact to every type of social circumstances but he strategically reduced the analytic frame that had allowed ritual to be a mere actualization of a macro-structure. Goffman showed particular interest in rituals that went awry, in performance failures, in different forms of embarrassment. He went further than Durkheim in this regard, but the author of *The Elementary Forms* had already noticed that the efficiency of rites was never guaranteed by their mere definition as religious rites, and that the actual performance, including its element of "surplus" and of pure pleasurable action, was determining in the assessment of ritual power. Durkheim and Goffman each wielded different analytical tools. Durkheim relied on written anthropological accounts and Goffman drew from direct observation. But obviously the former's theoretical assumptions depended to a large extent on implicit analogies with contemporary situations that he was able to observe himself; while the latter insisted on the central factor of situational co-presence, which was already an element of Durkheimian analysis, since gatherings and social concentration were a precondition for ritual performance. Many things have been added in interactional models of rituals that are informed by attention being paid to the properties of a local situation: for example, how attention is focused, or how a situation is controlled through performance and through a single definition of the situation. Durkheim's early definition of rite as a "representation" of drama has been enlarged and refined by Goffman who is well known for having used the analogy with drama, while at the same time reminding us that it was only a metaphor, and in his later works he gave us a complex set of analytical tools like frames within or around frames, and so on. What Goffman and Durkheim had in common—at the very least—was a sharp consciousness of the non-automatic character of ritual, and the equation of ritual and performance.

Randall Collins's recent attempt to build a general theory of interaction ritual is also beholden to Durkheim. Contrary to many views, Collins insists on the fact that Durkheim has a dynamic conception of ritual action. He says of *The Elementary Forms*: "Society becomes patterned by symbols, or more precisely by respect for symbols; but the symbols are respected only to the extent that they are charged up with sentiments by participation in rituals. Religion, the specific case under consideration here, is not simply a body of beliefs, but beliefs sustained by ritual practices" (Collins 2004:37). Here one can clearly see that discharge, viewed by Durkheim as a free and energetic expenditure of surplus, is necessary in recharging beliefs. Collins has made explicit the somewhat confused Durkheimian vocabulary of effervescence and revived it by building up

an analytical frame based on emotional energy. We now understand emotions to be essential in grasping Durkheim's intellectual framework. This notion was not terribly widespread in earlier studies of Durkheim. But recent readings of *The Elementary Forms*, even those mainly interested in epistemological issues like Anne Rawls' book (2004), are filled with the vocabulary of emotion. Rawls shows how "the idea that categories are experienced internally as emotions solves a problem for Durkheim" (ibid.:65). That explains the moral force of society and the perception that collective forces are necessary forces in rituals. Of course, the notion of social energy was always been strongly present in Durkheim's texts from the very beginning, but many readings of his work have played down this element. Now it has emerged in the full light of day, because the emotional approach makes a better fit with our contemporary view of society. Collins has developed his own model quite independently of Durkheim's conceptualization, and it will not be discussed at length in this chapter. But it serves as an excellent example of the fecundity of the Durkheimian construction when it is not rigidified in orthodox memories.

Of course, there is a major objection: how can we use "ritual" in order to give an account of all sorts of things, when Durkheim reserved the notion of rite to describe exceptional and intense moments of social life? If everything is ritual, then what is ritual? Sociality itself? Interaction as such? Malcolm Ruel warns us against the sloppy use of the concept of ritual: "Ritual cannot be treated independently from religious ideas. The treatment of ritual as 'symbolic action' often leads to a piecemeal and situational interpretation of ritual that departs from Durkheim's view of religion" (Ruel 1988:114). Such an orthodox standpoint has not been often adhered to in the second part of twentieth century. What Goffman did with the Durkheimian tradition was made possible by the fact that the author of *The Elementary Forms* had created a theoretical platform for extending the notion of rite to profane conditions. If Durkheim used primarily anthropological sources relating to Australian aborigines, he never hesitated in enlarging the scope of his inquiry to include examples taken from modern social and political life, the French Revolution being a case in point. Durkheim extends his investigation to encompass general history: "There are periods in history when, under the influence of some great collective shock, social interactions become more frequent and active. Men seek each other out and assemble together more than ever. Thus does that general effervescence result which is characteristic of revolutionary or creative epochs . . . This helps explain the Crusades, the French Revolution in both its sublime and savage aspects" (Durkheim 1912:241–42).

Durkheim's model is clearly trans-historic and aims at a general theory, which is made possible by his equating religion and society as a whole. But of course what Durkheim had in mind was not quotidian existence, but that intense moment in history when things and relationships

undergo brutal change. Such an extension is permitted by adopting a theory of interaction, and by transferring the sacred to the sphere of ordinary actions, two aspects that were not present in Durkheim's models, but which give a fair account of the construction of meanings and institutions in modern societies. One could well assume the contrary to be true. Contemporary societies seem to be massively deritualized. In the late 1980s, for example, the French anthropologist Daniel Fabre, raised an important question: "Can one still speak about rite in our contemporary societies? By importing this category, does not ethnology propound an illusory analysis, one that tries to understand the rite as the crystallization of a symbolic and cognitive system?" (Fabre 1987:3). Fabre gives a cautious answer. He says that although anthropology often makes a rather wild and uncontrolled use of rite so as to annex the territory of the present, the notion may nonetheless yield heuristic leads regarding the articulation of past and present when used properly. The sphere of rites is never frozen, but undergoes transformations all the time. This dynamic perspective was already present in Durkheim's work.

Festivals, rites, and rhythms

Having now seen the limits and the difficulties of exporting Durkheim's conceptualization of the profane and contemporary worlds, but having also seen the inventive uses of the Durkheimian tradition, we may at this juncture turn to the central question raised by this chapter. Is it not only possible but advisable to use neo-Durkheimian tools in the analysis of contemporary art festivals? There will be no final answer given to this question, but simply a contribution made to the debate. The material to be discussed derives from collective fieldwork undertaken over the past ten years, employs an ethnographic methodology, and deals with major festivals of Southern France, Avignon (theater) and Cannes (cinema).

The link between *The Elementary Forms of Religious Life* and contemporary French festivals is hardly a tentative one, and I am talking here about the French Revolutionary fête. Although they were failures in many respects, new republican ceremonies have aroused great interest at the time as well as in the nineteenth century. As Mona Ozouf notes, "[t]he Men of the Revolution took an extraordinary interest in the *fête révolutionnaire*. It was designed to make the brand new social link manifest, eternal, intangible" (Ozouf 1988:20). She views the fête as "a sacred theater of social contract" (ibid.:470). Like the historian Michelet, Durkheim took a positive view of the revolutionary fête as expressing a new society's strength and unity. Ozouf is very convincing in her assertion that twentieth-century historians of the French Revolution such as Albert Mathiez saw an element of religiosity in the explicitly lay-revolutionary fête because they were deeply influenced by the Durkheim's equation

between religion and society (ibid.:446). French Revolution is the most obvious case of a "transfert de sacralité" (transfer of sacred identity) to new things. Ozouf coined the phrase with reference to the Revolution and it behooves us to understand just how the sacred is transported from the realm of religion to more mundane regions of social life. At stake in such a transfer is the nation's self-image. Cannes and Avignon are of course professional and public gatherings devoted to a specific subject, but they are also much more than that: they involve a ritual presentation of the Nation.

It may seem surprising to assert a link between Avignon and Cannes, since they are very different both in terms of their subject matter (repertory and avant-garde theater one the one hand, commercial cinema on the other), and in terms of their economic and aesthetic history, and the relationship they form with audiences in a specific time and setting. But many common elements also exist. In both cases what is at stake is a strong link between artistic presentation and political issues. Both festivals sprang up in the aftermath of the Second World War, as attempts to reassess the place of the French nation in a new world order. French politicians have always attended both festivals, since they presented a special occasion for encounters between politicians and artists, although these were not always friendly encounters. In Avignon, where the audience has always been mainly French, the main theme from the start has been the self-depiction of the nation by means of theater. In Cannes, the initial and still ongoing project was to represent France to the world as it gathered for a fortnight on the Croisette. The parallel history of both festivals clearly shows that there is a powerful national and geopolitical agenda. This emerges not only when we examine the programmatic inscription of theses agendas in the course of a rather long history scanned by the annual rhythm (these festivals are great sources of collective memories), but also when we consider the political efficacy of an encounter which is organized to meet the requirements of broadcast and documentary processes. The Cannes Film Festival has more media coverage that any other sustained annual event in the world, while the Avignon Theater Festival has created its own system of documentation under the auspices of its founder—Jean Vilar—and thus rendered itself a perfect topic for research and for sociopolitical interpretation by the generations to come.

Since the late 1940s, Cannes has been viewed as a French stage for the presentation of the whole cinematographic world; here the festival-goer, whatever his or her status, is confronted with a vast array work, with heterogeneous cultural references and cinematographic codes, with stars, directors and critics. What we call "Cannes" is the simultaneous presence of a select group of films (representative of the whole of cinema), of peculiar forms of sociability and of certain celebratory rituals. In fact, many features of this international fête are largely dependent on local conditions, for instance on the codes which dominated casino life in the 1920s and 1930s, as well as on the traditional features of a beach resort. The rites

here are stylized forms of social codes that are part and parcel of winter tourism on the French Riviera.

The first attempts to create a movie festival in Cannes were just before the Second World War, when the social relationships of a leisured class were rapidly disintegrating. The main events, namely the fashionable winter "fête mondaine" and an evening at the casino, were losing their significance. Cannes developed after the war when summer-bathing tourism boomed on the Mediterranean shore, the beach becoming a showcase for presentation of the (suntanned) self, the elitist conception of winter tourism, with its aristocratic-like manners soon gave way, to a utopian beach democracy. One might describe the Cannes Film Festival as conjoining two main features of the Côte d'Azur resort. On the one hand, the legacy of winter tourism means that the great divide between actors and spectators is maintained according to a precise and ostentatious protocol; on the other hand, the beach democracy has developed its own conventions, which allow, at least formally, an equal access to public space for everyone.

The Avignon Theater Festival enjoys a unique status in French cultural history. It remains the best example we have of the powerful association between a state policy and an artistic mobilization. The French state has a long tradition of public intervention in cultural life, enabling and certifying cultural products as well as addressing the problem of democratic access to cultural goods, which over the course of the twentieth century became a political priority. Since the Popular Front of 1936, theater has been the paradigm of a cultural area, which can and must be transformed by public action. Pascal Ory has neatly shown how the idea that culture should be a decisive element in public service was able to develop and stabilize over time (Ory 1994). Theater belongs to the spheres of entertainment and public action. Simultaneously fête and discourse, ritual and political performance, it plays the leading role in celebrating ideas. This is particularly true for the idea of the nation, as well as for the notion of people's assembly. Even since the Enlightenment, and exemplified by such figures as Jules Michelet and Romain Rolland, French theater has been synonymous with democracy in action. The assembled people are represented on stage and feel the strength of their collective power. An open space under starry skies is very important in this respect, for it is the moment of "lay communion," far from both the preciosity of court theater and from the vulgarity of bourgeois theater. In French political culture, one has come to expect that theater should be the driving force in changing the relationship between stage-plays, and authors and audience, for it would appear to equate or at least hold out the promise of a united community. The hybrid nature of theater, between play and institution, is sufficient in defining the space of its republican ritualization. One may also add that it fills the void left by the Revolutionary Fête, emerging as a post-revolutionary ritual designed to reflect the nation back to itself,

although doomed largely to inefficiency in this respect. Of course, there is one other element in the progressive ritualization of French theater. Ever since the first years of the twentieth century, French artists have propagated the ideology of theater as a public service ("le théâtre, service public," as Avignon's founder, Jean Vilar, was fond of saying) because they hoped for their creative autonomy to be recognized and guaranteed by the state against the illegitimate taste of bourgeois philistine consumers. This paradox of state-guaranteed autonomy is a central feature of French cultural life and helps to explain the permanent ritual at these festivals of the artistic–political interface.

So far we have assessed the symbolic importance of these festivals and the fact that their annual rhythm, and the internal rhythmic divisions of time, are crucial to understanding how these events function. But hitherto there has been no form of exaltation or cultural madness that resembles Durkheim's analysis of aboriginal *corroborees*. There may be enthusiastic applause, or less frequently, silent or vocal protests, but never any real loss of control, if one does not count the squealing girls when Brad Pitt starts his walk up the steps of Cannes' Palais des Festivals. Over long years, theater and film audiences have been inured to many conventions, such as preserving silence during the show and hiding to some extent their feelings. In different ways, the feeling of belonging to a particular type of society and sharing specific behavioral codes are essential to the felicitous outcome of an event. This does not mean that unanimity is required and the public must be united. Sharing the festival codes is not the same as approving the selections of the organizers. Factional divisions are part of the game and to some extent provide the festivals with increased symbolic significance. In Avignon, for instance, the debates surrounding the festival are almost as important as the performances themselves. Avignon's founder, Jean Vilar, worked ceaselessly to create a space for debates which would embody the very essence of public theater in a modern democracy; the main goal was to change the spectator into a "participant," an idea that increased the ritual dimension of this summer gathering of theater-goers, and made for the closeness between actors and audience by promoting a certain spatial density and intensity of exchanges.

If we take a close look at *The Elementary Forms*, we quickly notice that Durkheim's analytical kit cannot be reduced to the ambiguous ideology of crowd psychology. There is an enormous difference between his impoverished lexicon of effervescence and exaltation, and the depth of his secondary analysis of ethnographic reports. Here he shows that there may indeed be some differentiation within the apparently more unified and regulated celebrations, and that there is always room for individual attitudes to manifest themselves in even the most collective of events. Of course, modern festivals are entirely different from *corroborees*, or at least from our representations of them. We know that the consumption of art

in contemporary societies involves a high level of reflexivity and role distancing. Brecht's *Verfremdung* (defamiliarization) was one of the first theories regarding such a relationship between artwork and audience, but there are others available now, and we tend to preserve an a-critical relationship to events that are not really labeled as artistic, since they would seem to involve the real crowd behavior of an undifferentiated mass (the best example being rave parties). One could discuss at length the accuracy of descriptions that equate audience behavior with a trance or delirium. But one can indeed disentangle Durkheim's model of collective behavior in public spaces from the usual view of effervescence as a total loss of control. Other features are more important here. The physical assembly of the group is essential, as is the frame or multiple frames of the event, to any understanding of those physical elements which give a gathering its unique character. For instance, Avignon's Cour d'Honneur, where the main plays are performed, offers specific characteristics which help create a physical setting based on the confrontation between a powerful architectural frame and an artistic gesture which must not only challenge the physical constraints but the whole history of theater itself presented (Ethis 2002). Ethnographic accounts allow for an understanding of the strong relationship between organizational frames and shared emotions. This is true for the world famous *montée des marches* at the Cannes festival, which, despite its rather cheap configuration (low-cost red carpet, uneven compliance to dress codes and occasional episodes of showy vulgarity), helps focus the world's attention and offer the participants, whether they be famous or complete nonentities, the feeling that they are part of the movie community, at least during the fifty seconds it takes them to climb the stairs (Fabiani 2001). There is a shared awareness of the situation, even if the participants' resources are unequal and if a few people have a much better view of the proceedings than others. So shared emotions do not necessarily mean unanimity or a lack of differentiation. At Cannes, ordinary people also love to climb the steps and compete for invitations. Such a sense of participation does not imply any loss of control; the playful dimension of the act can be seen in many "pastiche" ascensions of the stairs and in the craze for the photographs that local artists sell on the beachfront the day after the ceremony. In what turned out to be a controversial essay, I once argued that the Cannes rituals were rather "weak" to the extent that they were performed with a role distancing and a subdued tendency toward mockery, as witnessed in the cheap evening dresses and tuxedos that many climbers wear, or in the ostentatious stops in front of squadrons of press photographers along the way (ibid.).

Nevertheless, such events have important moral effects in that they maintain a collective belief in the necessity of public culture. What does that mean? We are witnessing every day the recess of shared emotions vis-à-vis cultural objects. Culture is consumed more and more on a strictly private basis, through the use of television and audiovisual devices.

Festivals of any kind help to revive the importance of public participation in the arts. One may think that such participation is merely token, as in Cannes where the vast majority of the public catch only ephemeral glimpses of the cinema magic they have come to see. But even if public participation is purely symbolic, it is still essential to reinforce belief in the power of culture so as to associate people and give them access to shared emotions, however disappointing they may turn out to be.

Thus, festivals share both moral and cognitive elements (Fabiani 2011). They rebuild and recharge a community by regularly performing rituals and by systematically archiving a memory of the events, as well as providing a shared understanding of what cultural life should be in the future. Festivals are always crowded with teeming argumentative people, who disagree about many things but who hold at least one belief in common: that the festival is the archetype of public space, where physical closeness and a right to speak define the primary conditions of collective life. That is the reason why their symbolic and political capital is extremely high, and that they are viewed on television by millions, and discussed by people who have never even gone to Avignon or Cannes. Cannes has done much to persuade us that cinema is not only a universal medium, but also a great art. Avignon has spread the notion of theater as a public service. And both of these events have played a fundamental role in framing our conceptions of culture, as well as being cognitive experiences that produce classifications and evaluations.

The main goal of this chapter has been to desimplify what has often been interpreted as the unregulated intrusion of irrationality into a highly rational construct: Durkheim's theory of society. We have played down the electric element in Durkheim's conception, so to speak, and privileged the moral and cognitive elements of collective life. Such an attempt is close to Susan Stedman Jones' stimulating rereading of Durkheim, which reinscribes the French sociologist in his republican context (Stedman Jones 2001).

Notes

1. This chapter is a revised version of: J.L. Fabiani, "Should the Sociological Analysis of Art Festivals be Neo-Durkheimian?," *Durkheimian Studies*, vol.11, 2005, pp. 49–66.
2. This is the translation found in Durkheim 1995[1912]:385.

References

Alexander, J. 2003: *The Meanings of Social Life. A Cultural Sociology*. Oxford: Oxford University Press.

Bachelard, Gaston. 1938. *La formation de l'esprit scientifique*. Paris: Vrin.

Bourdieu, P. 1967. "Champ intellectuel et projet créateur." *Les Temps modernes*, novembre.

————. 1979. *La Distinction. Critique sociale du jugement*. Paris: Les Editions de Minuit.

Collins, R.C. 2004. *Interaction Ritual Chains*. Princeton: Princeton University Press.

Durkheim, E. 1973[1890]. "The Principles of 1789 and Sociology." *Émile Durkheim. On Morality and Society. Selected Writings*. Ed. Robert Bellah. Chicago: The University of Chicago Press, 34–42.

————. 1893. *De la division du travail social. Etude sur l'organisation des sociétés supérieures*. Paris: Alcan.

————. 1912. *Les Formes élémentaires de la vie religieuse*. Paris: Alcan.

————. 1995[1912]. *The Elementary Forms of Religious Life*. New York: Free Press.

Ethis, E. 2002. *Le Spectateur réinventé. Le Festival d'Avignon sous le regard des sciences sociales*. Paris: La Documentation française.

Evans-Pritchard, E.E. 1965. *Theories of Primitive Religion*. Oxford: Clarendon Press.

Fabiani, J.L 1993. "Sur quelques progrès récents de la sociologie des œuvres." *Genèses*, n°11, mars, 148–67.

————. 2001. "Le rituel évidé: confusion et contestation au sein du Festival." In *Aux marches du palais. Le Festival de Cannes sous le regard des sciences sociales*. Ed. Emmanuel Ethis. Paris: La Documentation française, 65–80.

————. 2003a. "The Audience and its Legend. A Sociological Analysis of the Avignon Festival." *The Journal of Arts, Management, Law and Society*, 32(4):265–78.

————. 2003b. "Mondes intellectuels et sociologie des professions." Under the direction of P.M. Menger. *Les professions et leurs sociologies. Modèles théoriques, catégorisations, évolutions*. Paris: Editions de la MSH, 135–44.

————. 2011. "Festivals: Local and Global. Critical Interventions and the Cultural Public Sphere." In *Festivals and the Cultural Public Sphere*. Eds. G. Delanty, L. Giorgi and M. Sassatelli. London: Routledge.

Fabre, D. 1987. "Le rite et ses raisons." *Terrain*, 8: 3–7.

Gephart, W. 2000. "The Beautiful and the Sacred: Durkheim's Look at the Elementary Forms of Aesthetic Life." *Durkheimian Studies/Etudes durkheimiennes*, n.s. 6: 85–92.

Goffman, E. 1967. *Interaction Ritual*. New York: Doubleday.

Lepenies, W. 1988. *Between Literature and Science: The Rise of Sociology*. Cambridge: Cambridge University Press.

Lukes, S. 1973. *Durkheim. His Life and Works. A Historical and Critical Study*. London: Allen Lane.

Menger, P.-M. 2000. "L'art, les pouvoirs de l'imagination et la théorie des desires dans la théorie durkheimienne." *Durkheimian Studies/Etudes durkheimiennes*. n.s. 6: 61–84.

Michon, P. 2005. *Rythmes, pouvoir, mondialisation*. Paris: Presses universitaires de France.

Ory, P. 1994. *La belle illusion. Culture et politique sous le signe du Front populaire 1935–1938*. Paris: Plon.

Ozouf, M. 1988. *La Fête révolutionnaire*. Paris: Gallimard.

Pickering, W.S.F. 2000. "Durkheim, the Arts and the Moral Sword." *Durkheimian Studies/ Etudes durkheimiennes*, n.s. 6: 43–60.

Rawls, A.W. 2004. *Epistemology and Practice. Durkheim's* The Elementary Forms of Religious Life. Cambridge: Cambridge University Press.

Ruel, M. 1988. "Rescuing Durkheim's Rites from the Symbolizing Anthropologists." In *On Durkheim's* Elementary Forms of Religious Life. Eds. N.J. Allen, W.S.F. Pickering and W. Watts Miller. London, New York: Routledge.

Stedman Jones, S. 2001. *Durkheim Reconsidered*. Cambridge: Polity Press.

Watts Miller, W. 2004. "Total Aesthetics. Art and *The Elemental Forms*." *Durkheim Studies*, 10: 88–118.

Chapter 4

The Power of Imagination and the Economy of Desire

Durkheim and Art

Pierre-Michel Menger

§ 66 People first sense what is necessary, then consider what is useful, next attend to comfort, later delight in pleasures, soon grow dissolute in luxury, and finally go mad squandering their estates. § 67 The nature of peoples is first crude, then severe, next generous, later fastidious, and finally dissolute.

—Giambattista Vico, *New Science*, 1999 [1744], excerpt quoted in
Gombrich (1999)

Anyone who has read the founding works of social science knows that art and art-related matters and values are not central concerns for Marx or Durkheim. Without going so far as to claim that, because the question was only marginal for the author, it should be understood as *the* fundamental matter that his theory did not or could not encompass or account for, I will try to show that the problem of analyzing art does indicate some of the limits, interpretive uncertainties, and aporias that nascent social science ran up against. And across the distinct varieties of relativism by means of which sociology developed and prospered, the question of the value of art remained a persistent challenge for social science. The crucial problem for Durkheim (and for Marx before him, though he formulated it quite differently) may be defined thus: How can the extreme differentiation of artistic production, expressing as it does the advance of individualism—the consummate individual being the artist—be reconciled with the fact that the artworks engendered by the social dynamic of individualism elicit collective admiration? In other words, how can we account simultaneously for the uniqueness of artworks and the conditions in which they are produced, and the generality or universality of their meaning and the aesthetic pleasure they give? These questions had particularly strong resonance for Durkheim, because as he saw it the

advance of individualism in modern societies, driven by the division of labor and by task and skill specialization, was a threat to the social tie and group unity. He did not develop a specific analysis of the social meaning of art, nor did he study or cite a particular art discipline, creator, set of art-works, or art phenomena to illustrate his pronouncements on the subject. Nonetheless, a general thesis on art may be distilled from Durkheim's writings, and it may be summed up as follows: *no area or activity incarnates as fully as art the individual's taste for freely exercising his or her faculties, nor better symbolizes the autonomy of the subject, the infinite power and reach of the imagination, or the irresistible dynamic of innovation by means of which civiliza-tion may be thought to perfect itself; yet no area or activity is more likely than art to derail societies propelled by that dynamic.*

Durkheim's approach to art reveals the ambivalence and contradic-tions of his theory of individual action. In grappling with the phenom-enon of artistic invention, he was led to point up divergent forces of social evolution. On one hand was the increasing individualization of behavior, which, together with greater specialization of activities, was ineluctably transforming social life, causing societies to evolve in such a way that their members, once related by mechanical solidarity, now came together through organic solidarity. On the other was what Durkheim considered the pressing functional need for a regulatory norm apparatus that would limit the negative, anomic consequences of unchecked individualism, and contain its disaggregating power.

Philippe Besnard (1987:21–27) showed that the theory of anomie so central to Durkheim's work was developed in opposition to the views of the philosopher from whom he borrowed the term, Jean-Marie Guyau. It is to Guyau (1889) that we owe the first explicit attempt to analyze art from a sociological perspective. For him, anomie was a strongly posi-tive goal; it was the desirable and in any case inevitable result of the gradual individualizing of moral rules, religious beliefs, and behavioral models, and within an evolutionary framework, it amounted to eman-cipation at the scale of humanity as a whole. The consummate form of anomie thus defined was aesthetic activity, an activity in which individu-alism might express itself unfettered, thereby manifesting the immense power of creative freedom. This celebration of anomie was a primary target of Durkheim's thoroughgoing critique of what he viewed as the philosopher's anarchistic excesses. Above all, Guyau's thinking left him extremely wary of the liberating powers of aesthetic activity. To a degree commensurate with the sense of exaltation it generated in the individual, aesthetic activity seemed to undermine what bound individuals together in society; namely the moral and legal apparatus for managing the collec-tive obligations that any community forming a society had to abide by.

The constant tension between the two defining characteristics of aes-thetic activity—uniqueness of artists and artworks, collective admiration of them—led Durkheim to interpret the social meaning of art and its

development in two distinct ways. The sharply individual character of creative activities was seen as the outcome of an evolutionary process that was increasing differentiation of skilled work and its most sophisticated products, while the value universally attributed to major artworks was understood in terms of a cyclical notion of social change. This second notion enabled him to maintain that art was only fully realized, and only acquired its full social value, in connection with exceptional historical periods in which the individual fused with the group.

The ambiguity of art, the danger of individual deregulation

Art for Durkheim was an ambivalent field of activity. Kant had neatly captured this ambivalence in his two-point definition of art as purposeful and therefore eminently rational activity, yet activity with no determined purpose. This second characteristic was what guaranteed the freedom of art-making: in its highest forms, art was an activity without rules. Genius, according to Kant, creates without rules.

To characterize the ambivalent nature of art, Durkheim likened it to a luxury. This notion helped him define the relationship between the social and economic dimensions of activities that exceed any productive function, and to put forward the idea that activities that are not strictly utilitarian nonetheless have a place in the social and economic system. But luxury also designated excessive investment in extremely expensive production and consumption activities.[1]

What made art a luxury first of all was that the individual energy used in art-related activities was energy that had been released from the usual constraints: "These acts [heroism, holiness, art patronage, altruism] are not necessary, are adjusted to no vital end, and in short, are a superfluity; that is to say, they belong to the domain of art. After we have directed a part of our energy towards doing its daily task, we like to play freely, indulging ourselves to exert energy for its own sake, without any use, without any definite purpose in sight. This is the pleasure of playing a game, and aesthetic pleasure is only a superior form of it" (Durkheim 1933[1893]:430). This extensive notion of art led Durkheim to propose, alongside a partial aesthetics focused on art itself, a general aesthetics in which all areas of social life become infused with some of the defining traits of artistic activity. Having posited this, he could use art as a basis for criticizing economic utilitarianism, and attributing a positive, near-regulatory function to luxury or "the superfluous":

> Like intellectual life, moral life has its own aesthetic. The highest virtues inhere not in the regular, strict accomplishing of acts that are immediately necessary to the good of the social order but rather in free, spontaneous

movements, utterly unnecessary sacrifices that may even run counter to wise economic precepts. . . . Luxury items are the most costly not only because in general they are the scarcest, but also because they are the most esteemed. This means that life as people of all times have understood it does not consist exclusively in determining the exact budget required for the individual or social organism, or responding at lowest cost to external stimuli, or ensuring that expenses are proportionate to reparations. To live is above all to act, indeed to act without counting, simply for the pleasure of acting. (Durkheim 1974[1911]:108–9)

But imagination, the freest of the faculties and the source *par excellence* of artistic invention, almost irresistibly moves individuals to excessive behavior, since there are no defined purposes or observable rules to rein in the energy liberated by and for artistic activity. For Durkheim, playful activities—art being the most fully accomplished of them—draw us outside the sphere of moral life and the regulatory ideals of collective life. They bring to light the danger of deregulation that in fact threatens all individual activity. The threat inherent in art is the unchecked blossoming or proliferation of idiosyncrasy, which runs counter to the constraint of social rules. The forces that art reveals, far from being incidental, exist within every individual and must be contained by the group.

This explains why every passage on art in *The Division of Labor in Society* leads to evocations of disease, pathology, the deregulation of social life. For example: "In general, the same may be said of all aesthetic activity; it is healthy only if moderated. The need of playing, acting without [purpose] and for the pleasure of acting, cannot be developed beyond a certain point without depriving oneself of serious life. Too great an artistic sensibility is a sickly phenomenon which cannot become general without danger to society" (Durkheim 1933[1893]:230–40). This is because superfluity always tends to become excess and freedom to know no bounds. Art should work like morality does—as an economy of limits. If aesthetic activity abides by such limits, if it is practiced in moderation, then neither individual nor society has any cause to fear. But how could aesthetic activity let itself be contained by a sensible economy of limits and moderation? Can the need to play or act without purpose stop short of excess? What would the function of imagination be if from the very outset it were subject to authoritarian restrictions?

Durkheim incessantly intertwines these two lines of argument. By casting the analysis in psycho-physiological terms, he can describe a process in which the faculties come into equilibrium as the individual matures and is successfully socialized. But he is also ever concerned to examine how individuals' changing living conditions affect the risk of intemperance and anomie, and what social control mechanisms might limit that risk.

Before examining each of his arguments, it is helpful to see how they are connected. Through the ever-improving civilizing process

incarnated in the progress of societies and the accumulating mass of human accomplishments, forces are being liberated that differentiate productive functions, extend knowledge, and favor the full deployment of human creativity. These are also precisely the conditions required for gratifying individual development, since the tangible social result of this improvement process is increased individualization of living conditions, due to increasingly complex forms of interdependence and normative regulation.

The economy of individual needs and desires

Excess haunts individual behavior like a sort of inevitable natural evil. Why is the economy of needs and desires so fundamentally prone to disequilibrium? The question, a common one in classic philosophical anthropology, is handled by Durkheim in the following terms. Primary needs, i.e., the elementary forces that drive behavior, are only found in a pure state in animals, as Durkheim insists throughout book two chapter 3, section 2, of *Suicide*. Animal behavior manifests exclusively physiological needs, and this applies to both instinct and habit. As soon as such needs have been met through the discovery of objects that will satisfy them, they disappear. Animal behavior is thus naturally limited by the balance between need and means of satisfying it: "[the animal's] power of reflection is not sufficiently developed to imagine other ends than those implicit in its physical nature" (Durkheim 1951[1920]:246).

But what of man? Human needs are rooted in the body yet also partake of a complex mental life involving the active faculties of intelligence, reflection and imagination. In fact, it could be said that human needs are initially mediated by the imagination: the object imagined to be the means of satisfying the need mediates between the need and the object itself. Primary human needs are organic in origin. Though more complex than immediate primitive drives, they are likewise limited and allayed by acts of consumption.[2]

Though imagination and reflection play the role of initial mediators and spring into action as soon as organic needs arise they are much more active when it comes to the second category of psycho-physiological behavior determinants; i.e., superior needs, which Durkheim also calls desires. The objects of desires or superior needs are highly developed goods and forms of consumption—material and cultural goods generated by progress in the division of labor and ways of living such as comfort and luxury.

These "creations of social life" have an elective affinity with the intellectualizing and imagining that activate desire, because in contrast to needs "governed by bodily dependence" and satisfied by consumption that goes no further than satiation, superior needs are not satisfied by any

determinable quantity of well-being—as is demonstrated by the human quest for ever more refined comforts.[3] The role of imagination and intellectualization is much greater when it comes to activating superior desires of the sort typically fueled by social evolution. This is the very condition of civilizing development, or, to use Rousseau's word, the "perfecting" of man: imagination and thought create tensions that are both fruitful and threatening; they push civilization forward but also constantly, ineluctably threaten to create imbalance in the economy of individual needs and desires.

And for Durkheim there is indeed a pathology of desire, since the desires that prompt and propel the individual are unlimited. Left to follow their nature, individuals cannot of themselves inhibit their desires: "Irrespective of any external regulatory force, our capacity for feeling [*sensibilité*] is in itself an insatiable and bottomless abyss" (Durkheim 1951[1920]:247). The individual imagination is continually pushing outward the limits at which desires are assuaged or satisfied, constantly reactivating the quest for novel satisfactions—at the risk of squandering the person's vital energy. Imagination stokes the desire for novelty and inclines individuals to immoderate consumption of superfluous goods. It dangles inaccessible objects before the mind's eye, or objects so undetermined that no satisfaction can allay desire for them, even momentarily.

The immoderate activation of imagination may threaten an individual's very life. Like Pierre Janet (1889), Durkheim thought of each and every individual as having a determined amount or sum of vital energy: an individual could only survive if she were careful to "manage" that energy "capital." Desire has no inherent means of limiting itself, and desiring uses up vital energy, especially given that desires have to be satisfied with real objects rather than imaginary substitutes. (Durkheim's understanding here contrasts with Freud's.)

The social wellspring of intemperate desire

For Durkheim it was crucial to examine not only how the individual is affected, but also what factors differentiate the behaviors of distinct individuals and the resulting aggregate effects. Need satisfaction varies by the individual's position in the social hierarchy. And historical context also plays a role, in that aspirations and the levels at which inclinations can be satisfied are continually rising.[4] Clearly the inter-individual differences that had to be regulated were those internal to a given society. Through its coercive, restricting function, social organization exercised the same regulatory power on individuals as the organism on human physical needs, only in this case regulation served society's moral needs. Only social organization could impose itself on individuals as a legitimately superior power of constraint, and this was so because it fixed

conditions—accepted by all—for adjusting desires to opportunities for satisfying them. Thanks to meritocratic competition, Durkheim explained, the ideal of justice could be reconciled with class differentiation, thus making it possible to establish conditions of equal opportunity for entering the various occupations. Principles for fairly remunerating hierarchically distinct occupational activities could then be determined on this basis (Durkheim 1951[1920]:275ff).

Moreover, Durkheim continued, people in social categories where the wish was to rise and therefore to increase consumption had to be taught to moderate their desires. This was crucial in periods of abruptly accelerating social mobility, because that situation upset all graduation of desires until the system could regain equilibrium:

> Appetites, not being controlled by a public opinion that has become disoriented, no longer recognize the limits proper to them ... With increased prosperity, desires increase ... Overweening ambition always exceeds the results obtained, great as they may be, since there is no warning to pause here. Nothing gives satisfaction, and all this agitation is uninterruptedly maintained without appeasement. Above all, since this race for an unattainable goal can give no other pleasure but that of the race itself, if it is one, once it is interrupted, the participants are left empty-handed. At the same time the struggle grows more violent and painful, but from being less controlled and because competition is greater. All classes contend among themselves because no established classification any longer exists. (Durkheim 1951[1920]:253)

Durkheim's analysis of how differences in social condition are regulated and of the dangers of deregulation lurking in the social dynamic itself can be related to the thinking of a long line of authors, from Herbert Spencer and Georg Simmel to Pierre Bourdieu by way of Thorsten Veblen, authors with a critical interest in the symbolic wellsprings of social competition, conspicuous consumption and social distinction strategies. According to Durkheim, the objects of desire that intemperate individuals set their sights on are precisely those most directly expressive of social inequality. The imagination, feeding as it does on ever-new representations of desirable objects, finds nourishment for itself in the spectacle of others' lifestyles and consumption behavior. And where are the most desirable things to be found if not among the opportunities and possessions of those situated higher on the social scale, who consume luxury goods to increase their well-being? Are those goods radically superfluous? Or do they satisfy needs—needs that the upper class is able to satisfy before other people? As Durkheim saw it, though consumption of luxury goods generated envious comparison, the superfluity of those goods could at the very least serve the positive social function of curbing the tyranny of utilitarianism. Indeed, the very dynamic of civilization, its advance toward "perfection," implied moving beyond existing means—products, methods, practices,

behaviors—for satisfying higher human purposes. Luxury goods partook of this.

Against theorists of individualism such as Spencer, who deduced society from the individual, Durkheim affirmed the logical and sociological primacy of collective life. In this argument, the differentiation of individuals from each other and the deployment of their diverse, unequal abilities partook of the evolution of collective life .[5] As the division of labor progressed, it would necessarily amplify inter-individual differences and expression of them. But at other moments, Durkheim's vocabulary is virtualist, the suggestion being that the individual's potential would remain dormant, veiled, were it not for external circumstances:

> Everything occurs mechanically. A break in the equilibrium of the social mass gives rise to conflicts that can only be resolved by a more developed form of the division of labor: this is the driving force for progress. As for external circumstances and the various combinations of heredity, just as the contours of the land determine the direction of a watercourse but do not create it, they indicate the direction in which specialization is occurring in cases where it is needed, but they do not impose any obligation. The individual differences that they produce would remain in a state of virtuality if, in order to face up to new difficulties, we were not forced to give them prominence and to develop them. (Durkheim 1933[1893]:212)

We are confronted once again here with the ambiguities characteristic of any dualist construction being used to develop an argument that is at once logical and genealogical. Durkheim must both claim the unity of an origin—i.e., the primacy of the collective, the group—and slip in a principle of differentiation activated by external circumstances. He must identify a logical beginning and, from the very outset, contaminate it with a logical impurity in order for history to happen. Indeed, history in Durkheim's construction is nothing more than the sum of cumulative, exponential instances of a given society's non-coincidence with equilibrium (what economists now call being "out of equilibrium state"): equilibrium between needs and the environment, between functions and capabilities, between increasing labor specialization and inter-individual solidarity, between hereditary transmission of endowments, which automatically generates inequalities, and the moral demand for social equity.

In the world of innovation-rich consumption products, inter-individual relations as structured by class differences and the appetites stimulated by those differences find the perfect symbolic food for imaginarily satisfying needs that are incessantly being extended and renewed. That world is also the wellspring of individuals' envious comparisons of their own situations with those of others. The imagination works to undermine both the individual economy of restricting one's desires—an economy that, as we have seen, is perpetually and by its very nature in danger of being deregulated—and the group economy of disciplining needs born of

comparison. The ultimate paradox is that this is the only way the civilization-perfecting process can work to subordinate external forces to social forces, thereby "overturning the natural order" and ensuring that this social, socially won, liberty gets instituted over the constraining necessity of natural conditions (i.e., inter-individual inequalities grounded in "nature" and transmitted by the "natural" succession of generations).[6]

Art and community

In another line of Durkheim's thought and argument, art incarnates the ideal of community that social groups bring into existence and work to sustain or reaffirm in all major historical periods of collective "effervescence." Due to the particularly dense social exchanges characteristic of such periods, individuals come to feel and know the strength of interpersonal solidarity around shared ideals. This is why, as we shall see below, art amounts to a supplement, in the twofold sense of the term: a surplus and a means of compensating for an absence or lack.

The religious origin of art as conceived by Durkheim in *The Elementary Forms of Religious Life* (1995[1912]) provides the first and most important illustration of this. The essence of the sacred that defines the religious realm lies for Durkheim in obedience to an authority that is none other than the power of the social group itself, as it acts upon and within each member of the group. Religious beliefs are made up of collectively developed representations of human beings and the world; representations that derive from the given social community's particular set of morals, cosmology, and history. But the only way those beliefs can act on people and be reactivated is through representative symbols and rites: "Therefore the rite serves and can only serve to maintain the vitality of those beliefs and to prevent their memory from being obliterated—in other words, to revitalize the most essential elements of the collective consciousness and conscience. Through this rite the group periodically revises the sense it has of itself and its unity; the nature of the individuals as social beings is strengthened at the same time" (Durkheim 1995[1912]:379). From this conception of religion comes an interpretation of the fundamental components of artistic activity: its content is deeply implicated in the representative, dramatic nature of ritual ceremony, but this origin becomes blurred as one generation follows upon another and the group's founding events and narratives are forgotten, as its religious rituals become secularized or "mere public festivities."

The form that artistic activity assumes derives from the way it elaborates pleasing representations symbolizing the unity and authority of the group. Moreover, this condition is precisely the one required in order for religious ceremonies to work. On the one hand, the workings of the imagination are what makes it possible to symbolize the sacred:

[A]lthough religious thought is something other than a system of fictions, the realities to which it corresponds can gain religious expression only if the imagination transfigures them. Great is the distance between society as it is objectively, and the sacred things that represent it symbolically. The impressions really felt by men—the raw material for this construction—had to be interpreted, elaborated, and transformed to the point of becoming unrecognizable. So the world of religious things is partly an imaginary world (albeit only in its outward form) and, for this reason, one that lends itself more readily to the free creations of the mind. (Durkheim 1995[1912]:385)

On the other hand, it is only through artistically developed forms that religious worship attains its full moral efficacy. The free use of the imagination implied in making art signals the uncommon and indeed abnormal character of this form of "moral remaking":

That which made art exist makes it a necessity. [Art] is not merely an outward adornment that the cult can be thought of as dressing up in, in order to hide what may be too austere and harsh about it; the cult itself is aesthetic in some way. . . . Obviously it would be a great error to see only this aspect of religion or to overstate its importance. . . . [The cult] exerts its influence in a different direction than does a pure work of art. . . . a rite is something other than a game; it belongs to the serious side of life. But while the unreal and imaginary element is not the essence, it still plays a role that is far from negligible. That element enters into the feeling of comfort that the faithful draw from the accomplished rite. Recreation is one form of the moral remaking that is the primary object of the positive cult. (Durkheim 1995[1912]:385–86)

What is it in art that makes it both non-essential for the serious content of religion and religious ideals, yet indispensable to the symbolizing process? Art bears within it precisely that ambivalence that haunts Durkheim's theorizing: it is what allows for symbolizing the individual's duality. For an individual is both an authentic creator—precisely because he is capable of such inventive symbolizing—and a member of a moral community that indirectly uses such symbolizing to celebrate anti-individualist ideals.

Durkheim thus endows art with decisive power, and the ambivalence of that power may be apprehended by way of the pure logic of "the supplement" so subtly analyzed by Jacques Derrida.[7] Art comes to supplement discursive thinking, as that kind of thinking cannot really produce "symbolizable" religious realities; and art supplements the rite of the cult by providing what symbolization requires in order to be fully effective. But what exactly does it contribute? To answer this, we have to understand how art is able to de-individualize creations of individual imaginations.

The question of art comes up in Durkheim's discussion of another key problem of the relationship between the individual and the group: to what extent can value judgments be objective? Durkheim successively

(1) rejects the notion that a judgment is objective because it is common to a statistically significant segment of some population and (2) attempts to define objectivity in terms of a collectively agreed hierarchy of values. Both these types of solutions posit an intrinsic relationship between the characteristics of the object being evaluated and the judgment made of it, the underlying assumption being that the value proceeds directly from the nature of the thing. If that were the case, argues Durkheim, the judgment would result directly from the strength of that connection—a connection recognized by the group, the majority, or the average individual as irresistibly strong—whereas in reality, assessments of value vary greatly over space and time and the characteristics of things often have little or nothing to do with the value attributed to them. Durkheim's solution consists in accepting this variability, while de-individualizing the attribution of value: value assessment is supra-individual in that value is estimated by reference to collectively recognized ideals. However, those ideals are specific to a given society—this point enables Durkheim to provide a firmer ground to value attribution because it specifies the conditions under which judgment objectivity holds.

He still has to explain how those ideals are forged. Though supra-individual, they are neither transcendent nor timeless as they are the creation of a particular society. Durkheim once again generalizes his conception of the origin of religion by disconnecting two kinds of time. On the one hand, there are "hot" episodes of group history—crises, revolutions, great social movements that create ideals—episodes so effervescent that all difference between ideal and reality seems to have been abolished. Without going into detail, Durkheim lists "the great crisis of Christianity," the Reformation and the Renaissance, the French Revolution, the "great socialist agitations of the nineteenth century." It is during such periods, characterized by extremely dense interaction among individuals, that collective ideals are forged, "very simply the ideas by which social life paints itself, sums itself up as it is at various peaks in its development" (Durkheim 1974[1911]:116). On the other are "cool" historical periods, wherein the social tie goes slack: as the episodes of "fertile tumult" recede in time, individuals sense a separation between the ideal and the real. At such times, art is one means of keeping up and "revivifying" memory of group ideals: "This is the purpose of feasts, public ceremonies, either religious or secular, preaching of all sorts, the Church's, the school's, theatricals, artistic displays—in a word, everything that brings men together and enables them to commune in one and the same intellectual and moral life. These are like partial, weaker rebirths of the effervescence of the creative periods" (ibid.:116). Durkheim's understanding that social life is made up of alternating exceptional and ordinary periods suggests that group unity is actually forged in those extraordinary periods; i.e., that the united, ideal-forging society has really—historically—existed at certain times. It is somewhat surprising that Durkheim's descriptions of such

periods should be so vague, thin, and merely allusive. Indeed, his conception seems to oscillate between a colorful historical fresco and a cursory anthropology of celebratory acts.

In collective ideal-creating effervescence, and in the creation of religion and its rites, Durkheim sees a surplus of energy being liberated through a process of unfettered creation. Liberated through play or violence—in sum, through non-useful, non-utilitarian activities: "Moreover, because the intellectual forces that serve in making [the world of religious things] are intense and tumultuous, the mere task of expressing the real with the help of proper symbols is insufficient to occupy them. A surplus remains generally available that seeks to busy itself with supplementary and superfluous works of luxury—that is, with works of art" (Durkheim 1995[1912]:385). Durkheim's conceptual construction culminates in a description of a collective subject formed by the bonding interaction of individual consciousnesses. This subject is endowed with a new sort of psychic life, infused with uncommon energy and force of feeling; this in turn dispossesses individuals of their egoistic selves, moving them to create and innovate: "Swept along by the group, the individual loses interest in himself, forgets himself, gives himself over entirely to shared purposes. The magnetic center of his conduct shifts, it comes to be situated outside himself. The forces that rise thereby—precisely because they are theoretical forces—cannot readily be channeled or contained, nor do they adjust themselves to strictly determined ends; they feel the need to spread for the sake of spreading—playfully, aimlessly" (Durkheim 1974[1911]:114–15).

Durkheim's vision of the collective subject that dominates each individual consciousness is intimately related to his notion of individual action and energy, except that creative power in the collective subject is generated exclusively by the group and works exclusively in its service, for the unique purpose of projecting and symbolizing group unity and ideals. This is art's one positive accomplishment, since it is usually imbued with individualist intemperance and is therefore a threat to group cohesion. The conditions under which art works "well" like this are of course utterly exceptional and restrictive: historical moments of collective effervescence, the wellspring of ideal symbolizing. When art revivifies those ideals through its function of recollection, then and only then, for Durkheim, is it doing what art should do.

An economy of reserve stores

To adjust the creative capabilities of the imagination and its product—artistic activity—to the superior interests of the group, i.e., the work of inventing and symbolizing group values and ideals, and to render acceptable the powers of imagination, desire, invention, novelty, Durkheim had

to devise a story of origins—religious ones—and convulsions—the convulsions of history. Those forces constitute the substance of individualism and reflect the power of inter-individual differentiation factors, but they also represent a treasure for socialized humanity and make possible the forward movement of history. In elaborating his story, Durkheim in fact proceeded just as Rousseau had. And his genetic model of the origin of art is like his notion of how energy works in the individualist passions that engender creative invention and aesthetic rapture: a model of perpetually collapsing equilibrium states.

In the course he gave on Rousseau during the years he was writing *De la division du travail social*, Durkheim (1960[1952]) admirably brings to light the paradoxical workings of the genetic model Rousseau devised to derive society from the state of nature. The reason the state of nature amounted to a situation of perfectly stable equilibrium was that individuals desired no more than what was available, as this would meet their needs every time needs made themselves felt. The individual's environment was natural; there was no such thing as continuous, organized inter-individual interaction, and everyone's existence unfolded in unmarked time because the only horizon was immediate satisfaction of immediate needs. However, if individuals remained radically devoid of inter-subjective characteristics and time was no more than a continuous series of self-contained instants, if there were no time "periods" and nothing to be transmitted from one to the next, either by accumulated memory or by refashioning, then nothing could "happen": no history or historical movement. Durkheim carefully explains that departing from the state of nature amounted to upsetting an equilibrium. But how to invent the "fall" into history from outside it? How could pure origin be contaminated with accident? Very simply by rejecting the notion of pure and perfect origin, stable equilibrium, simple linear causality: "The existing equilibrium had to be upset, or, if it ever existed with some stability, there had to have been some causes that from the outset prevented it from being complete" (Durkheim 1960[1952]:76).

Two types of factors were responsible for man's departure from his original state of nature. One was exogenous, and therefore easier to slip into the narrative; it concerned external circumstances such as climatic variations, which amounted to a cyclical instability index, and natural accidents, floods, cataclysms, fires, earthquakes—everything that partakes of eventful natural history. The other factor, endogenous, pertained to man's dormant "potentials": perfectibility and the seeds of properly social inclinations and virtues, faculties that people possessed as potential, reason.[8] Of Durkheim's many commentaries on Rousseau's *Discourse on the Origins and Foundations of Inequality Among Men*, (1992[1755]) all of which aimed to bring to light the wellspring of the potential that was the source of all the differentiations and developments that had founded society and the social, we may cite the following, together with the urgent

teaching note that Durkheim wrote out alongside it, with its peculiar interlacing of the "possible" and "necessary," a striking indication of his ambivalent determinism:

> Does the savage complain of his existence and seek to change it? It could make him unhappy only if he had an idea of another state and if, in addition, the other state appeared to him in a highly attractive light. But "thanks to a wise providence, his potential faculties developed only when there was occasion to exercise them." He had only instinct, and instinct sufficed him; it did not lead him to social existence. In order to live in society, he needed reason, which is the instrument of adaptation to the social environment, as instinct is the instrument of adaptation to the physical environment. It came eventually, but in the beginning it was only virtual.(5).
>
> (5) [Durkheim's teaching note] *Read the entire passage. Very important, for it shows that social existence is not a diabolical machination but was willed providentially, and that although primitive nature did not necessarily lead to it, it nevertheless contained potentially what would make social life possible when it became necessary.* (Durkheim 1960 [1952]:74)

Otherness—that of other individuals, also that of differences in time and space, in expectations and comparisons, the difference of novelty— upsets equilibrium at precisely the same time as it is presumably procuring the resources that will invent new equilibria, which are forever temporary and precarious simply because they occur in historical time. Throughout his interpretive commentary, Durkheim is at constant pains to show that Rousseau did not consider society a degeneration of the state of nature, a definitive imperfection that irremediably doomed humanity to the incessantly reiterated disequilibria of history. To affirm the value and superiority of society over the state of nature, Durkheim pushed his observation to its logical conclusion: Rousseau's discourse on origins was an untenable fiction, as was the entire narrative of dormant potentials and the accidental intervention of "providence" in his *Discourse on Inequality* and in the "novel of origins" in *Essay on the Origin of Languages* (1990[1781]): "If there is some way of correcting these imperfections [of civilization, with its progress and evils] or making them impossible, the grandeur alone will remain, and perhaps this new perfection will be superior to that of the original state. The fact remains, of course, that such perfection will have been acquired at the cost of great suffering, but Rousseau does not seem to have asked whether the price will have been too high. However, the question is beside the point, for the circumstances that make society necessary are given and the hypothetical perfection of the state of nature is consequently impossible" (Durkheim 1960[1952]:91). It is fairly easy to see how Durkheim reiterates Rousseau's fiction of the genesis of society with the same set of concepts to be fit together, the same contradictions to be identified and dispelled. In his analysis of Rousseau's genetic model, Derrida relates the set of paradoxes

in Rousseau's theoretical fiction—precisely those that Durkheim himself pointed up—to a structure of original incompletion, lack. Nature, need, equilibrium were not enough for themselves; the faculties that came to compensate for (*suppléer*) the lack of something else were already present from the beginning, at the origin. The two thinkers' hesitations do indeed seem identical: they alternately conceived naturalness and social historicity as external to each other, and therefore logically and temporally separable, and interpenetrated; like potential-to-act and act.

Contradictions, hesitations, ambivalence—throughout this analysis, I have been pointing up these ill-adjusted aspects of Durkheim's argumentation. Clearly, Derrida's reading of Rousseau can be extended to Durkheim's thought. Instead of considering the contradictions and ambivalence as mere logical defects, which they are for any logic conceived in terms of identity and contradiction, we can grasp them by means of a logic of "supplementarity." Indeed, all the terms of Rousseau's and Durkheim's dualistic constructions fit together and work together in accordance with the paradoxical torsion of supplementarity, wherein development of an initial state both degrades that state and provides the principle that will compensate for and correct the degradation:

> From the first departure from nature, the play of history—as supplementarity—carries within itself the principle of its own degradation, of the supplementary degradation, of the degradation of degradation. The acceleration, the precipitation of perversion within history, is implied from the very start by the historical perversion itself. § But the concept of the supplement . . . should allow us to say the contrary at the same time without contradiction. The logic of the supplement allows the acceleration of evil to find at once its historical compensation and its historical guardrail. History precipitates history; society corrupts society, but the evil that links both in an indefinite chain [*qui les abîme*] has its natural supplement as well: history and society produce their own resistance to the abyss [*l'abîme*]. (Derrida 1974[1967]:179)

It follows that none of the initial features of any logical–historical schema of development-over-time is ever self-contained. If desires came to supplement needs, reason to supplement instinctive nature, imagination and liberty to supplement necessity, pleasure to supplement energy homeostasis, etc., this was because, to use Derrida's analytic terms, needs, nature, necessity, and equilibrium were not enough for themselves. And if imagination in Durkheim's theory, as in Rousseau's, fulfills such a crucial role, this is because it is what converts from virtual to actual. Imagination alone can handle the task of relating the two sets of terms—through the schema of the innate as dormant potential. For imagination is what breaks regulations and fuels transgressions. If nature is great with potential, holding itself in reserve, holding something back within itself, then imagination is what bursts the "sac," upsets the equilibrium containing that reserve

store. And to this reiterated triggering of ever only temporarily reparable disruptions there is no identifiable end.

Durkheim's texts on art, the power of the imagination, and the unstable economy of desire as I have interpreted them here are governed by a single type of argumentative logic, operative in all three of his great, densely historical, comparative, and typological works: *The Division of Labor in Society, Suicide* and *The Elementary Forms of Religious Life*. These books offer a fragmentary theory of the irresistible functional deregulation lurking in art as unfettered exercise of the imagination and liberty. They shed light on the temporal metaphysics of the author's functionalism, a metaphysics of virtuality as predetermination of the future, and as a means of suturing together discontinuities; a theory of history as a chain of temporary equilibria and critical accumulations of difference from equilibrium that engender new, improved equilibria, all partaking of progress toward perfection. But Durkheim's work does not prepare the way for sociological analysis of art, artistic practices or values, or conditions of art-making. The theoretical mantle is both too loose to allow for reflecting on the ordinary practice of artistic "labor," with its common properties and original characteristics, and too tight-fitting to allow for conceiving differentiation within the various spheres of artistic accomplishment or the upsets and breaks created by major art works and innovations. Less in sympathy with art than Marx or Weber, Durkheim did sense—if only through his labyrinth of concessions for warding off the danger—that art was a problem for a theory tirelessly laboring to account for equilibrium and social regulation. For art, like all creative production—scientific, intellectual, technical—is how history ferments and invents itself.

Translated by Amy Jacobs

Notes

1. At the time Durkheim was writing, the ambivalence of the "luxury" category was already quite familiar to economic theorists, as Joseph Schumpeter recalls in a long note in Part I of his *History of Economic Analysis* (1954). After mentioning "the confusing and confused mass of contradictory opinions on luxury," Schumpeter explains that while what characterizes consumption of luxury goods is that it goes beyond satisfying basic human needs and implies greater than subsistence spending, the main question that Hume, Smith and Malthus were interested in was whether this type of consumption worked in favor of economic production, by stimulating the development and maintenance of activities requiring a large workforce, or whether it was in fact fundamentally unproductive. In the latter case, it symbolized the ill of economically inefficient inequalities and engendered excessive social competition by enabling the aristocracy to use conspicuous (albeit ruinous) spending as a means of asserting its superiority over the bourgeois class, obsessed for its part with saving and making narrow-mindedly calculative (albeit productive) investments.

2. Most of these points are made in either *The Division of Labor in Society* or *Suicide*.
3. Durkheim's thinking here follows Rousseau's. He carefully read and commented on Rousseau's moral and political philosophy. As we shall see, the (posthumously published) courses Durkheim gave on Montesquieu and Rousseau in the 1890s at the University of Bordeaux show how clearly he discerned the paradoxes in Rousseau's fiction of a shift from the state of nature to social life. See *Montesquieu and Rousseau, forerunners of sociology* (1960). As both Robert Derathé (1950) and Jacques Derrida (1974[1967]) pointed out, what opens the way for progress, improvement, *perfectionnement* in Rousseau's theory is not reason but imagination, as a faculty of anticipation that can move beyond present reality. However, consistent with a venerable classical philosophical tradition, imagination as Rousseau understood it also carries with it the danger of excess, perversion: "It is imagination which extends for us the measure of what is possible either for good or evil, and consequently which excites and nourishes our desires with the hope of satisfying them. But the object which seems at first within our grasp flies away quicker than we can follow ... Thus we exhaust our strength without reaching our goal, and the closer we get to pleasure the further we are from happiness" (Jean-Jacques Rousseau, *Émile* (Paris: Garnier, 1872), p. 59; *Emile* http://www.ilt.columbia.edu/pedagogies/rousseau/
4. These two principles of variation were what created differences among individuals belonging to the same social group and among the various states of a single society over its history. They shared the same structure. According to Durkheim (1933[1893]:240), the difference between a learned man and a laborer in matters of aesthetic pleasure and harmony between the desirable and the realizable as dictated by their respective "conditions of existence," was homologous to that between the civilized man and the savage.
5. See *The Division of Labor in Society*, p. 278.
6. Durkheim writes: "[liberty] is so little a property inherent in the state of nature that it is, on the contrary, a conquest by society over nature. Men are naturally unequal in physical strength; they are placed in external conditions that give unequal advantages. Domestic life itself, with the property inheritance that it implies and the inequalities that flow from this, is, of all forms of social life, the one that most narrowly depends upon natural causes ... all these inequalities are the very negation of liberty. In the final analysis what constitutes liberty is the subordination of external to social forces, for it is only on this condition that the latter can develop freely. Yet such a subordination is rather an utter reversal of the natural order.... our [ideal] is to inject an even greater equity into our social relationships, in order to ensure the free deployment of all those forces that are socially useful" (*The Division of Labor in Society*, pp. 320–21).
7. Derrida's argument runs as follows: "The concept of the supplement ... harbors within itself two significations whose cohabitation is as strange as it is necessary. The supplement adds itself, it is a surplus, a plenitude enriching another plenitude, the fullest measure of presence. It cumulates and accumulates presence. It is thus that art, *technè*, image, representation, convention, etc., come as supplements to nature and are rich with this entire cumulating function. ... But the supplement supplements. It adds only to replace. It intervenes or insinuates itself *in-the-place-of*; if it fills, it is as if one fills a void. If it represents and makes an image, it is by the [prior] default of a presence. Compensatory [*suppléant*] and vicarious, the supplement is an adjunct, a subaltern instance which *takes-(the)-place* [*tient-lieu*]. As substitute, it is not simply added to the positivity of a presence, it produces no relief, its place is assigned in the structure by the mark of an emptiness. Somewhere, something can be filled up of *itself*, can accomplish itself, only by allowing itself to be filled through sign and proxy" (*De la grammatologie*, p. 208. Published in English under the title *Of Grammatology*, trans. Gayatri Chakravorty Spivak [Baltimore, MD: The Johns Hopkins University Press, 1974], pp. 1447–45).
8. In *Le rationalisme de Rousseau* (1948:12), Derathé recalled: "Durkheim is the first to have pointed out the importance in Rousseau's thought of this notion of virtual faculty." On this point see Derrida, *Of Grammatology*, p. 342, n. 20.

References

Besnard, Philippe. 1987. *L'anomie, ses usages et ses fonctions dans la discipline sociologique depuis Durkheim*. Paris: Presses Universitaires de France.

Derathé, Robert. 1950. *Rousseau et la pensée politique de son temps*. Paris: Presses Universitaires de France.

———. 1948. *Le rationalisme de Rousseau*. Paris: Presses Universitaires de France.

Derrida, Jacques. 1974[1967]. *Of Grammatology*. Trans. Gayatri Chakravorty Spivak. Baltimore: The Johns Hopkins University Press.

Durkheim, Émile. 1933[1893]. *The Division of Labor in Society*. Trans. George Simpson. New York: The Free Press.

———. 1974[1911]. "Jugements de valeur et de réalité." In *Sociologie et Philosophie*. Paris: Presses Universitaires de France.

———. 1995[1912]. *The Elementary Forms of Religious Life*. Trans. Karen Fields. New York: The Free Press.

———. 1951[1920]. *Suicide*. Trans. George Simpson. New York: The Free Press.

———. 1960[1952]. *Montesquieu and Rousseau, Forerunners of Sociology*. Trans. Ralph Manheim. Ann Arbor: University of Michigan Press.

Gombrich, Ernest. 1999. *The Uses of Images. Studies in the Social Function of Art and Visual Communication*. London: Phaidon.

Guyau, Jean-Marie. 1889. *L'art au point de vue sociologique*. Paris: Alcan.

Janet, Pierre. 1889. *L'automatisme psychologique: Essai de psychologie expérimentale sur les formes inférieures de l'activité humaine*. Paris: Alcan.

Rousseau, Jean-Jacques. [1762]. *Émile or On Education*. Trans. Grace Roosevelt. http://www.ilt.columbia.edu/pedagogies/rousseau/.

———. 1990[1781]. *Essai sur l'origine des langues : où il est parlé de la mélodie et de l'imitation musicale*. Paris: Poche.

———. 1992[1755]. *Discours sur l'origine et les fondements de l'inégalité parmi les hommes. Discours sur les sciences et les arts*. Paris: Flammarion.

Schumpeter, Joseph A. 1954. *History of Economic Analysis*. London: Routledge.

Vico, Giambattista. 1999[1744]. *New Science*. London: Penguin Books.

Dostoevsky in the Mirror of Durkheim

Donald A. Nielsen

Introduction

The names Émile Durkheim and Fyodor Dostoevsky are seldom mentioned in the same breath. And why should they be? At first glance, they seem worlds apart. Durkheim was a leading figure in the development of the new science of sociology, which he saw as distinctively, if not uniquely, French in origin and spirit. He was heir to a long tradition of French social thought, much of it utopian, socialist, and positivist in inspiration, which emerged in the wake of the French Revolution and included names such as Montesquieu, Rousseau, Fourier, Saint-Simon, and Comte, to name only a few of the figures he engaged. Durkheim rose to prominence within the French system of higher education, ultimately becoming the first Professor of Sociology anywhere, while at the same time engaging others in debates over the role of sociology in French higher education. Along with his collaborators in the Durkheim school, such as Marcel Mauss, Robert Hertz, and others, he created a distinctive approach to the scientific study of society, one with reformist intentions, including renovated socialist ideas free from the taint of Marxist historical materialism.

By contrast, Dostoevsky's early literary success in the mid 1840s with his novel *Poor Folk* was followed by a decade of penal servitude and military service in Siberia after he was arrested for crimes against the Czarist state. This unnerving experience of imminent execution, followed by years of imprisonment and exile in highly unpleasant circumstances, left a deep mark on Dostoevsky. It brought to the forefront of his consciousness a sense of guilt for his early flirtation with Western utopianism, made him view the horrors of his punishment in the Siberian penal regime as largely merited, resolved any ambiguities he might have had concerning the relative value of Russian and Western European religious

and secular cultures, and confirmed his commitment to a distinctively Russian variant of Christianity. Upon his return to Russia and a literary career, he authored a series of writings which were to gain him increasing fame in Russia and, ultimately, abroad. He became a strident critic of the influence in Russia of Western European rationalism, materialism, utopianism, utilitarianism, and socialism, and staked out a cultural standpoint which combined a focus on individual religious experience, religious nationalism supporting the Czarist state, and the unique value of the Russian Christ. His ideas were expressed in a series of complex and often provocative novels, as well as shorter writings which are now viewed as major landmarks in the history of world literature.

Despite their differing intellectual and personal trajectories, Durkheim and Dostoevsky have much in common. They were each fascinated by the role of religion in the social order, and the balance between the competing demands of the individual and society. Each was a keen analyst of the problematic character of modern life with its tendencies toward excesses of egoism, nihilistic derangement of experience, and collective madness, including suicide. Both held out hope, in differing ways, for a religious renaissance and the thoroughgoing transformation of society. Finally, in his own way, each was interested in how new and influential ideas, such as socialism, could pass from one national setting to another and, thus, become the focus of intense debate over the nation's future.

In these pages, I want to focus on an examination of Dostoevsky's life and work in light of the ideas developed in Durkheim's sociology, including those found in his study on suicide, his work on the sociology of religion, as well as several other writings by him and members of his school. I want to look at Dostoevsky through the mirror of Durkheim's ideas. However, in a mirror, one sees oneself, but with the polarities reversed. Thus, in my discussion, I hope also to shed light reflected from a Dostoevskian angle of vision on Durkheim's own thinking about the individual and society.[1]

Russia and Western Europe: inter-civilizational encounters

In their brief "Note on the notion of civilization," Durkheim and Mauss argued that some social phenomena (for example, sciences, technologies, cultural ideas, and ideals more generally) had the capacity to move beyond their original societal and national settings and become rooted in new locales. They used the term "civilization" to describe such transnational phenomena. Thus, civilizational phenomena are common to two or more societies, nations, or geographical regions (Durkheim and Mauss 1971[1912]). At the same time, as later commentators have noted, civilizational processes in which ideas flowed beyond national boundaries often

became the occasion for inter-civilizational encounters, frequently of a conflicted nature, depending upon the specific responses to alien ideas as they spread to new national locations (Nielsen 2004).

Throughout the nineteenth century, Russia stood in such a relationship of inter-civilizational encounter with Western Europe (Treadgold 1973). In the 1840s, the ideas of Hegel, Feuerbach, Stirner, Fourier, and others were hotly debated by Russian intellectuals. By the 1860s, materialism, rationalism, socialism and communism, anarchism, and other Western currents of thought wearing the mantle of "science" set the stage for a second wave of encounters between Europe and Russia. Thinkers responded in differing ways to these new cultural challenges and divisions among Westernizers and Slavophiles, Narodniks and Marxists, as well as a variety of other cultural and political groupings, became a common feature of late-nineteenth century Russia. The socialist, rationalist and utilitarian ideas of Westernizing intellectuals such as Nicolai Chernyshevsky gained a particularly strong foothold among Russian youth. Chernyshevsky's utopian novel *What Is To Be Done?* (1989[1863]), in particular, was embraced by reformers (who included Lenin, later on) and provided a central critical reference point for Dostoevsky's own literary efforts, such as *Notes From Underground* and *Devils* (Woehrlin 1971; Dostoevsky (1989[1864]; 1992[1871–72])). He had personally experienced the Westernizing movements of the 1840s and had suffered in prison for his flirtation with them. He came to believe that the generation of the 1840s, that is, his generation, including himself, was responsible for setting the stage for the resurgence of radical ideas and actions in the generation of the 1860s, including such nihilist figures as Nechaev (Hingley 1967; Pomper 1979; Verhoeven 2009; Moran 2009). As he wrote in a letter of 1873 to A.A. Romanov, "Our Belinskys and Granovskys would never have believed it if they had been told that they were the direct spiritual fathers of the Nechayev band. And it is this kinship of ideas and their transmission from fathers to sons that I have tried to show in my work" (Frank and Goldstein 1987:369–70).

These encounters had the effect of dislodging many thinkers from their own Russian cultural dwellings and resettling them within a house built from European ideas. Many Russian intellectuals abandoned Russia, either by choice or as a result of Czarist coercion and exile. In Dostoevsky's view, the youth of Russia in the 1860s lacked the intellectual resources to protect themselves from the infection represented by these Western ideas and, as a result, unthinkingly embraced them without heed to their impact on themselves or on Russia life. As he notes in a letter of 1878 to L.V. Grigorev, ". . . the young generation is seeking for truth with all the boldness of the Russian heart and intelligence, the only trouble being that they have lost their guides" and are too readily seduced by European ideas which, in Dostoevsky's view, were made even more mysterious and seductive because of Czarist censorship (Frank and Goldstein

1987:459). From the mid 1860s forward, Dostoevsky wrote a great deal about the effects of these inter-civilizational encounters between Russia and Western Europe. Many of his main characters, as well as his minor ones, reflect his conception of how much of Russian experience had been molded and largely perverted by Western scientism, materialism, social- ism, egoism, and a variety of movements claiming to liberate Russians from the inherited fetters of Czarism, Russian Orthodoxy, and their related social institutions.

Individualism: true and false

As commentators beginning with Marcel Mauss have noted, Durkheim was fascinated by the question of the relationship between individual and society (Durkheim 1962[1928]:32; Tiryakian 1962). Indeed this prob- lematic, in one or another way, informed most of his major writings. In his view, the modern cultural emphasis on the individual was a double- edged sword. On the one hand, the cult of the individual in modern society demanded moral and intellectual autonomy as an ideal to be achieved by each person in his or her own thought and conduct. On the other hand, there was a darker side to modern individualism. It appeared in the form of egoistic deformations of consciousness and resulted from the individual's isolation from the central forms of group life such as the family, the church, and the political community. As he wrote in his classic study of suicide, egoistic suicide was the most prevalent form of modern suicide and was one of the most noteworthy symptoms of a disease which threatened to destroy society unless checked by the inte- gration of the individual into new social forms, including occupational groups and new types of religious community (Durkheim 1951[1897]; 1984[1893]; 1995[1912]).

Dostoevsky saw egoism as one of the central symptoms of Russia's current malaise. He even included his own case as proof of its virulent spread, when he wrote to his brother Mikael in 1846, describing his reaction to the praise heaped on his first book, *Poor Folk*. "I have a ter- rible weakness—a boundless pride and egotism" (Frank and Goldstein 1987:39). However, Dostoevsky's concept of the individual also tran- scended the many egoistic deformations portrayed in his novels and pro- vides the reference point for an alternative, higher religious conception of individualism. In his view, those acts in relation to others which are com- pletely free of any element of individual self-interest not only embody a Christian ethic of altruism, but also express a higher form of individual- ism, indeed, the truest form of individuality. For Dostoevsky, the greatest altruism coincides with true individualism and the opposition between them dissolves into a higher identity (on this general topic see Nielsen 2005).

The problem of suicide

Durkheim's influential study of suicide as a social phenomenon charted a fourfold set of causes of suicide. Egoistic suicide resulted from a lack of integration of the individual into familial, religious, and political communities, while altruistic suicide emerged from an insufficient individuation, where the group was everything and individual person nothing. Anomic suicide emerged in situations where accustomed patterns of wants, needs, thought, and conduct were deranged by rapidly changes social circumstances and failed to achieve fulfillment, thus driving the unhappy individual to extreme, indeed, nihilistic responses. Anomie was the "disease of the infinite," in which the individual's thought and conduct was released from, and attempted to transgress, all existing limitations (Durkheim 1951[1897]:287). Durkheim thought egoistic and anomic conditions were most characteristic of modern society and constituted its central forms of social pathology (Nielsen 1999:89–103).

Dostoevsky's writings portray the effects on Russian life of egoism and Western political utopias such as socialism and anarchism. The outcome was the general desire to transgress established limits of thought and conduct, and a commitment to whole scale destruction as the only road to a radical transformation of society. This combination of attitudes and values in Russia went largely under the broad name of nihilism. As I have noted elsewhere (Nielsen 2005), this notion resembles Durkheim's idea of anomie, especially when the latter is understood as self-conscious anomism, that is, the quest for the perfection of man and society through the systematic destruction of all established forms of thought and conduct. Dostoevsky argued that the most destructive European currents of thought invading Russia involved this sort of prior destruction of existing organization. As he wrote in 1866 to M.N. Katkov,

> All nihilists are socialists. Socialism (especially in its Russian variety) specifically . . . requires that all links should be cut. Why, they are absolutely convinced that, given a *tabula rasa*, they could at once build a paradise on it. Just as Fourier was sure that if he succeeded in building one phalanstery the whole world would soon be covered with phalansteries—those are his own words. And our own Chernyshevsky liked to say that if he were given a chance to speak to people for a quarter of an hour, he was sure he could persuade them, then and there, to turn to socialism. Our poor, defenseless, Russians boys and girls have their own ever-present fundamental attitude, which will support socialism for some time to come, namely their enthusiastic longing for the right and the purity of their hearts. (Frank and Goldstein 1987:228–30)

As Durkheim noted, anomie and egoism have much in common and can readily combine within any individual (Durkheim 1951[1897]:258, 287). Egoistic consciousness disconnected from social moorings naturally

also attempts to create social worlds which break radically with existing arrangements. In a similar way, the phenomena of nihilism and egoism are coupled in Dostoevsky's writings. Dostoevsky sees egoism as an effort by the individual to isolate himself from society and humanity and become involved increasingly in the workings of his inner life to the point where the individual irritably resists the intrusion of others into his private world. This sort of self-imposed isolation also tends to reverse its polarities and gestate a kind of egoistic self-aggrandizement which sometimes reaches metaphysical proportions. The individual's desire to become God-like, if only to himself, is portrayed by Dostoevsky in *Devils* in a figure such as Kirrilov, who expresses the attitude of the man-God (contrasted with the true ideal given by Christ of the God-man). As the individual's isolation grows, so grows his sense of egoistic self-inflation.

The ultimate development of egoistic self-isolation occurs in suicide. Dostoevsky's novels feature many suicides, usually of central characters, often of the most morally questionable type. For example, Svidrigalov, Stavrogin, and Smerdyakov all commit suicide. They all suffer from self-imposed disconnection from any truly human engagement with others. Although not evidently evil, Kirrilov also kills himself, after having first called Stavrogin to account for his inability to act like a human being in his relationship to others. Yet, Kirrilov remains a victim of his own ego-istically driven metaphysical strivings in his very desire to become God-like, since wanting to be God or like God inevitably involves separation from the average run of humanity. For Dostoevsky's characters, when the egoistically turned inner life of the person has become exhausted with itself, nothing remains but self-destruction.

Socialism: pro and contra

In his lectures on socialism and the Saint-Simonians, Durkheim made a distinction between communist utopias and socialism. Communism was largely a literary product of intellectuals such as Plato and combined an opposition to property ownership with a strong element of asceticism. Such utopias have no principled connection with any particular phase of social history. On the other hand, socialism was the logical outcome of modern industrial conditions in the eighteenth and nineteenth centuries, and aimed at the reintegration of economic and commercial practices into the overall moral life of society through the agency of the state as well as other regulative institutions, including above all the religious community. Indeed, as Marcel Mauss noted, and demonstrated in his own way in his study of gift exchange (Mauss 1990), Durkheim had a horror of social conflict, including class conflict. Thus, his variant of socialism is decid-edly oriented toward the creation of social solidarity through the unifica-tion of classes and other groups by means of a common set of religious

symbols and moral rules. Durkheim and his school certainly supported some variant of socialism, one informed by moral ideas and ideals which would combat excessive economic egoism and help bring the anarchy and anomie of an industrial order characterized by an advanced division of labor, and a complex system of commercial relations, under collective regulation. Durkheim distinguished this form of morally regulated socialism from the historical materialism and "scientific socialism" of Marx and his followers, such as Antonio Labriola, whose work Durkheim criticized sharply for its excessively materialism and its failure to take account of the influence of religion in history and society (Durkheim 1978[1897]).

Dostoevsky made few distinctions among modern Western ideologies. He tended to fold socialism, communism, anarchism, and materialism into one intellectual bundle which, in the usage of his time, he most frequently entitled nihilism or anarchism. The only form of socialism (or communism) on which Dostoevsky placed any possible value was one rooted in Christian sentiments and the life of the Russian people. Simple interpersonal reciprocity in the exchange of necessities for the mutual satisfaction of equally simple needs seemed to be his economic ideal, one which found its most concrete expression in the life of the peasant community. Dostoevsky was not blind to the brutality, coarseness, and ignorance found among the common people of Russia, including its wide spread alcoholism, a topic featured prominently in many of his major novels. Nor was he necessarily opposed to the future development of society in a more progressive form, including intervention by the Czarist state, which would remedy these and other social evils (see, for example, his letter to A.N. Maidov in Frank and Goldstein 1987:250). However, he was adamantly opposed to Western utopian schemes, whether socialist or communist, arbitrarily imposed as ideals of life on the Russian people by a segment of its Westernized intelligentsia who thought they knew best how others ought to live.

On the other hand, it is not clear that he would have opposed the sort of moral integration of modern economic and commercial life into the moral order of society proposed by Durkheim and Mauss. Indeed, it is easy to imagine Dostoevsky admiring Mauss's analysis of the spirit of the gift. Dostoevsky's entire view of life was dominated by the idea that Christianity in its Russian form could ultimately permeate everyday life, including its economic activities, and transfigure even the most mundane and materially necessary transactions into new forms of truly human association, ones informed by the ideals of mutual love, brotherhood, and dedication to the imitation of Christ in every aspect of life. However, before this could happen, it was necessary for each and every person to renounce the endless quest for the satisfaction of new wants through material possessions and admit his guilt before others, forgive them and ask forgiveness of them in turn, and conceive of himself, each and everyone, as, in effect, one person in many bodies, parts of a larger

totality. This idea, as I have noted elsewhere, is not very different from Durkheim's own conception of society as a moral order which integrates each individual and each separate group into a totality of knowledge and conduct sacralized through the redeeming beliefs and practices of shared religious symbols (Nielsen 1999). Only in Dostoevsky's case, this ideal takes the form of a community modeled on a concrete variant of Russian Christianity, while in Durkheim's case, the ideal finds expression in more abstract, intellectual form: the identification of society, totality and God, a unity incarnated in the consciousness of each individual and instantiated in the practices of every major social group. Dostoevsky's image of all individuals as, in fact, one person is mirrored in Durkheim's reality of society as a single social substance.

Collective madness, social revival, and the quest for religious community

Durkheim thought that collective effervescences rooted in enhanced forms of social communication and collective interaction promoted cultural rebirth and provided the context for the creation of collective ideas and ideals (Durkheim 1995[1912]). Religious ideas played a particularly central role during such periods, since they provided the shared symbols necessary to forge new forms of collective life. On the other hand, he was equally aware that egoism, nihilism, anomic responses, and other forms of social pathology could also travel like a contagious disease through modern forms of communication, and could move across societal boundaries as readily as other cultural ideas and ideals.

I would like to discuss the problem of individual and collective pathology as it is represented in Dostoevsky's work and then move to a discussion of his image of collective salvation for Russia. The problem of individual transgression is best represented in the figure of Raskolnikov in *Crime and Punishment* (1866), while the problem of collective disorientation and madness is presented in it most compelling form in his novel *Devils*. I want to briefly and selectively discuss these two works and then turn to a treatment of his most complex novel, *The Brothers Karamazov*, in particular, the figure of Ivan Karamazov, perhaps Dostoevsky's greatest, if most enigmatic, portrait of an individual caught in the throes of an encounter between Russian and Western European ideas. I will not discuss these writings in chronological order, but instead will examine *Devils* first, since Dostoevsky's presentation of collective dislocation in that work is most congruent with Durkheim's sociological conceptualization of these problems as fundamentally collective in character. This work also provides the best frame of reference for the discussion of the more individuated forms of disorientation represented in the figure of Raskolnikov, which, in the end, are derived from collective, if non-Russian sources.

Only then will I turn to Ivan and Alyosha Karamazov, and Dostoevsky's final vision of the religious reanimation of society.

Dostoevsky's Devils *and the contagion of collective madness*

Dostoevsky's work is replete with dreams. They often play a central role in defining the main aims of his work. Among the most revealing of them for my present purposes is Raskolnikov's dream of a plague which enters Russia from outside its borders (Dostoevsky 1989[1866]:461–62). The plague lays waste to everything distinctively Russian. It serves in Dostoevsky's work as a metaphor for the influence in Russia of pernicious Western ideas and takes the form in his novel *Devils* of a contamination of social relationships by an alien spirit, a theme also developed in his short story, "Dream of a Ridiculous Man" (Dostoevsky 1994[1873–81]:942–61). The result is a collective madness or possession, symbolized in the book by Dostoevsky's use of the Biblical passage in which Christ drives demons out of the possessed man and into the swine, which in turn dash themselves to death over a cliff.

It is in *Devils* that this possession is conceived as collective and is meant to convey Dostoevsky's sense that Western nihilism, egoism, and materialism have infected all of Russia, especially its youth, with disastrous consequences. Indeed, the toll taken by these ideas is truly prodigious, and the dislocating results are similar to those noted by Durkheim in his analysis of egoism and anomie, and by Marcel Mauss in his essay on the dissociation of the individual's mental processes and ultimate death under the influence of alien influences (Durkheim 1951[1897]; Mauss 1979). None of Dostoevsky's stories is so laden with murder, suicide, and madness as *Devils*. Stavrogin is the proximate individual origin of the plague and he ends by committing suicide. However, in keeping with Durkheim and Mauss's (1963[1903]) analysis of the congruence between social currents and spatial categories, it also emanates from a particular spatial location, his and his mother's estate at Skvoresniki. Dostoevsky's narrator tells us that ". . . all the recent horrors were either directly or indirectly connected with Skvoresniki" (Dostoevsky 1992[1871–72]:747). Shatov is murdered by a group of conspirators led by Peter Verkhovensky, the nihilist modeled by Dostoevsky after the real figure of the anarchist and nihilist Nechaev. His wife Marya Shatova, newly returned and perhaps reconciled with him, yet pregnant with Stavrogin's child, dies tragically along with her newborn baby in a vain search for the already murdered Shatov. Ignat Lebyadkin, his crippled sister Marya Lebyadkina (also Stavrogin's perversely chosen wife), and their servant are murdered, presumably by Fedka the convict, who is murdered in turn after a violent encounter with Peter Verkhovensky, the immediate "carrier" of the plague throughout the community. Lizaveta Tushina is killed by a frenzied crowd, who blame

her for the Lebyadkin deaths because of her involvement with Stavrogin. Kirillov commits suicide out of a belief in the imminent Godmanhood which he supposes will result from taking his own life. Finally, there is Stepan Verkhovensky, a once prominent liberal of the 1840s and the tutor of the young Stavrogin as well as the neglectful father of the nihilist leader Peter Verkhovensky, himself inspired by Stavrogin's example. Stepan's weak and vascilating presence throughout the book marks him as indirectly responsible, along with others of the generation of the 1840s, for the derangement of thought and conduct of the later generation the 1860s and more directly responsible, through his miseducation of Stavrogin and his neglect of his son Peter, for the specific events which take place in and around Skvoresniki. He ultimately takes ill and dies in an attempt to escape from twenty years of self-imposed dependence on, and fantasized if unexpressed love for, Stavrogin's mother, the wealthy and widowed landowner, Varvara Stavrogina. She, in turn, is a domineering character, competing for status with others in the community, yet fearful of her son, Nicholas Stavrogin. She never misses an opportunity, even on Stepan's death bed, to ridicule him for his ineffectiveness. Only at his death does Stepan finally understand the nature of the collective possession that has been loosened on the community and, in line with Dostoevsky's overall religious motif for the novel, does so by recalling the story of Christ casting the devils into the swine.

In addition to these murders, suicides, and other deaths, symptoms of collective derangement stalk the rest of the community, especially the remaining political conspirators. After the murder of Shatov, they one by one lose their minds in varying forms of illness, remorse, despair, or confessional zeal. In the end, the entire community has become unhinged, a mental state portrayed by Dostoevsky in the ill-conceived and catastrophic artistic evening planned by the community's clueless leaders, and in the revolt of the factory workers and the incendiary attack on the town. Indeed, it would be difficult to find anywhere as vivid a portrait of the deranging effects on an entire community of false ideas and egoistic opportunism as in this novel.

Dostoevsky's treatment of these events goes well beyond an indictment, as his contemporaries already suspected, of the political ideas of Chernyshevsky, nihilism and the "new people" of the 1860s. It also goes well beyond his treatment of the intergenerational "curse" passed down from the generation of the 1840s to that of the 1860s, as presented in his *Notes from Underground* (Dostoevsky 1989[1864]; Morson 1981). In that latter work, whose positive, Christian message was badly mutilated by the censor, Dostoevsky is able only to satirize the absurdities of his man of the '40s, who has discovered in his maturity that the Western European rationalism and Fourierism on which he had been weaned as a youth no longer made sense when measured against his newly found understanding that man would rather live in a hole in the ground, and give the two

finger salute out of spite to the world's rational utopias, than to serve merely as a note in some imagined great harmony of the world. In *Crime and Punishment*, Dostoevsky portrays the effects of this Western disease in its individual manifestations in Raskolnikov, but in *Devils*, Dostoevsky's treatment of the problem appears more like that of a public health official examining the spread of a virulent, collective plague, albeit a fictionalized one. In this respect, he reminds one of Thucydides's portrayal of the social disorganization brought about by an actual plague in Athens at the beginning of the Peloponesian War (Nielsen 1996). Everyone is susceptible and hardly anyone escapes the disease, whose effects vary along a spectrum from murder, suicide, and madness to milder forms of self-centered contagion and blindness to the actual lives and needs of others. Everyone is susceptible because no one is entirely free of the fundamental flaw of egoistic self-absorption that provides the disease with a foothold in the individual and social organism. Everyone is susceptible because, in the end, everyone is collectively responsible. The illness, striking one, strikes all in turn.

Suffering and redemption: Raskolnikov redivivus

The idea of suffering is central to Dostoevsky's image of human redemption. However, for suffering to have a redemptive value, it must be voluntarily accepted in light of an awareness of one's sins. Only then is it a force for human self-regeneration. This vision is most fully expressed in *Crime and Punishment* in Raskolnikov's ultimate decision to confess his crimes, first to the earth, by kneeling down at the crossroads and demanding forgiveness of everyone, and then to the authorities, by giving himself up, freely confessing his crimes and embracing his imprisonment and suffering. This decision emerges very slowly from Raskolnikov's consciousness and he continues to resist its full implications until the novel's very end. The ground for his confession is laid by his prior belief in the truth of the story of Lazarus's resurrection from the dead, a belief which he readily admits under questioning by the police investigator Porfiry Petrovich well before his confession. Raskolnikov, deep down, remains a Russian. The buried levels of his Russian commitments are brought into the full light of day by his newly acquired soul mate Sofia's subsequent reading of this story (Dostoevsky 1989[1866]:221, 275, 347). Raskolnikov already believes the Gospel story, but does not yet comprehend its relationship to his own situation. Only through the death of the self, in the sense of the rational, calculating, egoistic self, the ideal of the Napoleonic "superman" to which he had aspired, can the new person be born. Even after his deportation to the Siberian prison, Raskolnikov remains for a time uncommitted to the new path implied in his confession, assumption of guilt and suffering. He remains unrepentant and isolated and is hated by his fellow prisoners

for it. Only slowly does the new vision of life penetrate into his soul and begin to work itself out through a personal transformation, at which point Dostoevsky breaks off his novel and gestures to the need for another separate story. In the end, *Crime and Punishment* is one of Dostoevsky's most optimistic stories of personal rebirth and Raskolnikov is one of his most characteristically Russian figures, initially seduced by false Western ideas, but capable with the help of Sofia's wisdom of a new start by embracing his truer Russian self.

Dostoevsky's view of guilt and responsibility does not end here with this individual case. In his view, one is responsible not only for one's own sins, but for those of every other person. Indeed, a kind of collective responsibility pervades Dostoevsky's sense of the human condition. We are each and all responsible for everyone else. Their sins are ours and vice versa. This is the case because, at bottom, we are all one person. In an insightful discussion of Dostoevsky's philosophy, Vyacheslav Ivanov has called attention to this remarkable and even frightening discovery (Ivanov 1966). The belief in Christ implies a unification of all men into one single moral personality, a theme whose fuller dimensions are brought out and further developed in the life and thought of Zossima in *The Brothers Karamazov*.

The further consequence of this discovery is that only conduct rooted in genuine altruism, concern for the true well-being of the other person, without any trace of egoism or self-interest, can save mankind. Even the slightest element of rational, egoistic calculation spoils the action and blunts its altruistic character. As noted above, Dostoevsky argues that this sort of altruistic behavior does not result in the diminution of the individual's significance, but, on the contrary, constitutes a higher form of individualism. Paradoxically, it is only through the fullest self-abnegation and genuinely selfless and altruistic conduct that true individualism can emerge. Here, Dostoevsky forges a new concept of individualism which transcends not only the self-interested egoism of the isolated individual, but also the modern Western concepts of legal and moral autonomy.

The application of such an ethic, rooted in the altruistic imitation of Christ and shared by all members of society, could turn earth could into a paradise. This would be a true utopia, in contrast with the false Western images of coordinated destruction and reconstruction. Dostoevsky is aware that change brought about through the collective self-transformation of the human soul could not occur quickly. He implicitly contrasts this sort of change to that achieved by a political revolution. Inner change of humanity on a vast scale can take place only over long historical periods. Thousands of years may be necessary to bring about such a change. Dostoevsky's conception of religious and social time can only be characterized as glacial. Yet, it is possible and remains the only true path toward the regeneration of mankind and the only way to escape from the almost certain mass carnage which will result from

the self-interested pursuit of power through political revolution. In this respect, the novel *Devils* provides the most powerful negative portrayal of a deranged world in which the ideal of altruism and true individuality has been replaced by pride and egoistically inspired collective madness.

Ivan Karamazov, the Grand Inquisitor and the Elder Zossima

Many of the themes dominant in his earlier work reappear in *The Brothers Karamazov*, but in a new form and with greater complexity. Although Alyosha Karamazov is announced at the outset to be the "hero" of the novel, the book's central religious and philosophical themes circle about the figure of Ivan Karamazov. Indeed, for better or worse, Ivan may be considered the book's protagonist. Dostoevsky himself asserted that books five and six of the novel, the chapters on rebellion, the Legend of the Grand Inquisitor, and the life and teachings of the Russian Monk, Zossima, represented the work's culminating points. In these chapters, Ivan presents his thoughts on those "eternal questions" preoccupying young Russians, including Dostoevsky himself. In keeping with what Mikael Bakhtin (1984) has called the "dialogical" character of his works, Dostoevsky presents a refutation of Ivan's thinking through his presentation of the life and teachings of elder Zossima, taken from the elder's own words by Alyosha Karamazov. Indeed, Alyosha's relative silence during Ivan's lengthy critical dissertations on God, divine justice, and the church is redeemed through his role in recording the ideas of Zossima, ideas which form an indirect refutation of Ivan's position.

Dostoevsky's novel is not merely dialogical; it is even more complex. Ivan and Alyosha converse, but in the midst of this conversation is inserted Ivan's little poem entitled "The Grand Inquisitor." Ivan composed it in prose, but did not write it down, and now recites it to Alyosha from memory. Thus, Dostoevsky places a character in his novel who, in conversation, inserts yet another story into the dialogue. Does the story of the Grand Inquisitor reflect Ivan's own beliefs? If so, what are they? The indeterminacy of Ivan's own worldview is one of the vexing problems in the interpretation of Dostoevsky's masterpiece. Dostoevsky himself seems to have intended the Grand Inquisitor's discourse to express Ivan's worldview and thought that, in the figure of Ivan and his legend, he had created a representative of atheism and socialism. On the other hand, in the elder Zossima, Dostoevsky would represent the idea of the true Russian Christ as an alternative to Ivan's European philosophy.

The Grand Inquisitor is patterned after the Biblical account of three temptations of Christ in the wilderness. In the Inquisitor's view, Christ went wrong by refusing to create bread, inject mystery into religious worship, and accept rule over the kingdoms of mankind. Instead, Christ gave mankind freedom, an unbearable burden. For many centuries since,

the Grand Inquisitor has been working, not with Christ, but with "him" (Satan) and claims to have completed Christ's work more perfectly than Christ himself by relieving humanity of the burden of freedom and sub-stituting instead miracle, mystery, and authority. In the process, he has satisfied mankind's need for a community of worship, an idea which brings the inquisitor's view within the orbit of Durkheim's notion that religion is ultimately a system of beliefs and practices shared by a moral community.

Alyosha responds in anguish that Ivan's tale is about Roman Catholicism and Jesuitism, not Russian Christianity. Indeed, Dostoevsky always viewed the Roman Church as the great source of deviation from the true Christ and as the ultimate source of those later secular, atheis-tic philosophies of socialism, anarchism, and materialism. As he wrote in 1870 to A.N. Maikov, "All of Europe's misfortunes, all, all of its ills, without exception, harken back to its loss of Christ with the establishment of the Roman church, after which they decided that they could manage just as well without Christ." On the other hand, "The whole destiny of Russia lies in Orthodoxy, in the light from the East that will spread to the blinded mankind of the West, which has lost its faith in Christ" (Frank and Goldstein 1987:358). In a letter of 1871 to N.N. Strakhov, he adds, "They have lost Christ in the West (through the fault of Catholicism) and that is the reason, and the only reason, why the West is declining" (ibid.:360). Dostoevsky argues that a new pan-Slav orthodoxy will offer the West a new message when the West has finally decayed. As he wrote to A.N. Maikov in 1869, "it will decay when the pope has completely distorted the image of Christ and thus engendered atheism among the defiled peoples of the West" (ibid.:309).

The character of Ivan is fraught with inner conflicts and contradictions. Yet, it is not like that of Svidrigaylov, Stavrogin, and other Dostoevskian creatures of darkness, all somehow monstrous in their individual trans-gressions, spider-like creatures waiting to snare their prey in the webs they have woven. Ivan may be a figure predominately of the profane "left," rather than the sacred "right," to adapt Robert Hertz's conceptualization (Hertz 1973[1909]); indeed, he is portrayed as such by Dostoevsky, who writes that Ivan's "right shoulder looked lower than his left" (Dostoevsky 1976[1879–80]:245). Despite this, Ivan is genuinely concerned about the spiritual dilemmas he poses. In this regard, he is like Dostoevsky himself, who wrote to A.N. Maikov in 1870 on his future work on the "life of a great sinner" (the original blueprint for *The Brothers Karamazov*) that "[t]he main question which will run through all the parts of the novel is the question that has tormented me either consciously or unconsciously all my life—the existence of God" (Frank and Goldstein 1987:331–32).

Ivan does not reject God—for despite everything, even Dostoevsky's seemingly authorial intentions, Ivan is no atheist—but the creation ema-nating from God, one which Ivan sees as flawed at its core. Indeed, Ivan

presents the classic theme of theodicy: the suffering of the innocent. This imperfect divine craftsmanship appears most clearly in the suffering of children, a suffering unwarranted precisely because of their innocence. Ivan and Alyosha share this concern for the children of Russia and, in that respect, both differ fundamentally from some of Dostoevsky's demonic figures, such as Stavrogin, who ambivalently confesses to the monk Tikhon his guilt in the suicide of an innocent girl he had seduced (Dostoevsky 1992[1871–72]:450–83). Indeed, Dostoevsky was rather obsessed with the mistreatment of children, and the theme appears repeatedly in his stories. For Ivan, adults have bitten the apple, so to speak, and perhaps deserve to suffer from their consequent guilt, but Ivan is no St. Augustine and believes children are different. They have not inherited any spiritual blemish from the Fall of Man which warrants the horrible abuse they often receive. Indeed, instances of their torments are recited by Ivan in the most gruesome and realistic detail, supplied by Dostoevsky from his sifting of contemporary journalistic accounts. Ivan's case against the imperfection of divine creation is irrefutable, or, at least, Dostoevsky seems to have thought it to be so and agonized over the adequacy of the response he offered in his account of Zossima's life and teachings (Dostoevsky 1976[1879–80]:756–52).

By contrast, Alyosha loves children, but says nothing in general about their existential situation and frequent victimization. Yet, he repeatedly engages them in their actual lives, questions, and problems. And they are drawn to him in turn. It is significant that the novel ends with Alyosha and a group of children gathered about the gravesite of Ilyusha, the unfortunate boy whose initial hatred for Alyosha and violent conflicts with the other children are resolved through Alyosha's intermediacy, and through the sort of mutual recognition of guilt and acceptance of forgiveness preached in another context by the elder Zossima. Indeed, Dostoevsky's depiction of childhood spirituality is remarkably sensitive and contrasts sharply with the novel's more prominent portrayal of adult lust, greed, hatred, resentment, and transgression. For Alyosha, and evidently for Dostoevsky, children are not merely to be seen as the innocent victims of evil and suffering at the hands of adults, as Ivan would have it. They are also capable, under the right circumstances, of spiritual transformations in accordance with the highest religious values. If they commit vile acts against their youthful fellows, as they sometimes do, they remain capable of change for the better. This developmental potential contrasts noticeably with the novel's other main characters (with the exception possibly of Alyosha, who is still young and has many childlike characteristics). To adapt Henri Bergson's terminology (Bergson 1959), the children, and even Alyosha to a degree, still act and think within the *durée* of lived time and the fullness of experience, a *durée* which partakes of creation and eternity, while the other adult characters have become fixed in place with rigidified emotional attitudes and ideas.

Dostoevsky feared that the impressionable youth of Russia, whose hearts still remained largely capable of attachment to higher spiritual values, lacked personal models to follow within Russia and would be seduced by false Western ideas peddled by ersatz prophets. This fear finds its most ambiguous resolution in *The Brothers Karamazov*, where the threat of Western atheism and socialism finds its realization in Ivan's unconscious wish for his father's death and his influence on the young lackey Smerdyakov, the factual murderer of old Fyodor Karamazov, but also in the eternally fresh quality of childlike consciousness, one already susceptible to evils deeds, but at the same time capable of learning a better path and avoiding the pitfalls of a life devoted exclusively to the baser side of "Karamazovism." The true ambiguity of Dostoevsky's formulation appears in his unwillingness to succumb to any simplistic myth of childhood perfection as a way to resolve Russia's dilemmas. The next generation may be as bad as the present one, perhaps worse. This historical drift could be altered only if proper educators could be found for a youth simultaneously hopeful and visionary, yet gullible and readily susceptible to false prophets. Perhaps this is Alyosha's true role in the novel: as educator to those younger than himself, one who still needs further education and experience, but who embodies enough initial goodness and wisdom to serve as a beacon to younger children at a vital phase in their development. Alyosha serves as an agent of what Durkheim would have called the "moral education" of youth (Durkheim, 1961[1925]), a goal to which Durkheim also devoted a good deal of effort.

On the novel's last page, the youth Kolya Krasotkin, who has become close to Alyosha, asks him if he really believes, as the church teaches, that after death they will all one day be reunited in a higher spiritual form. Alyosha responds positively out of a belief in eternity and the resurrection. He counsels the children that they must always love the dead Ilyusha as well as one another and keep that happy memory alive in their souls, even if they sometimes become bad, for this memory will keep their faith alive and allow their goodness to flourish (Dostoevsky 1976[1879–80]:733–35). That is the important thing. It will lead to ultimate salvation and resurrection, not only after death, but perhaps here on earth as well. As Zossima implies, the world could be a paradise if only we wanted it to be so. The child-centered conclusion to the novel comes as close as anything in Dostoevsky's work to a realization of ultimate spiritual perfection, unification of individuals in a community of love and remembrance. Perhaps it is not accidental that Dostoevsky's novel concludes on this note, if we recall that his own son, also named Alyosha, had died of an epileptic fit at the time when Dostoevsky was writing the novel. Perhaps it is also not so ironic that upon the completion of the novel, Dostoevsky went on to give his famous, prophetic speech at the Pushkin memorial.

Dostoevsky's Pushkin speech and the dilemmas of cultural renaissance

One of Durkheim's most fascinating ideas concerns the role of collective religious enthusiasms in the creation of new cultural forms. Durkheim argued that the birth of new ideas and ideals, as well as the renaissances of older cultural forms, took place within the setting of religious enthusiasms which unleashed collective emotional energies which then became fixed upon new symbols (Durkheim 1995[1912]). A fascinating feature of such cultural revivals was the way in which individuals instantiated the broader cultural changes taking place, standing as individual symbolic embodiments of the collective transformations. As Durkheim notes, Abelard embodied the new collective ideals of the twelfth century, while the person of Voltaire focused the collective transformations of the eighteenth century (Nielsen 1999:139–40). A similar case may be made for Dostoevsky's role in the revival of Russian religious and philosophical thought after his death. In particular, his Pushkin speech can be seen as the generating point for a collective effervescence focused on him as a prophetic voice attempting to lead Russia back to its true cultural roots, and away from the baleful influence of alien and destructive European ideas. Indeed, more than one commentator has come to view Dostoevsky as a prophet of Russia's future (Fueloep-Miller 1950; Knoeker and Ward 2001; Frank 2003; Moran 2009).

Dostoevsky delivered the speech at the dedication of the Pushkin memorial in 1881. The reaction to this speech is of particular interest as an indicator of the ways in which his ideas could serve as a source of religious and cultural renewal. Dostoevsky's speech was an enormous success. He wrote to his wife Anna on June 7, 1880 about its impact on listeners: "And, when at the end, I proclaimed the universal oneness of mankind, the hall seemed to go into hysterics, and when I finished there was—I won't call it a roar—it was a howl of elation. People in the audience who had never met before, wept, sobbed, embraced each other, and swore to become better, not to hate each other anymore but to love one another." He thought the effects of his speech might create ". . . the foundations of the future, the foundations of everything, even if I were to die" (Frank and Goldstein 1987:507). This account by Dostoevsky is supported by others who were present at the event (Sekirin 1997). Everyone was possessed by a general state of emotional enthusiasm; indeed, the reception of his speech bordered on mass hysteria. Dostoevsky was hailed as a "prophet" who brought a "new word" for Russia. The writer Turgenev, who was present at the speech and whose relationship with Dostoevsky had become seriously strained over their differing views of Russia and the West, embraced him after the speech, calling it a remarkable event. Dostoevsky's speech had focused everyone on the symbol of Pushkin, the widely revered Russian author, and, as a result, also on Russia and

its culture, its unique mission in the world, and, especially, on the human relationships which needed to be developed if Russia was to regain its identity and fulfill its world historical mission. In Durkheim's words, the event was a veritable collective effervescence, a promise of cultural renewal and the future transformation of Russian thought and sentiment.

Perhaps it is not surprising that there soon did develop a "Renaissance" of Russian religious and philosophical thought between 1890 and 1920, inspired, in part, by Dostoevsky's example. Writers such as Vladimir Solovyev, Sergei Bulgakov, Nicolas Berdyaev, S.L. Frank, Lev Shestov, and many others explored from varying perspectives the relationships among ultimate religious values, human consciousness, and social existence, giving rise to what has been described as a "Silver Age" of Russian spirituality, one distinct from the materialist, Marxist, and other social perspectives that were also being simultaneously advanced by better known figures such as Plekhanov, Lenin, and others and which were ultimately to become a leading force in Russian culture after 1917 (see, for example, Berdyaev 1974; Evtukov 1997; Frank 1993; Rosenthal and Bohachevsky-Chomiak 1990; Soloviev 2000, 2003; Shestov 1975).

This Pushkin speech sheds light on Dostoevsky's view of Russian cultural renewal. Dostoevsky was a highly volatile and emotional man, sometimes quite irritable and difficult because of his deeply emotional responses to situations. He disliked the calculating and excessively rational approaches to life and human relations that he found in such figures as Turgenev and Alexander Herzen, who he thought had become too Europeanized and lost touch with Russia through their long absences. The Pushkin memorial speech and the ensuing response mirrored Dostoevsky's sensibility, his belief that Russians could be weaned from their attachment to the less desirable features of Western European culture and redeemed from their implicit hatred of Russian culture. A momentary collective enthusiasm of mutual love and self-transcendence such as occurred at the Pushkin speech seemed proof to Dostoevsky that Russians, even the Westernizers, could change. Russia could become united around a "new word" and once again resume its mission of rescuing the West from its disastrous commitment to scientism, materialism, atheism, and socialism and spread the ideal of the Russian Christ to Europe.

Dostoevsky's hopes were ultimately to be dashed and his worst fears confirmed. Perhaps a sociologist might suggest this was altogether predictable. All collective enthusiasms ultimately fade. They leave behind memories and emotions attached to ideas and symbols gestated during periods of collective enthusiasm. These emotionally charged memories, now detached from the temporary bond of brotherhood in which they were initially created, are forced into combination with other ideas and interests rooted in the profane routines of divided individual and group existences and, in this context, must struggle to retain their vitality.

The enthusiasm resulting from the Pushkin memorial could not bridge the deep differences among various Russian groups, nor create shared symbols strong enough to permanently bind Russians together. The vows of permanent love and brotherhood may perhaps have been kept in individual instances, but many others rapidly retreated to their established positions. Also, we know that the group conflicts which split Russia into a variety of classes, political parties, religious groupings, and cultural ideals became more, not less, acute in the decades immediately following the speech. Newer symbolic representations of Russia's malaise emerged into prominence, ones closer to the European utopianisms hated by Dostoevsky. In the end, his future hopes rested on a view of cultural change which could not be sustained. When the collective enthusiasm created by his Pushkin speech subsided and encountered the realities of Russian politics, culture and society, including its increasingly capitalist economy, its developing urban proletariat, its conflicts over the terms of peasant emancipation, its continued Czarist autocracy, the Russian Orthodox church's monopoly of legitimate religious expression, and the activity of a variety of oppositional groups, the result was inevitably to diminish any sense of collective brotherhood or unitary commitment to a common ideal which Dostoevsky thought necessary for the revival of Russian (and European) culture. Dostoevsky's novels capture key elements of the spirit and sensibility of his time, and, as some have argued, they perhaps even have a prophetic quality, given subsequent developments in Russia after his death, but his view of Russian society remains incomplete. Despite his commitment to an ultra-realistic portrayal of Russian life through a literary representation of many of its exceptional figures and movements, his grasp of Russian reality was limited by his emphasis on the role of ideas in the formation of experience and on the literary audience to whom he addressed his writings. Dostoevsky thought a "new word" would be enough to counterbalance the ideas streaming into Russia from the West, and refocus Russia's intelligentsia on indigenous ideals. He ignored the fact that masses of people are not ruled by ideas alone, but by a variety of social currents largely outside of their individual control. If a symbol is to be created which appeals to their higher natures, it must be one congruent not only with their own putative ideals, but also with their fuller range of experiences.

In the Grand Inquisitor narrative, Dostoevsky contrasted the spiritual symbol embodied in Christ's statement that "man shall not live by bread alone, but by every word that proceeds from the mouth of God" (Matthew 4:4) with the inquisitor's exclusive symbolic emphasis on providing bread for the masses. He paid insufficient attention to the word "alone" in this famous saying. He recognized that, truly, man does not live by bread alone, but failed to remember that he also does require bread. As a result, it was neither Dostoevsky's literary symbol of Pushkin, nor his Russian religious symbol of Christ, but rather the revolutionary

symbol of Lenin, who provided the focus for Russia's emerging collective consciousness and who individuated the collective social forces of the decades after Dostoevsky's death. As Durkheim once remarked, a unified society is possible only on the basis of a "vast symbolism" (Durkheim 1995 [1912]). Regrettably, Dostoevsky's symbols, however powerful and perhaps even convincing from our present historical vantage point, were inadequate to his time.

Conclusion

In his study of sociology as an art form, Robert Nisbet (1976) suggested that there are substantial similarities between the portraits of social life created by nineteenth and early-twentieth century novelists and poets, such as Dickens, Balzac, Eliot, Tolstoy, and others, and the evocative and detailed analyses of society penned by pioneering sociologists such as Marx, Toennies, Simmel, Durkheim, and Weber. Nisbet had a point. It finds further confirmation in the present discussion of Durkheim and Dostoevsky. In a series of alternately brightly and darkly colored images, the latter author has invoked the spiritual life of Russia from the varied viewpoints of typical and realistically, indeed super-realistically, drawn characters, ones which capture essential features of late-nineteenth century Russian experience. Somewhat later, Durkheim gave us a conceptual and "scientific" analysis, hardly less detailed, of the derangements of consciousness and sensibility accompanying modernity's transformation of traditional society into one based on new forms of solidarity rooted in a complex division of labor, but lacking the collective beliefs and practices needed for the regeneration or even the full integration of society.

What would Dostoevsky have said had it been suggested that many of his aims, if not his precise means, were congruent with those of France's greatest pioneer of "scientific sociology"? What would Durkheim, who evidently never read Dostoevsky, have thought of the latter's prophetic call for a collective spiritual effervescence in Russian society through the power embodied in the common symbol of Pushkin? Such questions are undoubtedly speculative. Dostoevsky died in 1883, at almost the exact moment when Durkheim was embarking on his sociological career. Their paths did not, nor could they ever cross. However, ideas die hard and renewed combinations of old ones are always possible. It is of interest that Jane Ellen Harrison, the pioneering student of ancient Greek myth, ritual, and society, who was deeply influenced by the work of Durkheim and his school, should toward the end of her career have become increasingly interested in Russian culture (Harrison 1912; Nielsen 2002, forthcoming). She admired the religious ideas of Dostoevsky's early follower Vladimir Soloviev, a major figure in the *fin-de-siècle* Russian

spiritual Renaissance (Harrison 1962), translated into English (with Hope Mirrlees) the autobiography of Avvakum, the seventeenth-century Russian schismatic and Old Believer (Avvakum 1963[1924]), and favorably compared Tolstoy's emotionalist theory of art with Durkheim's own view of the relationship between ritual and art (Harrison 1913). Harrison never fully achieved the synthesis of classical Greek religiosity, Russian spirituality, and Durkheimian commitment to understanding the collective origins of religious revivals. It remains a task to be accomplished by future Durkheimians. But, as Dostoevsky wrote in another context, "all that might be the subject of a new tale . . . the present one is ended" (Dostoevsky (1989[1866]).

Notes

1. For background and historical information, the present work draws on the standard biographical studies of Dostoevsky's life and work, especially Frank (1976, 1983, 1986, 1995, 2003), Mochulsky (1967) and Grossman (1975), without necessarily citing pages where particularly well-known facts are drawn from them. I have profited from other accounts of his religious and social philosophy, especially Cassedy (2005), Gibson (1973), Lantz, (2004), Leatherbarrow (2002) and Scanlan (2002). I have also consulted a variety of other more specialized works dealing with particular aspects of Dostoevsky's work. They are cited at the appropriate points in the text. While I draw on some of the large and well-established interpretative tradition surrounding his work, many of the particular analyses of the figures and themes in Dostoevsky's major writings are my own and I will not now attempt a comparison of my views with those of other interpreters.

References

Avvakum, Petrovich. 1963[1924]. *The Life of the Archpriest Avvakum by Himself*. Trans. Jane Ellen Harrison and Hope Mirrlees, preface Prince D.S. Mirsky. London: Hogarth Press.

Bakhtin, M.M. 1984. *Problems of Dostoevsky's Poetics*. Ed. and trans. Caryl Emerson. Manchester: University Press.

Berdyaev, Nicholas. 1974. *Dostoevsky*. Trans. Donald Attwater. New York: New American Library.

Bergson, Henri. 1959. *Time and Free Will: An Essay on the Immediate Data of Consciousness*. Trans. F.L. Pogson. London: G. Allen & Company.

Bulgakov, Sergei. 1979[1907]. *Karl Marx as a Religious Type. His Relation to the Religion of Anthropotheism of L. Feuerbach*. Int. Donald W. Treadgold, ed. with preface Virgil R. Lang, trans. Luba Barna. Belmont, MA: Nordland Publishing Company.

———. 2000[1912]. *Philosophy of Economy. The World as Household*. Trans. and ed. with int. Catherine Evtukov. New Haven: Yale University Press.

Cassedy, Steven. 2005. *Dostoevsky's Religion*. Stanford, CA: Stanford University Press.

Chernyshevsky, N.G. 1989[1863]. *What Is To Be Done?* Trans. Michael Katz. Ithaca: Cornell University Press.

Coulson, Jessie. 1962. *Dostoevsky. A Self-Portrait*. London: Oxford University Press.

Dostoevsky, Anna. 1975. *Dostoevsky: Reminiscences*. Trans. and ed. Beatrice Stillman, int. Helen Muchnic. New York: Liveright.

116 *Donald A. Nielsen*

Dostoevsky, Fyodor M. 1989[1846]. *Poor Folk and Other Stories*. London: Penguin Books.

———. 1975[1861]. *The Insulted and Injured*. Trans. Constance Garnett. Westport, CN: Greenwood Press.

———. 1955[1863]. *Winter Notes on Summer Impressions*. Foreword Saul Bellow, trans. Richard Lee Renfield. New York: McGraw-Hill.

———. 2008[1861–62]. *Memoires from the House of the Dead*. Trans. Jesse Coulson, foreword Ronald Hingley. New York: Oxford University Press.

———. 1989[1864]. *Notes From Underground*. Trans. and ed. Michael Katz. New York: W.W. Norton & Company.

———. 1989[1866]. *Crime and Punishment. Third Edition. The Coulson Translation*. Ed. George Gibian. New York: W.W. Norton & Company.

———. 1976[1879–80]. *The Brothers Karamazov. The Constance Garnett Translation*. Revised by Ralph E. Matlaw, ed. Ralph E. Matlaw. New York: W.W. Norton & Company.

———. 1992[1871–72]. *Devils*. Tran Michael Katz. New York: Oxford University Press.

———. 1994[1873–81]. *A Writer's Diary*. 2 vols. Trans. and annotated Kenneth Lantz, int. Gary S. Morson. Evanston, Illinois: Northwestern University Press.

Durkheim, Émile. 1984. [1893]. *The Division of Labor in Society*. Trans. W.D. Halls. New York: Free Press.

———. 1951[1897]. *Suicide*. Trans. George Simpson. New York: Free Press.

———. 1978[1897]. "Review of Antonio Labriola, Essays on the Materialist Conception of History." In *Émile Durkheim on Institutional Analysis*. Trans. Mark Traugott. Chicago: University of Chicago Press, 127–30.

———. 1995[1912]. *Elementary Forms of the Religious Life*. Trans. Karen Fields. New York: Free Press.

———. 1961[1925]. *Moral Education*. Foreword Paul Fauconnet, trans. E.K. Wilson and H. Schnurer. New York: Free Press.

———. 1962[1928]. *Socialism*. Trans. C. Sattler, preface Marcel Mauss, int. Alvin Gouldner. New York: Collier.

———. 1973. *Émile Durkheim on Morality and Society*. Ed. with int. Robert Bellah. Chicago: University of Chicago Press.

Durkheim, Émile, and Marcel Mauss. 1963[1903]. *Primitive Classification*. Trans. with int. Rodney Needham. Chicago: University of Chicago Press.

———. 1971[1912]. "Note on the Notion of Civilization". Trans. Benjamin Nelson. Social Research, 38:808–13.

Evtukov, Catherine. 1997. *The Cross and the Sickle: Sergei Bulgakov and the Fate of Russian Religious Philosophy*. Ithaca, NY: Cornell University Press.

Frank, Joseph. 1976. *Dostoevsky: The Seeds of Revolt, 1821–1849*. Princeton, NJ: Princeton University Press.

———. 1983. *Dostoevsky: The Years of Ordeal, 1850–1859*. Princeton, NJ: Princeton University Press.

———. 1986. *Dostoevsky: The Stir of Liberation, 1860–1865*. Princeton, NJ: Princeton University Press.

———. 1995. *Dostoevsky: The Miraculous Years, 1865–1871*. Princeton, NJ: Princeton University Press.

———. 2003 *Dostoevsky: The Mantle of the Prophet, 1871–1881*. Princeton, NJ: Princeton University Press.

Frank, Joseph, and David I. Goldstein, eds. 1987. *Selected Letters of Fyodor Dostoevsky*. Trans. Andrew R. MacAndrew. New Brunswick, NJ: Rutgers University Press.

Frank. S.L. 1993. *Man's Soul: An Introductory Essay in Philosophical Psychology*. Trans. Boris Jakim. Athens, OH: Ohio University Press.

Fueloep-Miller, Rene. 1950. *Fyodor Dostoevsky. Insight, Faith and Prophecy*. Trans. Richard and Clara Winston. New York: Charles Scribner's.

Gibson, A. Boyce. 1973. *The Religion of Dostoevsky*. Philadelphia: Westminster Press.

Grossman, Leonid. 1975. *Dostoevsky: A Biography*. Trans. Mary Mackler. Indianapolis: Bobbs-Merrill Company.

Harrison, Jane Ellen. 1912. *Themis: The Social Origins of Greek Religion*. Cambridge: Cambridge University Press.

———. 1913. *Ancient Art and Ritual*. New York: Henry Holt.

———. 1962 [1921]."Epilegomena to the Study of Greek Religion." In *Epilegomena to the Study of Greek Religion and Themis*. New Hyde Park, NY: University Books, 17–56.

Hertz, Robert. 1973. [1909]. "The Preeminence of the Right Hand: A Study in Religious Polarity." Trans. Rodney Needham. In *Right and Left: Essays on Dual Symbolic Classification*. Chicago: University of Chicago Press , 3–31.

Hingley, Ronald. 1967. *Nihilists. Russian Radicals and Revolutionaries in the Reign of Alexander II (1855–1881)*. New York: Delacorte Press.

Ivanov, Vyascheslav. 1966. *Freedom and the Tragic Life. A Study in Dostoevsky*. Foreword Maurice Bowra, trans. Norman Cameron, ed. S. Konovalov. New York: Noonday Press.

Knoeker, P. Travis, and Bruce K. Ward. 2001. *Remembering the End: Dostoevsky as Prophet to Modernity*. Boulder, CO: Westview Press.

Lantz, Kenneth. 2004. *The Dostoevsky Encyclopedia*. Westport, CN: Greenwood Press.

Leatherbarrow, W.J. ed. 2002. *The Cambridge Companion to Dostoevskii*. New York: Cambridge University Press.

Mauss, Marcel. 1979[1950]. *Sociology and Psychology*. Trans. Ben Brewster. New York: Routledge.

———. 1990[1922]. *The Gift: The Forms and Reasons of Exchange in Primitive and Archaic Societies*. Trans. W.D. Halls, foreword Mary Douglas. New York: W.W. Norton.

Merezhkovsky, Dmitri. 1970[1902]. *Tolstoi as Man and Artist with an Essay on Dostoevsky*. Westport, CN: Greenwood Press.

Mikhailovsky, Nikolai K. 1978[1882]. *Dostoevsky: A Cruel Talent*. Trans. Spencer Cademus. Ann Arbor: Ardis.

Mochulsky, Konstantin. 1967. *Dostoevsky: His Life and Work*. Trans. M. Minihan. Princeton, NJ: Princeton University Press.

Moran, John P. 2009. *The Solution of the Fist: Dostoevsky and the Roots of Modern Terrorism*. Lanham, MD: Lexington Books.

Morson, Gary Saul. 1981. *The Boundaries of Genre: Dostoevsky's 'Diary of a Writer' and the Traditions of Literary Utopia*. Austin: University of Texas Press.

Nielsen, Donald A. 1996. "Pericles and the Plague: Civil Religion, Anomie and Injustice in Thucydides". *Sociology of Religion* 57(4):397–407.

———. 1999. *Three Faces of God: Society, Religion and the Categories of Totality in the Philosophy of Émile Durkheim*. Albany, NY: State University of New York Press.

———. 2002. "How Is A History of the Sociology of Religion Possible?: Reflections on Roberto Cipriani's *Sociology of Religion*", *International Journal of Politics, Culture and Society*. 15(4):613–23.

———. 2004. "Rationalization, Transformations of Consciousness and Intercivilizational Encounters." In *Rethinking Civilizational Analysis*. Said Arjomand and Edward A. Tiryakian (eds.). Thousand Oaks, CA: SAGE Publications, 119–32.

———. 2005. *Horrible Workers: Max Stirner, Arthur Rimbaud, Robert Johnson and the Charles Manson Circle—Studies in Moral Experience and Cultural Expression*. Lanham, MD: Lexington Books.

———. (forthcoming). *Jane Ellen Harrison and the Sociological Study of Religion*. New York: Edwin Mellen Press.

Nisbet, Robert. 1976. *Sociology as an Art Form*. New York: Oxford University Press.

Pomper, Philip. 1979. *Sergei Nechaev*. New Brunswick, NJ: Rutgers University Press.

Rosenthal, Bernice G. and Martha Bohachevsky-Chomiak. 1990. *A Revolution of the Spirit. Crisis of Value in Russia, 1890–1924*. New York: Fordham University Press.

Sandoz, Ellis. 2000. *Political Apocalypse: A Study of Dostoevsky's Grand Inquisitor. Second Revised Edition.* Wilmington, Delaware: ISI Books.

Scanlan, James P. 2002. *Dostoevsky as Thinker.* Ithaca, NY: Cornell University Press.

Sekirin, Peter. 1997. *The Dostoevsky Archive: Firsthand Accounts of the Novelist from Contemporaries' Memoirs and Rare Periodicals with a detailed Lifetime Chronology and Annotated Bibliography.* London: McFarland Company.

Shestov, Lev. 1975. *In Job's Balances. On the Sources of the Eternal Truths.* Trans. C. Coveny and C.A. Macarthey, int. Bernard Martin. Athens: Ohio University Press.

Soloviev, V.S. 2000. *Politics, Law and Morality.* Ed. and trans. Vladimir Wozniuk, foreword Gary Saul Morson. New Haven: Yale University Press.

———. 2003. *The Heart of Reality. Essays on Beauty, Love and Ethics.* Ed. and trans. V. Wozniuk. Notre Dame, IN: University of Notre Dame Press.

Terras, Victor. 1981. *A Karamazov Companion: Commentary on the Genesis, Language and Style of Dostoevsky's Novel.* Madison: University of Wisconsin Press.

Tiryakian, E.A. 1962. *Sociologism and Existentialism.* Totowa, NJ: Prentice-Hall.

Treadgold, Donald W. 1973. *The West in Russia and China. Religious and Secular Thought in Modern Times. Vol. 1, Russia, 1472–1917.* Cambridge: University Press.

Verhoeven, Claudia. 2009. *The Odd Man Karakozov. Imperial Russia, Modernity, and the Birth of Terrorism.* Ithaca, NY: Cornell University Press

Wasiolek, Edward. ed. 1967. *Fyodor Dostoevsky: The Notebooks for 'Crime and Punishment'.* Translated by E. Wasiolek. Chicago: University of Chicago Press.

———. ed. 1968. *Fyodor Dostoevsky: The Notebooks for 'The Possessed'.* Trans. V. Terras. Chicago: University of Chicago Press.

———. ed. 1971. *Fyodor Dostoevsky: The Notebooks for 'The Brothers Karamazov'.* Trans. V. Terras. Chicago: University of Chicago Press.

Woehrlin, William F. 1971. *Chernyshevskii: The Man and the Journalist.* Cambridge, MA: Harvard University Press.

Durkheim, *L'Année sociologique,* and Art[1]

Marcel Fournier

In a short article entitled "L'Ecole durkheimienne à la recherche de la société perdue: la sociologie naissante et son milieu culturel," E.A. Tiryakian proposes a provocative hypothesis: "There is a notable affinity between avant-garde art and the Durkheim school" (Tiryakian 1979:101). The author's intention is to detect the influence of the cultural environment on the Durkheim school by establishing a relationship—in the form of "des preoccupations partagées"—between that school and French avant-garde artists and writers at the turn of the century. His approach is inspired by a study by Robert Nisbert, *Sociology as an Art Form* (1976), in which Nisbert claimed that "Sociology and art are closely linked."

The evidence adduced in favor of the argument is scanty: it goes no further than a few generalizations: "Both impressionism and Durkheimian sociology have faced obstacles and aroused hostility because the works produced by them went against what one might call the 'natural attitude', as Husserl put it" (Tiryakian 1979:106). Or "The Durkheimians, at least a good number of them, felt the same feeling of world destruction as the avant-garde artists" (ibid.:112). And again: "This is why it seems to me that the Durkheim school's search parallels Proust's, inasmuch as the *Année*'s implicit, tacit agenda is a sociological quest for the Holy Grail, and that the *Année* could thus be titled: *In Search of the lost society*" (ibid.:112). And finally: "The Durkheimians found material in primitive societies which enabled them to outline the fundamental forms of social reality, in exactly the same way as avant-garde artists (such as the 'customs officer' Rousseau or, even more strikingly, Picasso, Apollinaire and Modigliani, amongst others) saw primitive representations as a doorway leading to basic forms of reality" (ibid.: 114). Well aware of the "limited frame of his demonstration," Tiryakian

concludes by hoping that his proposition may attract "a more thorough study in future" (ibid.:114).

Tiryakian's article is of interest less for its "exploration" of this question than for the emphasis it puts on the place of the arts in *L'Année sociologique*. By way of a chart entitled "Les arts dans *l'Année sociologique* (Première partie)," Tiryakian establishes that "the arts were not one of the main preoccupations of the most active members of the group" (ibid.:103) and that, with the exception of Hubert, the group's chief contributor in this area, "the heading of 'the arts' served as a training ground for the new members of the school" (Parodi, Lalo, Maître, Beuchat, Bianconi, Gelly and Jean Marx) (ibid.:104).

The study carried out by Tiryakian is extremely cursory. He himself adds that "It would be worthwhile to reread the analyses which have appeared under this heading. They would provide us with some insights which could well give the sociology of art a more elevated position than it enjoys at present" (ibid.:105). Having established a few initial points, Tiryakian declines to take his study any further. He may have felt he was on the wrong track. It is, indeed, true that we cannot assess the significance of the sociology of art in *L'Année sociologique* without addressing the question of whether and how art could be considered a proper object of study for (Durkheimian) sociology.

Should art be considered superfluous?

Although sensitive to art, as confirmed by his account of a visit to a Rembrandt exhibition in Amsterdam in July 1914—he confides that "the Ronde de nuit is one of the most admirable things I have ever seen"[2]— Durkheim himself has little interest in art: his own home contained few if any works of art. For this ascetic intellectual, art is something superfluous, it seems to him to be "luxury, an ornament that it is pleasant to have, but which one cannot be required to acquire." Furthermore, his first comment on art, in *De la division du travail social*, has an indignant tone: "in the case of individuals, as in societies, an intemperant development of the aesthetic faculties is a serious sign from a moral point of view" (Durkheim 1947[1893]:51–52). An interest in artistic activity can only be healthy provided it is "modéré": "Too great an artistic sensibility is a sickly phenomenon which cannot become general without danger to society" (ibid.:240). This sociologist, who condemns the egotism and indeed the overdeveloped individualism of his contemporaries, is suspicious of art precisely because it is "refractory to all that resembles an obligation, for it is the domain of liberty" (ibid.:51). Durkheim adds that, "Art responds to our need of pursuing an activity without end, for the pleasure of the pursuit, whereas morality compels us to follow a determinate path to a definite end. Whatever is obligatory is at the same time constraining.

Thus, although art may be animated by moral ideas or find itself involved in the evolution of phenomena which, properly speaking, are moral, it is not in itself moral" (ibid.).

Art, thus, differs from morality in the same way as play differs from "la vie sérieuse." But art is, as may be seen from Durkheim's brief comments on architecture in *Le Suicide,* a social fact:

> It is not true that society is made up only of individuals; it also includes material objects, which play an essential role in communal life. The social fact is sometimes materialized to the extent of becoming an element of the outside world. For example, a particular type of architecture is a social phenomenon, and it is incarnate in part in houses and buildings of every kind which, once built, become autonomous realities, independent of individuals. The same applies to routes of communication and transport, to the instruments and machinery used in industry or in private life which express the state of technology at a given moment in history, to the written language, and so on. Social life, having as it were crystallized itself in this way and fixed itself on material props, is by that very fact exteriorized and acts upon us from outside. [. . .] The child acquires his taste by coming into contact with monuments of the national taste which are the legacy of previous generations. (Durkheim 2006[1897]:3484)

Durkheim accords a serious role to art in the context of the sociology of religion which he formulates after 1895, in which he ascribes a central place to collective representations. In the preface to volume 2 of *L'Année sociologique,* in which he devotes a paper to "la définition du phénomène religieux," Durkheim establishes a close relationship between religion and the various manifestations of collective living: "Religion contains within it, from the outset, but in an inchoate state, all the elements which, as they have become disconnected from each other, as they have come into sharper focus, as they have interacted with each other in a thousand and one ways, have given rise to the various manifestations of collective living. Science and poetry both sprang from myths and legends, and ritual manifestations of the plastic arts arose from religious practices and ceremonies" (Durkheim 1969[1899]:4).

In *Les formes élémentaires de la vie religieuse,* Durkheim restates that "the most diverse methods and practices, both those that make possible the continuation of the moral life (law, morals, beaux-arts) and those serving the material life (the natural, technical and practical sciences), are either directly or indirectly derived from religion" (Durkheim 1968[1912]:319–20). He goes on to clarify his point: "It is a well-known fact that games and the principal forms of art seem to have been born of religion and that for a long time they retained a religious character" (ibid.:544). Because "the world of religious things is a partially imaginary world," it seems to "lend itself more readily to the free creations of the mind" (ibid.:545). Just as he does in *De la division du travail social,* Durkheim here associates art

with "A surplus . . . which seems to employ itself in supplementary and superfluous works of luxury" (ibid.). He does, however, accord art characteristics of its own: "Art is not merely an external ornament with which the cult has adorned itself in order to dissimulate certain of its features which may be too austere and too rude; but rather, in itself, the cult is something aesthetic" (ibid.:546).

The "Sociology of Aesthetics" rubric

Before the creation of an "Aesthetic Sociology" rubric, there were published, albeit sporadically, in *L'Année sociologique*, reviews of works and articles dealing with art. For example, in the section on criminal sociology Gaston Richard covered D. Ferry's work *Les Criminels dans l'art et la littérature*. For his part, Marcel Mauss drew attention to the publication of a text by L. Gadner on the "Sculptured Tomb of Hellas," explaining that figurative monuments "bear more clearly than poets' or philosophers' works the mark of their immediate milieu, the typical ideas and feelings about the dead" (Mauss 1898:205).

In the early volumes of *L'Année*, there could clearly be no question of "completeness" and covering all the branches of sociology: Durkheim wrote to Célestin Bouglé that "It is not even desirable that we should be [complete] from the outset. We have to leave room for future discoveries."[3] For those works which "are not numerous enough to require a section of their own," as is the case with the sociology of aesthetics, a catch-all topic was created: "Various."

In the first volume, the "Various" section included three topics: anthroposociology (Muffang), sociogeography (Durkheim) and demography (Fauconnet and Parodi). Durkheim would have liked to add to these another topic on the sociology of aesthetics, but the individual who was supposed to deal with this, Ouvré, according to Durkheim himself "has definitively moved towards novel writing." The organization of the various sections and topics represented a real puzzle for Durkheim: "It's a real bother for me,"[4] he admitted to his nephew, Marcel Mauss.

The topic "Sociology of Aesthetics" appeared for the first time only in the third volume of *L'Année* (1901–1902). The creation of this new topic is one of the striking innovations of that volume of *L'Année*. With the aim of providing space for consideration of a work by Hoernes, *Die Anfaenge*, Durkheim believed it would be helpful to create this new topic: "I've been thinking of doing so for some time," he wrote to Hubert; "This feels like the right moment to attempt it." It comes, then, as no surprise that responsibility for this new topic was given to Henri Hubert; he appointed Dominique Parodi, who had been involved in the review from the very beginning, to assist him. A history graduate, specializing in archaeology, Henri Hubert (1872–1927) was the "artist" of the group, at once an

art historian (he had been a student at the Ecole du Louvre), an amateur painter, and an art lover (primarily interested in Japanese prints). His artistic talent had been noted when he was a student at the Ecole Normale Supérieure, where he produced posters for student dramatic productions and caricatures of tutors. Hubert was a close friend of Marcel Mauss.[5] Both were in charge of the substantial section on "Religious Sociology." Dominique Parodi (1870–1959), a friend of Célestin Bouglé's, was a philosophy graduate and a contributor to *La Revue de métaphysique et de morale.* He had taught in a number of schools in the French provinces (Rodez, Limoges, Bordeaux and Rouen) before obtaining teaching posts in Paris, in the Lycée Charlemagne, followed by the Lycée Michelet, and the Lycée Condorcet. The problem of depopulation was one of his particular interests. In volume 1 of *L'Année,* along with Paul Fauconnet, he dealt with issues related to demography, one of the topics which came under the "Various" section; in volume 2, he went on to take on joint responsibility with Célestin Bouglé for the section on "General Sociology."

Parodi's collaboration on the "Sociology of Aesthetics" rubric was short-lived, and for the next volume, he was replaced by Marcel Mauss. In volume four, the "Sociology of Aesthetics" rubric was retained, but Durkheim was keen to allow himself enough time to achieve a clearer direction for this section:

> Because, if I am somewhat reluctant to take it further, that is because almost all we have in this area is good intentions. Personally, I have only ever thought of it incidentally. Now, if we are going to develop a sociology of aesthetics, it is not enough to be willing to do so – or even able to do so – or to have a general sense that aesthetic phenomena are social facts. We also need to have some idea of how to go about dealing with them sociologically. That is what we will all have to work on together. Until that happens, it is good that it exists as a category, but there is very little else we can do with it. (Durkheim 1987:510)

For volume 5, Claude Maître, a pupil of Mauss, takes on the topic, but only for that volume. Born in 1876, a student of the Ecole Normale (1895) and a philosophy graduate, Claude Maître studied under Mauss at the Ecole Pratique des Hautes Etudes. The "Various" section included four rubrics: "Sociology of Aesthetics," "Technology," "Language," and "War." In the following volume, the "Various" section remained marginal, consisting of some twenty pages. The "War" rubric disappeared to be replaced by a new section, "Socialism," responsibility for which fell to Paul Fauconnet. The seventh volume of *L'Année sociologique* appeared in 1904, and included a few changes, including the appearance of Paul Hourticq and Charles Lalo among its contributors. These two were former students of Durkheim, associated with the so-called "Bordeaux School." Lalo had just been appointed professor of philosophy at Bayonne, and assisted Hubert and Mauss on the "Sociology of Aesthetics" rubric. The "Various"

section now included, over and above the "Aesthetics," "Linguistics," and "Technology" rubrics, a new rubric simply entitled "Education." This new rubric disappeared in volume 8, with the "Various" section remaining marginal (comprising between 2 and 3 percent of the total number of pages devoted to reviews); it only henceforth consisted of the three rubrics "Sociology of Aesthetics" (Hubert), "Technology" (Hubert and Mauss), and "Language" (Antoine Meillet).

An anthropological perspective

With reference to the "Various" section, Marcel Mauss was to say that it was "general and insignificant" (Mauss 1969[1927], vol. 3:181); he was also to express regret at not having given more space to the three areas of knowledge represented by linguistics, technology and aesthetics. And in mitigation, he recognized that these three parts of the "Various" section "suffer from this lack of proportion." He wrote:

> Even our own work, along with the whole discipline of sociology, reflects the lack of works that deal with linguistics, technology and aesthetics. Indeed, it is somewhat embarrassing that we can give these areas so little attention . . . This shortcoming is no fault of ours; it would not have existed if Bianconi, Gelly, André Durkheim, and still others were still with us. But we should emphasize this unambiguously: these three areas – linguistics, technology, aesthetics – have a far more important place in social systems, both primitive and developed, than we have been able to allow them. (Ibid.:191)

Referring specifically to aesthetics, Mauss wrote in 1898 to his uncle: "In general . . . the role of / part played by aesthetic phenomena is neglected."[6] Later, he would write:

> The significance of the sociology of aesthetics is all the greater when we compare it to other areas to which we seem to attach more importance. We were, unfortunately, never able to emphasize this significance fully enough. Durkheim more than hinted at it in his *Elementary Forms of the Religious Life*, and we did our best never to lose sight of it in L'Année sociologique. And, of course, some rather exaggerated its importance – that old master Wundt, for example . . . but in general, sociologists tend to concentrate more on the classic problems of morality or economics, and the role played by aesthetics has been neglected. (Ibid.:193)

It should be added that the limited coverage accorded to aesthetics is the result of outside circumstances: it arises first and foremost from sheer chance—namely, the limited number of works published in that area: "Naturally, the luck of the draw in publications, our own work and tastes, and—above all—the sheer scale of our ignorance, have sometimes caused us to make mistakes. The (correct?) scale of the relevant facts, and the

exact significance of the ideas involved, have not always been fully appreciated" (Mauss 1979:213). The direction taken by *L'Année sociologique* was also influenced by the tragic events which were to decimate the group of contributors: "Had it not been for the War, the direction which what we have come to know as the French School of sociology would have taken is entirely clear. Imagine what would have happened had Gelly become our expert in aesthetics" (Mauss 1969[1926], vol. 3:498).

The area covered by the section on sociology of aesthetics was broad and ill-defined: it covered primitive art and archaeology, to be sure, but also literature—Greek poetry and tragedy, medieval poetry, etc.—music and games. It also included a review by Parodi of Henri Bergson's essay on laughter, which was published by Alcan in 1900. There is a clear resistance to the prospect of being limited to the categories, largely defined by the intellectual and academic worlds, which restrict the definition of aesthetics to those areas covered by the fine arts. The approach taken by *L'Année sociologique* is overtly anthropological. The only introduction written, by Henri Hubert, to this section explains: "It is useful here to draw particular attention to prehistory and ethnography" (Hubert 1902a:577). The adoption of such an approach, as Hubert was well aware, makes it difficult to define with any precision the area covered by aesthetics— an area which, in so-called primitive societies, has no real independent existence. Hubert went on to explain:

> We do not presume to explain art; still less to weigh carefully the relative significance of the roles played by the individual and society in the production of works of art. All we are doing is taking account of the social activities involved in that production and the sociological laws which arise from it. We are not investigating how art is affected by various social phenomena, economic or otherwise; if examples of these phenomena do not lead to conclusions about the sociological conditions of the production and development of art, then they should in general be catalogued under other headings. From the point of view we are adopting, *the study of art could be categorised both under technology and that of theories of representation* ... To formulate a general theory of collective representation, *art would probably occupy a central position*; it would provide models of synthetic, suggestive representations; and it is, of course, clear that analyses of the sensory, affective elements of representations would be especially rewarding. (Ibid.:578)

The social dimension of art

Even if Hubert avoided the question concerning "the respective parts played by the individual and society in the production of works of art," that difficult conundrum remained a key issue for the contributors: their intention was to emphasize the social dimension of art, as much in so-called primitive societies as in contemporary western ones. And

so, even for Parodi, who conceded that the nature of any given work of art was "essentially original, individual, concrete" (Parodi 1900a:170), art remained "a social whole, inseparable from the public which is always present in the artist's thoughts." Parodi went on to specify: "Without a public, there is no art." He concluded: "From now on, art can and must be studied in general sociology in terms of its essential relations with other social phenomena" (Parodi 1900b:575). And even if Parodi's intention was to replace the term "truth" with that of "sincerity," in the light of his reading of A. Baratoni's *Sociologica estetica*, he nonetheless recognized that the latter may be defined not only as "absolute subjective impartiality," but also as "a necessary social utility."

The aim, then, was to demonstrate that "at the basis of the work of art can be found social facts" (Chaillié 1906:588). Hubert himself referred to the literary manifestations of Greek thought as "in reality forms of the thoughts of the collective," inasmuch as they "are composed of the myriad thoughts—lucid, vague and obscure—which could gradually be brought into being by the repetition of these hallowed accords." This reflection brought him to pose "a further question": "How accurate is it to describe the poet as the organ of the thoughts of the collective, aware that he is drawing for inspiration upon these obscure concepts, floating in the ether?" His own initial response to this question was as follows: "Literature is sometimes, in the usual, limited sense of the word, an institution" (Hubert 1902b:588). In the same volume of *L'Année sociologique*, another contributor, Claude Maître, investigated "the deep sociological significance of the metaphor of the sonorous echo":

> Far from merely reflecting on the ever greater depths of the interior feelings that dominate him, is the artist above all the space where collective modes of feeling build up and take on clarity? Not only does the artist, if he is to express his emotion artistically, have to use the means of expression that society imposes on him, but the very emotive state he wishes to express is nothing more than the result of the effect that the collective sensibility has on his individual feelings. It is only from this point of view, sociological in nature, that the collective characteristics of the artist's impulsion – or rather, his feelings – may be determined. (Maître 1902:585)

Marcel Mauss, for his part, conceded that aesthetics could also become a branch of sociology—but only on condition that artistic phenomena should be studied "as objective facts whose causes are being sought"; and moreover that these "objective facts" should be seen as "not a private phenomenon," but as "a social institution," playing its own role in "public life." In other words, they should be studied as "essentially collective phenomena" (Mauss 1969[1903]:560).

Among the contributors to *L'Année sociologique*, the one who seems most closely identified with the study of aesthetics is Charles Lalo, notwithstanding that he took on responsibility for the "Sociology of Aesthetics"

section only once (and then in collaboration with Mauss and Hubert), and that he authored only a single review. In a survey of "La Sociologie en France depuis 1914," outlined by Durkheim and published in 1933 by Mauss, it was recognized that "sociological aesthetics in particular were the object of M. Lalo's work" (Mauss 1969[1933], vol. 3:444).[7] As the only contributor unambiguously associated with aesthetics, he comes across as an isolated figure, with no collaborative links or ties of friendship with the others.

The autonomy of art?

Marcel Mauss used Durkheim's rather rare and brief analyses of such questions to claim his thinking included a "substantial element relating to the phenomenon of aesthetics": the significance of the sociology of aesthetics is all the greater when we compare it to other areas to which we seem to attach more importance. We were, unfortunately, never able to emphasize this significance fully enough. Durkheim more than hinted at it in his *Elementary Forms of the Religious Life*, and we did our best never to lose sight of it in *L'Année sociologique* (Mauss 1969[1927], vol. 3:193).

From the sociological or anthropological point of view, the autonomy of art remains relative: instead of the artist's "absolute subjective impartiality," the sociologist emphasizes "art's role as a necessary social utility." Mauss was to explain in 1927 that:

> phenomena relating to artistic matters are, perhaps after those relating to language, the social phenomena which have most strikingly *transcended their own limitations*, at least in those civilizations which preceded our own. It is only in the modern period, and even then only in limited contexts, that art for art's sake has been able to become a viable concept. In other civilizations, art is involved in everything and leaves its mark on everything ... The fine arts, to adopt that vulgar distinction which Espinas made so profound, are therefore, just like common arts or practical skills, a phenomenon characteristic of communal existence, and not simply a part of that communal existence. (Ibid.:194)

In his attempts to delineate the area covered by sociology, Mauss identified special sociological categories, but only insofar as they represent "elements of social psychology." And even if it is easy to distinguish "religions, morality, economics, art, fine art and games, language," nonetheless "sociology will always seek to remind us of all relevant connections. For no explanation is complete until, over and above the physiological connections, material and morphological connections have also been identified" (ibid.:215).

By posing "the problem of language and symbol (the most general and critical problem in the field of expression)," Mauss distinguished himself

not only from linguists and aestheticians, who tend to limit themselves to their own specializations, but also from philosophers and those psychologists who operate on the level of generalizations: knowledge and symbols are "linked to the whole body of group activities and that body's very structure," in the same way as in studies of mental states, "the data that need to be taken into account are aesthetic, technical, linguistic, not only religious or scientific." Mauss was to add that "Even in that respect, there are combinations to be worked out and appropriate dosages to administer" (ibid.:229).

In his lengthy critical article "L'art et le mythe d'après M. Wundt," published in 1908 in *La Revue philosophique*, Mauss had also taken issue with the approach of art historians: "Artistic evolution too is much more complex than art historians would have it, and aesthetic and religious phenomena alone are not enough to explain its characteristics. All sorts of social factors—scientific, technical, economic—have a role to play" (Mauss 1969[1908], vol. 2:201). Referring to "ideal art, that free form of art which sets itself as its own and only object, and whose only purpose is aesthetic," Mauss conceded that "it could only have been possible in the field of architecture." But he did add at once that "we should not lose sight of the fact that even today's pure art still has a decorative function" (ibid.:200). Elsewhere he accused Wundt of not having abandoned "pure psychology to place art in its proper relationship with its social context"; in short, of not having carried out his study "in a rigorously sociological manner." He added that at no point in his study did Wundt

> bother to give us an idea of art, its basis, its function. Obviously this philosophical question should only be addressed with all necessary precautions, but it cannot be put off for ever. One must start by studying particular forms of art, but only in order to gradually form an idea of what art *is*, of its essential characteristics, the general needs to which it responds, the social context on which it depends ... Art is not only social in nature; it also has social effects. It is the product of the collective unconscious, but it is also that which we agree on, whose emotional effects are much the same for everyone at a given moment, in a given society. It is this nature and this function, most probably, which account for the similarities and the variations, the universal qualities and the instability of the idea of the beautiful. (Ibid.:205, 206)

Gabriel Tarde's "obsession with violet in art"

Gabriel Tarde, an important opponent of Durkheim, took up a position emphasizing the individual's capacity for inventiveness, but ensured that his own point of view was distinguishable from that of the "refined aestheticians," those advocates of an "art for art's sake" position. He also expressed indignation at "the painters of our new, contemporary school

[,who] profess a sort of anarchy of originality, individualism taken to the limit," and mockingly added "for all that, they are still the best examples one could hope to find of enslavement to a collective slogan which even skews their sense of colour and in particular imposes on them their obsession with the colour violet" (Tarde 1898:411). He went on: "Art . . . presupposes a public and an artist; a public that wishes to see or to hear visual, musical or literary works, created, more than that public appreciates, in line with the demands of its own overall taste, and always to some degree seeking to conform to that taste, even if its stated intention is to reform it. Not only does great art require such conditions, but even the most individualistic art cannot escape them. The impressionist who claims to be free of the influence of any school of art would not be an impressionist if it were not in fashion" (ibid.:417).

For Tarde, exactly as for Durkheim, art was "an essentially social phenomenon; art is an important branch of social teleology, a way to achieve a social aim" (ibid.:402). Thus, both Durkheim and Tarde associated art with "leisure and . . . pleasure," and more precisely with play; but, as Tarde was to specify, "a serious and profound form of play like love." Overall, both of them place their analysis of the fine arts in a historical and comparative context. For Tarde, "the four distinct sources for the historical evolution of fine art" are "ceremony, which Spencer studied so effectively, religious worship (especially funeral ceremonies), costume (male and female) and games" (Tarde 1898:43). For these two intellectuals, whose sociological outlooks are so distinct from each other, "that luxury which art represents," apparently so useless, "is, in reality, essential" (ibid.:458).

In its role as a genuine "attempt both to classify and to control sociological thinking," *L'Année sociologique* provides a good example of the uses of this "sociological outlook" in areas which were reputed to defy any explanation other than "descriptions of a historical type or . . . exegesis" (Karady 1979:75). Its format as a literary critical review had the advantage, for its contributors, that it enabled them to "avoid the need to carry out basic research in all the areas that interested them, but without excluding any one of those areas from their discussions on sociology"; it allowed them to "lay down the law authoritatively in a vast scientific domain even before they had explored it" (ibid.:16).

But for sociology, it was not easy to establish the status of art as a worthy object of study: in doing so, the discipline had not only to engage with others better established and more well-informed (philosophy, art history, etc.), but also to overturn a concept, that of the subject, the creative individual, which had great currency in the intellectual and artistic world. Moreover, sociology, more than any other discipline, is unwilling to subscribe to the theory of "art for art's sake." And if, borrowing Baudelaire's definition of modern art, we can maintain that "The beautiful is made of an eternal, immutable element . . . and of a relative and

circumstantial element which will be in turn or at once, the era, fashion, morality or passion," sociology seems in all likelihood disposed to place the emphasis on the second element of this definition.

Even if sociologists may have had links with avant-garde artists—in the case of Durkheim's followers via the anarchist Bernard Lazare, a friend of Lucien Herr, and Léon Blum, and via Romain Rolland, a novelist, art critic and graduate of the ENS (Tiryakian 1979:101)—it cannot be claimed that the Durkheim school enjoyed "an affinity with avant-garde art" (ibid.:114). Durkheim and his collaborators in *L'Année sociologique* could only establish art as a proper object of study by keeping it at arm's length, by following a kind of detour themselves: by studying the most elementary forms of art, namely, its manifestations in the simplest societies. And if there is, over and above this, a similarity of position between these groups of sociologists and artists of the avant-garde (Charle 1977), it is to be found in their basic approach: both groups discover aesthetics where it was not previously to be found. Both groups followed the same "detour": like contemporary art, the sociology of art can only exist by means of turning its attention, for the first time, upon primitive art.

It is, thus, not altogether by chance that, in one of the few texts he writes on art, Mauss, on the occasion of a Picasso exhibition (an artist of whom he claims to know little), sings the praises of indigenous art: "A beautiful mask from the dark continent, a Javanese marionette, no longer look ridiculous to us . . . We are beginning to grasp the fact that the art of our civilization is only one case of art more generally, that indigenous art is every bit as 'worthy' as much of our art. Contact with this art refreshes our own: it suggests new forms and styles, even when they are as stylized and refined by tradition as ours are."[8]

Notes

1. The first version of this article appeared in *Etudes durkheimiennes*, 12 (1987), 1–11. As was noted then, any complete version of this study would need to take account of the lifestyle of Durkheim and his disciples, of their various relationships with artists and writers and, more broadly, of the positions they occupy in the French intellectual milieu.

2. Letter from Émile Durkheim to Jean-Jacques Salverda de Grave, 7 November 1914, cited in *Etudes durkheimiennes*, 9 (November 1983), 2.

3. Letter from Émile Durkheim to Célestin Bouglé, Bordeaux, 20 June 1897, in Émile Durkheim, *Textes*, vol. 2, 398.

4. Letter from Émile Durkheim to Marcel Mauss, June 1897, in *Émile Durkheim*, 1998, 65.

5. Born in 1872, Henri Hubert and Marcel Mauss were, as Mauss was fond of recollecting, "frères siamois" and "jumeaux de travail"; when both were studying the history of religions at the Ecole Pratique des Hautes Etudes, they discovered they had a substantial intellectual affinity, and immediately became exceptionally good friends. It was Mauss who initiated his friend Henri into "le camp des sociologues" and introduced him to his uncle, one of whose first disciples he was, and of whom "il devient un des plus fervents en même temps qu'un des plus indépendants disciples" (Hubert 1979:205). In short, the story of *L'Année* in its early years was a story of family ties and friendship. Henri

Hubert's first writings in the *Revue archéologique* deal with "Two geometric inscriptions from Asia Minor" (1894) and *"Fibulae* [brooches] from Baslieux" (1899). See Fournier, 2007.

6. Letter from Émile Durkheim to Marcel Mauss (February 1898), in *Émile Durkheim*, 1998, 111–12.

7. Lalo was awarded his doctorate in 1908 for his thesis *Esquisse d'une esthétique musicale scientifique*, which he published that year with Alcan (the work was mentioned in *L'Annee sociologique* vol. 11, 1908, 788). The following year, he was appointed professor of philosophy at Limoges, and published a book on Aristotle in the 'Philosophes' collection. It was only considerably later, in 1933, that he came up to Paris, having been appointed a professor at the Sorbonne.

8. Marcel Mauss, 'Les Arts indigènes', 14, 1931, 1–2 (in Mauss, 1997). Mauss's students, some of whom were personal friends of his, included not only ethnologists who had a working knowledge of indigenous art, such as Germaine Dieterlen, a specialist in Dogon masks, but also others such as Michel Leiris (whose wife was curator of an art gallery), who had an interest in contemporary art. See Marcel Fournier, 1994.

References

Besnard, Philippe. 1979. "La formation de l'équipe de *L'Année sociologique."* *Revue française de sociologie*, 20(1): 7–32.

Chaillié, R. 1906. "Review of E. Marguery, L'oeuvre d'art et l'évolution." *L'Année sociologique*, 9: 588.

Charle, Christophe. 1977. "Champ littéraire et champ de pouvoir: les écrivains et l'Affaire Dreyfus." *Annales (Economie, Société, Civilisation)*: 240–64.

Durkheim, Émile. 1947[1893]. *The Division of Labor in Society*. Trans. George Simpson. New York: Free Press.

———. 1968[1912]. *Les formes élémentaires de la vie religieuse*. Paris: Presses universitaires de France.

———. 1969[1899]. "Préface." *L'Année sociologique*, 2. In Émile Durkheim, *Journal sociologique*. Paris: PUF, 135–39.

———. 1974. *Textes*, vol. 2. Paris: Editions de Minuit.

———. 1987. Lettre à Henri Hubert, 11 juillet. *Revue française de sociologie*, 28(3): 510.

———. 1998. *Lettres à Marcel Mauss*. Ed. with int. Philippe Besnard and Marcel Fournier. Paris: Presses Universitaires de France.

———. 2006[1897]. *On Suicide*. Trans. Robin Buss. New York: Penguin.

Fournier, Marcel. 1994. *Marcel Mauss*. Paris: Fayard. English translation: Princeton University Press, 2005.

Fournier, Marcel. 2007. *Émile Durkheim*. Paris: Fayard.

Hubert, Henri. 1902a. "Introduction à la section de sociologie esthétique." *L'Année sociologique*, 5: 577–78.

———. 1902b. "Review of H. Ouvré, *Les Formes littéraires de la pensée grecque."* *L'Année sociologique*, 5: 586–89.

———. 1979. "Texte autobiographique." *Revue française de sociologie*, 20(20):205.

Karady, Victor. 1979. "Stratégie de réussite et modes de faire-valoir de la sociologie chez les durkheimiens." *Revue française de sociologie*, 20(1): 49–83.

Maître, Claude M. 1902. "Review of Y. Hirn, *The Origins of Art."* *L'Année sociologique*, 4: 578–85.

Mauss, Marcel. 1898. "Review of L. Gardner, *Sculptured Tombs of Hellas."* *L'Année sociologique*, 1: 205–7.

———. 1969[1903]. "Review of F.B. Gummere, *The Beginnings of Poetry."* *L'Année sociologique*, 6: 560–65. In Marcel Mauss, *Œuvres*, vol. 2. Paris: Éditions de Minuit , 251–55.

————. 1969[1908]. "L'art et le mythe d'après Wundt." *Revue philosophique*, 66: 47–79. In Marcel Mauss, *Œuvres*, vol. 2. Paris: Éditions de Minuit, 195–227.

————. 1925. "L'œuvre inédite de Durkheim et de ses collaborateurs." *L'Année sociologique*, nouvelle série, 1: 7–29. In Marcel Mauss, *Œuvres* vol. 3, *Cohésion sociale et divisions de la sociologie*. Paris: Editions de Minuit, 1969, pp. 473–99.

————. 1927. "Divisions et proportions des divisions de la sociologie." *L'Année sociologique*, nouvelle série, 2. In Marcel Mauss, *Œuvres*, vol. 3. Paris: Editions de Minuit, 178–256.

————. 1979. "L'œuvre de Mauss par lui-même." *Revue française de sociologie*, 15(1): 209–20.

————. 1997. *Ecrits politiques*. Ed. with int. Marcel Fournier. Paris: Fayard.

Nisbet, Robert. 1976. *Sociology as an Art Form*. New York: Transaction.

Parodi, Dominique. 1900a. "Review of A. Lalande, *La dissolution opposée à l'évolution dans les sciences physiques et morales*." *L'Année sociologique*, 3: 164–71.

————. 1900b. "Review of A. Baratoni, *Sociologia estetica*." *L'Année sociologique*, 3: 575–79.

Tarde, Gabriel. 1898. *La Logique sociale*. Paris: Alcan, ch. 9 (L'Art), 393–459.

Tiryakian, E. 1979. "L'Ecole durkheimienne à la recherche de la société perdue: la sociologie naissante et son milieu culturel." *Cahiers internationaux de sociologie*, 66: 97–114.

Chapter 7

Marcel Mauss on Art and Aesthetics
The Politics of Division, Isolation, and Totality

Michèle Richman

The researcher will not set off as an aesthetician, but may return as one.
Marcel Mauss, *Manual of Ethnography*

Aesthetics has a bad reputation.
Jacques Rancière, *Malaise dans l'esthétique*

Introduction

The ambitions for this study are twofold: to examine the relatively neglected fields of art and aesthetics in the writings of Marcel Mauss, and to place them in dialogue with contemporary theory. Scholarship pertaining to Mauss's actual thoughts on these matters has lagged behind recognition for his role as mentor in the interwar encounter between radical ethnography and avant-garde cultural milieus (Clifford 1981).[1] In two major works, the place of aesthetics in his conceptualization of a "total" person is either absent (Karsenti 1997) or future research is called on to address it (Tarot 1999). The reasons for this lacuna are both material and ideological. Foremost is the practical matter that Mauss's scattered pieces on art and aesthetics have never been collected into a single volume. Nor could such an anthology be handily edited. As the welcome translation of his article on Wilhelm Wundt's study of art and myth attests, insightful observations are frequently embedded in review essays (see Mauss 2009). Moreover, the only sustained commentary on aesthetic phenomena appears in the *Manual of Ethnography*, based on lectures delivered at the *Institut d'ethnologie* between 1926 and 1938. Dense and notoriously unreliable,[2] these transcribed student notes nonetheless have proven irreplaceable for fieldworkers. For the general reader, they provide an intimation

of Mauss's famously controversial lecture style, as well as a comprehensive overview of the literature on aesthetics up to 1939. In his introduction to the 2007 translation, N.J. Allen rightly singled out the manual's fifth chapter on aesthetics as especially daunting, since students are directed to archive virtually every manifestation of the plastic arts—play, cosmetics, dress, ornamentation, dance, and musicals, as well as those of the "ideal" arts—drama, poetry, and prose. But it is also in its thicket of instructions that a guidepost for this project appears, signaling that the ethnographer could very well return from the field an *aesthéticien*, presumably because, "Aesthetic phenomena form one of the largest components in the social activity of human beings" (Mauss 2007:67).

The limited recognition meted to art and aesthetics in *L'Année sociologique* is difficult to reconcile with Mauss's assertion of their social centrality. If, as early as 1903, he triumphantly proclaimed they should figure as a branch of sociology, decades later both areas had failed to gain parity with the classical sociological topics of morality, religion, and economy. Victor Karady traced this marginalization to strict adherence among sociologists to the tenet that social facts be explained only by other social facts, thereby excluding works attributable to individual inspiration or psychology.[3] Mauss's explanation is more practical: aesthetics, along with linguistics and technology, were relegated to the amorphous category of "Divers" and allowed to languish for lack of specialists in each area. Writing in 1927, he laments the disproportionate attention devoted to certain divisions within sociology while exonerating Durkheim's legacy for perpetuating them (1969:191). Victim of the unforeseeable devastation wrought by World War I on the upcoming generation of sociologists that included the death of his own son, Durkheim himself could not have foreseen the inordinate burden it would become to fulfill the ambitious program he had set for *L'Année sociologique*. Mauss attempted to compensate by means of his own staggering quantity of reviews of publications in all three areas.

Mauss also pointed out that in *The Elementary Forms of Religious Life* (1912) Durkheim had addressed the question of art and aesthetics, just as he had proposed the sociological term "collective representations." The survey conducted for this study, however, documents Mauss's insistence that art and aesthetics be granted their rightful prominence within the sociological canon. To do so generated a process of ongoing critical reflection regarding the parameters of sociology and the discipline's status within the French academy, notably in regard to the domination exerted by philosophy, classical studies, and history. From the end of the eighteenth century, art and aesthetics fell under the purview of philosophy in the form of a quasi-theological and moral discourse that would become anathema to the modern human sciences.

For these reasons, it is necessary to contextualize Mauss's capacious revision of art and aesthetics within its overarching ideological agenda to dissociate sociology from idealist biases, and the academic *habitus*

perpetuating them. Sociology, he noted, subsumes and transforms the categories of preceding sciences, a process especially vexed in the case of art and aesthetics. Just as he argued for the importance of aesthetics, Mauss also warned against favoring any one category to the detriment of sociology's holism. So it is not surprising that Allen would highlight the following exhortation, "The fieldworker should make a practice of systematically rupturing all the divisions that I am expounding here from a didactic point of view" (2007:181). Similar caveats appear throughout the *Manual*, as in all of Mauss's work, forming a mantra to the effect that, "Things are no more divided than is a living being. We are beings who constitute wholes, collectively and individually" (ibid.).

Mauss's watchwords of "total" and "totality" resonate with Jacques Rancière's more recent diagnosis of the state of contemporary aesthetics. From his survey of the literature on aesthetics since Alexander Baumgarten coined the term in 1750, Rancière concluded that correlations between social identity and taste, while an indisputable component of sociological analysis, nonetheless elide a less visible mode of discrimination: the carving of the sensible realm of experience according to politically-motivated configurations (Rancière 2000). Following Aristotle, social entities have distinguished groups condemned to work from those deemed worthy of engaging in contemplation, thereby instituting the prejudice that members of privileged milieus were better endowed with the higher faculties they were encouraged to exercise. Borrowing from the literary critic, M.H. Abrams, the anthropologist Raymond Firth noted that aestheticism had idealized disinterested contemplation of art for its own sake, as evidenced in a one-to-one relationship between person and object. Effectively suppressing the producer, this model could be contrasted with precedents in history and philosophy that approached art, "with reference to human beings, events, purposes, and effects, which it could serve" (Coote and Spence 1992:23).

When compared with *The Manual of Ethnography*'s extensive chapter on aesthetics, it is revealing to find British anthropologists acknowledging that it was not until the 1950s and 1960s that their discipline initiated serious study of art in non-Western societies. The precondition for doing so was undoubtedly a rupture with the legacy of the earlier apotheosis of art in the wake of religion's waning influence. Due to restricted readership, however, Mauss's proposals for a global ethnographic aesthetics have not exerted an influence comparable to his better-known works. Turning to the model of exchange and communication found in the essay on the gift, for instance, Alfred Gell laid the foundations for an anthropological theory in the following terms: "The work of art is inherently social in a way in which the merely beautiful or mysterious object is not: it is a physical entity which mediates between two beings, and therefore creates a social relation between them, which in turn provides a channel for further social relations and influences" (Coote and Spence 1992:52).

The following presentation examines how Mauss revitalized the socio-logical goal of totality through a comparative ethnography of aesthetic experience. Central to this project was inclusion of non-Western peoples according to a new cartography of art production and aesthetic possi-bilities. If isolation is tantamount to repression, according to Freud, then for Mauss, an expanded sensorium tests the unconscious limits of one's own cultural and aesthetic *habitus*. The fieldworker will return an aes-thetician following an encounter with the division of the sensible realm into categories that do not correspond to Western assumptions or practi-cal categories. Mauss readily acknowledged that even among the seem-ingly homogeneous cultures studied by ethnography, aesthetic practices are not distributed uniformly. Because distinctions travel along social borders, some groups must pay to dance, or certain colors are reserved for the privileged. That evidence, however, does not obviate his contention that non-Western cultures highlight the arbitrary nature of all divisions, including those instituted by our own traditions. Taking the example of the fragmentation of musical drama, he remarked, "Nowadays we dis-tinguish between drama, tragedy and comedy: the full energy of German romanticism was required to put things back in order ... the ancient Greek tetralogy consisted of three heroic tragedies, leading to sacrifices, and one comedy; the whole, made up of tragedies and comedy, formed the drama. It is we who have atomized the whole complex" (2007:89).

Given the erratic appearance of ideas on art and aesthetics in his sprawling oeuvre, what—if any—are the conclusions to be drawn from Mauss's engagement with these matters? The answer proposed here takes its cues from a seemingly impatient Mauss, whose sociological imagina-tion grasps for the whole while reinventing the very categories required by the task. Totality, in the Maussian lexicon, is not an abstract ideal but functions as a vector of resistance to separation, division, and isolation: "Arts and techniques are interrelated, hence nothing should be seen in isolation" (ibid.:80). Politics in the sense connoted here reject the isola-tion of art, whether from the sources of its production, from other things, from everyday life, from cognitive activity, from its psycho-physiological substrate, or from the social and international networks in which it exerts agency. That many of the divisions Mauss rejected continue to inform the discourse relating to art and aesthetics will be viewed as symptomatic of its current malaise.

Comparing the incomparable

We have followed the method of exact comparison. (Mauss 1990:4)

By highlighting the meta-commentary that accompanies and frequently interrupts Mauss's lectures, we have reconstructed the various levels of

engagement motivating his method of ethnographic comparison. The primary one resides in its contribution to the reconstruction of a society whose social, economic, religious, and moral divisions are mirrored in the academic disciplines thwarting study of the whole person. Critical awareness of these issues was being honed by a veritable revolution within the New Sorbonne movement discussed below. After decades of training devoted to reinforcing the *génie national* under the cover of a general culture, the average French university student had minimal exposure to concrete social facts, especially those drawn from non-Western societies. Among Mauss's many admonitions to the French university system, we find the shocking disparity between extensive archives compiled for Native American tribes in the United States, and the virtual absence of reliable data for local French *départements*.

Durkheim's 1895 shift to the social basis for cohesion in the opposition between the sacred and the profane had prompted French sociology to adopt an ethnographically based, comparative methodology. Strategically, it allowed the sociologists to distance their discipline from the "simplistic and naively politicized, unconsciously abstract and nationalistic" (Mauss 1974:474) approach to history often found in the nineteenth century. Mauss illustrated history's inability to address the transnational or multi-racial facets of many cultural phenomena by means of the monumental sculptures of Angkor Wat, whose figures on a frieze defy a single, unifying identity: "An enormous army parades by us: priests, chiefs, arms, way of marching, clothing, coifs, gestures, all speak to a distinct civilization of unknown provenance and identity . . . Already at the close of the first millennium of our era, Indochina was a melting pot of races and civilizations" (ibid.).

French sociology's reliance on ethnographic materials has been imputed to a deficiency in research practices. The sociologists, however, never doubted their role as interpreters of what the ethnographer provides, at the same time reviling what Mauss characterized as the "dangerous" distinction made by British anthropology: "sociology, to the contrary, does not distinguish between peoples said to be savage, barbarian or civilized" (1969:175) because "there do not exist any un-civilized peoples" (1974:229). Durkheim had introduced his 1912 magnum opus by arguing for the relevance of the elementary forms of aboriginal religious life to the modern world, thereby reinstating the hoary French tradition of a critical discourse arising from cultural comparison that had been a hallmark of French thinking since the sixteenth century. Alternatively characterized by Claude Lévi-Strauss (1955) as anthropological thinking an ethnographic detour by Bruno Karsenti (1997), or the ethnological imagination according to Fuyuki Kurasawa (2004) the commonality among these terms is the impetus to extract from cultural comparison the basis for a critique of Western assumptions and practices that would also be featured in Mauss's major works.[4]

By 1924, the gift furnished the model of a total social fact irreducible to its constituent features, and resistant to translation according to Western criteria. Despite repeated efforts to exhaust the totality of this bedrock phenomenon of all civilizations, Mauss conceded that gift-exchanges also have an important *aesthetic* aspect deliberately omitted from his study (Mauss 1990:79, emphasis added). Moreover, aesthetic emotion imbues the entirety of exchange festivities, described this way:

> Yet the dances that are carried out in turn, the songs and processions of every kind, the dramatic performances that are given from camp to camp, and by one associate to another, the objects of every sort that are made, used, ornamented, polished, collected, and lovingly passed on, all that is joyfully received and successfully presented, the banquets themselves in which everyone participates; everything, food, objects, and services, even 'respect,' as the Tlingit say, is a cause of *aesthetic emotion*, and not only of a moral order or relating to self-interest. (Ibid., emphasis added)

If, as Mauss clearly stated on several occasions, he had no intention of addressing the aesthetic dimension, how are we to interpret this elusiveness? Most plausibly, I suggest, as a signal to the reader that like the gift, art and aesthetics overflow conventional definitions to restricted objects or phenomena in their ability to "color" virtually every aspect of social life. As such, they also bear comparison with another key social fact identified by Mauss—techniques of the body. Although the essay on the gift deliberately shirked further analysis of a ubiquitous aesthetic emotion, it did provide an exemplary methodology—the comparative approach Mauss would claim is tantamount to scientific experimentation (1969:170).

Mauss had forcefully deployed arguments in favor of a comparative approach in his entry for "Esthétique," dating from approximately 1920. At first glance, the posthumously published manuscript included in the section entitled "Nation, Nationalité, Internationalisme" (Mauss 1969) does not address aesthetics in the expected sense of art and beauty. Rather, it relays his socially charged assertion that borrowings in the area of techniques and aesthetics also serve to transmit ideas for the benefit of the masses: "One cannot exaggerate, contra the absurd reservations expressed by littérateurs and nationalists, the importance of technical borrowings and the human benefits derived from them" (1969:613). Transcultural exchanges enable one group to filter out national errors and absorb the benefits of foreign contacts, thereby constituting their allegedly national treasure. Calling for more research, Mauss nonetheless substantiates the preceding claim with the example of Greek science, since "we are starting to understand how the Greeks, by means of such intermediary peoples from Asia Minor, especially the Phrygians and Carians, benefitted from Egyptian geometry, Chaldean astronomy, Aramaic arithmetic, in the same way that they borrowed from Phoenician writing, etc." (ibid.:615). Mauss remained relatively modest regarding the incipient

nature of such findings, whereas Marcel Détienne, the noted classical scholar, has denounced the actual repression of such comparative studies by the classicist establishment. At stake is the possibility to "compare the incomparable" (Détienne 2000), thereby challenging the conviction relayed for over a century of historiography that the "Greek miracle" is unique in the annals of humanity. Art historians specializing in non-Western civilizations discern the persistence of the Greek myth in the insularity of their own discipline, overly beholden to classicism's idealized naturalism. Although the revival of interest in Greek art by Joachim Winckelmann in the eighteenth century coincided with exploration of the major civilizations of China, India, and those of the Middle East, alternative aesthetic models could not be recognized so long as classical criteria held sway. Moreover, a sharp distinction persisted in classifications of the so-called hieratic civilizations such as those just mentioned, and other cultures described as primitive or tribal. Belated recognition occurred only when formal parallels or homologies could be established between Western and non-Western arts. Mayan art, for instance, was favored due to its recognizable naturalism, whereas Aztec excess was not.[5]

Mauss's central artistic illustration under the entry on aesthetics is the Australian *corroboree*, described as a system of dramatic arts, or comprehensive spectacle and experience that mobilizes poetry, music, and dance. Because it also includes a psycho-sociological dimension—an individual who "loses" his *corroboree* can become so despondent as to allow himself to waste away—it frequently illustrates Mauss's critique of the inadequacy of Western categories regarding the arts. In this context, however, his primary goal is to stress the rapid dissemination of cultural phenomena over vast geographical expanses, eliciting his admiration for ongoing human exchanges, migration, or travel. Art and artifacts undoubtedly have always served as emollients in human relations. Here, however, they are also viewed as transmitting a rarely acknowledged intellectual dimension. Vehicles of ideas and of collective mentalities, things transmit knowledge. In the passage to follow, we find that musical instruments and the notion of the musical note are among the most archaic human inventions to arise from a collective process:

> The discovery of harmony and numeric laws governing chords marked a decisive moment in the history of human thought, when, at a comparable moment, the Greeks with Pythagoras and the Chinese around Confucius, spoke in terms of the tones, unison and harmonies of social life (Li=ki and Philolaos). Reason itself has a collective origin, not only in the sense of being the work of humans working together and in relation to their society; but it is collective in the sense of being the collaborative work of centuries of confrontation with social realities and experiences. These technical and aesthetic borrowings do not occur without transmitting ideas; they are transplanted, flourish and then return to their point of origin. (1969:615)

But the comparative method carries its own risks, as evidenced in the allegedly defective one practiced among some British anthropologists, or in the following example Mauss drew from a German colleague, whose work was otherwise praised. Starting from the assumption that certain peoples are categorized as primitive, he had tautologically described lyrical Polynesian poems as primitive, even if, in Mauss's opinion, "they [are] as artistic as any non-written ones in our Western culture" (1974:265). Guidelines regarding the viable implementation of the comparative method through attention to detail are discussed below.

Useless details

In fact, comparative ethnography will be valuable only if it is based on comparison between facts, not between cultures. (Mauss 2007:8)

Aware that students reacted negatively to the seemingly endless list of questions that are recorded in the *Manual*, or that they were disoriented by its profusion of facts, Mauss retorted, "one might see in these lectures simply an accumulation of useless details. But in fact, each of the details mentioned here presupposes a whole world of studies" (2007:7).[6] That claim's immediate verification resides in the *Manual*'s heavily annotated pages, a testament to its author's encyclopedic erudition. However, it can also be interpreted as an allusion to Mauss's work within the academic movement to which he made invaluable contributions. Seemingly isolated facts or throwaway observations, such as "myths are full of legal principles" (1969:217), acquire their far-reaching significance within the context of comparative research conducted in Indo-European linguistics by Emile Benveniste, Chinese studies by Marcel Granet, and Indo-European mythology by Georges Dumézil. These savants were united by the comparative method whose working assumptions Détienne aptly summed up in their consensus regarding *la pensée mythique* as a sort of historical unconscious or repository since the Indo-European world that functioned as:

[a] unitary language, encompassing major figures of social and spiritual life, possibly secreting the fundamental laws of mental life in society. To this already alluring claim, it proposed another, yet more violent possibility: to be a mode of thought destined to be effaced or undoing itself, a witness to proto-historic behavior with intimations of juridical, political or religious categories destined to emerge and triumph in the forms of rational thought to follow. Within the Greek realm, the anthropologist cohabited with the historian attentive to reconstruct the conditions of observation and analysis of a series of major phenomena: the advent of law, the institution of politics, the emergence of an ethics, or even the creation of money and the birth of philosophy. (Détienne 2000:38)

The assumption shared by these scholars is that the cultures relegated to the margins of classical history and culture exhibit proto-structures of behavior, social forms, intellectual activities, and, one must add, aesthetic techniques, that would flourish in the periods to follow. More radically, I would argue, Mauss enlisted archaeological evidence to destabilize a hierarchy or teleology among civilizations. Art and aesthetics pose an especially formidable threat to evolutionary assumptions. For instance, "excavations conducted among the cliff dwellers of Central America have yielded curious results: the finest basketry in the world is that found in the deepest archaeological layers" (2007:32). Mauss makes only brief allusions to prehistoric art, although the very early essay on primitive classification he co-authored with Durkheim has been singled out as a critical contribution to the paradigm shift that would facilitate acceptance of ice-age art's authenticity (Hurel 2011:95). Starting as early as the 1901 mapping of sociology with Paul Fauconnet, we find the redefinition of key terms such as "civilization" and "institution" as prerequisites to the ideological break with nationalist historicism. Civilization, Mauss reminded colleagues, is an international phenomenon.

Durkheim and Mauss further refined their definitions of sociology in the *Année sociologique* of 1913 as part of an ongoing effort to identify the international objects of sociological study. Their immediate conclusion was that despite the geographic extension of particular items, such as pan flutes, it is also documented that they constitute a system. In order to distinguish between social facts and those of civilization, they contrasted culturally specific phenomena such as political and juridical institutions, or social morphology, with exportable ones that can travel and be borrowed, such as myths, stories, money, commerce, fine arts, techniques, tools, language, words, and scientific knowledge. Rather than regard these latter phenomena as simply intrinsically susceptible to appropriation, the authors encouraged researchers to consider what makes a phenomenon truly international by means of the comparative method.

Another powerful antidote to earlier assumptions about civilization was the sociological revision to the definition of "institution." No longer restricted to fundamental social arrangements, this totalizing approach asserts that the social is everything, since ways of feeling, thinking, and acting among individuals would not be the same if they had lived in other human groups. Institution now encompasses special facts relating to the socialization of individuals according to "the usages as well as the fashions, the prejudices and the superstitions, the political constitutions or essential legal organizations [of a group]; for all of these phenomena are of a similar nature and differ only in degree" (1969:150).

Taken together, the revised categories of civilization and institution would spearhead *aesthétologie* (1974:452), a sub-specialty of sociology focused on civilization conceived as the international historical backdrop from which emerge distinctive social formations. Mauss proposed a more

elaborate definition in order to accommodate artifacts and ideas, given that the latter defy frontiers as readily as things, whether spreading political propaganda, religious beliefs, or scientific knowledge. Mauss may have expressed concerns regarding the display of objects representative of broad geographical expanses, and the possibility to classify them as objects into series in museums (1974:466), but he also wanted to show that their distribution results from borrowings. For the fieldworker, it is often difficult, if not impossible, to assess the geographical extensions of a civilization, since its frontiers or outer limits are as arbitrary as the appropriations or resistances to its contents.

Resistance

> Civilizations are more likely defined by the refusal of borrowings, than by the possibility of borrowings. (Mauss 1969:609)

Early on, sociologists noted that an international system is identifiable as much by what it omits as by what it includes: "The absence of pottery is a distinctive feature of Polynesian industry" (1974:453). Mauss would sharpen that observation by insisting that a missing thing or activity is not necessarily explained by a simple lack or absence; rather, international items would also provide the barometer of a group's resistance to innovations emanating from exogenous sources. Whether Arctic Indians who neither knew nor wished to know how to construct kayaks, the Eskimos who only rarely agreed to wear snowshoes, the French soldiers unable to utilize British hand shovels or vice versa, or the Court of China debating whether to adopt the superior Hun manner of mounting a horse—all these examples "demonstrate how civilizations are circumscribed by their capacity for borrowing and expansion, but also by the *resistances* of the societies that compose them" (1974:472). To address the social basis for these resistances required a notion that could account for the unconscious, infra level of social conditioning. To that end, Mauss revived the Aristotelian notion of *habitus* in the essay on techniques of the body, while endowing it with a more complex set of dispositions than would result from mere habit or imitation.

Equally fundamental to the success of the sociological project, it was necessary to point out that sociology had to overcome the resistance of sociologists themselves: "*Thus, there is nothing more difficult, even for us, than to account for the institutions we practice*" (1969:368, emphasis added). This stalemate—a profusion of facts, a scarcity of savants willing to subject their own society to the critical method—was expressed in slightly modified terms as late as the celebrated 1936 article on "Techniques of the Body." There, we recall, the dilemma facing the author was expressed as the lack of an adequate classificatory scheme to service his abundant

observations relating to the body. Polemically, he imputed a good deal of his frustration to the rigidity of disciplinary frontiers, since the contested space where academics "devour" one another posed a major obstacle to intellectual progress. In keeping with the self-reflexive injunction cited above to examine one's own institutions, he invoked an oft-reprised anecdote dating from his experience in World War I's trench warfare. The use of a spade to dig the trenches dramatized the deeply embedded nature of cultural conditioning: British soldiers in France discovered that they could not utilize the same tool as their allies, thereby necessitating the purchase of some eight thousand spades every time they switched responsibility for the task. For Mauss, this iconic situation dramatized the consequences of specialized cultural practices—a concrete, and highly costly, example of how technically specific even the most basic activity becomes as a result of training or *apprentissage*. The turn of the hand required to manipulate the spade is but an acute version of socialization encoded in virtually every gesture or mannerism required for participation in a social group.

That the gait of American nurses in a New York hospital figured as the scene of an epistemological epiphany is not entirely surprising to seasoned readers of Mauss. Denise Paulme regretted that his lectures were riddled with such personal stories, perceived as a disappointing substitution[7] for guidelines at the higher level of generality expected by students. Mauss himself explained his *méthode* in 1936: condensing decades of accumulated ethnographic observations under the catch-all rubric "Miscellaneous," the ethnographer's experiences ultimately prompted an understanding of their commonality as techniques of the body. Other contributing factors aside, what interests us here is the role played by personal anecdotes in the Maussian heuristic. Our argument is that the ethnographic detour was consistent with French sociology's critical thrust, energized by a comparative perspective that leveled the hierarchy among civilizations responsible for the socialization process of all its members. Irrespective of their actual achievements, every group produces a matrix of psycho-physiological, sociological, and ethnographic factors from which emerge whole persons. By encouraging an awareness of such processes, Mauss dramatically defied his listeners to place their own biases, as it were, on the analytical table. According to his opening salvo to students, "The young ethnographer embarking upon fieldwork must be aware of what he or she knows already, in order to bring to light what is not yet known" (2007:8). According to Pierre Bourdieu's apt characterization, sociology engages in a *social psychoanalysis* (Bourdieu 1979:9). For Mauss, the ostensibly personal experience was noteworthy because it revised the limits of the sociological paradigm by integrating a psycho-physiological dimension that would prove especially pertinent to an appreciation of aesthetics.

Techniques

> We refer here to an aesthetics considered in a very broad sense, encompassing all the pleasurable arts with beaux-arts, opposed to the arts of production or techniques that derive from technology. (Mauss 1974:256)

Mauss's solution to cluster bodily phenomena under the heading of techniques was consistent with his earlier writings, Nathan Schlanger has argued, which shifted the study of collective creativity from Durkheim's primary focus on moments of sacred effervescence, to the profane quotidian of production.[8] Techniques, however, are now equated with forms, because "[e]very technique properly so-called has its own form." (Mauss 2006:79). Forms are discernible in the group's ways of doing, and even being, as evidenced in the innovative notion of techniques of the body. In the process of exchange and borrowing, even civilizations acquire a form of their own: "Every civilization possesses its own geographical domain and form. . . . Everything has form . . . at once common to a great number of persons and chosen by them among other possible forms. And this form is found only here and there, at one moment and another" (1974:470). Local forms are *sui generis* and defy both the theory of mimesis and a more functional explanation: Gallic roofs bear no relation to their immediate environment.

Most noteworthy for our purposes is Mauss's argument that each of these discrete manifestations of form is inseparable from its aesthetic dimension. Although "[i]t is very difficult to distinguish aesthetic phenomena from technical ones" (2007:67), Mauss proposed guidelines. More complex than utility, the aesthetic resists efforts to enforce a categorical divide between form and function, since so many useful objects are actually reserved for ceremonial purposes. Beyond utility, one discovers an added dimension of game, play, and luxury. But whereas these assertions appear to shirk the questions of quality and value, Mauss makes explicit that an aesthetic imperative is manifested in virtually all social interaction and communication: "In religion, there is rhythm, that of poetry and music . . . there is drama as well . . . in dance, we find a beautiful image . . ., just as in etiquette and decorum, an elegance and beauty of manners are cultivated as assiduously as the duties for rites are performed. The greater part of needs, or rather tastes, and economic values as well, followed by techniques, *are commanded by a sense of the beautiful*, or by that which is physiologically good" (1969:194, emphasis added). Evidence for this ubiquitous will to beauty—activated by the drive to enhance what is given or "make special"[9] and transmitted by feats of technical refinement or formal innovation—has enabled anthropological theory, according to Alfred Gell, to subsume aesthetics under the technical virtuosity of art: "I consider the various arts—painting, sculpture, music, poetry, fiction, and so on—as components of a vast and often unrecognized technical system,

essential to the reproduction of human societies, which I will be calling the technology of enchantment" (Coote and Shelton 1992:43).

Mauss was unequivocal in placing the question of value judgment on a continuum within the social spectrum, so that the fine arts are broached as a characteristic of life in common, rather than a specialized or autonomous domain. Indeed, "[t]hey are even more representative of their society than their 'arts' or ways of doing/making. Their domain is one of the most vast, extending to all others, whereas the technical phenomenon appears, in history, to be well contained within its own realm" (1969:194). He addresses the mindset of the sociologist as well as that of the future fieldworker, both committed to discerning the specificity of a group in the distinctive features that constitute its style, since "[s]tyle corresponds to the overarching aesthetic in which a society wishes to live, at a given point in time" (2007:79). In a review of the literature on style, the art historian Meyer Schapiro concluded that style is the repetition of form within a group (Schapiro 1980). Mauss expanded this approach to form and style by declaring that virtually everything has a form, complemented by the seemingly extravagant claim that from a simple object's distinctive feature—his example is the Celtic *pot-a-bec*—he could characterize the entirety of a civilization.

Aesthetics as a counter-history

The truly great Ashanti plastic arts constitute a system of dense symbols; when one knows how to interpret them, they provide access to the moral, affective and not only imaginative life of the nation. (Mauss 1974:263)

At one point in the *Manual*, Mauss proposed to initiate the study of a culture through its things and their aesthetic dimension. What ethnography contributes to knowledge is not merely a record of everyday life or practical reason, but a counter-history to the official one. Things are inscribed with the knowledge a people has of itself and of its place in the universe, often by means of symbolic representations. Objects bear a historical weight in terms of their creation, circulation, and consumption. The object as a total aesthetic phenomenon is described this way: despite different categorizations according to technique, whether drawing, painting, or sculpture, or, according to the decorated material—wood, stone, weaving, cloths, metals, or feathers, the fact remains that each object can exhibit these different arts simultaneously, since "everything is done at the same time" (2007:80).

The diachronic complement to synchronic totality illustrates how it is that objects "write" history. In regard to textiles, we find, "[w]eaving is an important invention for humanity. The first woven material marked the beginning of a new era" (2007:55). Mauss stresses their significance as

markers of a history that is revelatory of the psycho-social development of humanity across borders. This is indeed a characteristic of his method of historical reconstruction via archaeological evidence, frequently focused on an apparently subjective phenomenon. In a similar vein, he called for breaking down distinctions between things and persons, the practical and the fine arts, for the following reasons: "In practical arts, humans recede their limits. They progress in nature, at the same time as beyond their own nature, since they adjust it to nature. They identify with the mechanical, physical and chemical orders of things. They create and at the same time they create themselves, according to the means for living ... and their thought is inscribed in things. Herein resides true practical reason" (1969:197). One of the most effective illustrations of "true practical reason" is also a poignant reminder of how the absence of written documents in the traditional sense relating to groups, individuals, or things, can isolate them from the master narrative of History: "Study the relationships between geometrical shapes. From time immemorial a good number of the theorems in plane and solid geometry have been solved by women basket-makers who have no need to formulate them consciously—basketry is often women's work" (2007:33).

For a new materialism: begin with the body

> To study the arts, we shall proceed as we did for techniques, by starting with the body. (Mauss 2007:74)

In this domain, Mauss rejects Wundt's division between plastic arts, such as music and dance, and the ideal arts, those where an idea presides: "But in this I only see an expression of our contemporary pedantry in matters of art. The Japanese see no difference between a painting and makeup" (2007:71). The *Manual* then devotes an entire subsection of the chapter on aesthetics to cosmetics, including the disfigurations it often entails. An important parallel can thus be drawn between the secondary status ascribed to cosmetics and that of decoration or the *arts décoratifs*, which remained the case throughout the twentieth century. That they refute demotion to mere surface phenomena is evident in the discussion of tattoos. A review of the existing literature on designs and markings on the body reinforces their obvious social symbolism. Like today, they function as a record of the individual's psychic history, with each design and inscription correlated with a moment or event of special import. Forming an armature against fears and fixations, tattoos frequently appear at points where "blood is beating" (2007:77), thereby inscribing a sense of the group's psychic obsessions. Similarly, aesthetics provides the overarching rubric for an array of bodily deformations that are explained as providing protection for the body's orifices. They furnish an inventory that would

appear the epitome of ethnographic oddities, were it not for the reminder that "[c]ircumcision is a form of tattoo; it is first and foremost an aesthetic phenomenon" (2007:77). Art and aesthetics are then placed in the category of a *social physiology*, with the accompanying explanation that they are "quite material, even when it seems a matter of the ideal" (2007:12).

Rhythm

Socially and individually, man is a rhythmic animal. (Mauss 2007:67)

One of the most important subsections of the chapter on aesthetics in the *Manual* is titled "musical arts." In it, Mauss delves into the primary layers of social conditioning in order to reveal how the individual body is synchronized with a particular group or culture's rhythms. It also calls attention to the frequently overlooked role of interdictions, separations, alternations, and transgressions in structuring the basic rhythms of social life. Distinct from any natural physiological substrate, social forms and their refinements in gestures, language, and the technical production of things, require one to question who does what, when, and how. The repetition of these techniques and forms is ultimately constitutive of a group's style.

Within this global rhythmic ensemble, psychology erroneously conformed to traditional aesthetic divisions by distinguishing singing from speaking, leading to the isolation of an aesthetic or artistic phenomenon from an informed analysis of its broader social manifestations. In this immediate context, Mauss refers to the "magnificent field" of a larger *poétique esthétique* that encompasses prayer and virtually any other form of oral communication in which rhythm exerts a discernible impact: "Poetry should be looked for in places where we do not put it—it should be looked for everywhere. There are rhythmic law codes ... Transmission through rhythm and formulae is the sole guarantee of the survival of oral literature; collective poetry imposes itself on everyone" (2007:90). The *Manual* furnishes other striking illustrations, such as the fact that in certain Australian societies, individuals modulate their voices to address officials of varying rank, compelling us to rethink the ways in which vocal intonation and rhythm are internalized according to a variety of social conventions.

The meshing of sound, rhythm, and technique is also featured in the essay on the expression of obligatory sentiments among Australian widows. Already singled out for demonstrating how Mauss's understanding of the symbolic order sutures the classical divisions between the individual and the collectivity, emotion, and meaning, the ritualized mourning chants must also be considered in regard to their aesthetic impact.[10] The women's seemingly inarticulate cries are always to

a certain degree rhythmical, stereotyped, and most often sung in unison. Moreover, their primary "aesthetic ejaculation" (1969:276) can evolve into refrains with interjections cutting into them, and possibly be paired with more complex chants. Sometimes they form alternating choruses, either with men or women. But even when the cries are not sung, the fact that they are emitted collectively carries a meaning totally other than that of a pure expression without significance: "In other words, they possess their *efficacy*" (1969:276). In this case, the aim is "to expulse a maleficent force or being" resulting from the ability of the wailing women to "enchant the enemy, the cause of death" (1969:276).

The *Manual*'s chapter on aesthetics opens with the assertion that "technical and aesthetic phenomena are designed to produce an *effect*" (2007:67, emphasis added). At other points, the question of efficacy surfaces in relation to magic *souffles* or breathing techniques, as well as religious prayers, and any other ritual in which an aesthetic dimension—especially evident in verbal or bodily rhythms—is present. In reference to these collective phenomena we find, "[t]hey are not simple words and acts, they are poems and chants and mimes. In both there exists the same collective element: the rhythm, the unison, the repetition pushed to degrees inconceivable for us. In this way it is in relation to the belief in the efficacy of these rhythms, that is, of the words and gestures, not in their crude stage, but rather formalized condition, that one must consider the notion of efficacy" (1974:122). The effect of the mourning chants derives from the modulations of sounds and cries into a full-blown work of collective artistry, whose mobilization of psycho-physiological energies and traditional forms of obligatory expression intensifies the natural feelings.

The nexus of aesthetics, techniques, magic, and enchantment in the assessment of art is central to contemporary theory, equally mindful of the pitfalls of isolating an object or phenomenon from its symbolic network. As argued by Gell, the efficacy of warrior shields derives from stunning visual effects that exert a sensory entrancement. Their psychological weapon is intimidation, induced by the superior quality of an object whose technical virtuosity surpasses the individual viewer's understanding. In a similar vein, Mauss described the women's chants as a form of enchantment, whose aesthetic magic serves to conjure an even more elusive enemy—the maleficent force of death expelled through the grieving widow's collective expression of grief. Both examples exert their full aesthetic import for the contemporary reader, however, by dint of the ethnographic detour's return to the present. Lest the discourse of magic and enchantment be misleading, we are reminded that that one of the rare constants regarding art is its ability to effect transformations. In reference to this "essential alchemy," Gell observes "[n]o matter what the avant-garde school of art one considers, it is always the case that materials and ideas associated with those materials are taken up and transformed into something else . . . drawing our attention to the essential alchemy of art,

which is to make what is not out of what is, and to make what is out of what is not" (Gell 1999:53).

Sociology as an art form

Sociology and descriptive ethnology require one to be at once an archivist, a historian, a statistician . . . as well as a novelist able to evoke the life of a whole society. (Mauss 2007:7)

With this declaration, we can provide an added response to the question of why aesthetics was catapulted to the forefront of Mauss's research agenda: *Because sociology's goal of seizing the totality of a group is an aesthetic feat*. Mauss compared the daunting task facing the fieldworker and all it entails—whether deciphering the synchronization of social exchanges with the calendar of ritual feasts or the dramatization of the collectivity's psychic tensions through ritual—to the achievements of a novelist. In his innovative article on the parallels between Durkheim and Proust, Edward Tiryakian (1979) pointed to their common quest for form. Mauss pursued the social totality in such forms as dance, "at the origin of all the arts" (2007:74), where music, the production of instruments, mime, decorations and masks, the role of persons who clap, those who make sounds with their mouths, those who move other body parts, how bodies coordinate with the instrumentation, the chorus as well as spectators, all contribute to the total effect and are inseparable from their promotion of social interaction.

I suggest that it is this detailed parsing of a particular moment in the social life of the group that justifies comparison to literature. Their commonality resides in the awareness that all social interactions obey a particular rhythm responsible for imparting a formal aesthetic that art reveals. As Mauss eloquently described it: "Every social state, every social activity, however fleeting, must be related to this unity, to this total integration, of an extraordinary nature . . . For what assembles them and causes them to live together, what makes them think and act in common and at once, is a natural rhythm, a willed unanimity, arbitrary perhaps, but always necessary" (1969:214). It is relevant to note that the word "necessary" here is no more an expression of belief in the immutability of social forms, than the definition of techniques as traditional acts, cited above, is a celebration of continuity. However powerful the unconscious, infra level of socialization, all civilizations are subject to change and receptive to superior techniques and knowledge, often introduced by aesthetic phenomena. Critical of the temptation to relegate any culture to a fixed place in time or development, Mauss insisted on the ever-changing vitality of social formations (1969:204). Living institutions, as they form, function, and transform themselves at different moments, furnish the discipline's

specific objects of study. Not surprisingly, Mauss adds that many of sociology's divisions are too much a reflection of current categories, inevitably ephemeral, and bound to be replaced since "[t]hey deeply bear the mark of our times, that of our subjectivity" (1969: 151). Conversely, we find an emphatic endorsement of a future defined by art: "In other civilizations, and doubtless it will be the case in future ones, art serves everything and colors everything" (1969:194).

Conclusions

We opened this presentation with Mauss's gambit that sociology transforms the categories of preceding sciences, followed by his acknowledgement that it actually subsumes them. I have argued that this is especially so in the case of art and aesthetics: the comparative method expands the Western canon by dint of putting into question existing institutions, in the Maussian sense, of ways of thinking, seeing, feeling, prejudices and presuppositions constitutive of a *habitus*. If nothing is more a matter of education and habit than art, then the role of the sociologist is to inventory, archive, and compare the global productions of art and aesthetics in an effort to deconstruct impediments to self-awareness of our own cultural condition. He showed us that to modify the categories of one's discipline is as dramatic a process as the adaptation and reconditioning required of the fieldworker immersed in another social or foreign group. The recurrent critique of Wundt's divisions between ideal arts and sensuous ones signals a pervasive assumption Mauss sought to undermine: "The notion of ideal art as the representation of ideas and sentiments of the authors and spectators is a modern one, . . . whose extreme version is 'art for art's sake'" (2007:82). What this translates into for the sociologist is the way in which art is enlisted to distance the individual from the collectivity, and art from its place within that group's (un)conscious. Sociology 's distinction is to make connections, thereby serving as a corrective to the methodology that draws a list of artistic "*Urtypen*" (1974:264) when it should be studying each and every art from every possible viewpoint, including, and often primarily, from that of the native. In concrete terms, here are the instructions which followed Mauss's sally that the ethnographer would return an aesthetician: "Within your general assessment include an assessment of the plastic arts, taken as a whole, in relation to other social activities . . . Rather than speaking in terms of the magico-religious character of Black art, mention the links that connect such and such art with magic and with religion in some particular Black society" (2007:82).

Although Mauss did not document the specific correlations between social rank and cultural consumption, he certainly pointed out that the ethnographic groups he studied were internally divided by taste, sense of beauty, musical forms, and so on. His primary focus was on the fact

that every group possesses its aesthetic because *tout se commande*, and everything has a form. All groups manifest an aesthetic sensibility—or range of sensibilities—that must be retrieved from the isolation imposed by Western criteria, and integrated into a global narrative. For the sake of museum collections, for the advancement of science, and as a minimal act of restitution, he was clearly eager to archive as much as possible of the societies virtually decimated by what he condemned as European colonial savagery. But we have also insisted that such a project, however admirable, does not entirely fulfill sociology's mandate to subject modern societies to the rigorous scrutiny shirked by earlier historians, in order to demonstrate the sources of such behavior in the institutions enabling it.

In keeping with the political reading of Mauss proposed thus far, we turn to the possibilities held out by a revolution modulating the realm of the sensible. Unlike upheavals directed toward the form of a State, this one would occur in the very mode of production of material life. It would do so by addressing the contradictions of what Rancière describes as art's current solitude, which nonetheless holds out the promise of a new community and new relations based on other foundations. But the realization of the latter would entail the demise of art's isolation, given that "a free community is one lived where experience is not divided into discrete spheres of daily life, art, politics and religion" (Rancière 2004:52). In the same vein, we recall that Mauss encouraged the reader to envision a future when art's efficacy would be recognized as coloring the entirety of social existence, thereby resolving his ongoing polemic with his own discipline that demoted aesthetic concerns to a secondary place among social phenomena. It would also vindicate his conviction that, "[w]e are far too inclined to think that our divisions are imposed on us, once for all, by the human mind; the categories of the human mind will continue to change, and what seems well established in our minds will one day be completely abandoned" (2007:74).

Notes

1. The reference here is to James Clifford's (1981) view of this encounter as fostering an "ethnographic surrealism," an admittedly utopian construct that has generated divergent reactions on both sides of the Atlantic. Given the limits of present study, I have intentionally concentrated on the challenges posed by reviewing all of Mauss's writings from the perspective of post-1945 attitudes toward the development of an ethnographic aesthetics.
2. In her introduction to French editions, former student and editor, Denise Paulme recounts that following Mauss's lectures, students would compare discrepancies among their notes.
3. See his introduction to Marcel Mauss, *Oeuvres 1. Les fonctions sociales du sacré* (Paris: 1968), p. 32.
4. For an overview of how these mechanisms function in Durkheim's work, see Richman (2002:7–18; 23–63).

5. For much of this information, I am indebted to Esther Pasztory's stimulating work. A far more nuanced discussion than I am able to provide here can be found in her *Thinking with Things. Toward a New Vision of Art* (2005).
6. Marcel Fournier furnishes a sampling of student reactions to Mauss's pedagogy in his *Marcel Mauss* (1994:598–604).
7. "If Mauss 'knew everything,' as we frequently joked, that did not lead him to complicated explanations. His understanding was so real, so personal, and so immediate, that it often took the form of elusive declarations, requiring the sometimes disappointed or simply dumbfounded listener to do the work of reflection and interpretation." Denise Paulme, Preface to the third edition (1989), Marcel Mauss (1967:IV), my translation.
8. For more on this, see Schlanger's introduction to Mauss (2006).
9. The rationale for this widely disseminated notion can be found in Dissanayake (1995).
10. This discussion appears in Karsenti (1997:179–82).

References

Bourdieu, Pierre. 1979. *La distinction. Critique sociale du jugement*. Paris: Les éditions de Minuit.
Clifford, James. 1981. "On Ethnographic Surrealism", *Comparative Studies in Society and History*, 23(4): 539–64. Reprinted in *The Predicament of Culture: Twentieth Century Ethnography, Literature and Art*. Cambridge, MA: Harvard University Press, 1988.
Détienne, Marcel. 2000. *Comparer l'incomparable*. Paris: Editions du Seuil.
Dissanayake, Ellen. 1995. *Homo Aestheticus*. Washington: University of Washington Press.
Durkheim, Émile. 1897. Préface. *L'Année sociologique* première année 1896–97:2.
Durkheim, Emile. 1912. *Les Formes élémentaires de la vie religieuse. Le Système totémique en Australie*. Paris: Presses Universitaires de France 1960.
Fournier, Marcel. 1994. *Marcel Mauss*. Paris: Fayard.
Gell, Alfred. 1992. "The Technology of Enchantment and the Enchantment of Technology." In *Anthropology, Art and Aesthetics*. Eds. Jeremy Coote and Anthony Shelton. Oxford: Clarendon Press.
Gell, Alfred. 1999. *Art and Agency. An Anthropological Theory*. New York: Oxford University Press.
Hurel, Arnaud. 2011. *L'abbé Breuil. Un préhistorien dans le siècle*. Paris: CNRS Editions.
Karsenti, Bruno. 1997. *L'homme total. Sociologie, anthropologie et philosophie chez Marcel Mauss*. Paris: Presses Universitaires de France.
Kurasawa, Fuyuki. 2004. *The Ethnological Imagination. A Cross-Cultural Critique of Modernity*. Minnesota: University of Minnesota.
Lévi-Strauss, Claude. 1955. *Tristes Tropiques*. Paris: Librairie Plon.
Mauss, Marcel. 1967. *Manuel d'ethnographie*. Paris: Editions Payot.
———. 1969. *Oeuvres 3. Cohésion sociale et divisions de la sociologie*. Paris: Les Editions de Minuit.
———. 1974. *Oeuvres 2. Représentations collectives et diversité des civilisations*. Paris: Les Editions de Minuit.
———. 1990. *The Gift. The Form and Reason for Exchange in Archaic Societies*. Trans. [*Essai sur le don*] W.D. Halls, foreword by Mary Douglas. New York and London: W.W. Norton & Company, Inc.
———. 1999. *Sociologie et anthropologie*. Paris: Presses Universitaires de France.
———. 2006. *Techniques, Technology and Civilization*. Ed. and int. Nathan Schlanger. New York and Oxford: Durkheim Press/Berghahn Books.
———. 2007. *Manual of Ethnography*. Trans. Dominique Lussier, ed. and int. N.J. Allen. New York and Oxford: Durkheim Press/Berghahn Books.

———. 2009. "Art and Myth according to Wilhelm Wundt," in *Saints, Heroes, Myths, and Rites. Classical Durkheimian Studies of Religion and Society*. Ed. and trans. Alexander Riley, Sarah Daynes, Cyril Isnart. London, 17–38.

Pasztory, Esther. 2005. *Thinking with Things. Toward a New Vision of Art*. Austin: The University of Texas Press.

Rancière, Jacques. 2000. *Partage du sensible: esthétique et politique*. Paris: Editions de la Fabrique.

———. 2004. *Malaise dans l'esthétique*. Paris: Editions Galilée.

Richman, Michèle. 2002. *Sacred Revolutions. Durkheim and the Collège de Sociologie*. Minnesota.

Schapiro, Meyer. 1980. "Style." In *Aesthetics Today*. Eds. Morris Philipson and Paul J. Gudel. New York and Scarborough, Ontario: New American Library. Reprinted from *Anthropology Today*, ed. A.L. Kroeber.

Tarot, Camille. 1999. *De Durkheim à Mauss. L'invention du symbolique. Sociologie et science des religions*. Préface d'Alain Caillé. Paris: Editions La Découverte/M.A.U.S.S.

Tiryakian, Edward. 1979. "L'Ecole durkheimienne à la recherché de la société perdue: La Sociologie naissante et son milieu culturel." *Cahiers internationaux de sociologie*, 66: 97–114.

Chapter 8

Too Marvelous for Words . . .[1]
Maurice Halbwachs, Kansas City Jazz, and the Language of Music

Sarah Daynes

The adage in Kansas City was . . . say something on your horn, not just show off your versatility and ability to execute. Tell us a story, and don't let it be a lie. Let it mean something, if it's only one note.

(Gene Ramey, in Dance 1985:267)

Les hommes pensent en commun par le moyen du langage.

(Halbwachs, 1994[1925]:53)

In the acclaimed documentary *Jazz* by Ken Burns, trumpeter Wynton Marsalis eloquently speaks of the unique connection shared by Billie Holiday and Lester Young, a connection which, he emphasizes, is rarely found:

When you play music, it's hard to really, even it's hard to explain verbally, but, when you play music, you enter another world, it's very abstract, and your sense of hearing . . . is heightened, and you're listening to another person and you're trying to absorb everything about them, their conscious-ness, what they mean when they're talking to you, what they're feeling like, where you think they're gonna go, and it's rare for people to really connect, you know, you think as jazz music is about communication and connection you would have a lot of it, but you don't have that much of it. (Swing: The Velocity of Celebration, 2000, 0:52)

For scholars of popular music, it might come as a surprise to hear that there is not much communication in jazz. After all, jazz is a fundamen-tally collective affair, which implies not only musicians playing together (whether just a few, or many as in big bands) but also musicians playing for, and with, an audience. As in all dance hall types of music, from the blues played in juke joints to reggae sound systems, communication

appears to be a cornerstone of jazz—at least of pre-1960s jazz—where musicians speak to one another as much as they speak to their public. The importance of call-and-response in the emergence and evolution of jazz has been pointed out many times; one has only to listen to any jazz recording from the late 1930s to literally hear and feel this communication, in particular through the call and response that happen between the rhythmic section and the solo instruments. Anyone who has seen Louis Armstrong scat over the music, or Jimmy Rushing look at Count Basie while singing, cannot but immediately know that there is a language there, a language shared, communicated, spoken—and that this language is precisely what jazz is about. This is especially evident with Kansas City jazz in the 1930s, which was based on the twelve-bar blues structure, unwritten music with "head arrangements," solos, and riffs, in striking contrast with the mostly white big bands of the time that dominated the music sales market.[2] For musicians to be able to play together without partitions or written arrangements, and for them to be able to play together and yet to allow for the rise of the solo, of improvisation, in particular of the saxophone, they had to be sharing a language. And yet, as Wynton Marsalis expresses, Kansas City jazz might be an exception, a specific combination of time, place, and exceptional musicians; or perhaps we could argue that the norm in jazz is a minimal language, which musicians share with the sole purpose of necessary communication, and which becomes exceptional only in certain cases—the voice of Billie Holiday and the saxophone of Lester Young speaking with one another in a sphere that seems to enclose only the two of them—but which, most often, is limited to something that simply (and only) allows musicians to play together.

In this chapter, I provide a simultaneous reading of "La mémoire collective chez les musiciens," an essay published by Maurice Halbwachs in 1939, and of Kansas City Jazz in the early 1930s. I focus on two of the conceptual questions raised by Halbwachs's essay: language, and communication; "Kaycee" jazz, for the reasons mentioned above, constitutes a particularly salient case to explore these questions, despite the fact that Halbwachs's essay seemingly focuses on classical music. The historical coincidence between jazz and "La mémoire collective chez les musiciens" is almost uncanny. Halbwachs wrote his essay in the late 1930s, as jazz musicians were "swinging hard" in Kansas City, though he did not hang out in the brothels and clubs on 18th and Vine where Coleman Hawkins, Lester Young, Mary Lou Williams, and Count Basie played, nor was he ever a small-town visitor in the "territory" traveled by The Blue Devils or the Twelve Clouds of Joy. Paris, where Halbwachs lived and worked, was in its own right a jazz city in the inter-war period: the "jazz craze" in the 1920s and 1930s brought dancers to Montparnasse and Montmartre, produced French musicians (most notably, Django Rheinardt) and aficionados, including the influential jazz critic Hugues Panassié, who founded the Hot Club de France in 1932; and many American jazz

musicians performed there in the mid 1930s, including Duke Ellington, Louis Armstrong, Coleman Hawkins, and Benny Carter.[3] Despite the historical coincidence, there is no indication that Halbwachs listened to jazz, and his essay focuses on music that is written and read, implicitly referring to classical music, in particular symphonic; and yet, he suggests that the language of musicians is based on sounds and, very interestingly in echo to Marsalis, that musicians are not interested in going beyond them: musicians, he says, "s'arrêtent aux sons, et ne cherchent point au-delà" (Halbwachs 1939a:50).[4]

This reputably difficult text by Halbwachs has seldom been used in the social analysis of music, with the notable exception of Alfred Schutz, whose essay "Making Music Together" (1964) provides us with a strong critique of Halbwachs's analysis, and of recent enquiries by Marie Jaisson (2007). Using Halbwachs as a blueprint for looking at Kansas City jazz, I will discuss two important tensions that are central to an understanding of the latter: written versus unwritten music, and the simultaneous rise of the rhythmic section and of the solo. These two tensions relate, in what Halbwachs calls "the society of musicians," to two important questions: respectively, that of musical language, and that of communication between musicians during a performance.

The conceptualization of language in Maurice Halbwachs's work

Halbwachs's 1939 essay on the collective memory of musicians, primarily devoted to classical written music, is a complex piece, in part because it raises the difficult question of language. In it, Halbwachs explores the role of language in memory, a theme that had already appeared, and yet was never fully developed, in his previous writings. Indeed, *The Social Frameworks of Memory*, which Halbwachs published in 1925, includes a chapter on language and memory; it is mostly devoted to the questions of dreams and aphasia.[5] The most interesting development is found in his discussion of aphasia, which draws heavily on the work of linguist Antoine Meillet (1921), strongly situated within the Durkheimian enquiry.[6] Halbwachs successfully uses aphasia as a case study to assert the social nature of language, which is not "an instrument of thought" but rather what conditions and structures it (Halbwachs 1994[1925]:68). He continues:

> We do not know how language works at the level of the brain, but we feel, when we speak, that we attribute a meaning to the words and phrases – that is, that our mind is not empty – and we also feel that this meaning is common to all of us. We understand others, we know that they understand us, and that, indeed, is why we understand ourselves: so language consists of a certain mental attitude, which can only be conceived of within a society, fictive or real: it is the collective function *par excellence* of thought. (Ibid.)[7]

Following Meillet's assertion that language is "eminently a social fact" (Meillet 1904–05: 1), Halbwachs is using even stronger terms here, which push the later reader toward structuralism and yet remain strongly located within the Durkheimian hypothesis: language is "the collective function *par excellence* of thought."[8] In rupture with prior psychological studies, he considers aphasia as a pathology that has to do with the psychic, rather than the organic, sphere. Further, it is not radically distinct from normality: in fact, he argues, an individual absent too long from a society in which language was rapidly changing would find himself in the same situation as an aphasic (1994[1925]:69). As in Freud's conceptualization of neurosis, in which the boundaries between the normal and the pathological are blurred if not non-existent, and as in Jakobson's use of aphasia, once again three decades later, to say something about language itself Halbwachs starts with a language disorder to explore how language works, and what it entails, in society: "Each normal individual living in a society should have a mental function allowing him to decompose, recompose and coordinate images, a function that allows him to match his experience and his actions with the experience and actions of the other members of his group" (Halbwachs 1994[1925]:70–71).[9] It is this "tuning" that the aphasic lacks; Halbwachs progressively distinguishes first between images and words, and second between words and what he calls a "conventional symbolism." The aphasic indeed does perceive the sensible world and can name objects; what he lacks is "the notion of schematic plan" and words that would allow him to apprehend and fix "the *relative* position of things" (ibid.:74; emphasis in original), as is obvious in the example of the drawing of a bedroom map, which he borrows from Henry Head's work on speech disorders (1920). Head observes, indeed, that the aphasic knows where objects are, but cannot express their position in relation to one another (Head 1920:146). Considering the influence of Meillet on structural linguistics, in particular on De Saussure and Jakobson, and Lévi-Strauss's claim over the heritage of Marcel Mauss, it is prodigiously interesting to see Halbwachs emphasize the distinction between things and the relations between them. At one point in his discussion, before he bifurcates toward the idea of social frames (which are, after all, the main object of his book), we are but one breath away from a structural analysis of thought: "What the aphasic lacks is not so much memories, as the ability to locate them within a framework—or more accurately, the framework itself" (Halbwachs 1994[1925]:76).[10]

He would need to be able, over and above individual images, to recognize the order in which situations occur in an impersonal form; such a notion, which is essential to individuals in a society if they wish to understand each other, when they speak of spatial locations and positions, is entirely beyond him: he can no longer match up the sensations he receives from objects he can sense with the sensations that others receive, or could receive; in a real

sense, he cannot put himself in their place. The loss of speech . . . is only one manifestation of a greater incapacity: our common set of symbols, that necessary basis for social understanding, has become more or less foreign to himHe [the aphasic] would need, above and beyond particular images, to be able to represent the order of situations in an impersonal form; such a notion, which is indispensable to men in society if they must understand each other, when speaking of places and positions in space, is definitely out of his reach: he can no longer tune the sensations that come to him from sensible objects with the sensations others do or could receive; in truth, he cannot take their place. The loss of words . . . is only a particular manifestation of a broader disability: conventional symbolism, which is the necessary basis for social intelligence, has become more or less foreign to him. (Ibid.:77)[11]

Halbwachs, however, remains faithful to the Durkheimian hypothesis of the social origin of thought, as posed in Durkheim and Mauss's analysis of the classificatory function (1967). Halbwachs is at the threshold; but he does not take the jump, only preparing it for Claude Lévi-Strauss. What indeed is Halbwachs trying to think through in this unfortunately un-translated part of his discussion? Precisely that language is not just meaning (De Saussure will speak of signification), nor is it just a combination of terms; it is, fundamentally, the way in which terms are related with one another. Language orders by the relations it builds between terms at an impersonal level; the aphasic sees, knows, and understands "the bed," but he is incapable of representing "the bed" in any other fashion but as a freestanding "thing." Indeed the aphasic is without language! Or rather, as Roman Jakobson argues almost two decades later, aphasia involves a disorder of the paradigmatic or syntagmatic axes of language (similarity/ contiguity; metaphor/metonymy).[12] Halbwachs here is on the way to recognizing what later came, with structuralism, to be its central feature: the fact that, before anything else, language is what orders, and provides the very structure of thought—it signifies by ordering and relating terms.

But for Halbwachs still, as for Durkheim and Mauss, order is a function, of which the variable modalities arise from social interactions and conventions, from the specific agreement that ties the members of a group. Language is an "attitude of the mind" that structures thought, yet it is the product of society. It is therefore also a necessary support for memory; Halbwachs points at this central role farther along in the same volume: "People living in society use words that they find intelligible: this is the precondition for collective thought. But each word (that is understood) is accompanied by recollections. There are no recollections to which words cannot be made to correspond. We speak of our recollection before calling them to mind. It is language, and the whole system of social conventions attached to it, that allows us at every moment to reconstruct our past" (Halbwachs 1992:173). Language here is treated not only as a system of words, but as a system of normative meaning that forms "the precondition for collective thought"; it is inseparable from what the

Durkheimians call collective representations, or collective consciousness, of which social life is "made up entirely" (Durkheim 1982:34). This strong hypothesis—which concerns the central place of representations in social life, and further the structural role played by language within—is at the heart of Halbwachs's conceptualization of memory; it is one that he reiterates in his 1939 article on the distinction between individual and collective consciousnesses: "They [psychologists] have failed to recognize the many factors which stimulate [man] from the outside, such as the institutions, customs, and interactions of ideas and especially of language, which, from infancy throughout his life, condition his understanding, his feelings, and his behavior and attitudes in a manner impossible for a man in isolation" (Halbwachs 1939b:812). The essay on musicians, written several years after *The Social Frameworks of Memory*, looks at language from a different angle, related to the interpenetration of individual consciousnesses rather than to social frameworks; hence, the question of communication becomes especially salient, but communication as based on a shared language.[13] How do musicians speak to one another? How do they share in making music? How do they play music together? The complexity of the musical performance pushes Halbwachs to focus almost exclusively on written music; or could we argue that what matters to him most is precisely the question of language and more specifically of written language? He treats the musical partition, and the system of notation it depends on, almost as a replacement tool for the brain; the score exists as a prosthesis for human memory, an external addition to the body that helps it in the remembering process.[14] The focus on written music is a consequence of Halbwachs's point of departure in the essay: the distinction between *words* and *sounds*, which he sets up in the opening sentence:

> The memory of a given word is different from the memory of another sound
> – natural or musical – inasmuch as a word always corresponds to an exterior model or schema, which is defined either by the collective's phonetic habits (based, that is, in an organic context), or by a printed version (that is, based on a material surface), whereas most people, when they hear sounds which are not words, can scarcely compare them to purely auditory models, because they possess no such models (Halbwachs 1980:158).[15]

What is implied here is crucially important. First, with language, Halbwachs is looking at a memory bounded not by social frameworks, an ensemble that incorporates not only collective representations and historical facts but also collective and individual emotions, but by a structured and structuring system of notation that does not solely depend on the latter. Second, in thinking about language, Halbwachs is guided by a care for cognitive processes that is often overlooked in readings of his work. For him, language cannot be thought about without inquiring into both the words (for example, the perception, whether read, seen or heard) and the structure they refer to (for example, the system of

language, which includes not only grammatical relations but, above all, collective representations, that is, the social sphere). It therefore matters for Halbwachs that sounds and words, as almost material things that are perceived before they signify, are not exactly similar in nature. Words, once perceived, are immediately understood within what Halbwachs calls an "external model" or "scheme." Sounds, on the other hand, are often perceived without being compared to any purely auditive model, because most individuals lack any knowledge of the latter.

This distinction between words and sounds, in turn, leads Halbwachs to distinguish between musicians and laymen, between men who live *in* music, and those who simply live *with* it. The latter represent most of us, individuals who have not studied music theory and cannot transcribe sounds into scores, nor scores into sounds. The parallel with aphasia is striking: could the layman be considered as a musical aphasic—someone who can feel, experience, enjoy, and even understand music, yet also someone who does not really penetrate the structure of music? Indeed, the grammar of music remains foreign to the layman just as the grammar of language is out of the aphasic's reach. Halbwachs argues that there is a crucial difference between musicians and non-musicians that has to do with the ability to read written music: for laymen, sounds can only be remembered through words (for example, musical lyrics) or through practice (for example, humming). In fact, therefore, Halbwachs distinguishes between individuals who perceive sounds and understand them within auditive schemes, and those who cannot. Is Halbwachs here saying that some of us hear sounds but lack the language they are a part of, in the same way in which an individual hears words in an unknown language? Somewhat, and yet not exactly. What Halbwachs refers to here has to do with the nature of the external model, or scheme, itself rather than with the fact that musicians have access to it while non-musicians do not. For him, there is a fundamental difference between the language of music and the language of words: music is a different world, one that musicians are immersed in, with the result that they are often drawn into it in an exclusive way, which somewhat precludes them from seeking anything other than sounds and the other members of the society of musicians. But more importantly, sounds and words, Halbwachs argues, are different in a more crucial way: the word is a sound that signifies, a sound that within the external scheme of language is linked to a content of meaning; the musical sound, on the other hand, does not signify, and it is not signified either by the written note. In other words, he argues that written music uses signs that are not signs, but commands:

> These signs represent notes, their pitch, their duration, the intervals that separate them. Everything happens as though they were so many signals, placed here as a warning to the musician, an indication of what he must do. These signs are not images of sounds, reproducing the sounds themselves.

> There is no natural link between the lines and dots that we see and the sounds that we hear. These lines and dots do not represent sounds, as they bear no similarity to sounds, but they do translate into conventional language a whole series of commands which the musician must obey if he is to reproduce the notes and their sequence with all its nuances, and to follow the rhythm indicated. (1980:161)[16]

In this way, musical notation does not aim to represent; it provides information, injunctions, and commands. The consequences of this argument are heavy. Is Halbwachs asserting here a difference in nature, or one in degree? Two problematic issues come to mind. First, the distinction between written and oral societies: that oral societies do not possess writing and do not fix in writing does not mean that they do not possess language, and yet the distinction gains its pertinence on the differences raised by the emergence of written language. This also leads, of course, toward the issue of the body (and therefore toward Schutz's critique of Halbwachs's analysis); the example of steel bands in Trinidad, and of the central part played by the visual observation of musical gestures, as opposed to the learning by ear of musical sounds, in the learning of a new musical part, is especially luminous (Helmlinger 2001).

Second, the distinction between the written word and written music, which Halbwachs sets up as a fundamental premise for his analysis, might easily be contested. The lack of an aim or function of representation (in Halbwachs's words, musical notation, unlike writing, commands), for instance, can be seen as characterizing both writing systems and musical notation (Will 1999:13); the gap between the written sign and the spoken word or sound exists in both cases. The difference between written and played music is very much akin to the difference between written and spoken language. In both cases, performance cannot be entirely represented on the sheet, which can be only a poor translation. Is the musical performance to musical notation what speech is to language? Kansas City jazz provides an interesting case to think about this question. I will do so by focusing on two seemingly paradoxical characteristics of Kansas City jazz: its most important features, indeed, are a focus on collective performance with limited reliance on written scores, and a simultaneous rise of the solo. Is the latter "playing alone," and how could it arise with a peculiar focus on "playing together"?

Playing together in Kansas City

How do we make music? How do we play music? Even in the case of composition, often portrayed as a fundamentally individual, and perhaps even necessarily lonely, process that shuts the composer off from the world of other human beings,[17] there is no doubt that music involves a

shared language. The latter encompasses the language of musical theory, which is used by the composer to organize sounds, but also a conversation carried on with other music. Following Halbwachs, we are submerged in language even when we are alone,[18] and the lone composer is not an exception to the rule. His music, at the very least, responds to other music and participates in a musical world fundamentally characterized by its social character. Incidentally, the musician in early-twentieth-century Kansas City can perhaps be seen as diametrically opposed to the composer who works in isolation, and for whom music is an affair between his own mind and a piece of paper. In Kansas City music was a largely collective enterprise, whether we talk of composition, arrangements, performance, or reception.

In the 1920s and 1930s, Kansas City was a magnet that attracted musicians from across the country. During the Great Migration, from the early teens to the late fifties, African-Americans traveled along three main corridors: from the southeastern states up to New York City through the Carolinas, Washington D.C., and Philadelphia; from Mississippi and Alabama up to Chicago and Detroit through Memphis and Saint Louis; and finally from eastern Texas and Louisiana west to California. Yet it is seldom mentioned that the Great Migration was not just a movement made of linear routes; people traveled around, as well. And African-American bands crisscrossed the "territory"; over the course of a year, a single orchestra would play as far north as the Dakotas and south as Houston or New Orleans, as far west as Colorado or even Washington State and as far east as West Virginia. As sax tenor Buddy Tate recalls, after he joined the Clouds of Joy in Texas, "we go out West, Midland, Texas, [to] an oil boom [town] . . . Then we'd go to Oklahoma City, play on a Sunday night . . . We would come as far as Kansas City, then we'd go back there as Territory bands . . . to Texas and Louisiana and all places like that down South" (in Pearson 1987:57).[19] In the 1930s, well before the slow decline of city centers and small businesses, and the inexorable suburbanization of much of the country, each town and perhaps even each crossroad had juke joints, bars, after-hours clubs, and dance halls where people socialized and danced. Touring bands would play both one-nighters in small places and longer engagements in towns with large ballrooms, or at summer resorts. Clarence Love, a successful bandleader, remembers that in 1929 he and his band "played places way out in the country. You'd think nobody is going to be here today. But here they come up in horse and buggies, wagons, and that night you'd have a *big* crowd. I betcha we played, in the state of Washington, every little town up in there . . ." (in Pearson 1987:38).

Just as bands were playing all around, musicians came to Kansas City not from a single, homogenous area, but from everywhere, and the music they could all play, the musical language they all knew and therefore shared, was the twelve-bar blues. How could up to a dozen musicians

play together without a common musical language? Whereas in a phil-
harmonic orchestra musicians play written music that they read on a
score—thereby making it theoretically possible to actually play "alone"
by strictly reading one's part—Kansas City jazz was almost entirely
unwritten, and the need for a common language and high level of com-
munication between musicians therefore much more obvious. This comes
in striking opposition to the popular swing bands of the 1930s, most of
them white, to which America danced. They relied almost exclusively
on written scores during performances, and little on improvisation; they
usually bought arrangements from African-American musicians—Benny
Goodman, for instance, relied among others on Fletcher Henderson's
arrangements. Most African-American orchestras in the 1910s and 1920s
relied entirely on improvisation and head arrangements for one simple
reason: most musicians could not read music, or did not want to, and
therefore had to play by ear.[20] It is hence important to understand how
special Kansas City jazz was in the American musical landscape. It actu-
ally came back to the roots of African-American music—call and response
sections, unwritten music, head arrangements, and a twelve-bar blues
structure—at a time when jazz had crossed over and become the "craze"
and, by doing so, had also become a polished, unsurprising performance.
What had at a point been a necessity—not writing the music because
musicians could not read—became, with Kansas City jazz, a fundamental
way of playing music with ramifications well beyond necessity. When
Alan Lomax recorded McKinley "Muddy Waters" Morganfield in the
early 1940s in Mississippi, he asked him about the songs he was playing:[21]

> Lomax: You remember what the first piece you ever tried to learn was?
> Morganfield: First piece I ever tried to learn was, How Long Blues, what-
> ever you wanna call it.
> Lomax: Did you learn that from a record or from seeing it?
> Morganfield: I learned that from the record.
> Lomax: How would you do? How would you learn that song?
> Morganfield: We just heard the song, you know, put out, Leroy Carr (?) put
> it out.
> Lomax: Would you sit down with the record and play a little of it and then
> try and play it?
> Morganfield: I just got the song in my ear and went on and just tried to play
> it.

Playing by ear does not imply a lack of musical proficiency or virtuos-
ity, and this is where Halbwachs's essay becomes most problematic. If
musical language is equated with music theory, which makes it poss-
ible to write music out, then the musicians who cannot read fall outside
of the musical language. That was, incidentally, a major argument used
to qualify African-American music as simple, or simplistic: how could
unlearned musicians play complex music, and how could their music

actually be music? Yet it is quite obvious that not only does unwritten music rely on musical language, and demand both a mastering of musical technique and some degree of virtuosity, but it actually relies on language with more urgency than written music does. When the prosthetic score disappears, a shared language that forms the basis of communication between musicians becomes even more necessary. They need to understand one another to be able to play together; to use Marsalis's terms, the musician needs to know "what they [other musicians] mean when they're talking to you." As drummer Jo Jones points out,

> You don't just throw different people together and expect to get a performance, unless you know something about the experience *they* have had. They may set up a program in which one guy's not speaking to this other guy anymore. . . . If they're playing off a sheet, then it doesn't make any difference. All they've got to do is say hello. But when you've got a part, and you've got to play from here [heart], you'd rather not play with this other guy because you'll get in his way of thought. Always remember that we are playing our experiences, have got to project our experiences, of what we've had in common. We set that to music, according to the tune. (Dance 1985:57–58)

While playing by ear does not preclude musical technique, it has important consequences for music making. Above all, it allows for interpretation within performance. It is well known that interpretation is also an important part of sight-reading, whether in jazz or in classical music; the musician always interprets the score in her own way, thereby making her performance of fixed, written music unique. However, the prosthetic score places limits upon the process; music that is written also becomes music that is fixed, even if performance is able to unfix it to some extent. Unwritten music, on the other hand, lends itself to flexible interpretation, and even calls for it. As Cooper argues in her analysis of reggae music, oral literature gives as much, if not more, importance to the constantly renewed interpretation of the text as it does to the text itself (1995:118). Similarly, in blues and jazz, it is interpretation that matters most. It is not a coincidence if blues, jazz, and rhythm and blues all rely heavily on a "treasure chest" of existing songs, which are interpreted over and over again; and this is found in an even more acute form in reggae and hip-hop, which transformed the use of versions or sampling into the cornerstone of a musical style.

While jazz, as time went by, moved away from reinterpretation and closer to composition, reggae and hip-hop followed the opposite path. The figure of the artist, in jazz, became more individualized and oriented toward composition—in many ways therefore increasingly conforming to the archetype of the Western artist, lost in his creative activity and separated from the world around him, both from his fellow musicians and his audience. In reggae and hip-hop, conversely, the artist is one

immersed in the world, one that cannot create without the music already produced before and around him, one whose rise and fall depend on the close presence of his audience in performance; reggae artists need not only an already existing version to create on, they also fundamentally rely on those who decide their fate in the dance hall.

The same was true for Kansas City jazz, which parallels, perhaps unexpectedly, dancehall reggae in so many ways. The territory bands, which often followed the same route and played in the same venues as burlesque shows, had the central task of satisfying an audience hungry for dance. They also engaged in musical battles with one another, usually at the point of rotation between two bands succeeding one another in a venue, or on specific nights promoted as a "battle of the bands," such as the annual ball of Kansas City Local 637, the African-American Musicians Union founded in 1917. The most popular bands, such as Bennie Moten's Orchestra, the Blue Devils, George Lee or the Twelve Clouds of Joy, were constantly building their reputation on their ability to engage with one another in long nights during which they tried to outplay one another and win the heart of the audience. When back in Kansas City, musicians would challenge one another until the wee hours of the morning or even lunchtime the next day, in what came to be called "spooks' breakfast." Mary Lou Williams famously recalls her window screen scratched and her name shouted from down in the street in the middle of the night: it was Ben Webster enjoining her to come along and check out Lester Young and Coleman Hawkins "battling it out" at the Cherry Blossom club. All the sax tenors in town, including Herschel Evans and Ben Webster, had been playing there since the afternoon; they didn't stop until Lester Young took the night, early in the morning.[22]

The mechanism at work here is one that privileges reinterpretation, rather than composition, as a major creative process. As Ogren points out in her study of 1920s jazz, "Improvisation is central to jazz performance . . . and virtuosity is measured not merely by the technical proficiency of players but also by their ability to perform new musical ideas consistently. Improvisation can also take place collectively in the exchange of musical ideas between instruments or sections of a jazz band or combo. In the earliest jazz performances, improvisation was developed through a heterophonic ensemble style" (Ogren 1992:13). Indeed the central importance of playing by ear in blues and early jazz does not simply "unfix" the music by liberating interpretation; it also defines the way in which music is made and played, much like a hidden impulse that runs through the underlying structure of music. Freedom in interpretation becomes the ground for improvisation, both in (unfixed) performances and in the way music is composed, arranged, and written; and virtuosity, as Ogren indicates, becomes primarily measured by the ability of a musician to perform and to do so in an original way. Hence what seems to be a paradox in Kansas City jazz—the simultaneous rise of solo improvisation and focus

on collective performance through head arrangements, call-and-response, and unwritten music— has to be seen, perhaps surprisingly, as a peculiar ensemble in which each term is both consequence and cause for the other. While playing by ear implies more freedom of interpretation, and therefore more improvisation and perhaps even more individuality, it also implies a fundamentally collective way of playing music, which necessarily presupposes intense communication between the musicians who cannot rely on a score to play together but have, as Marsalis or Jones would say, to talk to one another. Although music is never played as a simple aggregation of parts, which would make it possible for each musician to simply read and execute the score for his instrument without paying any attention to others, playing by ear makes communication absolutely necessary, not only because the score does not exist, but also because of the importance of call-and-response, within and between the rhythm section and solo instruments.

Kansas City jazz was not written; it was also, most often, not composed. In place of composition, bandleaders (as well as other musicians from the band) used arrangements; further, as noted previously these were mostly what are called "head arrangements": unwritten arrangements made spontaneously while playing, and then retained in memory by musicians. Bandleaders carried a "book," which was a record of songs including original arrangements. The territory bands, indeed, had to play to a most varied audience, from all-white crowds in the Dakotas or Wyoming, who requested waltzes and what musicians called "sweet music," to all-black crowds of connoisseurs in Kansas City, who enjoyed not only concerts, but above all jam sessions; they therefore needed an extensive stylistic repertoire. But all the best bands to come out of Kansas City at the time were characterized by their unmatched ability to produce arrangements while playing, to improvise together, and to remember head arrangements from one night to the next. Count Basie himself speaks most clearly about this process:

> That's where we were at. That's the way it went down. Those guys knew just when to come in and they came in. And the thing about it that was so fantastic was this: once those guys played something, they could damn near play it exactly the same the next night. That's really what happened. Of course, I'm sitting there at the piano catching notes and all, and I knew just how I wanted to use the different things they used to come up with. So I'd say something like "okay, take that one half a tone down; go ahead down with it and then go for something." We'd do that, and a lot of times the heads that we made down there in that basement were a lot better than things that were written out. (Basie and Murray 2002:199)

It is fascinating to compare this with the way Duke Ellington, in New York, was making music at about the same time. Whereas Basie was mostly an arranger, who centrally used "riffs" that were improvised upon,

Ellington was a composer, in the classical sense of the term. He invented the music. Yet in comparison with classical music, the composing process here again relied primarily on improvisation and head arrangements. In Ellington's own words,

> I can score with a lead pencil while riding on a train. But usually I gather the boys around me after a concert, say about three in the morning, when most of the world is quiet. I have a central idea which I bring out on the piano. At one stage, Cootie Williams, the trumpeter, will suggest an interpolation, perhaps a riff or obbligato for that spot. We try it and, probably, incorporate it. A little later, Juan Tizol, the trombonist, will interrupt with another idea ... Thus, after three or four sessions, I will evolve an entirely new composition. But it will not be written out, put on a score, until we have been playing it in public quite a while. And, this is important to remember— no good swing orchestra ever plays any composition with the same effect twice. (Panassié 1960:204–5)

What Panassié says of Fletcher Henderson's orchestra also applies to Basie's: "The musicians understood each other" (ibid.:199). When music played together is based on improvisation, on arrangements that have not been written but that are being remembered and reenacted, then the musicians need to understand one another. It is not a coincidence if Kansas City jazz's strongest influence was the blues: the rise of solo improvisations was inextricably linked to call-and-response, individual freedom to the collective endeavor.

Playing alone in Kansas City jazz: the rise of the solo

What is a solo? The history of jazz is not only a history of playing together, it is also a history of the individualization of each instrument, one after the other becoming autonomous in its own right. Early New Orleans jazz was fundamentally oriented toward collective interpretation, toward the disappearance of each singular instrument within ensemble playing; the major goal of each musician was to contribute to a collective endeavor rather than to distinguish himself. The geographical move from New Orleans to Kansas City, Chicago, and New York, following the shutting down of Storyville in 1917, paralleled a growth in solo playing, most notably with Louis Armstrong at the trumpet. With Fletcher Henderson's orchestra, in New York, one can hear how far the music has been taken from New Orleans's marching bands: solos follow one another, and yet the musicians still play together. What is peculiar with Kansas City jazz is the crowning of the saxophone, an instrument that had so far hardly been used as a solo instrument. More than to a series of exceptionally gifted saxophonists—such as Coleman Hawkins, Lester Young, Herschel Evans, Ben Webster, and later Charlie Parker—it is to a way of playing

music that Kansas City owes the rise of the saxophone as solo instrument. But as in the above discussion of written and unwritten music, the tension between the individual and the collective, between playing music alone and playing music together, between the solo and the rhythm section, is not as paradoxical as one might think. As Ralph Ellison asserts, jazz is "an act of individual assertion within and against the group. Each true jazz moment (as distinct from the uninspired commercial performance) springs from a contest in which each artist challenges all the rest; each solo flight, or improvisation, represents (like the successive canvases of a painter) a definition of his identity: as individual, as member of the collectivity and as a link in the chain of tradition. Thus, because jazz finds its very life in an endless improvisation upon traditional materials, the jazzman must lose his identity even as he finds it" (Ellison 1964:234). Indeed, the very emergence of solo improvisation, despite placing emphasis on individuality, necessitates heightened communication. In other words, it is only by playing music together, in an acute sense, that musicians can play alone. I am not thinking here about an analysis in terms of community, or art-worlds, and of their influence on music playing through the grammatical framing of the musical performance, or on the relationship between "personal orientations and impulses" and "socially sustained conventions," as can be found in Martin's excellent analysis of improvisation in jazz (2006:129–79) as well as in Berliner's study of New York jazz musicians (1994), which show how situated within a socially produced language improvisation is. Rather, I am thinking in terms of the musical conditions themselves for solo improvisation to arise. As the composer is commonly imagined as a lonesome individual, so is the jazz soloist—and this is especially the case with the iconic saxophonist. The archetypical jazzman, in the collective imagination, is usually thought of as having retreated into his (since he is a man) own world, immersed in his musical dreams and inspiration, as in Herman Leonard's famous photograph of Dexter Gordon, dreamily smoking, saxophone poised languidly on his lap, far removed from the smiling and obviously gregariously human drummer Kenny Clarke behind him. Yet the solo not only needs the rhythm section to support it, it also has to answer it in a call-and-response manner. Contrary to common thinking, solo improvisation does not happen in a vacuum, and it certainly does not happen in isolation from other instruments and, therefore, from other musicians. This is especially salient in Kansas City jazz; although often overshadowed in the way jazz is considered, it is the combination of Freddie Green at the rhythmic guitar and Jo Jones at the drums—arguably the greatest rhythm section in the history of jazz—that allows Lester Young and Buck Clayton to exist as soloists; indeed, during solo improvisation, the rhythm section continues to play, and it holds, as it were, the solo up. As Panassié argues: "The term 'solo' improvisation is entirely relative . . . improvisation may still be considered collective: the soloist may play in such a way that the

drummer is compelled to swing in a different fashion, or may sometimes lead the guitarist or the pianist to modify some chords, but similarly the rhythm section may, by its playing, drive the soloist down a path he had not originally foreseen" (Panassié 1960:62).

Not only does the soloist need the musicians of the rhythm section: he answers them. Most Kansas City jazz recordings provide a remarkable illustration of this process. The reeds and the horns, the piano, the guitar, and the drums all engage in a conversation; they talk with one another, respond one another, improvise with one another. Kansas City jazz, therefore, provides what could be first thought as a counterexample to Halbwachs's essay on musicians; yet, it also supports Halbwachs's thesis, which in fact does not set up an opposition between written and unwritten musical language that would deny that the latter is actually language (see Schutz 1964), but rather can be read as a reflection on musical language, shared by musicians. Let us clarify this assertion.

Back to Halbwachs: music and language

What is distinctive about a combination of head arrangements, improvisation, and the twelve-bar blues is the fact that, as LeRoi Jones reminds us, "not only are the various jazz effects almost impossible to notate, but each note *means something* quite in adjunct to musical notation" (Jones 2010:19). This brings us back to the epigraph of this chapter, in which Gene Ramey sums up what Kansas City jazz was about: telling a story, as opposed to demonstrating that one is a virtuoso; or, rather, being a virtuoso in storytelling rather than simply in technique. Like the bluesman, and with or without a singer, the jazz musician is speaking; he is a storyteller. Hence Kansas City jazz might be thought to be an exceptional counterexample to Halbwachs's analysis of musical language, and conversely, an exceptional example in support of Schutz's essay. It shows no need for musical notation except for an entirely practical reliance on written arrangements when going on the road; on the contrary, not only does performance rely on unfixed interpretation and originality, virtuosity is actually defined by the ability of a musician to improvise within the frame provided by a discussion between musicians and often between the latter and the audience. What is language here? It is fundamentally communication—what Schutz calls a "tuning-in relationship," which clearly goes well beyond written music: "Social interactions connected with the musical process ... are doubtless meaningful ... but this meaning structure is not capable of being expressed in conceptual terms; they are founded upon communication, but not *primarily* upon a semantic system used by the communicator as a scheme of expression and by his partner as a scheme of interpretation" (Schutz 1964:197). Schutz's critique, therefore, centers on Halbwachs's concern with the

structure of music (ibid.:200), and the correspondence he makes between musical notation and musical language (ibid.:202). But is Halbwachs really making this correspondence? He came very close to conceiving of language primarily as an ordered and ordering relation between terms, and if he had completed his argument in this way, there would be no difficulty in arguing that what is valid for musical notation is, too, for music itself. What is music? Sounds themselves do not make music; it is their organization that does so—that is, not only the relations of distinction between notes or sounds, but also the distinction in time between sounds, as well as between sounds and the absence of sound (as in a simple beat, a finger against a piece of wood, which becomes music by the rhythm, i.e., by the alternation between sound and silence). Further—and the history of the sociology and anthropology of music subsequent to Halbwachs's work has demonstrated it repeatedly—music is also a language through the collective representations it carries (for example, Martin 1995). The definition of authenticity in jazz is a particularly telling example of the ways in which music is thought, and felt, to be meaningful in relation to culture and identity.[23] More than half a century after Halbwachs's essay on musical memory, it seems that to conceive of music as a language, despite the variations in the definition of language itself, is an acquired fact among social scientists. Yet, Halbwachs has much to bring to us. His focus on written music was not a fantasist, or ignorant, choice; and neither was he arguing that music in its entirety was reducible to notation. Quite the contrary. Here is, I believe, the error made by Alfred Schutz when reading Halbwachs: he is taking the essay at face value, without acknowledging that Halbwachs's reflection is guided by problematics that reach well beyond music.

When Halbwachs looks at music, he is primarily guided by a care for language not in the sense of communication, but rather in the sense of the grammar of language. What interests him is not exactly how musicians communicate, but what structural language they use to play and especially remember music independently from the individual variation brought in by emotion, experience, performance, or collective specificities at the level of the band or the orchestra. Behind this interest stand his worries regarding the rise of Nazism in inter-war Germany, and with them a reflection on the "good" society, which we know had been the central endeavor of the Durkheimian school since the 1890s. Indeed, this is the background landscape for his focus on a scientific musical language, which stands against, or at least aside, the emotional uses of music, of which, while writing this essay, he finds an example with the exaltation of Wagner on the other side of the Rhine. Musical notation is seen as the language of objectivity and universality, while performance stands for emotion and particularity; in the words of Marie Jaisson the "collective memory of experts" is presented as a tool to oppose "social memory, profane tradition" (1999:170).

This broader context also implies the problematic issue of the fragmentation in modern societies, which Halbwachs had been facing since the publication of *The Social Frameworks*, and which constitutes one of the most important problems raised by classical sociology, from Weber to Durkheim to Mannheim. If modern society is characterized by an atomization of groups, and therefore a plurality of collective memories, how is it possible for it to hold together and produce social cohesion? As pertinently pointed out by Jaisson (1999:168), this question had been left unanswered in *The Social Frameworks*; and it is a crucial question, one that had become more and more pressing for Halbwachs as the 1930s wore on and as the menace of war increasingly loomed over Western Europe. Musical notation becomes for Halbwachs, as the objective support for a memory of experts, perhaps a more valued or higher form of memory that opposes scientific expertise to lay, fragmented and fragmenting memory, and at least a form of memory that is fundamentally shared beyond individual experiences as well as collective identities, including nationalism. Hence Halbwachs comes to think about normative issues concerning memory—his main task in *The Social Frameworks* was solely to demonstrate the social character of memory and the existence of collective frameworks that sustain it. Is there a memory that unites and one that divides? Through its scientific character, musical notation brings together, while the musical performance, because it lends itself to being interpreted and emotionalized, can be used as something that separates. The essay on musicians, let us not forget, was destined to be the first chapter of a book; this project was cut short by Halbwachs's deportation and subsequent death at Buchenwald in 1945, and was posthumously published in 1950.[24] Not only does his reflection on musical memory represent a move away from his previous conceptualization of memory, through the distinction between the memory of experts and that of laymen, it also has to be seen as his point of entry to conceptualize time. To a living collective memory, Halbwachs opposes history, which is removed from daily life and its vicissitudes. Here Halbwachs is not only talking about history as a discipline: he is also talking about historical time. Memory becomes history at the point where it ceases to be alive in collective consciousness; and yet, what is dead is also what everyone shares, what goes beyond collective or individual particularities. In 1925, Halbwachs had demonstrated the fragmentation of memory in modern societies, characterized by an increased division of labor: to each group, a unique collective memory. It is not enough to invoke Durkheim's hypothesis that modern societies produce solidarity through difference; how does society avoid the entrenchment of groups increasingly foreign to one another? The memory of expert, of which musicians give just one example, can play the role of a uniting rather than dividing memory, precisely because it functions as a grammar of social life, rather than as lively, changing, emotional communication. It provides not only a shared ground capable of bringing together groups

otherwise distinct and with various, sometimes opposed, interests and goals as well as memories; it also provides a shared ground formed out of expertise, that is, based on reason and not on emotions.

And what is music after all? The social sciences have emphasized the social uses of music, which presuppose that music functions as a language, whether in the structuralist or post-structuralist sense of the term or as a more simple concept. Music, as a symbolic system, expresses identity and supports group formation (Seeger 1994), is used as a marker in ethnic processes and encapsulates world-views (Behague 1994:v), or participates in the construction of collective memory (Daynes 2010); Merriam isolated ten such functions assumed by music (1964:219–26). Hence the main goal of the social sciences of music can be seen as typically Durkheimian, although few scholars would claim this inheritance: to demonstrate the social character of music. And yet, as a sociologist of music as well as a music listener, I am also aware of what, in music, seems to escape what scholars would call "the commonly agreed meanings of the group or society in which the particular music is created" (Shepherd 1977:7; this is also expressed by Halbwachs, who talks about a prior agreement (1997[1939a]:31). Individuals can be touched by music even when they are completely foreign to the cultural and social context of the music they hear; and unknown, foreign music can also evoke similar images in a group of individuals. Does that invalidate the social character of music? Certainly not. But it points to the importance of another pole in the conceptualization of music: that of emotion. Sounds, indeed, have the power to evoke, almost independently of the social context in which they are organized. Music is both language and emotion, and music is also both language and speech, both grammar and the communication that happens between musicians, and between the musician and the audience. Maurice Halbwachs, in his essay, starts by making a fundamental distinction between musicians and non-musicians. This distinction does not imply that non-musicians cannot understand music, or enjoy it, or interpret it. Similarly, the distinction between insiders and outsiders in the scholarship on music does not imply that the latter cannot "get" anything from the music. But non-musicians and outsiders read music outside of the conventions that are available to musicians and insiders; the process of interpretation is based on individual experience and emotions. Does this matter? I have, in this chapter, used the example of Kansas City jazz; it is well known that both jazz and especially the blues make an extensive use of double-entendre, by which seemingly innocuous songs will, to insiders, express much more than is explicitly said. An outsider, therefore, will understand something of what is said, but might not have access to what is really said, which raises the issue of interpretation. If taken in its usual form, the debate over interpretation focuses on the question of truth, opposing true and false meanings. Yet, there is another way to look at interpretation: this is the angle suggested by Halbwachs. Implicit in his

reflection is an opposition not between true and false interpretations of music, but between reasonable and emotional interpretations. The question is not whether non-musicians can or cannot hear music, but rather how they hear music in contrast to musicians; conversely, it is not that outsiders cannot make something out of music, but what they make out of it falls out of the collective agreement that exists between insiders.

The richness of this angle also makes the richness of Halbwachs's often underestimated contribution to the scholarship on music, for it displaces the argument over language and interpretation toward fruitful thinking. And it does so in the most useful ways for our contemporary societies, in which the issue of the legitimacy of culture (from videos on YouTube to television channels to blogs) has become intensely important. Halbwachs was concerned with the uses of individual and collective emotions at a time when nations were prone to their centralized manipulation; it is our turn to be concerned with the same uses, which are taking a very different, atomized form. How do we think about the increasing importance, and legitimacy, of individual interpretations, which are more than any other based on subjective experiences and emotions? By thinking about how musicians and non-musicians hear and interpret music, Halbwachs is helping us think about the legitimacy and consequences of interpretation.

Notes

1. Lester Young, "Too marvelous for words," recorded in New York City, March 1950.
2. Jazz big bands at the time favored an eight-bar structure, sight-reading, and arrangements. Kansas City jazz was "bluesier," based on the twelve-bar blues structure, without scores, and with collective, spontaneous, unwritten arrangements called "head arrangements."
3. For more details on jazz in inter-war France, see Shack 2001 and Jackson 2003.
4. Musicians "stop with sounds, and do not seek beyond them."
5. This chapter is severely truncated in the English translation of *The Social Frameworks* (Halbwachs 1992), containing only pages 79–82 of the original French chapter, which runs from pages 40 to 82 (Halbwachs 1994). Consequently, when quoting from untranslated passages, I will provide the reader with a personal translation, with the original French text in a corresponding endnote.
6. See in particular his essay "Comment les mots changent de sens" ("How words change meanings") published in the *Année sociologique* in 1904–05 (ninth edition), which is the text Halbwachs refers to, albeit in its 1921 edition.
7. "Nous ne savons pas en quoi consiste le mécanisme cérébral du langage, mais nous sentons, lorsque nous parlons, que nous attribuons aux mots et aux phrases une signification, c'est à dire que notre esprit n'est pas vide, et nous sentons, d'autre part, que cette signification est conventionnelle. Nous comprenons les autres, nous savons qu'ils nous comprennent, et c'est d'ailleurs pour cette raison que nous nous comprenons nous-mêmes: le langage consiste donc en une certaine attitude de l'esprit, qui n'est d'ailleurs concevable qu'à l'intérieur d'une société, fictive ou réelle: c'est la fonction collective par excellence de la pensée" (Halbwachs 1994[1925]:68).
8. Note the mysterious allusion to a society *fictive or real*, which is not without recalling Max Weber's emphasis on the real or imagined character of origin as a basis for the

formation of ethnic groups (Weber 1978:389). What does Halbwachs mean here? Is the society of musicians a *fictive* society? I will return to this point in the conclusion of my essay.

9. "Il y aurait dans l'esprit de tout homme normal vivant en société une fonction de décomposition, de recomposition et de coordination des images, qui lui permet d'accorder son expérience et ses actes avec l'expérience et les actes des membres de son groupe" (Halbwachs 1994[1925]:70–71).

10. "Ce qui manque à l'aphasique ce sont moins les souvenirs que le pouvoir de les replacer dans un cadre, c'est ce cadre lui-même" (Halbwachs 1994[1925]:76).

11. "Il lui faudrait, au-dessus et au-delà des images particulières, se représenter l'ordre des situations sous forme impersonnelle; une telle notion, indispensable aux hommes d'une société s'ils veulent se comprendre entre eux, lorsqu'ils parlent des lieux et des positions dans l'espace, décidément le dépassent: il n'est plus capable d'accorder les sensations qui lui viennent des objets sensibles avec celles qu'en reçoivent les autres, ou qu'ils pourraient recevoir; en réalité, il ne peut plus se mettre a leur place. La perte des mots . . . n'est qu'une manifestation particulière d'une incapacité plus étendue: tout le symbolisme conventionnel, fondement nécessaire de l'intelligence sociale, lui est devenu plus ou moins étranger" (Halbwachs 1994[1925]:77).

12. Jakobson 1956, among others. It is fruitful here, of course, to reread Lévi-Strauss's wonderful passage on metonymy and metaphor regarding the classification and naming of birds, dogs, cattle and horses in *The Savage Mind* (1968:204–8).

13. This association between language and communication through the use of a semantic system is actually one of the strongest criticisms made by Schutz to Halbwachs in his 1964 essay "Making Music Together": "the following objections to Halbwachs' theory must be raised: (1) He identifies the musical thought with its communication. (2) He identifies musical communication with musical language which to him is the system of musical notation. (3) He identifies musical notation with the social background of the musical process" (1964:201).

14. An interesting excursus here could lead us to explore the parallels between the score as a prosthesis for the musician's memory and Sigmund Freud's reflections on progress and prosthesis in *Civilization and its Discontents* (written in 1929, as he was already himself using ill-fitted and painful replacements for his jaw): "With every tool man is perfecting his own organs, whether motor or sensory, or is removing the limits to their functioning. . . . Man has, as it were, become a kind of prosthetic God. When he puts on all his auxiliary organs he is truly magnificent, but these organs have not grown onto him and they still give him much trouble at times" (Freud 2010:43–44).

15. "Le souvenir d'un mot se distingue du souvenir d'un son quelconque, naturel ou musical, en ce qu'au premier correspond toujours un modèle ou un schéma extérieur, fixé soit dans les habitudes phonétiques du groupe (c'est à dire sur un support organique), soit sous forme imprimée (c'est à dire sur une surface matérielle), alors que la plupart des hommes, lorsqu'ils entendent des sons qui ne sont pas des mots, ne peuvent guère les comparer à des modèles qui seraient purement auditifs, parce que ceux-ci leur manquent" (Halbwachs 1939a:19).

16. "Ces signes représentent des notes, leur hauteur, leur durée, les intervalles qui les séparent. Tout se passe comme si c'était là autant de signaux, placés en cet endroit pour avertir le musicien et lui indiquer ce qu'il doit faire. Ces signes ne sont pas des images de sons, qui reproduiraient les sons eux-mêmes. Entre ces traits et ces points qui frappent la vue, et des sons qui frappent l'oreille, il n'existe aucun rapport naturel. Ces traits et ces points ne représentent pas les sons, puisqu'il n'y a entre les uns et les autres aucune ressemblance, mais ils traduisent dans un langage conventionnel toute une série de commandements auxquels le musicien doit obéir, s'il veut reproduire les notes et leur suite avec les nuances et suivant le rythme qui convient" (Halbwachs 1939a:23).

17. Portrayals of the composer parallel portrayals of the artist: both are seen as fundamentally "other worldly" during the process of creation. Examples include Mozart struggling with himself when composing the Requiem in Milos Forman's film *Amadeus* (1984), a deaf Beethoven retreated within his own mind (and sounds within), or the lonesome jazzman as in the case of Charlie Parker.
18. In response to Blondel's childhood memory, Halbwachs asserts that "in reality, we are never alone" (1997:52).
19. For more memories about the Territory Bands in the 1920s and 1930s, told in the musicians' own voices, see Pearson 1987, chapters three (on the territories), four (on the Twelve Clouds of Joy), and five (about the Blue Devils).
20. In the 1930s, the ability to read music greatly varied among African-American jazz musicians. Those who could—like Buck Clayton, for instance—were used as musicians but also as arrangers; biographies of Louis Armstrong (Teachout 2010) and Count Basie (Basie and Murray 2002) accurately describe their late training in musical reading.
21. Muddy Waters, *The Complete Plantation Recordings*, Chess Records, 1993. Interview #1, recording session of August 24–31, 1941, Stovall Plantation, Stovall, Mississippi.
22. "I happened to be nodding that night, and around 4AM., I awoke to hear someone pecking on my screen. I opened the window on Ben Webster. He was saying, 'Get up, pussycat, we're jammin' and all the pianists are tired out now. Hawkins has got his shirt off and is still blowing. You got to come down.' Sure enough, when we got there Hawkins was in his singlet taking turns with the Kaycee men" (Dahl 2001:86).
23. See three very different accounts on this topic: Austerlitz 2005, Gerard 2001, Ogren 1992. On authenticity see Peterson 1999.
24. The manuscript was put together by Jeanne Alexandre, sister of Maurice Halbwachs and wife of the philosopher Michel Alexandre. See Gérard Namer's preface (Halbwachs 1994:7–12) for an account of the controversy regarding its publication.

References

Austerlitz, Paul. 2005. *Jazz Consciousness: Music, Race and Humanity.* Wesleyan: Wesleyan University Press.

Basie, Count, and Albert Murray. 2002. *Good Morning Blues: The Autobiography of Count Basie.* Cambridge: Da Capo Press.

Becker, Howard. 2004[1951]. "The Professional Dance Musician and His Audience." In *Popular Music: Critical Concepts in Media and Cultural Studies*, Volume I, Ed. Simon Frith. New York: Routledge, 213–26.

Behague, Gerard. "Introduction" in *Music and Black Ethnicity: The Caribbean and South America.* Miami: University of Miami, v–xii.

Berliner, Paul F. 1994. *Thinking in Jazz: The Infinite Art of Improvisation.* Chicago: The University of Chicago Press.

Cooper, Carolyn. 1995. *Noises in the Blood.* Durham: Duke University Press.

Cugny, Laurent. 2004. "L'idée de forme dans le jazz." *Cahiers de Musiques Traditionnelles,* 17:143–60.

Dahl, Linda. 2001. *Morning Glory: A Biography of Mary Lou Williams.* Berkeley: University of California Press.

Dance, Stanley. 1985. *The World of Count Basie.* New York: Da Capo Press.

Daynes, Sarah. 2010. *Time and Memory in Reggae Music: The Politics of Hope.* Manchester: Manchester University Press.

Driggs, Frank, and Chuck Haddix. 2006. *Kansas City Jazz: From Ragtime to Bebop.* New York: Oxford University Press.

Durkheim, Émile. 1982. *The Rules of Sociological Method*. New York: The Free Press.
Durkheim, Émile, and Marcel Mauss. 1967. *Primitive Classification*. Chicago: The University of Chicago Press.
Ellison, Ralph. 1964. *Shadow and Act*. New York: Random House.
Freud, Sigmund. 2010[1930]. *Civilization and its Discontents*. New York: Norton.
Gerard, Charley. 2001. *Jazz in Black and White: Race, Culture and Identity in the Jazz Community*. New York: Praeger.
Halbwachs, Maurice. 1992. *On Collective Memory*. Chicago: The University of Chicago Press.
———. 1994[1925]. *Les cadres sociaux de la mémoire*. Paris: Albin Michel. Partial translation in *On Collective Memory*, 1992.
———. 1997[1939a]. "La mémoire collective chez les musiciens." In *La Mémoire Collective*. Paris: Albin-Michel, 19–50.
———. 1939b. "Individual Consciousness and Collective Mind." *The American Journal of Sociology*, 44(6): 812–22.
Halbwachs, Maurice. 1980. "The Collective Memory of Musicians." In *The Collective Memory*. New York: Harper and Row, 158–86.
Head, Henry. 1920. "Aphasia and Kindred Disorders of Speech." *Brain*, 43:87–165.
Helmlinger, Aurélie. 2001. "Geste individuel, mémoire collective: Le jeu du pan dans les steel-bands de Trinidad & Tobago." *Cahiers de Musiques Traditionnelles*, 14: 181–202.
Jackson, Jeffrey. 2003. *Making Jazz French: Music and Modern Life in Interwar Paris*. Durham: Duke University Press.
Jaisson, Marie. 1999. "Temps et espace chez Maurice Halbwachs." *Sciences Humaines* 1(1): 163–78.
———. 2007. "Mémoire collective et mémoire des musiciens chez Maurice Halbwachs." *Dimension e problemi della ricerca historia*, 2: 73–84.
Jakobson, Roman. 1956. "Two Aspects of Language and Two Types of Aphasic Disturbances." In *Fundamentals of Language*. The Hague: Mouton, 69–96.
Jones, LeRoi. 2010[1963]. "Jazz and the White Critic." In *Black Music*. New York: Akashic Books, 15–26.
Lévi-Strauss, Claude. 1968[1962]. *The Savage Mind*. Chicago: The University of Chicago Press.
Lippincott, Bruce. 1958. "Aspects of the Jam Session." In *Jam Session: An Anthology of Jazz*. Ed. Ralph Gleaso. New York: Putnam, 168–74.
Martin, Peter. 1995. *Sounds and Society*. Manchester: Manchester University Press.
Martin, Peter. 2006. *Music and the Sociological Gaze: Art Worlds and Cultural Production*. Manchester: Manchester University Press.
Meillet, Antoine. 1904–05. "Comment les mots changent de sens." *L'Année sociologique*, 9: 1–38.
———. 1921. *Linguistique historique et linguistique générale*. Paris: Société de Linguistique.
Merriam, Alan P. 1964. *The Anthropology of Music*. Evanston: Northwestern University Press.
Monson, Ingrid. 1996. *Saying Something: Jazz Improvisation and Interaction*. Chicago: The University of Chicago Press.
Ogren, Kathy. 1992. *The Jazz Revolution: Twenties America and the Meaning of Jazz*. Oxford: Oxford University Press.
Panassié, Hugues. 1960[1942]. *The Real Jazz*. Westport: Greenwood Press.
Pearson, Nathan W. 1987. *Goin' to Kansas City*. London: Macmillan.
Peterson, Richard. 1999. *Creating Country Music: Fabricating Authenticity*. Chicago: The University of Chicago Press.
Schuller, Gunther. 1986. *Early Jazz: Its Roots and Musical Development*. Oxford: Oxford University Press.
Schuller, Gunther. 1991. *The Swing Era: The Development of Jazz, 1930-1945*. Oxford: Oxford University Press.

Schutz, Alfred. 2004[1964]. "Making Music Together." In *Popular Music: Critical Concepts in Media and Cultural Studies*, vol. 1. Ed. Simon Frith. New York: Routledge, 197–212.

Seeger, Anthony. 1994. "Whoever We Are Today, We Can Sing You a Song About It." In *Music and Black Ethnicity: The Caribbean and South America*. Ed. G. Behague, Miami: University of Miami, 1–16.

Shack, William. 2001. *Harlem in Montmartre: A Paris Jazz Story Between the Great Wars*. Berkeley: University of California Press.

Shepherd, John. 1977. "Media, Social Process and Music." In *Whose Music? A Sociology of Musical Languages*. Eds. J. Shepherd, P. Virden, G. Vulliamy, T. Wishart. New Brunswick: Transaction Publishers, 7–52.

"Swing: The Velocity of Celebration," in *Jazz*. Dir. Ken Burns. PBS, 2000. DVD.

Teachout, Terry. 2010. *Pops: A Life of Louis Armstrong*. New York: Houghton Mifflin Harcourt.

Weber, Max. 1978. "Ethnic Groups." In *Economy and Society*. Two volumes. Berkeley: University of California Press, 385–98.

Will, Udo. 1999. "La baguette magique de l'ethnomusicologue: Repenser la notation et l'analyse de la musique." *Cahiers de Musiques Traditionnelles*, 12: 9–33.

Chapter 9

Total Art

The Influence of the Durkheim School on Claude Lévi-Strauss's Reflections on Art and Classification

Stephan Moebius and Frithjof Nungesser

In his works Claude Lévi-Strauss repeatedly draws on art as a subject of anthropological reflection. For the son of a painter, the fine arts played an important role along with literature, and music, which is of enormous importance as a subject and above all as a scientific model. Initially, that is, in the late 1930s and in the 1940s, his deliberations on the aesthetic dimension of material culture were concentrated on the art of indigenous societies he investigated. Along with the somewhat unemotional ethnographic studies, earlier analyses also include impassioned texts that express his enthusiasm and his intensive, "almost carnal bond" (Lévi-Strauss 1982[1975]:10) to this art. This applies particularly to the art of the indigenous peoples of the Pacific Northwest Coast that he encountered in exile in New York, especially in the "magical place" (Lévi-Strauss 1943a:175) of the American Museum of Natural History.[1] In later works—especially those starting from the late 1950s—the scope of his thought on art theory expanded enormously in time and space, whereby the assumptions become stronger and more general. It seems here as if Lévi-Strauss wants to explain his own affinity to "primitive art" by means of his structural anthropology. The focus of interest shifts more and more to the relationship of art and language, the connection between artistic rendering and the specific qualities of the "savage mind," as well as ascertaining the contrasts between primitive and modern art.[2] Hence, the continual occupation with the fine arts predates the often-cited "revelation" (Lévi-Strauss 1963[1958]:33) of structuralism, accompanies it, and finally establishes a close connection with it.[3]

Using those works relevant to art theory, the development of Lévi-Strauss's structural anthropology can be traced from a specific and revealing perspective. Of particular interest here are the earlier articles often neglected in the literature. It is apparent that fundamental theses and

deliberations can be found here that prefigure later arguments and for-mulations. In a certain sense his reflections on art can even be considered as exemplary for Lévi-Strauss's works on the specifics of the "savage mind."

We intend to demonstrate that the ideas of Lévi-Strauss in art theory—just as in his works on the theory of classification and knowledge in general—were directly and decisively influenced by the classification theory of Émile Durkheim and Marcel Mauss as well as by the concept of the "total social fact" formulated by Mauss.[4] The arguments presented here call into question a portrayal frequently to be found in the literature and conveyed in different ways by Lévi-Strauss himself, namely that of the "born structuralist" who, without knowing it, always thought in a structuralist way, even at the tender age of two years old.[5] This is also true for related interpretations, such as those of Philippe Descola who made the case in a 1992 interview that the development of Claude Lévi-Strauss's structuralism can in no way be traced back only to the influence of structural linguistics, but that decisive significance must be attributed to his ethnographic experiences in Brazil. The specific idiosyncrasies of Amazonian societies lend themselves to a structuralist view according to Descola (see Knight and Rival 1992:12).[6] Without a doubt, the ethno-graphic experience was of fundamental importance. Yet, this experience, like all experience, was not pure and virginal. If one wants to under-stand how Lévi-Strauss made the transition from ethnography to struc-tural anthropology without being fooled by any of the distorted images described, then one must especially consider the intellectual context in which the young Lévi-Strauss moved. One must ask which guiding con-cepts Lévi-Strauss took into the field in the mid 1930s[7] so that out of an examination of the Amazonian material, a structuralist theory could finally emerge in the mid 1940s. This is done here using Lévi-Strauss's reflections on art.[8]

In order to support the formulated theses, proof must first be provided that the considerations of art in Lévi-Strauss's early texts are substan-tially influenced by Durkheim and Mauss, even if these writings them-selves seldom mention this (section I). Pursuant to this, the connection of Lévi-Strauss's entire work on classification to the Durkheim school is demonstrated using this art-theory discourse (section II). In this way, it will ultimately be possible to correct the inapplicable image of the "born structuralist" (section III).

I

A preoccupation with art can already be found in some of Lévi-Strauss's early ethnographic works. Some of these texts particularly express enthu-siasm for these art forms. This is true for the short article on the facial art of

the Caduveo in the surrealist journal *VVV* (1942), or the encomium to the art of the Northwest coastal Indians in the *Gazette des beaux-arts* (1943a). Theoretically richer in comparison are the studies of the Bororo (1936), the essay on "Split representation in the art of Asia and America," which was included in *Structural Anthropology I* (2006[1963]:245–68), and the corresponding sections of *Tristes Tropiques* (1974[1955]).[9] The thoughts relevant to art theory from these more systematic works and their resemblance to the Durkheim school will now be examined.

In the Bororo study, which is incidentally the first ethnographic work by Lévi-Strauss, the aesthetic aspects of material culture are examined under the title "Expression concrètes de la structure sociale" (Lévi-Strauss 1936:288). The Bororo traditionally decorate "[a]lmost all objects . . . with emblems" (Lévi-Strauss 1974[1955]:225). In his essay, Lévi-Strauss studies the logic behind these decorations (see Lévi-Strauss 1936:288–95). Thus he determines that the adornment of objects correspondingly serve to identify clans and partially the moieties of the village as well. On hunting bows, for example, the number and arrangement of rings made out of palm bark make it identifiable to which clan the weapon holder belongs. By the ceremonial decorative bows, the clan as well as the moiety of the owner can be recognized through the combination of various types and colors of feathers. Lévi-Strauss can show evidence of the same logic for the decoration of arrows as well as characteristic Bororo penis sheaths ("a strange place in which to carry a standard") (Lévi-Strauss 1974[1955]:225).[10]

Just as with the dances, songs, names, or the use of certain techniques or objects, the coats-of-arms and their composition can be assigned to a clan. These privileges of the clans are strictly adhered to (see Levi-Strauss 1936:277f., 287f.). The things that are important to the society are accordingly classified by means of the social organization, that is, by means of clans and moieties, and their handling is correspondingly regulated. Formulated generally:

> It was because men were grouped, and thought of themselves in the form of groups, that in their ideas they grouped other things, and in the beginning the two modes of grouping were merged to the point of being indistinct. Moieties were the first genera; clans, the first species. Things were thought to be integral parts of society, and it was their place in society which determined their place in nature. (Durkheim and Mauss 1963[1903]:82f.)

According to Lévi-Strauss, however, not only the handling and composition of objects by the Bororo conform to their social structure. This similarly applies to the morphological structure of the village: "The village's morphological structure is a direct image of its social organization" (Lévi-Strauss 1936:271). He makes this clear with the example of the Bororo village Kejara (see ibid.:270–75). In Lévi-Strauss's words, this is reminiscent of "a cartwheel, the rim being the family huts, the spokes the paths and the men's house the hub" (Lévi-Strauss 1974[1955]:220; see fig. 9.1).

Figure 9.1. The Bororo village Kejara (© Claude Lévi-Strauss's Estate, reproduced with permission)

Thus, not only in terms of kinship, but also physically the village is split into two exogamous matrilineal moieties. The clans take up smaller segments within the moieties, which in turn are divided into three classes. The young bachelors live in the large men's house in the center of the village (due to the matrilocality). The fundamental societal structure is therefore mirrored in the adornment of objects just as in the physical layout of the village. If one wanted to generalize these explanations of Lévi-Strauss for the morphology of Kejara, one could formulate the following law: "In societies with a totemic organization, it is a general rule that secondary groups of the tribe—moieties, clans, sub-clans—are spatially disposed according to their relations of kinship and the similarities or differences of their social functions" (Durkheim and Mauss 1963[1903]:63).

Accordingly, these few lines already suffice to discern the massive back references of these ethnographic works to the studies of the Durkheim

school on primitive classifications and social morphology. In everything concerning the interlacing of the social structure, the morphology, the material culture, and the structuring of knowledge (from the everyday duties all the way to cosmology), Lévi-Strauss's study of the Bororo can count as a straightforward application of what Durkheim and Mauss describe in their "famous essay" (Lévi-Strauss 1973[1962]:39), "On some Primitive Forms of Classification" (Durkheim and Mauss 1963[1903]).[11] Even if it is not clear whether Lévi-Strauss in his Bororo study shared the radical socio-epistemological and quasi-evolutionary claims of Durkheim and Mauss at that time, he still attempts to furnish evidence from the Bororo for the assumptions these two make for the Australian aborigines or the Zuñi Indians: that the "classification of things reproduces this classification of men" (Durkheim and Mauss 1963[1903]:11). For the Bororo as well "the idea of the camp is identified with that of the world . . . The camp is the center of the universe, and the whole universe is concentrated within it" (Durkheim and Mauss 1963[1903]:65).[12]

In the 1945 essay on the "Split representation in the art of Asia and America," Lévi-Strauss developed these thoughts further, and the influence of structuralism is already perceivable. As opposed to the Bororo essay, this study focuses solely and completely on the realm of art and illuminates it through employing a comparative perspective—with respect to space as well as time. The objects of the analysis are artefacts from Siberia, China, New Zealand, North America, and South America from different historical phases spanning from prehistory to the present. He sees this comparison as legitimate due to the striking analogies between the art forms of these cultures, and "these analogies derive not so much from the external aspect of the object but from the fundamental principles" that these artworks obey (Lévi-Strauss 2006[1945]:56–57). In contrast to the comparative works of others, however, he does not want to argue on the basis of the historical spread of these principles. It is much more his intention to clearly repudiate the possibility of diffusionist explanations (see ibid.: 56–58, 64f.).[13] However, as he did later in the areas of kinship systems, totemism, or mythology, Lévi-Strauss also resists in the area of art the idea of "throwing out the baby with the bath water" (Lévi-Strauss 1969[1962]:115) because of this difficulty. Just because the road of historical explanation is closed, in no way must the researcher capitulate in the face of variety and apparent coincidental nature of the phenomena and cease with comparative research: "But if historians maintain that contact is impossible, this does not prove that the similarities are illusory, but only that one must look elsewhere for the explanation" (Lévi-Strauss 2006[1945]:57).[14] The task of science is not to speculate about possible diffusion, but to find the causes for these analogies.

In his comparison, Lévi-Strauss concentrates on the major similarity between the different aesthetic traditions: the split-representation. This can be seen in ancient China and on the Northwest coast, where the

motifs are each dominated by starkly abstracted and schematic representations of animals, as well as in South America and New Zealand, where painting (in contrast to sculpting) is ruled by the ornamental and decorative. Lévi-Strauss then expands the tenets of Boas and Creel that had been developed independently of one another, and maintains that not only on the Northwest coast and in China, but also in the case of the Caduveo of the Mato Grosso, and the New Zealand Maori, this division results from the joining of two profiles that, together, create a frontal representation (see ibid.:58–59, 60, 64).[15] In contrast to the other art forms in which this projection technique necessarily leads to an (axis-)symmetric representation, the Caduveo cosmetics produces an asymmetry through a horizontal division, which admittedly can be interpreted as a "complex symmetry" (ibid.:59) at the same time.[16]

The decisive point is now that these analogies would remain in need of explanation even in the face of the (clearly impossible) proof of historical contact, because even "the discovery of a unique origin for split representation would leave unanswered the question of why this means of expression was preserved by cultures which, in other respects, evolved along very different lines" (ibid.:64). Not only the change, but also the stability, is in need of clarification. And whereas one certainly can explain the transition, i.e., the adoption of cultural practices, by way of "external connections" its preservation can only be made comprehensible by "internal connections" (ibid.:64–65). He now wants to understand these "internal connections" by means of "structural analysis of forms" (ibid.:57).

In his essay, Lévi-Strauss attempts to employ such an analysis to uncover the structural relationships between the fundamental principles of the examined works of art and the social organization of the respective societies. Initially he makes this apparent in the various art traditions. For North and South America, for example, he maintains that both arts "carry out decorations by means of stencils, and create ever-new combinations through the varied arrangement of basic motifs. Finally, in both cases, art is intimately related to social organization: motifs and themes express rank differences, nobility privileges, and degrees of prestige. The two societies were organized along similar hierarchical lines and their decorative art functioned to *interpret and validate the ranks in the hierarchy*" (ibid.:62; emphasis added). Accordingly, the vertical social structure is not only translated by the artefacts, but also fortified. Lévi-Strauss emphasizes this interplay of the artworks' symbolizing and preserving moments for other regions as well: "Tattooings are not only ornaments. As we already noted with respect to the North West Coast (and the same thing may be said of New Zealand), they are not only emblems of nobility and symbols of rank in the social hierarchy; they are also messages fraught with spiritual and moral significance. The purpose of Maori tattooings is not only to imprint a drawing onto the flesh but also to stamp onto the mind all the traditions and philosophy of the group" (ibid.:64).

But what is the common "fundamental element" of these various socie-
ties which explains why this "inner relationship" can be found in them,
while others do not "translate" their mode of social organization in a com-
parable way (ibid.:67)? Lévi-Strauss claims that the concept of the mask
could clear the path toward an explanation. He contradicts Boas (see
ibid.:58ff.) who interprets the split representation as the inevitable con-
sequence of projecting any three-dimensional object onto a flat surface.
Instead, the division is only imperative where the three-dimensional form
of the mask is transferred to a two-dimensional surface or an object that
does not have the form of a face (see ibid.:68). The puzzle is still not con-
clusively solved by this, however. It is true that according to Lévi-Strauss,
the mask plays a central role in all the cultures researched (see ibid.:68).[17]
But this also can be said for the societies of the Pueblo Indians or of New
Guinea without the representations here correlating to the principle of
splitting. In these societies, however, and this is the material point, the
masks are neither related to the hereditary social hierarchy, nor is the
chief function the supernatural "creation of classes and castes" (ibid.:69).
In the societies examined, on the other hand, the mask is what first gives
the individual his "human dignity," his personality, his rank (ibid.:65). At
every moment, it gives him his position in society. Removing the mask
means the individual "must be torn asunder" (ibid.:69). For this reason, in
these societies the masks are not to be separated from the face, in contrast
to those societies in which they also are ever present, but merely fulfill
a decorative function. According to Lévi-Strauss, the splitting and the
idiosyncratic distortion in perspective that arises by the transfer to a flat
surface can only be explained through this inseparability (see ibid.:65). It
would therefore be misguided to reduce the split in representation only
to "the graphic representation of the mask." It must be seen much more
as "the functional expression of a specific type of civilization" (ibid.:69).
Hence, without being conscious of it, indigenous artists symbolize the
elementary principles of their societies in their works.

In *Tristes Tropiques* Lévi-Strauss takes up the facial drawings of the
Caduveo once again. His explanations build upon the considerations
presented, but on the whole they look at the objects of study from
another perspective. More detailed than in the essay on "Split represen-
tation," here he deals with the interior differentiations of the drawings.
This time the split representation and its connection to a "sociological
theory of the splitting of the personality" (Lévi-Strauss 2006[1945]:65) are
not in the foreground, but rather the analogies between the composition
of the face drawings and the organization of hierarchies and kinship. In
the Caduveo, Lévi-Strauss sees one of the last remnants of a once great
culture of Mbaya-Guaicuru, which was supposed to have been a kind of
feudal Indian society (see 1974[1955]:178ff.). The extremely hierarchical
character of this society still exists today. Accordingly, the Caduveo are
divided into three endogamous marriage classes (noble, warrior, slave),

which are each divided into further subclasses. Because the population is distinctly smaller relative to earlier times, the number of marriage classes remained constant and the endogamy imperative was maintained, marriages befitting one's rank became increasingly improbable. Accordingly, among the Caduveo a general antipathy toward reproduction is discernible (see ibid.:182, 188) and therefore the majority of the population was gained through adoption as a consequence of warring expeditions.[18]

Nearly identical to this system of social organization is that of the Bororo, who live at the edge of the former realm of the Mbaya. However, the dangers of segregation such as those that can be observed by the Caduveo are attenuated by the Bororo through the existence of moieties. Misalliance might still be forbidden, but marriage to a member of the other moiety is imperative: "It is fair to say, then, that the asymmetry of the classes was, in a sense, counterbalanced by the symmetry of the moieties" (ibid.:196).[19]

The clue in Lévi-Strauss's argumentation is rooted in the assumption that the facial art of the Caduveo would represent just that kinship organization of the Bororo through its specific interplay of asymmetry and symmetry (see ibid.:196f.; see figure 9.2). Thus, by means of a kind of *écriture automatique*, the Caduveo artists would constantly and unconsciously draw what their pride forbade them to put into practice: "But the remedy they failed to use on the social level, or which they refused to consider, could not elude them completely; it continued to haunt them in an insidious way. And since they could not become conscious of it and live it out in reality, they began to dream about it. Not in a direct form, which would have clashed with their prejudices, but in a transposed, and seemingly innocuous, form: in their art" (ibid.:196f.).[20] Consequently, the Caduveo are a society "ardently and insatiably seeking a means of expressing symbolically the institutions it might have, if its interests and superstitions did not stand in the way" (ibid.:197).[21]

At this point, Lévi-Strauss's analyses of Bororo and Caduveo culture converge with his thoughts on social morphology and his analyses of art. Not only the spatial morphology of the village, but also the graphic morphology of the artwork directly translates the social organization: "We need only study a plan of a Bororo village . . . to see that it is organized in the same way as a Caduveo pattern" (ibid.:196).[22] It becomes clear here that the Durkheimians' fundamental ideas about social morphology and classification theory had a significance that should not be underestimated, for the very early Bororo study as well as for the study on split representation, which focuses solely on the arts. It is therefore not surprising that Lévi-Strauss writes in a letter to Marcel Mauss on March 14, 1936 that his research on the Caduveo and the Bororo was strongly inspired by him.[23] Even if these references are not explicitly made in the articles, they are nevertheless clearly recognizable.

Figure 9.2. The Caduveo facial and corporeal design reproduced by a native woman on a sheet of paper (© Claude Lévi-Strauss's Estate, reproduced with permission)

Therefore, by looking into his early studies on art it can be shown that the influence of the Durkheim school on Lévi-Strauss can in no way be reduced to his work on the anthropology of kinship. While the influence of Mauss in particular is mostly recognized in the literature in this area, this does not extend to other areas of work (see, for example, Leach 1974; Deliège 2004; Keck 2005; Kauppert 2008; Reinhardt 2008). But that is not sufficient. In light of Lévi-Strauss's early reflections on art, a connection can be demonstrated between his entire work on the anthropology

of knowledge and the Durkheim school, which will now be considered. Mauss's concept of the "total social fact" will likewise be of significant importance in this context.

II

In *Myth and Meaning* (1978:16ff.) Lévi-Strauss points out that he wrote *The Savage Mind* and *Totemism* (both published in 1962) primarily to refute two influential interpretations of "primitive" thinking. One is the utilitarian–functionalist interpretation in which the thinking of preliterate people is completely determined by their basic needs, which they constantly had to struggle to fulfill and which therefore completely occupied them. He finds this theory formulated primarily by Bronislaw Malinowski (ibid.:15). The second is Lucien Lévy-Bruhl's influential idea that indigenous people think in an affective and emotional way (ibid.:16). According to Lévy-Bruhl, their thinking therefore cannot be referred to as intellectual because it cannot clearly differentiate and does not exhibit any capacity for abstraction. Lévi-Strauss considers all of these interpretations fundamentally flawed. Instead, he wants to show that the *pensée sauvage* has non-utilitarian and intellectual characteristics in considerable measure. He is solidly convinced "that man has always been thinking equally well" (Lévi-Strauss 1963[1958]:230).

As in other areas of Lévi-Strauss's work—such as in the anthropology of kinship—significant points of Lévi-Strauss's position within the debate on the characteristics of indigenous thinking are anticipated in his ethnographic writings of the 1930s and 1940s. The early and strong influence of the Durkheim school on these early works, as our thesis states, can help to make this positioning comprehensible. At the same time, it becomes clear why Lévi-Strauss makes positive references to the Durkheimians at several points in his later work on the logic of the "savage mind." This thesis, however, should not be understood as saying that he took on the positions of the Durkheim school uncritically. Rather, Lévi-Strauss's later contributions represent a profound change in the sociology of classifications and knowledge, as it was formulated by the Durkheim school. Nonetheless, his later works not only document his stout opposition to the utilitarian, functional, or affective theories of knowledge but also reveal his close kinship with the *durkheimiens*.

In this section, the close kinship between Lévi-Strauss's anthropology of knowledge and Durkheim and Mauss's sociology of classification will first be worked out. Following that, by using Lévi-Strauss's early works on the aesthetic dimensions of indigenous culture it will be demonstrated that his criticism of utilitarian and affective theories, as well as his affinity to Durkheimian sociology, can already be discerned in his early writings.

For Lévi-Strauss, Malinowski is the major representative of the utilitarian position. In general he comprehends culture "as a means to an end" that "allows him to live, to establish a standard of safety, comfort and prosperity" (Malinowski 1965[1944]:67). He therefore understands it "instrumentally or functionally" (ibid.:67f.). This constant struggle to fulfill basic needs is reflected in the native's perception of the world: "The road from the wilderness to the savage's belly and consequently to his mind is very short, and for him the world is an indiscriminate background against which there stands out the useful, primarily the edible, species of animals or plants" (Malinowski 1948:27). These thoughts are transferable, for example, to the explanation of totemism: "Since it is the desire to control the species, dangerous, useful, or edible, this desire must lead to a belief in special power over the species, affinity with it, a common essence between man and beast or plant" (ibid.:28). Accordingly, totems become totems because they have great importance for physical existence—as a threat or a basic food source. And what is true for totems is true for the entirety of thinking—what is useful is classified.

This utilitarian view is countered by Lévi-Strauss with his presentation of the "science of the concrete" that naturally emerges out of indigenous thought (Levi-Strauss 1973[1962]:16). He fills pages (see ibid.:4ff.) in *The Savage Mind* with examples of this science being rich in categories and detail, particularly with regard to "useless" things: "It may be objected that science of this kind can scarcely be of much practical effect. The answer to this is that its main purpose is not a practical one. It meets intellectual requirements rather than or instead of satisfying needs" (Lévi-Strauss 1973[1962]:9). Durkheim and Mauss (1963[1903]:81) had already formulated this in very similar words: "Moreover, these systems, like those of science, have a purely speculative purpose. Their object is not to facilitate action, but to advance understanding, to make intelligible the relations which exist between things." The tendency to project a purely utilitarian orientation back onto preliterate cultures had also been criticized by Mauss: "It is our western societies who have recently made man an 'economic animal'" (Mauss 1999[1925]:76).

Lévi-Strauss sees the work of Lucien Lévy-Bruhl as representative for the affective interpretation of the "savage mind"—and thereby for the second position he opposed with his writings. In his writings Lévy-Bruhl tried to provide evidence that indigenous cultures had "a decided distaste for reasoning, for what logicians call the 'discursive operations of thought'"; that they have "but slight perception of the law of contradiction"; and that their intellect seldom detached itself from sensory perception (Lévy-Bruhl 1966[1922]:21, 11, 24). Yet, he does not regard their thinking as pathological or childlike. Rather, he considers it "to be normal under the conditions in which it is employed, to be both complex and developed in its own way" (ibid.:33). This world of "pre-logical thinking" accordingly exists, in contrast to "ours," in a "system of mystic

participations" (ibid.:35, 55), in which no difference exists between one's self and others, dream and reality, here and there. Accordingly, for Lévy-Bruhl, the relationship between a human being and his or her totem animal presents itself as follows: between the totem, which reveals itself to the individual in a dream and makes it understood what it requires in this dream, and the person, "there is a connection which investigators have never been able to make clear, and which doubtless is not intended to become so" (ibid.:119).[24]

This portrayal of the indigenous intellect as pre-logical and undifferentiating is diametrically opposed to Lévi-Strauss's view. Contrary to Lévy-Bruhl's opinion, the native's thought "proceeds through understanding, not affectivity, with the aid of distinctions and oppositions, not by confusion and participation. Although the term had not yet come into use, numerous texts of Durkheim and Mauss show that they understood that so-called primitive thought is a quantified form of thought" (Lévi-Strauss 1973[1962]:268).[25]

So Lévi-Strauss invokes Durkheim and Mauss in his critique of Lévy-Bruhl (see also Lévi-Strauss 1987[1950]:34; 1983a[1973]:24ff.). Rightfully? If one looks at their essay on classification, it stands out that near the end, they doubt the native's capacity for conceptual classifying on the grounds of "sentimental affinities" (Durkheim and Mauss 1963[1903]:85ff). Whether or not this approaches Lévy-Bruhl's thesis, it is to be considered here that neither of the authors assumes two principally different ways of thinking—as Lévy-Bruhl does. Two circumstances support this thesis: one is that Durkheim and Mauss do not assume that indigenous thinking constitutes a separate mode of thought that is principally to be differentiated from classifying and discerning thought. Rather, they argue that a difference exists in how classifying is done: "We thus arrive at this conclusion: it is possible to classify other things than concepts, and otherwise than in accordance with the laws of pure understanding" (ibid.:85). No doubt is cast on the validity, coherence, or rigidity of this thinking and it seems worth emphasizing for both authors that they are in no way dealing with "curiosity-value" (ibid.:42f., 77). Secondly, the quasi-evolutionary narrative that underlies Durkheim and Mauss's essay on classification provides evidence that the authors do not assume that the two ways of thinking are fundamentally irreconcilable: "Primitive classifications are therefore not singular or exceptional, having no analogy with those employed by more civilized peoples; on the contrary, they seem to be connected, with no break in continuity, to the first scientific classifications. In fact, however different they may be in certain respects from the latter, they nevertheless have all their essential characteristics" (Durkheim and Mauss 1963[1903]:81).[26]

Hence, despite references to the affectivity and backwardness of primitive thinking in the 1903 essay—aspects which Lévi-Strauss decisively criticizes and repudiates—significant agreement can be found between

Durkheim, Mauss, and Lévi-Strauss with regard to the characterization of the "savage mind." This can be determined negatively through their common rejection of the positions taken by Lévy-Bruhl or Malinowski. The agreement can be formulated positively using their common assumption of "the totality of indigenous thinking." By referring to the classification essay, Lévi-Strauss emphasizes this agreement in *The Savage Mind* and comments that Durkheim and Mauss had "discussed global classifications of tribes"[27] (Lévi-Strauss 1973[1962]:57). He, too, comprehends the thinking of preliterate societies as a kind of "total thinking." In another passage (1978:17) he asserts the "totalitarian ambition of the savage mind." So what is meant by that?

For one thing, this means that the discussed systems of classification itemize the "totality of things," "all details," and "all the facts of life" (Durkheim and Mauss 1963[1903]:83, 67, 14), consequently providing "a veritable arrangement of the universe" (ibid.:43). Secondly, the concept of totality refers to a kind of total determinism, characteristic of this thinking, which Lévi-Strauss wants to render plausible by referring, for instance, to Mauss and Henri Hubert's essay on magic (Lévi-Strauss 1973[1962]:11; see Mauss 2001[1904]). Accordingly, indigenous thinking "can be distinguished from science not so much by any ignorance or contempt of determinism but by a more imperious and uncompromising demand for it which can at the most be regarded as unreasonable and precipitate from the scientific point of view" (Lévi-Strauss 1973[1962]:11). One can therefore picture the "savage mind" as a space filled with a large number of elements in which each element is connected to every other one. The spatial change of an element would accordingly lead to a complete reformation of the network. This is why the total determinism of the "savage mind" not only entails the complexity of the science of the concrete and its drive to form homologies, but also its inability to isolate singular causal relationships.[28]

The characteristics of this "total thinking" can be demonstrated through the example of the Caduveo's facial paintings. These deal with what Lévi-Strauss calls *"organic wholes* wherein style, aesthetic conventions, social organization and religion are *structurally related"* (Lévi-Strauss 2006[1945]:71; emphasis added). Depending on which interpretation of Caduveo art one uses, different series of homologous levels emerge.

The 1945 essay concentrates on the splitting of representation and attempts to prove that this ultimately corresponds to the dualism of face and mask, of nature and culture, "person and impersonation, individual existence and social function, community and hierarchy" (ibid.:67). But further dualisms that are significant for society are also implied: for example that of art with and without physical objects, i.e., between wood carving and painting, which, in turn, is interlocked with the division of man and woman because the men are responsible for the carving of objects whereas the women are responsible for painting (see ibid.:62). In the end, one can actually follow this dualism up "to its most abstract

expression" because even here this dualism finds itself represented by "the social and supernatural orders" (ibid.:67, 69).

In *Tristes Tropiques*, the interpretation is targeted more toward the structural entanglement of the artworks' composition principles, the unconsciously desired rules of kinship organization, and differences in the social structure of Caduveo society. The asymmetries in the facial drawings correspond to vertically differentiated classes, whereas the desired kinship organization through moieties is mirrored in the symmetry of the overall composition of the cosmetic representation.

Both analyses—which are not contradictory according to Lévi-Strauss (see Lévi-Strauss 1973[1962]:190)—demonstrate the totality and the striving for homology which distinguish the "savage mind." The paintings are a medium, a combination of mnemonic and corporal techniques that concurrently symbolize and maintain social order. With Mauss, they can be understood as "'total' social phenomena" because within them "all kinds of institutions are given expression at one and the same time" (Mauss 1999:3): the facial art is not reduced to its aesthetics; instead, dimensions of the religious, legal, moral, political, and aesthetic intersect inseparably within it.[29] At the same time, the manner of this intersection is not coincidental. Quite the opposite, the various relational systems of differences (see Lévi-Strauss 1969[1962]:149f.) correspond to each other and exhibit a homologous relationship: that means that the proportion of graphic elements in the drawings corresponds to the proportion of natural and social individuals or to the proportion of classes to one another etc. Accordingly, the Caduveo practice a sort of total art.

While Lévi-Strauss, along with Durkheim and Mauss, can therefore account for Caduveo art as intellectually sophisticated and striving for homology, he would reject any explanation that draws on the instrumental or "affective" value of these works. Moreover, similarly to myths, the arts even represent a predestined area of research for him in which a critique of such modes of explanation can be formulated. This is also true for the fine arts. It may be true that indigenous art, in contrast to Western art, is mostly bound to functional objects (see Lévi-Strauss 1973[1962]:27–28). Nonetheless, their composition largely defies external constraints.[30] Just like the many examples of complex classifications from *The Savage Mind* (see ibid.:4ff.) that also capture the non-useful, the aesthetic composition of useful objects is also explained not by instrumental action, but within the context of a symbolically organized scheme of meaning. Only within this scheme could one reflect meaningfully on utility maximizing actions of people or societies. In short: culture, not practical reason, is in play here (see Sahlins 1978).

At the same time, these art forms are in no way affective and irrational. They are not based on incomprehensible emotions of the native but are means of recognizing and expressing differentiated thoughts. Despite their foreignness they can—contrary to the ideas of Lévy-Bruhl—be

meaningfully interpreted by anthropologists. But not only that: precisely because these artworks appear so foreign, and precisely because they are largely independent of concrete usefulness and external constraints, Lévi-Strauss contends that they lend themselves to uncovering the universal principles of the mind. Because what is valid in the analysis of myths is valid here as well: If the creations of the human mind that are the most foreign, the most free of external constraints, and the most free of usefulness are subject to an order, then this order must be universal. Therefore, despite their otherness, indigenous art and, with it, the "savage mind" on the whole obeys the same fundamental rules as domesticated thinking.

III

In the first section of this study it could be demonstrated that Lévi-Strauss's reflections on art in his early writings were strongly influenced by the Durkheim school. This cannot be readily seen in the references found in the texts. It becomes apparent, however, in his general ethnographic approach, in his way of argumentation and in certain central concepts drawn upon for the analyses. From a wider perspective, however, the fine arts can be seen as a kind of *pars pro toto*, i.e., as only one (albeit methodologically privileged) cultural area among others whose analysis might reveal the characteristics of the "savage mind." For this reason, by using this part of his work it could be proven in the second section of this essay that Lévi-Strauss's entire anthropology of knowledge stands in the tradition of the Durkheim school. The imprint of Durkheim's and Mauss's writings is recognizable negatively in Lévi-Strauss's opposition to theories like those of Malinowski and Lévy-Bruhl. It is therefore not surprising that he draws on significant concepts of Durkheim, and especially Mauss, in order to support his criticism. In a positive way, points of agreement can be established on the common characterization of indigenous thinking by means of its striving for homology and its totality, something which was reemphasized with the example of Caduveo painting.

Consequently, we have to conclude that the effects of Durkheim and Mauss on the work of Lévi-Strauss can in no way be reduced—as often happens with respect to Mauss—to his important contributions to the anthropology of kinship. It is much more the case that also his writings on art in particular and his works on classification and knowledge in general would have been inconceivable without the *durkheimiens*. The fact that Lévi-Strauss was in contact with Mauss since the beginning of the 1930s and was directly advised by the latter in his field research supports this view.

The insight into the enormous effect of the Durkheim school on Lévi-Strauss's work must not, however, conceal the important differences

between Durkheim and Mauss on the one side, and Lévi-Strauss on the other. To name the most important ones: firstly, in contrast to Lévi-Strauss, in their essay on classification Durkheim and Mauss formulate a quasi-evolutionary narrative, beginning with the "rudimentary classifications" characterized by "mental confusion" and an "indifferentiation," proceeding to increasingly complex "primitive" classifications that finally join "with no break in continuity" with scientific thinking (Durkheim and Mauss 1963[1903]:9, 6, 6, 81). Secondly, Lévi-Strauss (see above all 1969[1962]:141f.) vehemently criticizes the "theory of affectivity" that—as could be seen—was hinted at in the essay on "primitive classifications," but later would play an especially important role in Durkheim's *The Elementary Forms of Religious Life*.[31] Thirdly, unlike Durkheim and Mauss, Lévi-Strauss presents not a sociology, but an anthropology of knowledge. Lévi-Strauss would not agree with the radical thesis that "the first logical categories were social categories" (Durkheim and Mauss 1963[1903]:82).[32] Instead, he would insist on the anthropological universality of intellectual activity, which in turn is the basis of all social categorizing.[33] Accordingly, Lévi-Strauss would distance himself strictly from a causal argumentation that takes its start from the social organization and views the other homologous levels as consequences of these fundamental social categories.[34] Hence, despite its close kinship to the Durkheimians, Lévi-Strauss's anthropology represents a clear departure from their sociology of knowledge.

In light of Lévi-Strauss's early analyses of indigenous art that precede (and later accompany) the influence of structuralism, it could be shown that the often-presented picture of the isolated intellectual and the born structuralist is inapplicable. This often accepted and seldom questioned picture, which is widespread especially due to the considerable effect of Lévi-Strauss's *Tristes Tropiques* (1974[1955]), largely ignores the scientific influences and the institutional context of his ethnographic expeditions and early writings:

> [D]espite his attempt to project an image as an alienated outsider, there is ample evidence that Lévi-Strauss himself was already taking part in a corporate existence by the 1930s and 1940s and that he went to rather great lengths in *Tristes Tropiques* to hide this fact. . . . He also chose to minimize his own involvement with other professional anthropologists and often created the false impression that he was working completely on his own. There is only a single rather vague reference to the institutional sources of financial support for his expedition, and, in contrast to the descriptions of his professors at the Sorbonne, there is no real discussion about his contacts to Marcel Mauss, Lévy-Bruhl, and other prominent French anthropologists of the period. (Pace 1986:37f.)

We agree with Pace. Neither Levi-Strauss's self-representation nor Descola's interpretation of his intellectual development are convincing.

Descola underestimates the theoretical underpinnings of the (ethno-graphic) experience in favor of an object of research that ostensibly speaks for itself; and Lévi-Strauss projects the result of his intellectual development onto its beginnings. Both interpretations concur in one specific respect, however, because they promote and confirm an established picture of Claude Lévi-Strauss: that of a lone and brilliant researcher who found his own way to his structural anthropology through confrontation with the naked object, independent of scientific influences, or personal research contexts, following only his "neolithic kind of intelligence" (Lévi-Strauss 1974[1955]:53; Lévi-Strauss and Eribon 1988:vii).

Meanwhile, an analysis of Lévi-Strauss's reflections on art reveals that his mind was anything but a blank sheet of paper when he began his field research in Brazil. Quite the opposite: as his ethnographic texts and his correspondence with Marcel Mauss attest, his field research followed very specific guiding concepts, significant parts of which he took from the work of the Durkheim school.

Notes

We would like to thank Karen Pommer for the translation of this paper, Erwin Stolz and Martin Griesbacher for the painstaking search for all the English citations and Amy Koerner for important final corrections of the draft. For helpful comments we would like to thank Marcel Hénaff.

1. Lévi-Strauss himself also collected indigenous art in New York and maintained a lively exchange with the Surrealists about it (see Lévi-Strauss, Eribon 1988:33f.).
2. This is particularly true for extensive sections of *Conversations with Claude Lévi-Strauss* by Georges Charbonnier (Charbonnier 1969[1959]), the first chapter of *The Savage Mind* (1973[1962]), his critique of Picasso ([1966] see Lévi-Strauss 1983a[1973]:276ff.) and the "Ouverture" to the *The Raw and the Cooked. Mythologiques Volume One* (1964[1983b]:14–32). In *Look, Listen, Read* (1997[1993]) on the other hand Lévi-Strauss occupies himself exclusively with "modern" art, whereby for him, this term generally comprises Greek art after the fifth century BC and Italian art starting with the fifteenth century AD (see Charbonnier 1969:57).
3. Lévi-Strauss's contact to Jakobson—and thereby to structuralism—dates from the year 1942 (Hénaff 1998:251). The first genuinely structuralist essay "Structural Analysis in Linguistics and in Anthropology" appears in 1945 in the periodical *Word* (see Lévi-Strauss 1963[1958]:31–54).
4. By focusing on the Durkheim school, we do not negate the influence of other currents on Lévi-Strauss's positions in art or classification theory as, for example, that of Franz Boas and his school. This, however, would necessitate a longer and more extensive study.
5. Lévi-Strauss conveys the portrayal of the "unconscious structuralist" in various ways. Whereas he reports his mother's story in *Myth and Meaning* (1978) in which he "structurally" analyzed words based on their graphic appearance before he could read (see Lévi-Strauss 1978:8, 11), in *Tristes Tropiques* (see Lévi-Strauss 1974[1955], S. 56ff.) his structuralism already seems prefigured by his youthful interest in geology, psychoanalysis and Marxism (see also Massenzio, Lévi-Strauss 2001:420). Another version can be found in the documentary *Claude Lévi-Strauss*, broadcast on November 24, 2008 on the

German–French television channel *arte*, where Lévi-Strauss reports that he understood structuralism in a sudden flash while looking at a blowball. Following this self-inter- pretation, Jakobson's "revelation" of structuralism only made explicit and conscious what previously was an unconscious and "naive structuralism" (Lévi-Strauss, Eribon 1988:41). Lévi-Strauss's intentional contouring of a very particular image of himself is analyzed particularly by David Pace (see 1986:1–40). Targeted omissions and emphases regarding one's own intellectual biography belong to this strategy—as Pace establishes especially in Lévi-Strauss's autobiographical work *Tristes Tropiques*.

6. On the ethnography of the Amazonians, Descola says: "The type of ethnography that was done [in Amazonia] was very down-to-earth—a pity because if these societies appear very simple, they are actually extremely complex. They couldn't be understood by traditional approaches. Thus, there is no functionalist anthropology of the Amazon! That was twenty years ago. This is not because there were few British in the Amazon. It is because the material doesn't lend itself to that type of approach. It lends itself more to structuralism." (Knight and Rival 1992:12) Descola is not only a student of Lévi-Strauss, but also, as current director of the *Laboratoire d'anthropologie sociale*, in some ways his successor.

7. Lévi-Strauss's expeditions in central Brazilian Mato Grosso followed in the years 1935/36 and 1938 (see Hénaff 1998:247ff.).

8. Lévi-Strauss did not develop a systematic theory of art. Art serves much more as a subject matter used to develop anthropological ideas. "What he has given us are a series of incisive observations on the nature of aesthetics as a cultural phenomenon" (Heyer 1972:33) (see also Vazan and Heyer 1974:202). For that reason, in the text (as well as in the title of the essay) we use terms such as "considerations," "reflections," or "observa- tions" in art theory.

9. The ethnographic parts of *Tristes Tropiques* are viewed in part as "early writings" here as a substantial portion of them is taken from early articles with varyingly substantial changes. For example, sections of the ethnographic articles on the Nambikwara (esp. Lévi-Strauss 1943b, 1967) were included extensively and partly almost without revi- sion in Lévi-Strauss's 1948 monograph *La Vie familiale et sociale des Indiens Nambikwara* (1948) which he submitted for his doctorate as "thèse complémentaire" (*The Elementary Structures of Kinship* formed the "thèse principale") (see Lévi-Strauss, Eribon 1988:50f.). This ethnographic study, however, already originated in the course of the year 1941 (see Lévi-Strauss and Eribon 1988:31; Hénaff 1998:250), in other words even before the article was even published. Sections of this monograph (and with them, the essays) were then later taken again for *Tristes Tropiques* (see Lévi-Strauss 1974[1955]:300–4; 309–17). In part, however, explanations and theses can be found in corresponding pas- sages of *Tristes Tropiques*, which go beyond what was presented in the articles. These passages frequently contain clearly stronger and more speculative theses, which would surely have been too daring for the more substantive ethnographic essays, but possibly and in part were also developed only later.

10. It is to be noted here that not all objects are decorated with reference to the social organi- zation. It is much more that this artistic principle applies primarily to the ceremonial objects. Of the three types of bows known to the Bororo, it is only the hunting and cer- emonial bows, but not the conventional bows that are marked, whereas of the four types of arrow, only the one produced for the jaguar hunt bears a coat-of-arms in the feather- ing. The decorated penis sheaths are also only to be worn in the setting of ceremonies.

11. This connection is also mentioned by Edmund Leach in a review of Rodney Needham's English translation of the classification essay: "That the nature of primitive society must be closely linked with the nature of *la pensée sauvage*, and that the categories of this *pensée sauvage* may be very different from our own was first seriously considered by Durkheim and Mauss in an essay published in *L'Année sociologique* in 1903" (Leach 1964:61).

12. In addition to the correspondence to the classification essay by Durkheim and Mauss, noticeable similarities can be established between Lévi-Strauss's analysis of the Bororo and Mauss's study on the "Seasonal Variations of the Eskimo" (see Mauss 2004[1906]). In this work, Mauss deals primarily with the examination of the sociocultural consequences of the "double morphology" of the Inuit and with the social law standing behind it. The relationship between social and logical categories plays a lesser role here. The organization of the Inuit in core families (as opposed to a kinship structure stemming from marriage classes) would complicate such proof considerably. The similarities between Lévi-Strauss's Bororo essay and Mauss's study of the Inuit can especially be established through two facts. First, Mauss's study devotes more attention than the classification essay to the relationship between social morphology and the handling of material things (see ibid.:70ff.). The same is true for the examination of the meticulous system of obligations, which Lévi-Strauss studies in Bororo society (Lévi-Strauss 1936:286–88; 1974:229). The other—and even more apparent—fact is the resemblance to Mauss in the description of the Bororo's division of the day in an intensively religious phase in the night and a secular phase during the day (see Lévi-Strauss 1974[1955]:218f.). This rhythm of social life, viewed by Mauss as a general social law, is the central object of the study on the Inuit: "Furthermore, though this major seasonal rhythm is the most apparent, it may not be the only one; there are probably other lesser rhythms within each season, each month, each week, each day. Each social function probably has a rhythm of its own." (Mauss 2004[1906]:79)—That these two essays of the Durkheim school have a special meaning for Lévi-Strauss can be seen in his article "French Sociology". Lévi-Strauss (1945:512) praises the "pioneer achievement" of Durkheim and Mauss. The classification essay, "though suffering from over-simplification, makes one regret that others did not follow the same direction." On the same page, Lévi-Strauss refers to Mauss's study on the Inuit as a "jewel" of French Social Anthropology. For a more general discussion of Mauss's work see Moebius 2006a.

13. In the essay on Northwest coastal art, for example, Lévi-Strauss already expressed criticism of Paul Rivet's famous tenet concerning a pre-Columbian contact between Polynesia and America (see Lévi-Strauss 1943a:179ff.; see also 2006:56). On the other hand, he relates positively to another founder of the *Institut d'ethnologie*. Mentioning his essay on the "Idea of the Person," Lévi-Strauss points out that also "my master, Marcel Mauss, chose to suggest that everything in the art and customs of the Northwest evoked for him a mysterious and very primitive China" (Lévi-Strauss 1943a:178).

14. A very similar formulation occurs in the 1955 article on "The Structural Study of Myth": "Therefore the problem: If the content of a myth is contingent, how are we going to explain the fact that myths throughout the world are so similar? It is precisely this awareness of a basic antinomy pertaining to the nature of the myth that may lead us toward its solution" (Lévi-Strauss 1963[1958]:208).

15. On closer inspection of the artwork, this assumption may be unconvincing in its generality. In regard to the art of the northwest coast, for example, various authors affirm the meaning of the symmetry (for example, see Holm 1965:84ff.). However, the idea that the symmetry generally arises from the interplay of two profiles, as Lévi-Strauss along with Boas assumes, is not generally shared. With respect to the Maori, it remains an assumption (Lévi-Strauss 2006[1945]:65f.) without evidence or proof. If one looks at the tattoos, no profiles can be discerned. For the Caduveo, this assumption is also less than convincing—it can be plausibly applied to only one drawing (figure 2.2. in Lévi-Strauss 2006[1945]:59), whereby the conclusion is in no way imperative. In others, no profiles are distinguishable.

16. An ideal-typical drawing of a face by the Caduveo, as Lévi-Strauss imagines it, is asymmetric, if one mirrors it along a horizontal or vertical axis. With the exception of the mouth ornamentation, however, it is point symmetric from the intersection of both axes, which is found approximately at the root of the nose.

17. While reference to the cultural significance of the mask is hardly surprising with respect to the Northwest coast, it is far from obvious with regard to South America, Polynesia, and China. However, Lévi-Strauss also recognizes masquerade techniques in the facial tattoos of the Maori and Caduveo. Concerning China, he points out clues to the earlier meaning of the mask in literature (see Lévi-Strauss 2006[1945]:68).

18. To name an example, at the beginning of the nineteenth century, fewer than 10 percent of the people belonging to a Guaicuru group did so due to blood ties (see Lévi-Strauss 1974[1955]:182). In regard to the Caduveo, Lévi-Strauss even speaks of an "inverted racialism" (ibid.:195).

19. The interplay of hierarchy and reciprocity in the Bororo, which allegedly corresponds to the symmetry and asymmetry in the Caduveo drawings, is described more precisely by Lévi-Strauss in his earlier article "Reciprocity and Hierarchy" (1944a). He attempts to explain the dual organization of the Bororo and other societies in "On Dual Organization in South America" (1944b).

20. Carroll criticizes Lévi-Strauss for also ascribing a "strain towards reciprocity" along with a "strain towards hierarchy" to the Mbaya and the Caduveo in *Tristes Tropiques*, against ethnographic evidence (Carroll 1979:179f.): "It is his [Lévi-Strauss's] hypothesis that the opposition between symmetry and asymmetry in Caduveo design reflects this opposition between hierarchy and reciprocity in their social structure" (ibid.:180). However, his criticism completely mistakes Lévi-Strauss's argumentation which actually maintains that the symmetry in Caduveo art expresses the unconscious desire for the *nonexistent* reciprocal organization of kinship in Caduveo society.

21. To some extent, these thoughts were already included in the essay of 1945. On the one hand, he maintains at the end of the study that one can certainly draw conclusions from the artwork about social structure and historical changes of the social order, etc. (see, for example, Lévi-Strauss 2006[1945]:69). On the other hand, he comments on the Caduveo art that the "baroque and affected quality would thus represent the formal survival of a decadent or terminated social order" (ibid.).

22. Similar to the Caduveo paintings, Lévi-Strauss emphasizes not only the symbolizing, but also the preserving function of the village structure: "Once they had been deprived of their bearings and were without the plan which acted as a confirmation of their native lore, the Indians soon lost any feeling for tradition; it was as if their social and religious systems . . . were too complex to exist without the pattern which was embodied in the plan of the village and of which their awareness was constantly being refreshed by their everyday activities" (Lévi-Strauss 1974[1955]:221).

23. Mauss's influence on Lévi-Strauss can already be determined at least ten years before that of structuralism. Mauss influenced Lévi-Strauss from the very beginning of his education and field research. This is shown, for example, in a letter of October 4, 1931 in which Lévi-Strauss asks Mauss for advice for his ethnographic studies, or in another letter out of São Paulo on March 14, 1936 in which Lévi-Strauss thanks Mauss for his advice (see Fonds Hubert-Mauss, IMEC, Box MAS 8.3.). The early exchange with Mauss is of special interest because in *Tristes Tropiques* Lévi-Strauss claims that he was an "avowed anti-Durkheimian" (Lévi-Strauss 1974[1955]:63) when arriving in Brazil in 1935. In his biography of Lévi-Strauss, Bertholet writes that Lévi-Strauss came in contact with Durkheim through Paul Fauconnet in late 1930 or early 1931. According to Bertholet he "hated" Durkheim at this time (cf. Bertholet 2003:46ff.). Hénaff claims that only when he had to teach Durkheim in São Paulo as a requirement of the curriculum he started to develop a great admiration for his work (cf. Hénaff 1998:247). Hence, Lévi-Strauss's contact with Mauss and his developing admiration for Durkheim pre-date or accompany his first ethnographic experiences. Later, Lévi-Strauss even claimed that "I am probably at this moment [i.e., ~1955] nearer than any of my colleagues to the Durkheimian tradition" (Lévi-Strauss 1974[1955]:63). In 1958 he even dedicated his *Structural Anthropology* to Durkheim. For Lévi-Strauss's view on

Durkheim see also his article on the occasion of the centennial of Durkheim's birthday (Lévi-Strauss 1983a[1973]:44–48).

24. Consequently, Malinowski's and Lévy-Bruhl's descriptions of the "savage mind"— and this can easily be found in their respective explanations of totemism—differ in that, as Lévi-Strauss states, the former conceptualizes this thinking as "coarser" and purely instrumental and the latter as "fundamentally different" in comparison to "our thinking" (see Lévi-Strauss 1978:15f.). It should be noted that Lévy-Bruhl's analysis deals with individual totemism while Malinowski analyses collective totemism. This blend of logical equal yet differing "totemisms" is one of the fundamental problems of the "totemistic illusion" that Lévi-Strauss wants to put an end to (see Lévi-Strauss 1969[1962]:83ff.).

25. The position of Lévy-Bruhl also led to controversies with the Durkheim school. Durkheim, Mauss, Robert Hertz, Henri Hubert, and Lévy-Bruhl met regularly at the *Institut d'anthropologie* founded in 1911. In 1925, Mauss founded the *Institut d'ethnologie de l'université Paris* together with Lévy-Bruhl and Paul Rivet. For more on Lévy-Bruhl, see Cazeneuve (1972) and Moebius (2006b:81–84).

26. See also the critique of Lévy-Bruhl in Durkheim's *The Elementary Forms of Religious Life* (Durkheim 2001[1912]:182).

27. In the French original Lévi-Strauss writes that "Durkheim et Mauss ont médité sur les *classification totales* de certaines tribus" (Lévi-Strauss 1962:77; emphasis added).

28. Lévi-Strauss (1973[1962]:10) makes this clear with an example: "This preoccupation with exhaustive observation and the systematic cataloguing of relations and connections can sometimes lead to scientifically valid results. The Blackfoot Indians for instance were able to prognosticate the approach of spring by the state of development of the foetus of bison which they took from the uterus of females killed in hunting. These successes cannot of course be isolated from the numerous other associations of the same kind which science condemns as illusory."

29. It is fitting her that Lévi-Strauss refers to Mauss's concept of the "total social fact" as the *"credo* of contemporary ethnology" in his 1953 overview article "Panorama of Ethnology." He continues: "However different in their methods, all these works arrive at the common conclusion, first proposed by Marcel Mauss, viz., that any social system forms a whole and that it is impossible to understand any one aspect (economic life, religion, social institutions, art, etc.) without considering it in function of the whole" (Lévi-Strauss 1953:85). For more, see also his "Introduction to the Work of Marcel Mauss" (1987:24ff.). See Moebius (2006a:129–36) for the effects of Mauss on the social and cultural sciences in general.

30. In contrast to the privileged art form of music, the fine arts always remain tied to a certain degree to the demands of the material (see Lévi-Strauss 1973[1962]:27). Contrary to music with its "unnatural" tones, even their basic elements—color and form—are subject to the constraints of nature (see Lévi-Strauss 1983b[1964]:18ff.). For Lévi-Strauss this difference justifies the "privileged place" (Lévi-Strauss 1983b[1964]:18) that he grants to music above painting or sculpting. Therefore music would actually be the equivalent to myth. Nevertheless, the fine arts also remain free in such a measure that the inability to reduce the indigenous intellectual activity to usefulness and affect can clearly be detected by them. For a critique of Lévi-Strauss's hierarchization of the arts see Brenner 1977.

31. On Durkheim's argumentation in the *Elementary Forms* Lévi-Strauss (1969[1962]:141f.) writes: "[I]n the last analysis Durkheim derives social phenomena as well from affectivity. His theory of totemism starts with an urge, and ends with a recourse to sentiment. . . . But Durkheim's theory of the collective origin of the sacred . . . rests on a *petitio principii*: it is not present emotions, felt at gatherings and ceremonies, which engender or perpetuate the rites, but ritual activity which arouses the emotions." For more, see Joas's (1993:64) objection to Lévi-Strauss's critique. For the crucial role played by other

Durkheimians (especially Mauss) in the genesis of Durkheim's later sociology of religion see Moebius 2012.

32. The most influential and detailed critique of Durkheim and Mauss's argumentation was formulated by Rodney Needham (1963).

33. As if in the presence of Lévi-Strauss, Durkheim (1998:320) formulates this difference in a letter to Mauss in the spring of 1902: "The mental operation called classification was not formed in one piece by the human brain. Thus, something has to be responsible for bringing the people to classify the world. The genera are not contained in the things. They are created. . . . From this we can conclude that the logical hierarchy unintentionally reflects the social hierarchy." Translation by the authors.

34. This difference—just as the other two—becomes obvious only in the later writings. In his early ethnographic work Lévi-Strauss is not that much concerned with these rather theoretical questions. Here, he focuses on the empirical homologies between different layers of the ethnographic material (therefore, one cannot say for sure whether or not he would have agreed with Durkheim and Mauss at that time). The question how exactly the relationship between these homologous layers can be analyzed becomes a major task after his early ethnographic phase. Inspired by the structuralism of Jakobson he develops a "linguistic model" which later—in the *Mythologiques*—is replaced by the "musical model" which focuses on the concept of transformation. "Transformation," in turn, means both transposition (between different homologous layers) and variation (production of the new forms) (for more on this see Hénaff 1998:159–89).

References

Bertholet, Denis. 2003. *Claude Lévi-Strauss*. Paris: Plon.

Brenner, Art. 1977. "The Structuralism of Claude Levi-Strauss and the Visual Arts." *Leonardo*, 10(4): 303–6.

Carroll, Michael P. 1979. "Lévi-Strauss on Art: A Reconsideration." *Anthropologica*, 21(2): 177–88.

Cazeneuve, Jean. 1972. *Lucien Lévy-Bruhl*. New York et al.: Harper & Row.

Charbonnier, Georges. 1969. *Conversations with Claude Levi-Strauss*. London: Cape.

Deliège, Robert. 2004. *Lévi-Strauss Today*. Oxford et al.: Berg.

Durkheim, Émile. 1998. *Lettres à Marcel Mauss*. Paris: Presses Universitaires de France.

———. 2001[1912]. *The Elementary Forms of Religious Life*. New York: Oxford University Press.

———. 1963. *Primitive Classification*. Ed. Rodney Needham. London: Cohen & West.

Hénaff, Marcel. 1998. *Claude Lévi-Strauss and the Making of Structural Anthropology*. Minneapolis: University of Minnesota Press.

Heyer, Paul. 1972. "Art and the Structuralism of Claude Lévi-Strauss." *The Structurist*, 12: 32–37.

Holm, Bill. 1965. *Northwest Coast Indian Art*. Vancouver; Toronto: Douglas & McIntyre.

Joas, Hans. 1993. "Durkheim and Pragmatism: The Psychology of Consciousness and the Social Constitution of Categories." In: Id.: *Pragmatism and Social Theory*. Chicago: University of Chicago Press, 55–78.

Kauppert, Michael. 2008. *Claude Lévi-Strauss*. Konstanz: UVK.

Keck, Frédéric. 2005. *Claude Levi-Strauss, une introduction*. Paris: Pocket.

Knight, John, and Laura Rival. 1992. "An Interview with Philippe Descola." *Anthropology Today*, 8(2): 9–13.

Leach, Edmund. 1964. "Review of Primitive Classification." *Man*, 64: 61.

———. 1974. *Claude Levi-Strauss*. Chicago: University of Chicago Press.

Lévi-Strauss, Claude. 1936. "Contribution à l'étude de l'organisation sociale des Indiens Bororo." *Journal de la Société des Américanistes*, 28(2): 269–304.
———. 1942. "Indian Cosmetics." *VVV*, 1: 33–35.
———. 1943a. "The Art of the Northwest Coast at the American Museum of Natural History." *Gazette des beaux-arts*, 24: 175–82.
———. 1943b. "Guerre et commerce chez les Indiens de l'Amerique du Sud." *Renaissance: revue trimestrielle*, 1(1–2): 122–39.
———. 1944a. "Reciprocity and Hierarchy." *American Anthropologist* (New Series), 46(2): 266–68.
———. 1944b. "On Dual Organization in South America." *America* 1751–82. *Indigena*, 4(1): 37–47.
———. 1945. "French Sociology." In *Twentieth Century Sociology*. Eds. Georges Gurvitch, Wilbert E. Moore. New York: Philosophical Library, 503–37.
———. 1948. *La vie familiale et sociale des indiens Nambikwara*. Paris: Sociéte des Américanistes.
———. 1953. "Panorama of Ethnology 1950–1952". *Diogenes*, 1(2): 69–92.
———. 1962. *La pensée sauvage*. Paris: Plon.
———. 1963[1958]. *Structural Anthropology. Volume 1*. New York: Basic Books.
———. 1967[1944]. "The Social and Psychological Aspects of Chieftainship in a Primitive Tribe: The Nambikuara of Northwestern Mato Grosso." In *Comparative Political Systems; Studies in the Politics of Pre-Industrial Societies*. Eds. John Middleton, Ronald Cohen. Garden City, N.Y: Published for the American Museum of Natural History [by] the Natural History Press, 45–62.
———. 1969[1962]. *Totemism*. Harmondsworth: Penguin Books.
———. 1973[1962]. *The Savage Mind*. Chicago: University of Chicago Press.
———. 1974[1955]. *Tristes Tropiques*. New York: Atheneum.
———. 1978. *Myth and Meaning: Five Talks for Radio*. Toronto; Buffalo: University of Toronto Press.
———. 1982[1975]. *The Way of the Masks*. Seattle: University of Washington Press.
———. 1983a[1973]. *Structural Anthropology. Volume 2*. Chicago: University of Chicago Press.
——— 1983b[1964]. *The Raw and the Cooked. Mythologiques Volume One*. Chicago: University of Chicago Press.
———. 1987[1950]. *Introduction to the Work of Marcel Mauss*. London: Routledge.
———. 1997. *Look, Listen, Read*. New York: Basic Books.
———. .2006[1945]. "Split Representation in the Art of Asia and America." In *The Anthropology of Art. A Reader*. Eds. Howard Morphy, Morgan Perkins. Oxford: Blackwell Publishing, 56–73.
Lévi-Strauss, Claude, Didier Eribon. 1988. *Conversations with Claude Lévi-Strauss*. Chicago: University of Chicago Press.
Lévy-Bruhl, Lucien. 1966. *Primitive Mentality*. Boston: Beacon Press.
Malinowski, Bronislaw. 1948. *Magic, Science and Religion and Other Essays*. Boston: Beacon Press.
———. 1965[1944]. *A Scientific Theory of Culture and Other Essays*. Chapel Hill: The University of North Carolina Press.
Massenzio, Marcello, Claude Lévi-Strauss. 2001. "An Interview with Claude Lévi-Strauss." *Current Anthropology*, 42(3): 419–25.
Mauss, Marcel. 1999[1925]. *The Gift: The Form and Reason for Exchange in Archaic Societies*. London: Routledge.
———. 2001[1904]. *A General Theory of Magic*. London: Routledge.
———. 2004[1906]. *Seasonal Variations of the Eskimo. A Study in Social Morphology*. London: Routledge.
Moebius, Stephan. 2006a. *Marcel Mauss*. Konstanz: UVK.

————. 2006b. *Die Zauberlehrlinge: Soziologiegeschichte des Collège de Sociologie*. Konstanz: UVK.

————. 2012. "Die Religionssoziologie von Marcel Mauss." In *Schriften zur Religionssoziologie*. Marcel Mauss. *Hg. und eingeleitet von Stephan Moebius, Frithjof Nungesser und Christian Papilloud*. Berlin: Suhrkamp, 617–82.

Needham, Rodney. 1963. "Introduction." In *Primitive Classification*. Émile Durkheim, Marcel Mauss. Ed. Rodney Needham. London: Cohen & West, vii–xlviii.

Pace, David. 1986. *Claude Lévi-Strauss. The Bearer of Ashes*. London: Routledge.

Reinhardt, Thomas. 2008. *Claude Lévi-Strauss zur Einführung*. Hamburg: Junius.

Sahlins, Marshall. 1978. *Culture and Practical Reason*. Chicago: University of Chicago Press.

Vazan, William, and Paul Heyer. 1974. "Conceptual Art: Transformation of Natural and of Cultural Environments." *Leonardo*, 7(3): 201–5.

Chapter 10

Sex, Death, the Other, and Art
The Search for Mythic Life in the Work of Michel Leiris

Alexander Riley

The only goal of the work of art is the magical evocation of inner demons
... Art as play impregnated with religion. Art, the bastard child of play and
religion. (Michel Leiris, *L'Homme sans Honneur*, 50, 149)

Michel Leiris is perhaps the single most important writer working at the
shadowy interstices between the human sciences and literature. Should
they so desire, readers who know French will doubtless find some ground
for opposing this claim, as there exist a number of twentieth-century
French writers who, like Leiris, insisted on ignoring orthodox boundaries
between the two realms and succeeded in their lifework in establishing
unique constellations of connections between them. Some of the giants of
the post-1968 generation who achieved international recognition could be
discussed here: Foucault, Derrida, and Baudrillard explored the philos-
ophy and theory of the social sciences while simultaneously pursuing
writerly projects and questioning the way in which we write about the self
and the social. Some with less widely extended reputations who nonethe-
less would be a part of this conversation include Edgar Morin and Jean
Duvignaud, sociologists with strong connections to artistic worlds. Morin
wrote about cinema and, with Jean Rouch, made the groundbreaking eth-
nographic film *Chronique d'un été*; Duvignaud was intimately involved in
the world of Parisian theater and wrote several novels. But the assertion
that Leiris is chief among these writers in the contribution his work makes
toward the weakening of the traditional understanding of the radical dif-
ference of social-scientific writing and literature per se will be recognized
by informed readers as at least defensible, if not self-evident. What comes
in the remaining pages of this chapter is intended to stand as the case in
defense of the assertion.

Leiris is, at his core, a Durkheimian thinker, though this simple statement will require some work to be made comprehensible to those with only a passing knowledge of his work. There exists a renegade Durkheimian genealogy, a way of thinking about society and especially about the key conceptual tool of Durkheimian sociology, the sacred, that is distinct from the thought of Durkheim himself and his orthodox interpreters. This is a rather complicated bit of intellectual history, which I have treated in more depth elsewhere (Riley 2010), that might be summarized as follows. A set of key intellectual, political, and aesthetic positions distinguishes the meaning of the work of Durkheim himself from a group of his students, beginning with Marcel Mauss, Robert Hertz, and, to a lesser degree, Henri Hubert, and leading through some of Mauss's students of the 1920s and 1930s, and including Leiris. This renegade Durkheimianism approached the study of society and the construction of an intellectual identity in a manner that differed in important ways from that of Durkheim himself. In brief, it was drawn to the impure, instead of the pure, sacred (the former evident in the transgressions of popular festivals; the latter in the revered entities and symbols of orthodox religious practice), radical political engagement rather than ascetic scholarly withdrawal from practical politics, and the celebration and construction of aesthetic and artistic projects rather than positivist suspicion of art (ibid.:174–200). In the first generation of this renegade Durkheimian tradition, i.e., Mauss, Hubert, and Hertz, the distinctions were still more or less embryonic and require considerable exegetical effort to demonstrate clearly. By the 1930s, the staid anti-aesthetic positivism of Durkheim (or at least of an orthodox reading of Durkheim) had been significantly modified by figures in the radical avant-garde, who were drawn to both modernist aesthetics and the radical possibilities of the Durkheimian rethinking of society and the sacred. Georges Bataille, who is the subject of two chapters in the present volume, is undoubtedly the best known of this group, but Leiris is the most direct descendant in the renegade Durkheimian line. As a student of Mauss and a practicing ethnographer, his connection to French ethnology is far more direct than Bataille's, and his involvement with literary and artistic modes of expression and movements is at least as strong, and in some ways stronger.

Leiris's connection to the Durkheimian school is first of all empirical and biographical. Durkheim died in 1917, too early for Leiris—who was born in 1901 and evinced no real interest in ethnography or the theoretical and conceptual language of French sociology until the 1920s—to have had personal contact with him. In the late 1920s and early 1930s, however, he attended the courses of Marcel Mauss at the Ecole Pratique, perhaps receiving instruction from the master on ethnological method for colonial administrators, missionaries, and explorers (Armel 1997:307). In *Frêle bruit*, the final volume of his massive autobiographical work *La Règle du jeu*, Leiris describes Mauss as "a French sociologist, whose pupil I was, and whom I am reluctant to call a 'sociologist', since to do so is to

mutilate him, to attach a label to this respected scholar" (Leiris 1976:35). His intellectual closeness and personal affection for Durkheim's nephew are poignantly indicated in the particular pain caused Leiris by Mauss's criticisms of his first book, *L'Afrique fantôme*, which Mauss considered to "lack scientific seriousness" (Armel 1997:349). In a letter to Georges Bataille that expressed criticisms of the direction of the Collège de Sociologie, the radical intellectual group of the late 1930s in which both were central participants, Leiris defended the French sociological school of "Durkheim, Mauss, and Robert Hertz" against those who would attempt to make insufficiently rigorous use of their theories, especially that having to do with the sacred: "Although I do not deny the importance of the sacred in social phenomena, its vital importance in our thinking, I believe that to emphasize as much as we have the role of this area of knowledge—to the point where we have even promoted the sacred to the position of our only explanation for certain phenomena—contradicts the Maussian notion of the 'total phenomenon'" (Leiris 1979:549). There are, Leiris goes on, two possible paths of development for the Collège: (1) as a "moral community" and (2) as a "a scholarly society devoted to research into pure sociology" (ibid.). Both are possible, he notes, and he could envision participation in either, but "a choice must be made, and if we are writing in the sociological tradition as established by Durkheim, Mauss and Robert Hertz, we must of necessity abide by that tradition's methods" (ibid.:549).

So Leiris must be considered a student of Mauss, and by extension also of Durkheim and Hertz, in at least the sense described above. His work from the early 1930s onward is saturated in his encounter with the central Durkheimian cultural sociological concept, the same one over which he had disputed with Bataille in the letter cited above: the sacred. Conceptually, during at least the final sixty years of his life, Leiris was doing Durkheimian work insofar as he was examining the sacred, in a number of different styles and genres but always with an eye on the renegade Durkheimian understanding of the concept. He was also investigating a central question about the relationship between writing and knowledge of the social world that would have presented itself almost inevitably for someone confronting the world of both literary and sociological production: How does the sociologist or ethnographer produce written knowledge of the Other? In his writing about the sacred and the Other and their relationship, Leiris was always, if sometimes in a manner requiring a bit of interpretive translation to see it, making pronouncements on art: on its status in a modern Western world wherein the sacred in its primitive forms is attenuated to the point of desiccation; on its relationship to religion and to social science; on its status as a practice and as a vehicle for the construction of a life; and on its capacity to respond to the one horror that threatens to make human dignity impossible, which is the reality of death.

The left sacred as the touchstone of the artistic life

In January 1938, Leiris gave a paper at a Collège de Sociologie meeting, a startling essay bearing the title "Le sacré dans la vie quotidienne." As Denis Hollier notes, at this point in his life, Leiris had written none of his socio-autobiographical works with the exception of *L'Afrique fantôme*, a peculiar journal of field notes from an African expedition, and *L'Age d'homme*, the essay that was to be the beginning of the massive auto-biographical work that would occupy him for the remainder of his life. The former was published in 1934, while the latter, though written the following year, would not be published until 1939. Hollier calls the essay for the Collège the "charnière" (hinge, or turning point) in Leiris's intel-lectual vision from his purely literary activity to his ethnographic work (1979:186). "Turning point" is perhaps not the best term here, at least not if we read it as implying a turning away from something toward some-thing else, for there was no turning away. There was simply an expansion of the definition of literature to encompass ethnography, and especially auto-ethnography of the kind Leiris produced over the course of the work on his lifelong masterwork *La Règle du jeu*. Traces of this project are appar-ent already in *L'Afrique fantôme*, as I will show shortly. But the full-blown project is only clearly presaged in the intellectual and writerly style of "Le sacré dans la vie quotidienne."

What exactly takes place in "Le sacré dans la vie quotidienne"? Leiris endeavors to delve back into his childhood to uncover some of the central symbolic structures that framed his perspective on the world, himself, and other people. As a renegade Surrealist, he had already digested much of the psychoanalytic flavor of that movement and had indeed himself undergone psychotherapy as part of his own project of self-understand-ing, so he saw structures emerging in childhood as of particular power in later life. The question he poses at the outset is "what does the sacred consist of *for me*?" (1979[1938]:60, emphasis in original), and the discern-ing reader notices immediately that Leiris has been reading Durkheim, Mauss, and Hertz, for sacredness is already binary in his understanding in just the way we find it in the Durkheimian school. In Leiris's family home in the sixteenth arrondissement in Paris, there were sacred objects and places of a distinctly pure variety, connected almost invariably to the paternal authority of the Father and/or the parental couple: the father's hat, which he hung up on a hat rack every night on returning from the bourgeois sacred activity of work; his Smith & Wesson revolver, ultimate manifestation of paternal might; the jeweled box (*porte-or*) in which he kept the gold coins that gave off a sacred glow not unlike that contained in the decorated shell jewelry that housed the spirits of ancestors and was exchanged in the Kula ring described by Mauss; the wood stove (*salaman-dre*), which provided food and warmth for the household; the parental bedroom, literally the site of generation of the family. Opposed to these

were impure objects and places: the W.C., where he and his older brother cleaned up every night and engaged in imaginative games and storytelling, forming what Leiris called a kind of secret society and frequently discussing the greatest of taboo subjects in a bourgeois French household of this time, sex; the "no man's land" of a semi-wooded field near his home which had to be traversed on the way to another transgressive sacred site, the Auteil race track, where games of blind chance decided the distribution of significant sums of wagered money (ibid.:73–74).

This brief but pregnant work was the first finished product to emerge from a notebook Leiris probably began compiling in the fall of 1937. He continued to add to the notebook even after the delivery of the talk at the Collège de Sociologie in early 1938 (Leiris 1994:27). It makes some sense to think of the finished essay as the presentation of some of the empirical material demonstrating the theory's utility, and the notebook as the site where the theory and conceptual language were most systematically elaborated. The contour of the sacred and its experience is carefully explored in the notebook. The sacred emerges at the moment there exists dichotomy, heterogeneity, a threshold (ibid.:93). It is exotic, "of a radically distant land" (ibid.:30). It is seemingly contradictory, both intimate and strange at once, and when one experiences it, one is at one and the same time "in communion to the maximum degree" and "most desperately alone" (ibid.:118). The experience of the sacred, in other words, permits apparent contradictions to be reconciled insofar as it is an experience of totality: "It is in the realm of the sacred that we are simultaneously the most ourselves and the most other. Because with the sacred, we are dealing with totality" (ibid.:89).

Throughout the notebook, the impure or left sacred takes precedence in Leiris's discussion. This is intimately tied to the sacrilegious, thus anyone who desires to be in touch with sacrality is called to transgression and sacrilege (ibid.:93). He refers to this impure sacred with a number of other terms, each paired with an equivalent of the pure, or right, sacred. The impure is also the "acute sacred," opposed to the "latent sacred," the latter of which consists in "the peace of that which protects the taboo" (ibid.:90), while the former shatters taboo. The sacrilegious sacred is connected to the strange, "'magical' world" of prostitutes, drug addicts, and madmen, "fantastic creatures" who are not of the "'religious' world" (ibid.:157). This further elaboration of the left/right sacred binary can be found, as I have described elsewhere (Riley 2010:160–64), in the work done by Mauss and Henri Hubert to distinguish the mechanisms that provide power to religion and magic, respectively. Elsewhere in *L'Homme sans Honneur*, the right and left sacred become "'good' and 'bad' infinity": "The 'heads or tails' of alcohol: sometimes, thanks to alcohol's enabling us to escape ourselves, it's good infinity, and the act of communion is successful; other times, the abyss yawns wide, alcohol serves to isolate— when one was within the compass, one now goes beyond it, everything

goes to pot, frays away . . . The same is true of women" (Leiris 1994:82). The pure is the petrified form of the sacred, while the impure is nascent: "Hence the need to study the sacred 'in its nascent state', rather than in its petrified forms (religion, fatherland, morality, etc.), which are the right sacred inasmuch as they are codified, and thus represent order, rules, the ideal norm" (ibid.:90, 93). He even endeavors to assign a color code to the psychology of the sacred: the "exaltation" of red denotes the right sacred, the "depression" of black the left, and white the profane (ibid.:42).

In a particularly powerful passage in the notebooks, Leiris recognizes the presence of death in every instance of the manifestation of the sacred in his own life: "If I honestly consider when I have truly had the impression of being 'in the sacred', it has only ever been when death was present" (ibid.:117). He then provides a number of examples, including his own suicide attempt in 1937 and the cultural spectacle of bullfighting, about which more shortly. A third example he provides is the (in)famous Saint-Pol-Roux banquet in 1925, where, at a Surrealist fête in honor of the Symbolist poet, Leiris was nearly lynched by a crowd, then beaten by the police who intervened to "save" him, after shouting anti-French epithets[1] out a window in response to jingoist insults aimed at his German friend Max Ernst. He mentions also the experience of watching another friend, the writer Collette Peignot (Laure), on her deathbed making the inverse sign of the cross as a provocation to Leiris and others present (who included her lover Georges Bataille):

> Real sacred horror: the cold shiver down my spine when I saw C. [Peignot] as she died half-making the sign of the cross (I should add: it was done the wrong way round – she touched one shoulder, then the other: and that was all. If one insisted, as Christians do, on interpreting the slightest word and gesture, this sign would have a blasphemous, demonic meaning) with an expression of joy and irony, like a little girl playing a silly joke on us all. Half-making it, not finishing it off, as though she had wanted to go to the edge, to scare us all. (Ibid.)

In this same section of the notebook, he wonders whether, if a hail of shells had fallen on them as they surrounded Laure on her deathbed, he would have had the required sense of honor to remain there or if he would have sullied the sacred moment by fleeing for his life (ibid.:118).

Death, then, is the supreme sacred entity and experience, and Leiris believed the artist must be centrally occupied in wrestling with it. He even suggests the possibility, or at least his own desire, on at least some occasions, to believe that through the art of writing one can in a sense escape death. During the time he was filling the notebook that would become *L'Homme sans Honneur*, he had apparently come to doubt this personal faith; he recounts Gerard de Nerval's story of l'Abbe de Bucquoy, who quit the priesthood because he remained incapable of performing miracles, and describes his writer's block in a similar vein: "So I no longer

write—or I hardly do—since I realized clearly that writing cannot achieve this miracle: escape from the world of the senses (that is, from the wear and tear of time, from suffering and from death)" (ibid.:70). But he would circle around it repeatedly throughout his life, sometimes experiencing radical doubt ("I have moved far away from seeing the act of writing as something sacred" (1997[1948]:203)) and sometimes coming back to the view that writing holds out the "very real illusion of escaping from the clutches of death" (Marmande 1992:33).

If death sets the horizon for the artist's/ethnographer's task, sex serves as its constant companion, an equally dangerous and attractive transgressive sacred pole. As Bataille showed masterfully in his *L'Érotisme* (2011[1957]), death and sexuality are intimately wound up together, doomed lovers of a sort in the tragedy that is humankind, as is demonstrated by so many artistic images of Death embracing and kissing a living human as a way of bringing her to the other realm, or from phrases like the French "petite mort" for ejaculation, literally, "the little death." In *L'Age d'homme*, Leiris writes "one might say that the seizure of death has an analogy with the sexual spasm, of which one is never conscious, strictly speaking, because of the collapse of all the faculties which it implies and because of its character as a momentary return to chaos. The well-known sadness after coitus derives from this same delirium inherent in any unresolved crisis, since in the sexual involvement as in death, the climax is accompanied by a loss of consciousness, at least partial in the former case" (1984[1939]:51). Sex is at its core, then, an accomplice of death, not its opponent, and not something with which one can seek to oppose or escape death. But for Leiris in *L'Homme sans Honneur*, sex is nonetheless something that allows the possibility of an experience unavailable otherwise. In the world in which he finds himself, a modernity seemingly centrally concerned with chasing honor and sacrality out of all its previous places of refuge, including the realm of sexuality, in order to destroy them, an important question presents itself to the pursuer of the sacred: "how to ensure that communication is not prostitution, communion not an orgy, sacralization (or fusion with the Other, with that which is most intimate) not profanation?" (1994:126). In the sexual encounter of two Others of extreme difference (male and female), "alone with each other," it is possible, if not inevitable, that "fusion . . . takes place . . . without prostitution, or rather, with a minimum of prostitution . . . the sacred will be, not in certain things or people, but in the relationship I maintain with certain things or people" (ibid.). In modern societies, such fusion is "almost miraculous" because "everything is dissociated" as a rule (ibid.:129). This initial dissociation and radical difference is perhaps even necessary for sacred unity: "Rather than a fossilised 'communion of the saints' or harmony of 'noble savages', what we have is the desperate efforts of individual daemons to link up and become unified" (ibid.:130). Leiris even speculates that not all sexual contact opens the participants

up to this sacred experience: "Where love is concerned, it is a question of establishing a link between two people who are already radically different by virtue of their sex, besides any individual distinctive characteristics . . . everything becomes blurred where homosexual love is concerned: a love which, lacking as it does the necessary difference between participants, almost amounts to masturbation" (ibid.). Ultimately, again, this impossible seeking of plenitude is the search to elude death; as he recounts in a later essay, quoting from one of his earlier journals: "Fearful love: to clasp a part of the outside world in order to have the illusion of deflecting its laws. The desire for a shared love: to be the entire universe for a fraction of the universe, so as to be able to believe that your end will be the end of the world. We make love the way certain people say their beads during a storm" (Leiris 1997[1955]:197).

It is a significant act that Leiris gives the notebook a title: *L'Homme sans Honneur*. Who is the *Man without Honor*? He is

> the one for whom all things – having lost their magic, having become equal, indifferent, profane – are now shorn of their virtue, as he himself is now 'without honor', lacking as he does any reason to act . . . This search for honor, like a lost ring, that is to say, the link which one can use to reintegrate oneself into the world, in exchange for a pact with whichever privileged element one may choose. What is necessary, then, is to review everything which in some sense seems to me to have prestige, so that I may finally establish what I hold dear, what I can establish a value system on. *A more explicit title would be 'The Search for Lost Honor.'* (Leiris 1994:46, emphasis added)

To this notion of honor, he relates the "the myth of literary glory, not in the petty sense of success, celebrity, vulgar honors, but in the noble sense of prestige, mana. Cf. Roussel, for whom success was no more than a means (a vain means, at that) of reviving his old sensation of 'glory'" (ibid.:48–49). The question, then, is how to live in relation to something sacred, something that makes possible a mythological and glorious life. This is not art, at least not art in its orthodox formulation, nor is it scholarship and science, both of which are oriented toward nothing capable of sustaining one in the face of the stupid suffering of life and its equally ludicrous end in decay and death. Leiris had to invent a new form of writerly work to overcome the limits of these two dead ends. The task of the writer or artist is simply (but at the same time dauntingly) the work of creating one's own myths, indeed, of making his own life into the pursuit of a myth and the heroic tale of the protagonist of a myth:

> The only possible antidote would be an equal ability to forge oneself a myth of heroism, a myth which would at every moment dominate one's actions. Why do I not write poems more often? Because poetic activity presupposes such a heroic myth, or at least a tragic awareness which does not transform

into a simple case of defeatism ... The true poet is the one for whom the
poetic imagination comes to replace all other modes of thinking, even in the
least favorable, most tragic circumstances ... The problem for me, then, is
this: how, in the current circumstances, can one pass from a *fictive* poetry to
a *mythic* poetry? More generally, how can I stop being a hack and become a
creator of myths? (Ibid.:62, 65, 113)

For the artist, as for everyone else but still more dramatically, given his
effort to produce his work and live his life according to the dictates of a
myth, death is the horrifying limit that at once presents a monumental
obstacle to the task and serves as the primary challenge of his heroism:
"I do not exist, I am not a man, since nothing can make me forget that I
must die ... The question I pose, then, is this: nothing can be worth my
dying for it, since it is precisely the fact that I will die that removes the
value of everything" (ibid.:69). The sacred is that which can "hold its
own against the sheer scale of death, that which death does not devalue,
that which keeps its savour and its weight despite the existence of death"
(ibid.:113–14).

Literature and the Other: the poetic annihilation of orthodox ethnography in Leiris's African journal

By the time Leiris was composing the essay on the sacred, he had argu-
ably already recognized that the task of investigating the sacred required
a focus on the self, as such an intimate experience could be most fully (if
still aggravatingly incompletely) explored only as a lived experience. But
this was a destination at which he arrived as part of a journey that took
him first to "the field" in search of the sacred. As noted previously, the
first book Leiris published, in 1934, was his journal from the Africa expe-
dition of 1931–33; this is several years prior to the undertaking of the essay
on the sacred. We can understand both the expedition itself as well as the
project of writing the field notes, and preparing them for publication, as
the necessary workshop for the theoretical advance of the sacred essay
and its source notebook. Leiris had been sought out for his writerly ability
to serve as the field note taker for the expedition, and he was one of only
four individuals who made the entire trip across the continent (Armel
1997:311). The very title of the book that emerged from this project pres-
ages the radical status of the book as a literary object: *L'Afrique fantôme*,
Phantom/Ghostly Africa. In a preamble written nearly a half century after
the original publication, Leiris summarized the meaning of the title, and
the trajectory of the entire book, in a few poignant sentences:

it is an allusion, to be sure, to the appeal to my taste for the marvelous
made by certain spectacles I had been captivated by, or certain institu-
tions I had studied, but it is above all an expression of my disappointment

– characteristic of an ill-at-ease westerner who had hoped that his long travels through more or less distant lands and a genuine contact, achieved through scientific observation, with their inhabitants, would make a new man of him, more open, cured of his obsessions. This disappointment, to some degree, led the egocentrist I still was to use the go-between of a title to deny that Africa in which I had found so much, but had not found salvation, the full plenitude of its existence. (Leiris 1981[1934]:7)

The connection between ethnographic research and art was evident in the expedition, and not only in the fact that research on native ritual art and masks was one of its central goals.[2] Even before the expedition left Europe, art was called on to aid ethnography materially: the avant-garde writer Raymond Roussel (a friend to whose work Leiris would much later dedicate a critical essay) contributed 10,000 francs of his own money to the trip, and a boxing gala (attended by Pablo Picasso among other artistic luminaries of the Parisian cultural world) was held to raise funds (Armel 1997:307–8).

The entire book stood as a scandal to orthodox ethnography, and indeed to the entire model of the social sciences on which this model of ethnography and ethnographic writing rests. The whole of the history of anthropology, and indeed of the social sciences, is the history of the encounter with the Other. To meet the Other, what must one do? The orthodox anthropological answer, in Leiris's time as well as in our own, is that one must go to remote parts of the world and interact with "primitive" peoples, learning their arcane languages, spending months or years farming and hunting and feasting with them, perhaps contracting tropical diseases as a sort of badge of cultural achievement, living far away from the centers of modernity, indeed putting to the knife all the advantages of modernity in the effort to peel down to the core of the pre-modern Other. Often this effort by the anthropologists has been marked by intense ideological projects—whether colonialist goals of conquest and the making useful of these peoples and their worlds for the desires of we moderns, or anti-colonialist ones of the politically progressive anthropologist who secretly (or openly) despises modernity and its concomitants and romanticizes the primitive Other, identifies with him, desires the impossibility of being him, and therefore works ferociously to ensure that no taint of the poison of modernity (which the anthropologist recognizes he wears like a suit covering his entire being) is allowed to touch the native and desecrate his sacred status. The ethnographer goes to the native Other as the scientist goes to his laboratory—armed with method and with theory, and with a spirit that will enable him to know by resisting participation in the native world and insisting on his status apart—an observer who knows. When the anthropologist comes back from the tropics or the Arctic or whatever other exotic realm he has visited, he brings with him not only true knowledge of the Other, but also a new status himself. He is

now the expert on Otherness, the true sage of the native world and native being. He has become something of a scientific holy man, able to cure at least himself, if not also his readers and his students, of the disease of ethnocentrism and situatedness, because he has rubbed elbows with the holy men out there who exist outside of, and in radical ignorance of, our own world and our way of doing things. The scientific ethnographer, despite his pronouncements to the contrary, does not give up the sacred, but his sacred constitutes a complete dedication to the belief that he can unlock the secrets of the Other through his meticulous, scientific annotations and a ferocious refusal to train the penetrating vision of ethnographic critique on himself.

At the moment he left Europe for Africa, Leiris apparently had some conviction, based in his admiration for the ethnographic enterprise in France and particularly for the work of Marcel Mauss and the school of ethnographers he was producing, that "science ought to take the place of literature" (Armel 314), but from nearly the beginning of the expedition, and notwithstanding the fact that he attempted to produce a number of texts in the wake of the publication of *L'Afrique fantôme*, which in fact drew on field experiences during the expedition and hewed closer to the orthodox ethnographic line, it became clear that he could not be the kind of observer and writer who can reduce his vision sufficiently to produce truly orthodox ethnographic writing. In the end, Leiris took deadly seriously the notion that we only manage to know the self by and through the comprehension of the Other, and that both tasks are necessarily interrelated and impossible to complete. What Leiris produces in his encounters with the anthropological Other, whether in his journal from the Dakar–Djibouti expedition, or his account of the possession rites of the Zaar (1980), or his study of the secret language of the Dogon (1992[1948]), inevitably contains some elements of orthodox anthropology but it remains a very different kind of animal. Even in works like his study of the Dogon secret language, wherein he makes considerable concessions to the stifling blueprints and models provided by traditional ethnography, his work was bitterly denounced by orthodox academics as too "writerly." He recounts in *L'Homme sans Honneur* of a Collège de France professor, the Islamic scholar Louis Massignon, who criticized the Dogon book; the good professor took Leiris to task because he "does not express [himself] consistently with the spirit of Indo-European languages, he attaches more importance to 'poetic' proofs than to 'syllogistic' proofs, and proceeds not in a discursive manner, but by 'successive explosions of thought'" (Leiris 1994:74, 77).

But neither is the product of Leiris's efforts a facile, banal example of the kind of postmodernist navel-gazing that can be found today in abundance both in some multicultural poetry journals and also in some of the reflexive ethnography journals and presses, where the ethnologist writes solely about herself under the guise of interaction with Otherness. There is now an entire genre of literature in the American university that

calls itself "autoethnography," much of which consists of the biographical tales of academics, drenched in the mundane details of lives lived entirely in the shadow of educational institutions. Leiris was able to neatly erase the distinction between the (merely) literary act of writing about one's life as a narrative, of picaresque interest as a piece of literature, and the (never exactly) scientific act of ethnography, accounting for the lives of some people who are to be accounted for because of the contribution their story makes to our knowledge of humankind. He put the difference to the flames and did not stop at simply endlessly talking about why the two were inseparable. He got directly to the business of incorporating the one and the other in the self-same writerly, artistic act. In this vision, neither the traditional literary figure, imagining himself free from the Other, the social world, and the constraints they impose, nor the social scientist of the textbooks, armed with pith helmet and, today, computer transcription software and imagining himself standing free of the Other and yet in full knowledge of his motivations for acting, can hope to approach what most basically matters in the human world.

Why is Leiris's ethnographic writing superior to orthodox ethnography? First, unlike stock anthropological writing, Leiris's work is the work of a poet and evinces deep appreciation of the mystery of language in the course of the examination of self and culture. Stock ethnographers, by the very terms of their trade as normal scientists, simply cannot do this. They have their vision provided for them by "the literature" and a style of writing it prescribes, informally as norm as much as by explicit rule. Seemingly every article or chapter in an orthodox ethnography begins with an account of "something that happened in the field," something strange and apparently inexplicable, presented in a generally leaden descriptive passage that may, here and only here, make an effort at literary presentation, and this is always the set-up device for the introduction of "the literature" as a way to explain, and thereby de-mythologize, the peculiar goings-on in the land of the Other: "Look, they are like us, we are like them!" There simply is no space, and usually little interest, to be sure, in pulling back from the descriptive business at hand sufficiently to wonder how the materials, the actual tools of which we make use to describe cultural realities shape what we can tell, how we can tell it, and why we do so. For Leiris, these matters are of profound importance, a fact that can be discerned not only in the way in which he wrote his ethnographic studies but also in the aspects of Other cultures he chose to take as his object in them. In the Dogon book, as the title makes apparent, it is a secret language used by the elderly men of the group during the ritual of the Sigui, which takes place only once at very great intervals, roughly every sixty years, that is the object of his attention. His book on possession rites among Ethiopians of Gondar explored the ways in which the performance style of the possessed constitutes a hybrid form of theater, dance, and poetry.

Secondly, Leiris is emphatically engaged in what we might call the creation of an anthropological literature of *ek-stasis*, a sociology of the extra-mundane residing outside of stock, orthodox social science, and somewhere in an interstitial space separating but also joining social science, literature, and psychoanalysis. In Leiris's vision, we experience the Other, potentially at least, only in ecstatic moments; by definition, ecstasy, *ek-stasis*, is, following closely from the Greek, "to be or stand outside oneself, a removal to elsewhere." The English translation has increasingly been sapped of all its complexity and grandeur in American usage and is now basically seen as an equivalent of "joy," but this is a distortion, for, in the Greek, there is no necessary implication of happiness. Perhaps, in the escaping of the normal state of consciousness, happiness or fulfillment could follow, but so too could fear, trepidation, or new emotional states unfamiliar to us in normal consciousness and so unclassifiable by the orthodox psychological language of emotion. Leiris is in *L'Afrique fantome*, among other things, writing a sociology of *ek-stasis*, and one of the chief paths to ecstasy, as he more explicitly explored in the notebooks on the sacred, is through sexual encounter, and especially sexual encounter, real or imaginary, with the Other. We can see the central place sex occupies in the very opening phrases of *L'Afrique fantome*:

> Left Bordeaux at 17.50. The dockers place a palm on the Saint Fermin[3] to show the work's done. A few whores say goodbye to the crewmen they slept with the night before. It seems they came to the quay when the boat arrived to invite the men to spend the night with them ... [later, on the first day on board ship] The sea is smooth ... As far as other animals go, there are cats on board, and a little goat which the crew brought back from Sassandra 18 months ago. It's a mascot. From time to time, it gets excited: its cock comes out, it turns its head and bites its own member. Between Le Havre and Bordeaux, in such a state, it apparently pissed on Moufle. Another time, it pissed on its own nose. (1981[1934]:19)

So, in the first moments as he boards the ship that will take him away from Europe and into the land of the Other, we have observations of the whores kissing goodbye the sailors with whom they have spent the previous night, and a goat on board the boat with an erect penis who pisses on himself as he chews on it; the journey literally begins in the ecstasy of the primal transgression of the sex organs and their functions. Sex is always, for Leiris, charged with myth and the sacred, and sexuality without mythology is something that saddens him in the absence (1997[1948]:167). The sexual act is in his view a "magical act": "I have always more or less regarded coitus as a magical act, expected from certain women what one might expect from an oracle, treated prostitutes like the priestesses of Apollo" (1981[1934]:413). It connects us to the world of myth, both in waking practice and in dreaming anticipation.

Throughout *L'Afrique fantôme*, Leiris recounts his sexual dreams, his erotic desires for some of the women he meets, and his engagements with local rites that are highly sexually charged. Among these sexual dreams, we find the following: "I dreamed that I was making love, perfectly amiably, with a frigid woman who was trying to shy away from the man she was supposed to excite. I was working away at it, but all my efforts were practically useless. To get her worked up, I abuse her, calling her, among other things, a bitch. We take our leave of each other in a very tender way, but neither of us came" (ibid.:367). At Toukoto in Mali, at the conclusion of a feast, he describes an invitation to orgy by the local administrator, who tells the gathered assemblage to go off and make babies because, in the broken French Leiris reiterates, ". . . 'plenty babies, plenty taxes'" (ibid.: 65). During the performance of a griot at Malen Nyani, Leiris describes the "obscene pantomime" in which the griot engages, pretending to show the assembled his bare buttocks and his penis, and then simulating coprophagia (ibid.: 46). Even moments of seeming reserve are sometimes highly sexually charged: At Allahina, Mali, Leiris recalls two young women who brazenly came forward to look at him and allowed him to caress their cheeks, prompting local men to complain later to another member of the entourage about the shameless behavior of the women (ibid.:50). In one pristine entry in the journal, which was written during an encounter with the Kirdi people of Cameroon, he captures the essence of the utopian (sexual) fantasy that has led him (and many others) to Africa and other exotic locales: "Stay here. Do nothing. Settle in the mountains. Take a wife and make a home. Such is the utopic desire that these people instill in me" (ibid.:197).

He did not, of course "stay here," but came back to Europe, and to his basically bourgeois familial life. Yet the sexual powers that had touched him there stayed with him. There were even some significant tensions and problems presented in his marriage as a result of the relations he had established, or dreamed of establishing, in Africa. In Ethiopia, he met Emawayish, an Ethiopian princess who was versed in the possession rituals of the Zaar. He studied her invocation of the possessive trance closely, eventually producing a book-length ethnographic manuscript on the topic. But scholarly study could not preempt human, physical desire and attraction. He was moved by this "princess with a face of wax, married to a man from the Italian consulate" (ibid.:329), who in trance performed intriguing physical acts and sang strange songs (Leiris 1981[1934]:432–33), and there is some uncertainty about precisely how far their relationship extended. Tellingly, it is precisely during his interaction with Emawayish that he writes some of his most pointed criticism of orthodox ethnographic method, which "imposes that terribly inhuman stance of 'observer' in circumstances where one would do better to let oneself go" (ibid.:433).

This exploration of sexual union as sacred practice and the writerly work of describing it in a combination of ethnographic detail and poetic

voice can be found elsewhere in Leiris's work. The most concentrated effort in this regard outside *L'Afrique fantôme* is in an essay published in the second volume of *La Règle du jeu*, "Voilà, Déjà l'Ange!" Here, Leiris describes his encounter in Algeria, while stationed there as part of his military service, with a young local prostitute, Khadija. In Khadija, he found "someone who had just demonstrated to me that there still existed in our day—at least in certain regions—something analogous to what sacred prostitution must have been in the ancient world" (1997[1955]:203). He tells of sleeping in the prostitute's bed while she entertained other men (thus showing his privileged status), and, later that night, while the two of them made love, of perceiving

> something like the pulsations or slight contractions one could perceive deep in the gallery of a mine if the earth were alive and if the men who work it, lost in its folds, received a response emanating from the most distant part of that great sentient animal; something comparable to me . . . to the proof . . . of the real, rather than mythological, existence of a sexuality hidden within metals, and also to the illusion I had that with my own eyes I had seen the ultimate foundation of the world when (during a visit to the École de Physique et Chimie I had made at the urging of one of the teachers at that institution) I observed the standard experiment designed to show 'Brownian motion' . . . It was almost this heart of the earth, mineral soul, innermost being of fate and of things that I had thought I was touching when I perceived the tangible signs of Khadija's joy. (Ibid.:210–11)

He describes the blood on her pillow from an earring that had cut her ear as they are engaged in intercourse in mythical language: "what I saw was a tragic princess breathing her last in the wavering light of the flames as I pressed bloody Khadija against me in the gloaming" (ibid.:208). Denunciations from the orthodox ethnographers directed at the moral sin of his carnal acts with Khadija would certainly satisfy the requirements of their discourse, but would fail utterly to speak to the profundity of the effort Leiris is here making to bring ethnographic writing and experience into explosive, ecstatic contact with a poetic approach to language and the life of the artist.

The death of art in the art of death: tauromachy as sociological and literary object, autobiographical literature as tauromachy

It is in Leiris's essay on the *corrida*, the bullfight, which was published in 1938 but whose subject had fascinated Leiris for at least a decade previously, that I believe we find the most compelling piece of his writing uniting the various concerns with which this chapter has been occupied.

Leiris was passionate about the *corrida* throughout his adult life. It not only was an explicit focus for works like the one we are preparing to examine here, and a topic to be presented under one or another microscope in other writing; it haunted his very dreams, and in a way clearly tied in with sexuality and death. In *Nights as Day/Days as Nights*, Leiris recounts the following dream from late 1954:

> In need of money, I hire myself out as a bull in a corrida. As the papers are being signed, the impresario insists that I undergo an inspection to make sure that I indeed have the five horns stipulated by the contract; he has after all guaranteed that he will furnish a "bull with five horns." Two of these horns are supposedly on my head; two more are the protrusions of my shoulder blades which the impresario verifies by touching them. My wife is present and I tell her it gives me the chills to be touched there, just below my nape, on the very spot where the death-blow will fall. She says to me: "It's just a lousy morning you'll have to get through. Once it's all over, you'll feel fine . . ." I get incensed: "Once it's all over, I'll be dead!" Beside myself with rage, I shout at both of them: "You don't give a shit about me! I'm not going to fall for this!" And I add: "I'd rather take my chances as a bullfighter!" The contract will not be signed and the dream ends there. (1987[1961]:152–53)

He concludes with a tongue-in-cheek statement that locates tauromachy squarely in a discourse saturated by the sexual sacred: "Almost everybody to whom I have recounted this dream has asked me where my fifth horn was located" (ibid.:153).

A Taurean in zodiacal terms (born April 20, 1901), Leiris was apparently only in his mid twenties when he discovered the *corrida*. Personal friendships with Picasso and other Spanish-born artistic figures who frequented the same circles Leiris did, as well as cultural politics of the epoch,[4] contributed to Leiris's interest, but it was ultimately the *corrida* as a machine for reproducing myth and heroes that attracted this mythology-obsessed writer. The essay on tauromachy is dedicated to Collette Peignot, the writer and lover of Georges Bataille who shared Leiris's passion for the bullfight and for living myth, the same woman who Leiris, Bataille, and a handful of other close comrades had seen perish on her deathbed in the scene that dramatically affected Leiris for the rest of his life, which is recounted above.

He begins his consideration of the object by detailing what the *corrida* is *not*. It cannot be considered as merely a sport, though it has sporting elements; the "bullfighting code allows the 'player' only a very small number of permissible 'plays' in relation to the considerable number of forbidden ones," which approximates the calculus of many sports, but in the latter the "rules constitute merely a loose framework . . . [whereas here it is a matter of an essentially] magical operation with a meticulously calculated development, in which questions of etiquette and style take precedence over immediate effectiveness" (1984[1939]:39–40). But if it is

not a sport, neither is it simply an art form, at least not if we consider art as it is considered in the academies and the museums; the most obvious factor distinguishing it here is the proximity of death and the risk of grave physical injury, almost never realistically in play in most art. The bullfight is, according to Leiris, a "revealing spectacle" that occupies a uniquely holistic place in human experience:

> Certain sites, certain events, certain objects, certain very rare circumstances [which] give us, in fact, the impression, when it so happens that they appear before us or that we are caught up in them, that their function in the general order of things is to put us in touch with what is most intimate, and usually most turbid, if not most impenetrably hidden, about ourselves. It would seem that such sites, events, objects and circumstances have the power to momentarily bring to the flatly uniform surface by which we usually cling to the world some of the elements which belong more rightly to the life of our hidden depths, before letting them—by sinking all the way down the other branch of the curve—return to the miry darkness whence they'd ascended. (2007[1937]:23–24)

Tauromachy is seen by Leiris as a kind of Maussian total social fact: it is at once a sporting event, a work of art, and a sacrifice with the same basic contours evident in the religious rites classified under that term (Armel 1997:378). The secret power of tauromachy is the dramatic proximity of purity and violence, the stunningly bright *traje de luces* juxtaposed against the gore and blood of the horses, the bull, and perhaps of the *torero* as well. The impure or left sacred is at its very core. The event is centered on what Leiris calls a "fissure" or a "deviation," a stain or taint on something otherwise pure and perfect, which inextricably alters and augments the beautiful, turning it into tragedy:

> Thus the current idea of a beauty based upon a static mix of contraries is implicitly out of date: since it is necessary for it to contain an element playing the forceful role of first sin, what constitutes beauty is not only the bringing into contact of opposed elements, but their very antagonism, the extremely active way in which they tend to collide with each other, there to leave a mark like a common wound, a depredation. Only that which suggests the existence of an ideal order which is supra-terrestrial, harmonious and logical will be beautiful, but an order which simultaneously possesses—like the taint of an original sin—the drop of poison, the touch of incoherence, the grain of sand that makes the whole system run out of true ... All will come to pass, eternally so, between these two poles acting as living forces: on the one hand, the *right* component of immortal, sovereign, plastic beauty; on the other, the *left* component, sinister, siding with misfortune, accident, sin. Like all things that are thrilling to the extent that, being mythical renderings of our internal structure, they enlighten us about ourselves at the same time as they resolve our contradictions in a single accord, the beautiful will theoretically take on, rather than the allure of a conflagration, that of an equivocal struggle, of an intertwining, or better yet

a tangency, a coupling of the straight line and the curved, a marriage of the rule and its exception . . . tauromachy can be taken for the typical example of an art in which the essential condition of beauty is a difference of phase, a deviation, a dissonance. No aesthetic pleasure would thus be possible without there being violation, transgression, excess and sin in relation to an ideal order serving as a rule; nevertheless absolute licence, like absolute order, could only ever be an insipid abstraction devoid of meaning. Just as lurking death gives colour to life, so sin, and dissonance (which contains the seeds of, and suggests, possible destruction) confers beauty on the rule, extricates it from its state of fixed norm and turns it into an active, magnetic pole from which we move away or towards which we tend. (2007[1937]:34, 35, 36, 43–44)

The emergence and eventual assertion of supremacy of the impure sacred is progressive in the bullfight. A *corrida* is divided into three parts: the *tercio de varas*, the *tercio de banderillas*, and the *tercio de muerte*. Three different human actors engage the bull in each third. First are the *picadores*, who endeavor to wound the bull's neck muscles sufficiently so as to make him drop his head and level his horns; the dual effect is to lightly fatigue the bull so he is not overly energetic in the remaining two-thirds of the event and also to provide the proper aesthetic of the lowered head, which makes possible the necessary angle for delivery of the *estocada*, the final death blow, by the *torero*. The *banderilleros* then enter the plaza and thrust colorful barbed spears into the bull's back with athletic, courageous skill; again, the goal is both practical (place the *banderillas* in such a way as to ensure the bull charges in an even manner, not favoring either side in a way that could drastically endanger the *torero*) and aesthetic (the exciting colors of the *banderillas*). Finally, the *torero*, or *matador* (literally, "killer") who will come to prepare the sacrifice, or, if things go differently, himself become it. The impure sacred "more and more assert[s] itself" as the event goes on; the violence is brutal but unspectacular at the outset, and becomes truly "maleficent" only with the operation of the *muleta*, the stick that holds the red cloth used to lure the bull to charge and to facilitate the succession of *pases* that serve as the aesthetic material by which dramatic tension is built until it achieves its *dénouement* with the *estocada* (ibid.:65). The operation of the *muleta* is, according to Leiris, "essentially founded upon perversity: the seduction of the bull through the shimmering of the fabric, the temptation of the *torero* who increasingly verges on the fall—a sort of blossoming of evil in intense and artful clapping, in the bright sunshine of a Luciferian beauty" (ibid.:65–66). By the last stages, the delirious spectators cry for the *matador* to make passes with his left or impure hand (the most dangerous ones) by shrieking "La izquierda!" (ibid.:66). It is in this third and final stage, after the flirtation with the impossible goal of plenitude through the dazzling beauty of the *pases* (where the spectators are led to believe, for an instant, in the unity of the movements of the bull and those of the *torero*, as, in Leiris's analysis, lovers believe they are unified in the brief

intensity of the physical consummation of their love), that "the flaw [is] clearly revealed . . . [and] the victim . . . immolated" (ibid.:64).

But if impure left asserts itself progressively during the event, it also paradoxically merges with the right and the two opposed categories become one. Leiris cites Baudelaire in a discussion of the need for "misfortune" to be present in order to perceive beauty (ibid.:59). Left transgression cannot be let free to reign supreme, lest all social order collapse: "it is understood that the spectators will only be fully satisfied if the matador has taken upon himself the entire 'left' share—drunk the poison down to the last fatal drop—before the *estocada*, a sacramentally retributive thunderbolt, reinstates the right" (ibid.:66). At the *estocada*, it is revealed, in a flash, that the sacrificial victim, initially perceived to be the *torero*, is in fact the god himself, the bull, who has now given "his share and can return to the place whence he came, no longer a threat to anyone" (ibid.:60). Leiris thus sees in the *corrida* a painstakingly fine-tuned and "impeccably ordered ritual: a skillful handling of the left side of things, more and more expressly situated, that is to say, defined and trained, so that it may suddenly vanish and give way to the right" (ibid.:66–67).

As we have already seen, where the sacred is found for Leiris, sex and death cannot be far away. Death's presence here could only be denied by someone wholly ignorant of the nature of the event. For Leiris, tauromachy achieves an engagement with death that eludes "senile . . . philosophers and religious system-builders," who desire only to "banish" death; instead of this cowardly and ultimately impossible dream, the *corrida* "incorporate[s] death" into life, explicitly, non-metaphorically, rigorously (ibid.:70). Spectators know beforehand that they will encounter death at this site; what they do not know is who or what death will strike and how its strike will be achieved and received. For the participants, of course, death is the inescapable risk of entering the rite. The sexual symbols and meanings of tauromachy require a bit more exegesis. Leiris notes that eroticism depends on either sin (conceived in Romantic terms) or *luxe* (luxury), and aesthetically it relies on the presence of a "fissure" (ibid.:48). The tauromachic *pase* is the revelation of this fissure, and the to and fro, in and out, nearly touching and unified but yet separated, movement of the *pases* mimes another carnal encounter charged with sacred power based in the attempted unison of two disparate entities, the male and the female (ibid.:51). The swift movement from plenitude to disillusion at the conclusion of the sexual act is semiotically indistinguishable from the *estocada* and the killing of the bull, an act of disgust following the failure and disappointment of attempted union (ibid.:54). The phallic *estoc* discharges into the wound it creates, and the sublime ecstasy of the *pases* is dissipated immediately into nothing.

So, tauromachy as ethnographic object, as object of art, as sacrificial ritual, as spectacular enactment of the encounter with the Other, and as element in personal experience to be poetically written in the endeavor to

cheat death, which yet cannot be cheated. Leiris prefaced *L'Age d'homme* with a brief introduction entitled "The Autobiographer as Torero," in which he expressed the idea of literary and ethnographic writing as a kind of artistic tauromachy, implying great risk, if not the risk of actual death, in the required revelation of private fantasy and emotional disrobing in a textual form available to any potential reader. At least one writer has seen this text as a text we can read as "the preface to Leiris' entire work" (Bailly 1992:35). Whether we follow Bailly or not, it remains beyond debate that Leiris sought in his analysis of tauromachy a way to write through art, sex, and death.

Notes

1. Among his shouted challenges to the mob: "Down with France!"; "Long live Germany!"; and, the worst yet, "Long live Ab el-Krim!" (the name of the leader of a North African resistance movement against French colonial rule that briefly established the Republic of the Rif).
2. The expedition's leader, Marcel Griaule, mined the data he collected during the journey for his masterwork on Dogon masks in 1938.
3. Fermin of Amiens is a Catholic saint of local importance in southwestern France.
4. The attachment to the heroic Spanish anti-fascist resistance of the Civil War of the 1930s was widespread in the French intellectual left, and things Spanish took on an attractive allure in this light.

References

Armel, Aliette. 1997. *Michel Leiris*. Paris: Fayard.

Bailly, Jean-Christophe. 1992. "A River with no Novel." *Yale French Studies*, "On Leiris," 81: 35–45.

Bataille, Georges. 2011[1957]. *L'Érotisme*. Paris: Les Éditions de Minuit.

Hollier, Denis, ed. 1979. *Le Collège de Sociologie*. Paris: Gallimard.

Leiris, Michel. 1981[1934]. *L'Afrique fantôme*. Paris: Gallimard.

———. 2007[1937]. *Mirror of Tauromachy*. Trans. Paul Hammond. London: Atlas Press.

———. 1979[1938]. "Le sacré dans la vie quotidienne." In *Le Collège de sociologie*. Ed. Denis Hollier. Paris: Gallimard, 60–74.

———. 1984[1939]. *Manhood: A Journey from Childhood into the Fierce Order of Virility*. Trans. Richard Howard. Chicago: University of Chicago Press.

———. 1992[1948]. *La Langue secrète des Dogons de Sanga (Soudan français)*. Paris: Éditions Jean-Michel Place.

———. 1997[1948]. *Rules of the Game, Volume 1: Scratches*. Trans. Lydia Davis. Baltimore: Johns Hopkins University Press.

———. 1997[1955]. *Rules of the Game, Volume 2: Scraps*. Trans. Lydia Davis. Baltimore: Johns Hopkins University Press.

———. 1987[1961]. *Nights as Day, Days as Night*. Trans. Richard Sieburth. Hygiene, CO: Eridanos Press.

———. 1976. *La Règle du jeu, IV: Frêle bruit*. Paris: Gallimard.

———. 1979. "Lettre de Michel Leiris à Georges Bataille." In *Le Collège de sociologie*. Ed. Denis Hollier. Paris: Gallimard, 549–50.

———. 1988[1987]. *Francis Bacon.* Trans. John Weightman. New York: Rizzoli.

———. 1994. *L'Homme sans Honneur, notes pour Le sacré dans la vie quotidienne.* Presented and annotated by Jean Jamin. Paris: Jean Michel Place.

Marmande, Francis. 1992. "Michel Leiris: The Letter to Louise." *Yale French Studies*, "On Leiris," 91: 28-34.

Riley, Alexander. 2010. *Godless Intellectuals: The Intellectual Pursuit of the Sacred Reinvented.* New York: Berghahn.

Apophasis in Representation
Georges Bataille and the Aesthetics and Ethics of the Negative

S. Romi Mukherjee

The apophatic aesthetic

Georges Bataille was an enemy of "art." He loathed all that attempted to redeem the base with appeals to the lofty, cultivated a sustained distrust of "absolutes" and "beauty," and saw through the hypocrisies of high culture and other bourgeois loci of distinction and anxiety. It would then appear misguided to speak of "Bataille and art." However, Bataille was not simply an aesthetic reactionary. Rather he suggested a reworking of the *dispositif* of "seeing" which, in his view, should be tantamount to being blinded and indeed torn apart. The capstone of knowledge is found in the dialectical inversion of the positivist gaze, in the blind spot of reason and in the liminal passage between the human and its Other. This "site" is moreover one constituted by the unraveling of semiotic coherence and the descent into non-form, night, and void. And paradoxically, it is from within the interstices between this night and the black hole of the eyes that Bataille's "aesthetic" begins; art, if it was to exist for Bataille, was a bastion of dark sensuality where the aesthetic is swallowed by the ecstatic and the value of the work is found in its capacity to call into question the very nature of human project. The Bataillean aesthetic thus cannot be illuminated if one remains bound in conventional notions of art as the province of the painterly, the writerly, the plastic, and the *beaux*.

Bataille tried to outbid art. Outbidding art moved by way of the subversion and refusal of art's formal and structural limitations, its history, its pretensions, in favor of a repositioning of the aesthetic in what it uncomfortably flees from—flies, excreta, howls. In a broader sense, Bataille outbid ethics, epistemology, and all forms of totemism through a rabid aesthetic that violated rather than consoled. While "outbidding" does

mean befouling beauty, it also means displacing reading practices and bringing sensorial experience to grapple with that which it perpetually disavows. What this would entail would be nothing short of a project to collapse aesthetic *habitus* which, in its aversion to the repugnant, canalizes the apprehension of the beautiful into certain ideal forms. "Beauty" is neurotic.

Bataille also outbid the Durkheimian tradition, and did so by guarding Durkheimian paradigms while perverting them and interpolating the Durkheimian edifice with its blind spot. On one hand, in shifting the site of the aesthetic away from the Arts and toward a more experiential regime of imaginative, representational, and ritual life, he echoed Henri Hubert's forays into *sociologie esthétique* in the early days of *L'Année sociologique*. Influenced by *The Elementary Forms*, he too recognized archaic religious life to be the well-spring of the aesthetic, which was not one social fact among others, but rather a symbolic force and real energy that shot through all of social life in its totality, one which he also readily used to criticize the modern. A dramatist of the sacred, he also lamented to disappearance of temporal, spatial, and experiential undulation between these domains and how "we no longer know how to employ blood and bones to effect a rupture with the regularity of days ... the modern spirit has only put in place methods applicable to literature or painting" (Bataille 1970a:273–74). While never ceasing to invoke Durkheim as authority, Bataille rallied against Durkheimian utility and envisioned a "lacerating" sacred, which would tarry with the impossibility of the human project and force it into immediate confrontation with its "headless" negativity. He "insisted on the Durkheimian theme," but knew that "what excludes the Durkheimian solution is the identity between sacred–social, magical, and erotic elements" (Bataille 1970b:171), an identity that opened up a decidedly non-Durkheimian space. Bataille's sacred exploded Durkheimian representation and posited non-symbolic forms of language which possessed no grammar and moved, by way of desublimation, torrents of effusion which shattered Durkheim's symbolic moral substrate. And in the grips of the sacred, an alchemical function revealed itself; the anxiety of human finitude and abjection could be transformed into collective ecstasy. Such was also the essence of the aesthetic: the plunge into horror that created the possibility for sovereignty, freedom, and ethical life. Denis Hollier (1997:68) is thus right to refer to Bataille as "dualist materialist," a non-dialectical thinker of two worlds that know nothing of the other: "the world we live in," a world organized against the world of expenditure, which Bataille also calls "the world we die in," "a world for nobody," "a world from which subjects have been evacuated, the world of the non-I." And the dualisms he erected tarried explicitly with the Durkheimian edifice.[1] W.S.F. Pickering (2000:116) has suggested of Durkheim that his response to the question of "what lies behind the representations," would be "reality," insofar as "all reality

is representable and knowledge can only come from representations of reality. Man is in fact a representing creature." Bataille's response to what he might interpret as a false problem would rather be that the representation is precisely what needs to be exploded in order to enter into the tragic void between the two worlds; precisely where one becomes non-human; precisely where one incarnates the "non-known" or a "non-knowledge" that lays bare the paucity of the human.

Bataille's aesthetic and moral sensibility must also be understood against the backdrop of the malaise of inter-war France, and the shared perception of an Occidental world on its last legs where modernity's great projects were already considered failures. It was too late for the moral toning up that the Durkheimians called for. Rather, for Bataille, what was necessary was not the establishment an aesthico-ontological identification between the individual, the totem, the representation, and the transcendent social, but the desecration and disintegration of all ontology *tout court*. The Bataillean aesthetic articulates itself from within the ruins of ontology, there where we would least expect it.

Bataille is the ultimate theorist of the negative, that de-ontic site that surpassed language, but nonetheless traversed conscious life as a looming traumatic trace, a horrifying excess that was always there but barred— the catastrophe to come. The Real is negativity incarnate or what Diana Coole (2000:6) calls a creative–destructive force that engenders as well as ruins positive forms. *Contra* Kojève, who flabbergasted the inter-war avant-garde by proclaiming Stalin as the end of history and announcing the evacuation of all negativity from the world, Bataille pleaded for the existence of a man of "unemployed" and "recognized negativity," one who feels "horror" at "looking at negativity within himself," a horror which "is *no less likely to end in satisfaction than in the case of a work of art* (not to mention religion)" (Hollier 1988:91). Post-history may not be Kojève's "Sunday of Life," but as Christopher Gemerchak suggests (2003:19), a Bataillean "Sunday of the Negative," an empty day where the sacred as negativity is unleashed against man's domination of nature, which quickly becomes a form of domination over man. On this Sunday, when no one went to church, "recognition" was also an awareness of the outside of representation. In other words, there remained for Bataille, as Vincent Teixeira argues, a "power of destruction and recreation, an 'aesthetic negativity,' produced by dispossession, calling into question and destabilizing the homogenous world" (1997:92). The artistic quest was thus deeply political for Bataille, insofar as they were constituted by the heterological demand to cut through the post-historical Sunday of the twentieth century with the alterity of the Real.

Bataille was a highly repetitive writer of a finite set of themes and variations. However, underneath such repetition is a straining, striving, and pushing toward, this aesthetic negativity which can never fully reveal itself. Hence, Richman also writes that Bataille "strained a rhetorical

muscle to maintain his discourse at the level of death" (1982:8), and death was not only the pinnacle of the Bataillean aesthetic insofar as it was the most radical of alterities, but also a figure of metonymy for all heterological experience. Bataille's straining was not merely stylistic; it was an attempt to bring the aesthetic negative to the threshold of articulation through a practice of unsaying and unfolding. The aesthetic, like many of Bataille's texts themselves, is thus "apophatic," a term tied to the negative theological tradition that refers, on one hand, to negation, but also to a certain type of performativity, which, according to Michael Sells (1994:3), "affirms ineffability without turning back on the naming used in its affirmation of ineffability ... unnameability is not only asserted but performed." The aesthetic is a type of unsaying and Bataille's theory and theoretical performativity are radically apophatic. But Bataille's own apophasis does not move in any systemic manner, and unraveling it in order to illuminate his aesthetic theory and its inversions of art, culture, and the Durkheimian, demands that we too strain and rethink the visual imagoes of Bataille's cosmogony, and genealogically reconstruct his apophatic aesthetic.

Spheres

It begins with the eyes rolling back into the head; Bataille's father was afflicted with syphilis and suffered bouts of blindness, and the inability to control the expulsion of feces: "The child had to place him on the bedpan on which getting out of bed 'with difficulty' ... the needs that in fact without embarrassment, he satisfied under the eyes of everyone (of his son, but what eyes would he assume for a child conceived in blindness other than eyes likely to see *everything*), the spectacle of 'brutalizing abandon' he gave, with eyes rolled back" (Surya 2002:8). Unseeing is also an "unsaying"; blindness is the condition for aesthetic experience where seeing everything necessitates a confrontation with the shadowy non-site beyond ocular normativity. The aesthetic requires eyes which are nothing but all-seeing—where thought dissolves into incommensurability. The mind's eye is blind, but encompasses a "night" that will be alternately referred to as "negativity," "non-god," the "void," the "limit," and the "non-discursive" among the many apophatic nodal points of Bataillean aesthetics. The absolute epistemology of Hegel was unable to confront this limit. The dialectic cannot subsume its non-dialectical other and, no different than the blind spot of vision, knowledge too is laden with *la tache aveugle*. The blind spot is the negative analogue to the eye and thus, the locus of aesthetic negativity: "a blind spot ... which recalls the structure of the eye ... While the blind spot of the eye seems to be of little consequence, the nature of understanding actually dictates that the blind spot carries more meaning than understanding itself ... the spot merits

attention: it is no longer the spot that is lost in knowledge, but knowledge in itself" (Bataille 1951:129).

Conventional representational life, burdened by comfortable modes of seeing that assert a metaphysics of subjectivity, reduce aesthetic life to a state of false totality that betrays the real kernel of sensorial experience, the blind spot where sensation and *sens* are denuded. The frontiers of the aesthetic open here insofar as the transcendent aesthico-moral antinomies that customarily produce "seeing" fall apart.

The eye must be pierced, or extracted in the same way that the metaphysical totality that transcendent aesthetic experience assumes must be crushed. The glassy eyes of the father roll back into a body that is no longer upright and embodies no law whatsoever. In 1928's *The Story of the Eye*, Bataille, or Lord Auch, explores his primordial obsession with the homologies between, inter alia, eyes, eggs, bull testicles, sun, orb, and Earth—homologies which create one semiotic chain that apophatically maps the Bataillean aesthetic. The orgies narrated throughout the novella represent immanence to be the end result of the crushing of eyes, eggs, and balls, and the strained expenditures of physical, earthly, and cosmic bodies in a never-ending movement of loss that leads nowhere. The representations do not refer to reality or anything at all; rather, immanence is a "continuity" which establishes a continuum of tactility, typified by the identity of bodily and terrestrial flows.

The text is also an allegorical attempt to apothatically crush the (eye) "I" who narrates and attempts to master the narrative and the women of the novella through a virility that can never be total. Moreover, the novella's climax was based on real events. In 1922, in Madrid, Bataille watched as famed toreador Manuel Granero had his eye pierced by the horn of a bull, resulting in his immediate death. In Bataille's recollection of the moment: "on Simone's seat was a white plate with two white peeled balls, glands like pearls, the size and shape of eggs, slightly bloodshot, like the orbs of an eye . . . Granero was beat back by the bull and pinned against the balustrade; the horns struck the balustrade three times at full speed and, on the third lunge, one horn plunged into the right eye and through the head . . . two globes of equal size and consistency had been propelled in opposite directions at once" (Bataille 1970a:56–57).[2] The body too must be decomposed as a holistic and self-assured apparatus, and along with it its own metaphysical projection of Being. Bataille's contributions to the review *Documents* thus, cut the body and the cosmos open into a series of part-objects that were points of relay for the forces of the negative. In "Eye" (1928), he played with Surrealist ocular tropes, inspired by Bunuel and Dali, and again telescoped the relations between the eye as "cutting edge," the eye as "cannibal delicacy," the "eye of conscience," the "lugubrious eye," and the "living eye," etc. (Bataille 1968:187–88). However, beyond the corporality of these orbs, lay the true seat of unseeing, the blind spot that lived, and secreted within the human head itself: the

pineal eye.[3] For Bataille, it was the blind spot of civilization and classical reason, that which escaped the head from within the head and made men drunk on negativity. It produces an "existence" which "no longer resembles a neatly defined itinerary from one practical sign to another, but a sickly incandescence, a durable orgasm" (Bataille 1985:82). The pineal eye does not see, but rather as Allan Stoekl remarks, "is experienced *communally* . . . the eye/anus/brain in its ejaculation/defecation/thought becomes an erotic and sacrificial object not just for an isolated individual, but . . . perhaps, even by implication, for an entire civilization at the end of history" (Stoekl in ibid.:xiii).

In this, a post-Durkheimian end of history, society as transcendence had imploded and, with it, a mode of seeing that transposed an idea of the world onto the world, establishing a positivist ontological comfort. And where the totem and social once stood, one now only glimpsed the presence of void. The experience of the pineal is neither social nor social scientific insofar as this de-centering opposes rules and method and is devoid of full content. The apophatic eye introduces a "lawless intellectual series into the world of legitimate thought" (Bataille 1985:80), and contemplating "sinister solitude," "it is not a product of understanding," but rather "an immediate existence," which, moreover, "eats the being, or more exactly, the head" (ibid.:82). As such the pineal eye, where the eye becomes the anus, which becomes the mouth etc., is the excretion of negativity from within the pit of the skull where it enters into a chiasmus with the "fecal sun," which de-creates the world by breaking nature's chains and collapsing into a limitless void (ibid.:85).

The sun is the nucleus of the forces at play within this economy of unseeing and undoing. Energy ceaselessly accumulates to be expended without compensation, purpose, or objective (unilateral discharge). That which bestows life and engenders life-aggregates runs off into loss and dissipation. Two suns: the radiant sun of fall that delivers the harvest and the black sun that wastes itself. Although functioning as our principle of light and "good," the sun does not allow itself to be directly gazed upon; incandescence and unbridled aggression, production and unproductive expenditure, radiant and black, the sun embodies the general economy of the universe. The solar will be dual; transcendent in the domain of "project," immanent in the domain of expenditure.

Excreting and ingesting, the sun is also a locus for pineal aesthetics and, when scrutinized, it is a mental ejaculation, foam on the lips, and an epileptic crisis. The scrutinized sun is identified with the man who slays a bull (Mithra), with the man who looks along with the slain bull (ibid.:57). This is also Bataille's man of art, a (dis)figure of mouth/anus/sun/eye who understands his status as cosmic dejecta. Icarian, he longs to be the sun, but is thrust back to the status of "a creature who, under a sick sun, is nothing other than the celestial eye it lacks" (ibid.:90). He is the sun's vomit which he naively challenges in the name of totality. The sun's rays

castrate his vision. The confrontation with the wasteful sun that ravishes is precisely where normative aesthetics and the "beautiful" crumble; the condition for aesthetic wholeness or redemption lies in the state of forsakenness. In other words, solar immanence, unseeable and akin to epileptic foam, is the reservoir from which artistic practice and aesthetic experience must emerge. Let the black sun run its course; *contra* the designs of academic painting which sought solar elevation, art is actually the stopping of the principle of the good sun itself.

And what of the Earth, that sphere "covered with volcanoes, which serve as its anus" (ibid.:8)? The aesthetic is not a human activity any more than the Earth is the center of the cosmos. The aesthetic production of human animals is embedded in not only the general economy of nature, but in what can only be described as a Bataillean cosmo-socio-techno-ecosystem wherein the distinctions between the human and the non-human are swallowed up in the frenzied expenditures of a pineal cosmology. Here, the foam on the lips is the foam of the sea and the Earth, a homological double for the ejaculations and emptying of the head, the eye, anus, sun etc. As Bataille thus notes, "the terrestrial globe has retained its enormity like a bald head, in the middle of which the eye opens on the void is both volcanic and lacustrine" (ibid.:84). The apophatic aesthetic brings the lacunae of the terrestrial void to interpolate earthly abundance. Communication is not an intra-human modality, but the transformation of the non-human world into a place of non-discursive rapprochement, which impossibly moves toward the hidden substrate of the solar flow that secretes not Being, but fractured beings. Bataillean anthropology begins with fluxes of nature and lowers itself into the void precisely where it amasses its documents, which resist museums, and confound anthropos *tout court* insofar as they are sediments of the Earth to which human life is simply one flow of energy. Bataillean anthropology is thus actually a physics, measuring the collective movement of each particle that is composed of solar energy, unleashed and equally devoured by the Earth (Bataille 1970a:518). The challenge then, for art, would be to (de)create with the pineal eye, to bring it to gaze into the glassy eyes of negativity.

Low

For Bataille, it also began with the razing of a Church. In *Notre-Dame de Rheims* (1918), German shelling burns the cathedral to flames and "in the red glow of flames and in the acrid smoke, is the symbol of war as crazy and brutal as fire . . . and I thought that corpses themselves did not mirror death more than did a shattered church as vastly empty in its magnificence as Notre-Dames de Rheims" (Hollier 1992:17).

The desire to become upright and embody morality was doomed to failure. The symbolic, the law of the father, and the church, find themselves

immolated and the morality of the spire proves to be a sickness that leads to its own desecration. If God is absolute lack, we too figure as God's absolute lack: gods are always as powerless as their creatures (reciprocal lack). And with our virgin lady mutilated and the congregation reduced to the status of corpses, the a-theology to come would be one of ruins and ruining. Religion, the genesis of art, will be low.

As Hollier (ibid.:23) argues, the text function as the origins of the "anti-architectural gesture" of Bataille's non-system that "undermines and destroys everything whose existence depends on edifying pretensions." Demolishing the edifice does not result in an inversion of the Church's foundations, where the spire would plunge downwards or construct a subterranean architecture. Immanence is not an inverted transcendence. Unities do not replace one another; Bataille was a negative dialectician, and collapsing the architecture with appeals to the low and decline meant exacerbating the latter, and dramatizing the antagonism between the two worlds to the point of incommensurability. The low is a hermeneutic of aesthetic critique and, also, another world.

Architectural composition, the desperate attempt to epistemologically erect sovereign authority, plagues, inter alia, physiognomy, dress, music, and painting (Bataille 1970a:171). Architecture is a collective lie in which high aesthetic practice is implicated. Architectural composition hides terrain, dissimulates verticality, and conceals the anarchic pulsions that vibrate underneath the foundations. Architecture is paranoid and runs toward symbolic heights in the mad rush from organic negativity. The falsehood of architecture holds civilization hostage and denies that humans only represent one intermediary step in a morphological chain where we are actually located "between monkeys and the great edifices." Against Maussian morphology, Bataillean morphology would bring the material substrate to oppose society itself.

Architectural physiognomy, from the Indo-European system of the *varnas* to the present day, has homologized the head with not only the seat of thought, but also with the atmosphere, the priestly, and the sovereign. Conversely, the foot, and more specifically, the "most human part of the body" (Bataille 1985:20), the big toe, are identified with the vile, the untouchable, and the abject; for Bataille, "human life entails, in fact, the rage of seeing oneself as a back and forth movement from refuse to ideal, and from ideal to refuse—a rage that is easily directed against an organ as base as the foot" (ibid.:20–21). This rage is misplaced and cultural taboos on the foot serve only to re-embolden the monstrousness of the big toe to which the head and the eye are terrestrially doomed. In addition, beyond bringing the too-human big toe to interpolate the human categories of language and art, Bataille was also reorienting the Freudian theory of fetishism away from perversion., According to Alan Bass (2000:29), in fetishism "while the operation of defense always implies an attempt to convince oneself that something disturbing has not

been registered, the defense always implies that the disturbance has been registered." For Bataille, one never succeeds in convincing oneself and the traumatic trace seethes through the defensive construction, which does not compensate for castration, but rather articulates it simultaneously. Bataille argues that the foot fetishist does not replace the empty site of castration with a false totality. He is "seduced in base manner . . . opening his eyes wide . . . before the big toe" (Bataille 1985:22), which cuts through the defense and opens not only the wound of castration, but the wounding that constitutes the human as torn between high and low. Base seduction opposes Freudian seduction in the same way that the empty site of the phallus ceases to be the part object par excellence. Entering into the wound begins with the Bataillean injunction that "any amateur of painting loves a canvas as much as a fetishist loves a shoe" (1970a:273).

The anthropoid foot raises the body from mud and bars itself from the subterranean. Once raised, it objectifies nature and develops a "language of flowers" which codes, for example, a rose with "love," "ideal beauty," "nobility," and "purity." But for Bataille, "love smells like death," and the truth of the beautiful rose lies in the putrid roots, "swarming under the surface of the soil, nauseating and naked like vermin . . . the ignoble sticky roots wallow in the ground, loving rottenness just as leaves love light"[4] (1985:13). He recognized in roots the disrobing of joy and the denuding of beauty, revealing a sordidness that corresponded to the underbelly of aesthetic longings. Moreover, against Durkheim, Bataille's base materialism, plunging into the puerile dimensions of *être* in lieu of *devrait-être* (ibid.:5), will cut through social facts in order to muck in "raw phenomena" (ibid.:16). Bataille's radical naturalism recognizes that before society and religion, the human is posed in relation to climate, mud, storms, and flies, and embedded in a proto-social natural rawness. However, base materialism is not necessarily a-religious, but rather a Gnostic heresy against the church fathers and the fathers of sociology. And in Gnostic traditions, Bataille thus located a ". . . materialism not implying an ontology, not implying that matter is the thing-in-itself . . . *Base matter is external and foreign to ideal human aspirations, and it refuses to allow itself to be reduced to the great ontological machines resulting from these aspirations* . . . it was a question of disconcerting the human spirit and idealism before something base" (ibid.:49–51, emphasis added).

Practicing such a materialism proceeds by scouring being of idea and ideal, and submitting wholly to the active principle that is matter, an autonomous matter of that other world which does not oppose form. And in a series of Gnostic reliefs, Bataille would find an aesthetic tendency that refused ontology by melding the natural orders: gods with human legs, serpent bodies, the heads of cocks and donkeys, acephalic images flanked by animal heads, etc. The human form is shattered into the animal, whose representation remains surprisingly unchanged on the level of iconicity,

suggesting an anti-anthropocentric hierarchical conversion. Man does not simply become kangaroo, as in Durkheimian effervescence, but is reduced to the animal. These reliefs were important for their early attempt to confound the human, ontology, and virility/totality insofar as it "is only in a reduced and emasculated state that one finds the base elements" (ibid.:52). More importantly, they confound all aesthetic paradigms based on identity and open up to a chthonian flow where the positivist tidiness of form and meaning is unraveled. The apophatic strategy is to push toward the outside of such positivist ontology from within the world of human representation itself.

Getting low is also about digging and there does indeed exist a Bataillean archeology where the excavation of the vestiges of past igno-bleness serves to supplement contemporary debates on the identity of the human. In any early numismatic portrait, Bataille would, on one hand, theorize the dominant aesthetic vision of any given society to be rep-resentative of its symptoms and anxieties, and on the other hand, rally prodigal Celtic *maladresse* against Greek academicism. The noble Greek horse is debased in the deformities of Celtic coins, collapsing the academic desire to again merge in ideal the form of the body, with the forms of the world, and the forms of thought. The Celtic horse, on the contrary, is ani-mated by an "aggressive ugliness . . . a frenzy of forms, transgressing the rule and realizing the exact expression of a monstrous mentality" (Bataille 1970a:161–62). In Bataille's rendering, Celtic abjection, its respect for the horrors of natural life, was a powerful critique of the academic desire, one which he struggled to remobilize against modernity's ideals. Moreover, the Celtic coins revealed the alternance of human life as ensconced within the alternance of the general economy of nature, again opening the path to a materialism that was not simply ugly, but also a critique of plastic forms which only express themselves as society's symptoms—whence comes the negation of all that is not compatible with actual human life (ibid.:163).

Crucial, then, to Bataille's aesthetic is the value of the formless as the site where form breaks apart, or where one is in between forms. In other words, the key aesthetic polarity, according to Bataille, was not that between form and line or structure and content, but rather between spittle and form. Presaging the post-modern interest in the abject, Bataille had early on understood the abject as an un-saying revolt against bourgeois mores and aestheticism. In "The Use Value of D.A.F. Sade" (1985[1929–30]), Bataille would conclude that excreta remained a vital and liberatory substance that could effectively challenge and subvert bourgeois homo-geneity. In Sade, bourgeois appropriation and the working class as excre-tion are merged in a total heterogeneity where "the one who eats his shit vomits: he devours her puke" (Bataille 1985:94). With the impossibility of revolution and the demise of the alternating rhythm and fusion of appropriation and excretion, the homogenous world would have to be

sacrificed in an orgy where excreta is consumed the bourgeois. And this was among the many tasks of art. The orgy was also the place of "non-form," which did battle with bourgeois and "academic men, for whom happiness was simply an affair of the world taking shape" (ibid.:31). The absence of form is an affront to the cleavage between the high and the low, which has from the nascence of modernity dictated taste, vision, and a world of clear dimensions. Heterology accelerates the entropy of the world, turns categories and classes back on themselves, and actually reveals how there is only no-thing to represent. Abjection and formlessness are not states and, although embodied in spittle, excrement, and flows, they resist thing-ness. As Yve-Alain Bois and Rosalind Krauss (2000:245) therefore suggest, one cannot simply set apart the abject as a type of negative essence; formlessness is predicated upon the refusal of substance and substances necessitating that the concept of no-thing be aesthetically operationalized (without recourse to representation).

Bataille affirmed a painterly practice where the canvas is an index of the entropic abject flow. Thus, in Picasso, Bataille (1985:24) notes how the dislocation of forms leads to a dislocation of thought, bringing the intellectual movement to abort itself. In Dali, he would recognize an irreversible ugliness that was sovereign in its overturning of the great prisons of the intellect (ibid.:27). In Masson, he gleaned the tension between the desire to be "total" and its impossibility, resulting in nothing short of a "pure aesthetic" (Bataille 1988:40). And in Miro, who did not produce paintings, but was rather "killing painting," decomposition left us with "traces of god knows what disaster" (Bataille 1970a:255).

The aforementioned painters were all Surrealists and, as is well known, Bataille too frequented Breton's circles until his excommunication in 1930 where he was lambasted as "a vile esthete." The fallout would result in a series of ad hominem attacks between the two men, but what was truly at stake was the aesthetic battle for the "outside" of the world, a battle for authenticity and for non-system. This was a war between ideal and matter, between sur-realism and the Real, redemptive love and fiery eroticism, art and apocalypse, and the eagle in the sky and the old mole in the ground. In his celebrated indictment of Surrealism, "The Old Mole and the Prefix Sur in the Words *Surhomme* and Surrealist," Bataille pled his case. He reproached the Surrealist spirit for its desire to elevate and sterilize the low, and argued that such a tendency was nothing more than the priggish flirting with the low that ends in its domestication in the bourgeois prison. The Surrealists may have claimed to be on the side of the low, but had to "sacralize" or "surrealize" it, in order to make it palpable to their tastes, resulting in an aesthetic condescension, which looked down from a seat of values that was high above (Bataille 1985:33). They simply did not want to be really scared, and remained a "peevish aristocracy," trapped in a "servile idealism," and the "juvenile dialectics" of poetic agitation (ibid.:41). They betrayed neither classical epistemological

and aesthetic categories nor their own class positions. Surrealism was a pathology, not a revolutionary art, which not only remained bound to the literary and the painterly, but, actually feared the unconscious. The low was not only authentically aesthetic and intrinsically revolutionary, but was also the index of good health. The confrontation with the negative is the condition for full liberty and organic vitality.

Don Juan Redux

In the *Contra-Attaque* days of 1934, Bataille was thirty-seven years old, dazed, delirious, and sick with History. As Surya notes, he traversed Europe as the very image of death itself, "by turns sick, drunk, rheumatic, drifting from one hotel to the next, and going crazy from Dark Italian wine and from this woman who was more uncompromising and pure than any other" (Surya 2002:209). The woman was "Dirty" (Dorothea), who, with Henri Troppmann, would confront the hangover, reflux, and dyspepsia of progress in *Le Bleu de Ciel* (2002[1935]). Infinity was no longer tenable and in the novella, a tale of anti-Don Juanism,[5] the law castrates. Drunk on dark wine again in Tossa de Mer, in April of 1936, Andre Masson and Bataille danced to Mozart's Don Giovanni. They gave birth to a new man and a new myth. Bataille said to Masson, "make me a god without a head—you'll find the rest,"[6] and the result was that

> Man has escaped from his head like the condemned man from prison. He has found beyond himself not God, who is the prohibition of the crime, but a being who ignores the prohibition. Beyond what I am, I meet a being who makes me laugh because he is without a head, who fills me with anguish because he is made of innocence and of crime: he carries a metal dagger in his left hand, flames like those of the Sacred Heart in his right hand. He unites in the same eruption Birth and Death. He is not a man. He is not even a god. He is not me but is more me than me: his stomach is the labyrinth where he has lost himself, lost myself with him and in which I rediscover myself being him, that is a monster. (Bataille 1995a:text without page numbers)

Mystery continues to enshroud the activities of Bataille's secret society *Acéphale*, but we do know that Bataille, according to Leiris at least, was "quite serious" (Lévy 1991:175) in his desire to create a headless religion, an idea whose origins dated back to 1925–26. Leiris proposed the name "Judas" for the group.[7] Judas was replaced by a new Overman, a headless monster who incarnated the frenzy of Dionysos and the lawlessness of Don Juan. The *Acéphale* was a myth founded on the death of god and the invocation of a new politico-aesthetic paradigm that would oppose all monocephalic structures. The new religion also needed a totem which would be a repository of the "totally other"; it needed a mythical structure to articulate its disgust and embrace the forces of the destinal. As

Jean Clair (2010:39) has further suggested, Bataille's endeavor epitomized an epochal aesthetic transition; the head without a body, the decapitated head, was the leitmotif of nineteenth century, but the "new man" of the twentieth century was undoubtedly headless.

The *Acéphale* was raised from the depths to do battle against utility and philosophical absolutism. Ecstatic and tragic, he was also a distant relative of Mithra, Orpheus, Christ, the Minotaur, and Osiris. Undomesticated, he did not know the world, had not internalized its laws and, lacking reason, was incapable of doing so. As pure and unbridled tumult, he is cataclysm and emblematic of the necessity to become *"tout autre"* (1995a: text without page numbers).

His genitals are covered by a skull, merging sex and death, creation and castration, and expenditure and finitude. The flames in the right hand, according to Masson, signify not the sacred heart of the crucified, but those of "our master Dionysos" (Léonard-Roques, Valtal 2003:63). His torso is flayed, revealing the labyrinth where one finds the Minotaur and Ariadne's thread. His monstrous toes grip the earth. But while embodying nature's plenitude and force, he is simultaneously a figure of incompletion. As the inverse of normativity he cannot be total. As pure bios, he is the monstrosity of Being scoured of its contents. The different drawings of *Acéphale* hence place him in unstable and liminal circumstances: he is seated on a volcano; he teeters in balancing a mountain and a cloud; he is projected in the air by an explosion, probably volcanic; the body of a monster; in losing his integrity, he ceases to correspond to the plentitude of the world, reducing himself to fragments of emblems, translating rather the "principle of insufficiency" or "principle of incompletion" of Man which was, according to Maurice Blanchot, the foundation itself of the communitarian project of *Acéphale* (ibid.:65). Bataille (1995c:20–21) desired that the *Acéphale* "mythologically express sovereignty devoted to destruction, the death of God," and be a "super-human who IS the death of God"; he is a "catastrophe without end," a non-teleological space of incomplete becoming, a dynamism that seeks no point of rest. Like the Overman, the *Acéphale* is a bridge, and a critical apparatus divorced from all temporal forms of power. He is the impossibility of both magico-sovereign and communitarian binding, and perched atop the volcano by himself, he is the solitude of non-human singularity. He is the contingent and aleatory nature of human existence that threatens to destroy, and in his case, disembowel. The *Acéphale* thus preached the eternal return against modern civilization's illusory coherence and its fantasy of bourgeois security, while rallying against the monocephalic orders of Christianity and Nazism. As a decapitated king and a pagan beast-god, he raged against permanence. He was the advent of a limitless order of immediacy, which incarnated the earth, but was simultaneously groundless.

Bataille's war, moreover, was one between two politico-aesthetic orders and codings of the chthonic. Monocephalic order condensed force

and, in privileging relative stability and conformity to natural law, was doomed to atrophy or totalitarianism. Through leveling, consensus, and democratizing immanence, democracy contained within it a structural corollary to fascism. The question then was how to rediscover the heterogeneity inherent in democracy's many heads, and insure that they not be reduced to a monocephalic structure. The head as an end enslaves force and disavows the infinity of nature. Politics, religion, art, and society had to be dismembered in order to achieve the immanence that the death of god promised. Bataille thus wanted to unveil the existence of a new plane of mythical life characterized by pure affectivity: whether understood as left-fascist or democraticizing, the *Acéphale* was the immanent god of the left-sacred. Achieving immanence meant mastering Nietzschean laughter which was also dual in its nature like Dionysos; it was the delirium of being swept up in nature's exuberance, but also the giddiness that accompanies the descent into non-being.

Dionysos' historical refrain in the postmodern can be explained by his eternal status as the beast-god who incarnates the raging and the exorbitant forces of too much life, too much earth, and too much wine. But, above all, Dionysos, as "too much," is a figure of alchemical purging. Following Nietzsche and Bataille, all of these characteristics inform the Dionysian aesthetic, constituted by loss, contingency, misrecognition and innocent suffering. Like religion, Dionysos always returns, and he returned with heightened vigor in 1930s and became one of the key drivers of the French political and artistic avant-garde, the orgiastic point of origin for a new culture to come. Bataille's articles on the Dionysian, historically important for their early defenses of Nietzsche against fascist appropriation, are nonetheless flailing rhapsodies which set tragic Dionysian life forces against the *völkisch* phantasms of the Nazis in nothing short of a contestation of Dionysian aesthico-politics: "On one side a constitution of communal forces riveted to a narrow tradition—parental or racial— constitutes a monarchial authority and establishes itself as a stagnation and as an insurmountable barrier to life: on the other, a bond of fraternity . . . and the goal of their meeting is not clearly defined action, but life itself—EXISTENCE, IN OTHER WORDS, TRAGEDY" (Bataille 1995b:18). Bataille was not simply reclaiming Nietzsche from Hitler, but reclaiming exuberance in a desperate attempt to return Dionysos and his imagoes to the left. Against the Nazi homogenization of social life and its radically immanent chosen race, Bataille would counter a Dionysian "chthonianism," which sought to recompose society through a cathartic and natural binding which revealed the true essence of the beast-god in an immanence that crystallized without a *Führerbefehl*. Dionysos may have reigned over a sect, but he was no *chef*, and his magical sovereignty emerged from his own dismembering. In other words, as Bataille suggests, "TO CESARIAN UNITY THAT GIVES RISE TO THE LEADER OPPOSES ITSELF THE COMMUNITY WITHOUT A LEADER, JOINED BY THE OBSESSIVE

IMAGE OF A TRAGEDY ... men are only aggregated by a leader or by tragedy ... a truth which will change the aspect of human things begins here: THE EMOTIONAL ELEMENT WHICH GIVES AN OBSESSIVE VALUE TO COMMON EXISTENCE IS DEATH" (ibid.:18). Dionysos embodies the tragic drives of Life as it teeters constantly between annihilation and harmony. For Bataille, the essence of the Dionysian mysteries remains tied to the play of Life veering toward death and hence, no state, leader, or organization can either domesticate or institutionally deploy Dionysos.

As the 1930s wore on, Bataille's Dionysian delirium would grow more rabid and his will to turbulence would coalesce with his already honed will to tragedy. Dionysos and Jesus share many attributes. Both are lacerated. Both typify the alchemy of bread/blood/wine and promise their eventual return. In Dionysos-Crucified, Bataille imagined the frenzy of a new meta-political community joined in its mutual tearing, one which lives, paradoxically, only for and through sacrifice. Dionysus and the crucified thus open a tragic procession of bacchants and martyrs (Hollier 1988:340); Dionysos-Crucified is pure liminality and the paroxysm of folly and revolution/rebellion. In other words, the contagion of tragic communities bound by death and sacrifice could resist the atomization and individualism of modernity and capital through the will to excess and dissolution.

But these prophecies would do little to combat to Nazi shelling. More importantly, we should recall that the Dionysian theatre, which was once the center of the Greek polis, was replaced by the city as war machine and then the city as center of commerce, and then, in an ultimate historical sublation, a site of commerce that proceeds from within the state of exception that is the permanent war. This historical transition corresponds to a mutation in collective lived aesthetic experience.

Beyond reification

If, for Bataille, the capstone of one's being was the immanence and continuity of death, then sacrifice was the causal principle of humanity. And in Bataille's theory, sacrifice is elevated to a religious and aesthetic principle. But although Bataille's sacrificial paradigm is all encompassing, it was not necessarily a total social fact in any pure sociological sense; Bataille had little interest in facts, but rather only in the violent undulations that they attempted to constrain. Sacrifice was less a fact than the flight from servitude, the glorious act of creative destruction that liberates being from its closed state, and the artistic act itself; it was precisely what had been lost in a modern representational world of artistic utility.

Immanence is that which does not happen, and requires that being be depersonalized and indeed made sacred through dismemberment. The

aesthetic is a chiasmatic site of violence; the artist violated by the Real, violating the object itself, again apophatically straining, and creating an artifact that is the violation of the world which will violate the spectator. From the perspective of the aesthetic, the sacrificial is a processual tensor which unleashes a chain of ruining that creates the conditions for *communitas*. One must thus speak of art as a plane of sacrifice, and the aesthetic as the experience that shrouds it. Art makes sacred, and functions as a hierophantic port that moves us from this world to the other through an act of dehumanization. Hence, religious experience—from wherein the aesthetic is born—is the vanquishing of real thingness in victims and, through ontological projection, ourselves. We too must then become void of moral content. What sacrifice illustrates is the presence of the inhuman within the human, opening the "invisible brilliance of life that is not a thing" (Bataille 1989:47). Religious and aesthetic liminality is achieved through the destruction of the "thing" within the thing. That is, sacrifice, in its quest for the inhuman-religious-aesthetic, eschews all human and symbolically based relations. Sacrifice destroys an object's real ties of subordination, and art too must liberate in a similar manner. And Bataille did not equivocate: "the secret of art is given in this proposition: like the sacrifice, the victim, *art takes its object out of the world of things*" (Bataille 1988:421, emphasis added). Art violates the object by inundating it with negativity and formlessness.

In addition, art was indeed an "exercise in cruelty," which directed its sadism at the "painter condemned to please" (Bataille 1970b:40); the sacrificial aesthetic cuts through and explodes artistic works which content themselves to simply re-present world appear, by making the world disappear. Art must then be set as aside as the accursed share, and it must, as Bataille argues, represent horror precisely in order to open to possibility. Sacrificial art then vanquishes art itself and raises itself to glorious ritual while reasserting the raw realities of the sacred against beauty, a profane concept of which the sacred knows nothing. One must choose between the museum and the negativity incarnated by the sacred, or rather between the profane art of high civilization and the sacred art of the low which strains toward sovereignty. The aesthetic was an "attitude toward death" ensconced in the dynamism of nature's general economy where there reigns a movement that demands that *la mort soit* (ibid.:240). This attitude was a plunge into prodigality without measure and the ultimate abandoning of material or spiritual speculation, which in capitalist economies represent "atrophy" while reveling in accumulation.

In "The Utility of Art," Bataille (2008:212) thus suggests that the art of a desacralized civilization is doomed, and that beyond the closed realm of the plastic arts, a new autonomous art should evolve, one which is forever in quest of a lost world, the sacred world. Its autonomy would lie in its capacity to inject into the world of things the alterity of meta-death. It would be a series of wounds deliberately etched into the profane: and

unable to be instrumentalized, but certainly not "art for art's sake," it would be the "will to think the impossible . . . and attain a marvelous moment, suspended, a miraculous moment" (Bataille 1976:249). This instant of sovereignty, moreover, can only be attained by the sovereign artist who is not a *sur-homme*, but the victim of a self-inflicted wound.

Driven by a "solar obsession," Van Gogh cut off his ear for a prostitute—a sacrifice made for the church that was the brothel. His sacrificial microcosm and passage to the act function as the real and allegorical ground for artistic practice as mutilation; the mutilation is the work of art itself and the wound is homologized to the representation which functions as its trace. And in Bataille's rendering, Van Gogh morphs into the modern solar god, divesting himself of his entrails in the ultimate act of artistic sovereignty;[8] to be sacrifier, sacrificer, and victim, like Van Gogh, to make one sacred by making one give irrevocably, is the crescendo of artistic being. And it also confounds the sacrificial structure outlined by Hubert and Mauss, for whom such mixing is only possible for mythical, that is ideal, beings (Bataille 1985:61). In moving past Hubert and Mauss's logic wherein a "victim is made sacred" as a substitute for the sponsor of the sacrifice who, in turn, profits from the other's death, Bataille's Van Gogh pushed sacrifice to a threshold beyond disinterested interest in which one transforms oneself into the dying god and passage between the sacred and the profane, modifying one's own moral and ontological being, and profiting from the gifts and "shares" that one bloodily bestows upon one's self. Hubert and Mauss sought to overcome the Catholic annihilationist imperative to self-immolation and auto-crucifixion which was antithetical to the constitution of a Republic that depended rather on civic sacrifice, and giving of oneself, not a total "giving up" of oneself. Bataille's post-Catholic annihilationism would rather posit the preeminence of a total sacrificial drive where one incarnates sacrificial liminality, becoming solar and becoming free. Van Gogh's mutilation carries no immediate social function, but becomes the means for the painter to achieve a radical freedom where one is precisely free to indulge, free "to vomit his own being just as he has vomited a piece of himself or a bull" (ibid.:70). Art as sacrifice and sacrifice as art were rejections of the human, communion, and the social. Promethean in nature, Van Gogh was a mythical mixing where "mythical" means transhuman (Bataille 1970a:654–55).

Bataille would develop these concerns and, as the ambiance of the inter-war years grew more urgent, transpose them on the meta-politics (a politics of politics) that was developed at the Collège of Sociology (1937–38); the Collège was that sacred foyer where he along with, inter alia, Roger Caillois, Michel Leiris, and Jean Paulhan, developed a neo-Durkheimian sacred sociology which would examine the manifestations of the sacred in the social field, all the while erecting a politics that sought to resacralize that same field which had grown listless and incoherent. Apropos the aesthetic, the lesson of the Collège was resoundingly clear:

art is an impoverished form of myth, something done alone, which, more-
over, thwarts the very possibility of community insofar as it denies the
existence of the social energetics that unleash the orgiastic to which myth
is dialectically bound. Aesthetic negativity was also a political negativity
and engaging the latter also meant plunging into the contagious power of
the executioner's mask, the shaman's incantations, Teutonic orders and
centauric brotherhoods, and also the fasces and lictor axe. They searched
to construct a meta-political hermeneutic which interpolated the poli-
tics of the left with sacred negativity, but their quest for new anti-fascist
sacred politics (that bemoaned really-existing democracies) lodged them
in an untenable double-bind.

As for Bataille's own contributions, his most explicit engagement of art
came in a piece entitled the "Sorcerer's Apprentice" (in Hollier 1988). For
Bataille here, the possibility of being total was precluded by the instru-
mental rationalism of contemporary society which fragmented being.
L'homme integral was pure refusal and polymorphous; he served nothing.
And for Bataille, art in its contemporary condition, a condition which
opposed the sacred, served to exacerbate fragmented life. The function of
art was equivocal and "the writer or artist does not always seem to have
agreed to renounce existence . . . Art and literature express something that
does not seem to run around with its head cut off like erudite laws . . . In
images of the imagination all is false . . . those who have served art have
renounced making what an uneasy identity has compelled them to bring
to light into a true world" (Hollier 1988:15).

Art indulges in portraits of the imagination that neither oppose this
existence nor surpass it. In the contemporary world, the imagination too
is reified and cursed by the falsehood that comes from crippled existence.
In addition, the fictions produced by literature, by virtue of their proxim-
ity to this world, remain obfuscated by ideology and, unable to grapple
with "destiny's conflicting movements," never achieve profound exist-
ence or the Bataillean Real where total man is born of negativity.

Art cannot be in service of this world, and destiny's conflicting move-
ments are only subdued when they are mediated through fictional para-
digms which defer the Real by suspending it in representation. Destiny
remains unfulfilled and, deprived of destiny, men are convinced that the
world will be here again tomorrow, just as it was today. Artistic life was
thus the pivot for abnegation, a place of hollow dreams that perpetuated
disassociated existence which was not existence at all. And presaging
his own later formulations, Bataille would further argue that continuity
unfolds in the true world of lovers, a world beyond art where "beings find
each other": "[i]t would be vain to deny that the hearth thus ignited con-
stitutes a real world . . . this world constitutes one of the rare possibilities
in actual life, and its realization presents a character far less distant from
the totality of existence than are the worlds of art, politics, or science . . .
in any case it would be a mistake to consider it as the elementary form of society"

(Hollier 1988:19, emphasis added). Glimpsed in the solar burst, the world of lovers flanks the world of art as an impossible frontier. And the sovereign world of lovers neither founds the social nor knows the social insofar as "myth is born in ritual acts concealed from the static vulgarity of a disintegrated society, but the violent dynamic belonging to it has no other object than the return to lost totality" (Hollier 1988:23). Hence, conceding the death of the social, Bataille was also announcing the end of the Durkheimian alteration between the sacred and the profane, which is entirely surpassed in the Bataillean opposition between the world (within which art, science, and politics are closed) and the mythical non-human world glimpsed in the metaphor of lovers. Therefore the aesthetic of the Real opposes the static vulgarity of art, exploding into its confines in ephemeral instants only to be barred from it along with the sacred which too is of another order. For the dissatisfied, for those who recognized the death of politics and were neither moved by the discoveries of science nor capable of being aesthetically roused, myth would prove a last bastion. But Bataille did not theorize myth; myth, for Bataille, could heal shattered life, and although he recognized that "myth is perhaps fable" (ibid.:22), he refused to concede its death.

In Bataille's denunciations of art one senses the presence of a deep political despair born of both political and aesthetic impotence. And responding to art's inability to point the way out of the tragic *entre-deux* of contemporary homo-duplex, and approximate the sacred, the aesthetic was projected into an elsewhere that was material (baseness) and mythical (the world of lovers). The reified imaginary was betrayed in the fact that artists were not titans and despite their idiosyncrasies were very much the same as all of us. As Richman suggests, the untenability of art for Bataille emerges from the very fact that "great works are distinguished by the *éclat* or *dépense* ... but the artist, despite his aesthetic celebration of expenditure, nonetheless, continues to write, to publish, to read" (Richman 1990:149). Bataille also continued to write, publish, and read, while simultaneously theorizing the impossible displacement of an aesthetic of expenditure to the experience of expenditure as life's sole aesthetic principle, an art that no one could own or exchange.

Besieged by the forces of history and internal disputes concerning its mission, fidelity to Durkheim, rigor and efficacy, the hothouse that was the Collège would fail and fade in 1939. Bataille would go on to seek passage to the world of lovers—by himself.

Torture photos

Abandoned and, in his eyes, equally betrayed by his colleagues, Bataille began work on his mystical riposte to St. Thomas, the *Summa Atheologica*, a three volume corpus, where war, religion, and an atheological

iconography would again fuse, not in historical time or in the world of politics, but in Bataille himself. The question for Bataille was not, however, simply about displacing politics to inner experience, but also reconstructing an aesthetic around the inner, an interiority that would replace the full Catholic aesthetic with a world of representation that fully engaged the harrowing ecstasy experienced before an absent god; an aesthetic of wounded subjectivity becoming the wound that was the Earth—of ruined men ruining themselves in the midst of historical ruins. Bataille would sacrifice and sacralize himself, and, inspired by Angela de Foligno (Hollywood 2002:60–80) and St. John of the Cross, become the void that was superior to a humiliated god who could only be an atheist. The aesthetic was participatory and, far from a simple act of apprehension, it entailed that one use the image as a pivot for the experience of self-wounding.

One cannot separate Bataille's religious and political sensibilities from his development of the apophatic aesthetic, insofar as all three sites were (un)grounded in the experience of their very impossibility. What began in religion would be diverted to the political, only to culminate in the mysticism of "inner experience," which was both a retreat from politics and religion and their most radical reconfiguration. It was also a reconfiguration of the senses and *sens*. Bataille's search for political community was, thus, relegated to an internal drama that confirmed and compensated for his lack of agency, a lack that in inner experience he would ceaselessly enlarge. But regardless of whether we interpret inner experience as a politics or the fleeing of politics, one cannot deny that it is a place of translation; through inner experience, formlessness is thus translated on political time and the liquidation of the images attached to the dialectical movement of history.

Bataille's mystico-eroticism was neither calculated, rule-bound, nor something to be learned. However, it did include ascetic–aesthetic practice which Bataille described as the entrance into the "alternation of exaltation and depression, emptying existence of its contents"; the quest for the empty-zero state deprived of agency which is a healing structure (Bataille 1961:39). Moreover, in replacing compensatory morality with the sacrificial, he inadvertently replaces the Republic with the wound, the symbolic representation with tearing. Durkheimian morality, replete with its transcendent totemic structures, could not instantiate the "wound, the pain necessary to communication" and thus real sociality (ibid.:50). In other words, if "the crucifixion is the wound by which the believer communicates with god" (ibid.:51), in God's humiliated absence, communicability can only be engendered through a wounded humanity, divorced from consistency, morality, and rest; but like the community formed around the abject body of Christ, we too had to disclose our abjection. The method was violence and a dramatization that mimicked the movements of sacrifice, where one "breaks internally with the particularity

that encloses me in myself" (ibid.:57). Aesthetic experience therefore also includes the overcoming of the representation of selfhood, upon which all acts of perceiving are mistakenly predicated. And dramatization is intrinsically aesthetic insofar as, following Kalliopi Nikolopoulou, it "emerges in conjunction with visuality . . . Bataille draws on its acoustic and tactile aspects. The wind howls in our ears and strikes our bare skin. Visual, acoustic, or tactile, dramatization is the contestation of language in the domain of affect" (Nikolopoulou 2009:99), Bataille refused to close Hegel's circle and become the sage who secretly feared madness. He aspired to become the remainder of logos, the secular, and the knowable—the remainder of art.

It is also in *Le Coupable,* the first volume of the summa, that we first encounter Fo Chou Li, the would-be assassin of Prince Ao Han Oaun, who, upon being caught was sentenced to Leng Tch'e or the Torture of a Hundred Pieces.[9] Bataille was haunted not only by the severed limbs of Fo Chou Li, but also by the executioner who carefully performed the amputations (Bataille 1961:63). It is not clear if Bataille knew if he was looking at a photo that resembled the crucifixion but the photo was the key to the method of dramatization that Bataille would elaborate in the second volume of the Summa, *L'Expérience intérieure* (original 1943/1955), where, liberated from his solitude, he would also argue for the authority of experience.

Inner experience opposed all dogmatism and the servitude attached to both confessional and mystical state in favor a bondless confrontation with God as Nothing and the God of Nothing that was revealed through fever and anguish. A variation of Loyola's exercises, dramatization forced one "to go beyond what one naturally felt" (Bataille 1951:28) and enter the dark labyrinth of experience, where Ariadne's string was cut (ibid.:45). Denuded through the sacrificial violence of inner contestation, "man" was overcome by the negative and bereft of desire; "inner experience is the contrary of action" insofar as "action is entirely dependent upon project" (ibid.:59). Existing in a void, he is the "being who dies" that flees the limits of the "being who lives" and achieves the sovereign summit by becoming the "vertiginous hope, burning fever, where the limit . . . is pushed back" (ibid.:86). Inner experience is catastrophe, not salvation (where being goes nowhere).

However, while ecstasy had no intrinsic object, Bataille would stare at the Chinese torture victim who he used as the "point of dramatization": "I fixate on a photographic image—or sometimes the memory of it—of a Chinese man who must have been executed in my lifetime . . . the patient, chest flayed, twisted, arms and legs severed at the elbows and at the knees. His hair standing on end, hideous, haggard, striped with blood, beautiful as a wasp . . . I write 'beautiful'" (ibid.:139–40). Hollywood argues that while Bataille engaged in dramatization and reconfigured the War into the war of inner-experience, he was also using the image of the

Chinese torture victim as a "stand in for those victims of Nazi violence" (ibid.:62). However, in sacrificing himself vis-à-vis his identification with the torture victim, the question of his complicity with the executioner is also posed. Bataille's abiding interest in sacrificial communities from his early perversion of Mauss and Hubert to the failed experiment of *Acéphale* attest to not only a will to victimhood, but a wrestling with internal sadism as well. Far from liquidating the sadistic and masochistic in the act of identificatory *jouissance*, Bataille incarnates both tendencies simultaneously. Whether considered as pacifism, abnegation, or the search for a new aesthetic communal ground, Bataille was confronting more than Nazi victims in *L'Expérience intérieur*. In 1947, he later wrote: "We are not simply the possible victims of executioners: the executioners are like us . . . Our potential is thus not simply for pain, it also extends to passion for torturing" (Bataille 1988:266).

Affliction

The only future for art would necessarily be the dramatization of "the point," where it would be apophatic if not silent. Yet, the revealing of inner experience as communicative required an apophatic exposition that wrote the point, a "thanotagraphie" (Teixeira 1997:98). Bataillean apophatic writing is a type of sacrificial writing which plays in the space between saying and its collapse. It does not communicate through depiction, but moves by way of evoking the torrential immediacy of the point as paroxysm of the overcoming of linguistic, social, and metaphysical grammars. Sells (1994:9) reminds us that "many apophatic writers suggest that the reader cannot understand what is being said until she becomes it," becomes the "meaning event" which is "that moment when the meaning has become identical to the act of predication." But as a low mystical practice, inner experience does not move to ontological identification; writerly practice here does not simply reconfigure transcendence as immanence, but eliminates the very possibility of the former as a condition of communication. The "war" is displaced to the ground of writing itself, where the "the writer" dies in the event. This is a deontological writing of nonunion which does not conclude or find any resolution in the possibility of *coincidentia oppositorum*. Bataille does not aspire to burn away distinctions through the overflowing of mystical love, but moves to sustain the burning of anxiety that cannot be overcome with the rapturous work of the mystic's longing. Hence, the reason for writing a book was to "cease to be," requiring "that I die. To not be had become an imperative exigency of being, and I was condemned to live not as a real being but as a fetus that had been tainted before term and as an unreality" (Bataille 1970b:143).

The years between 1942 and 1959 were also marked by a flurry of apophatic thanato-poesis of which the culmination was *L'Impossible*

(1962), originally titled *Hatred of Poetry*. The impossible evokes the negativity of language—an expenditure on the level of the word. Beyond poetry is Bataillean apophasis where poetry strains to become a language of tactility that also functions as an intimation of the wound. Hence, poetry is "the evocation by words of inaccessible possibilities," which "opens the night to the excess of desire," exceeds this world, reveals and denudes the unknown, in a suspended night (Bataille 1962:188). A poesis without an object, it approximates, through the grain of language, the paucity of all that which attempts to complete itself. The impossible is glimpsed in a language of agitated descent where the self no longer can imagine totalities or even preserve itself as human. Smooth communicative language is eclipsed by the "holocaust of words," a bloody language that can only fail in its unraveling. It is a dramatic discourse of rejection of and by the world: "What had I done, I thought, to thus be rejected into the impossible . . . nothing can escape you now. If God is not, this desperate cry in your solitude is the extreme limit of the possible: in this sense, there is not one element of the universe submitted to him! It is submitted to nothing, dominating everything" (ibid.:97). If poetry is the quest for the sacred, it only becomes sovereign when acknowledging the sacredness of its own bereftness. "The Impossible" is exile where solitude transforms every being into the lone man of anguish. A language of fire, where life is lived on the condition that one burns (ibid.:29); the impossible is an ineffable non-substance that is only intimated in the aporia of signification. The self is undone in the infinite impotence experienced in the chasm between the world to which one is no longer subjugated and the world that can never have you. As Marie-Christine Lala argues, Bataille's "impossible uses the object-as-lack as a medium to translate something irreducible, which makes it impossible to render it directly accessible . . . the text of *Haine de la poésie* struggles to dramatize it, to expose it . . . Language, the body and the subject reach their own limits in this trial by the impossible and by death" (Lala 1995:107). However, although the impossible is the site of a trial, we should recall that "death" in this context, like "God" and "night," functions as another name for deontological non-content. Bataille was no stranger to the play of the ineffable names of god and the negative theological tradition. The name names no-thing and, as Sells further notes, in the apophatic tradition, "if X is ineffable in this rigorous sense, it cannot be called X . . . no statement about X can rest as a valid statement, but must be corrected by a further statement, which itself must be corrected in a discourse without closure" (Sells 1994:207). Bataillean apophasis recognizes the impossible to be unnameable, but in the name of sustaining anguish and the trial of being ousted from the world of things, he cannot correct himself or dialectically climb in unlimited non-closure. The point evades the cumulative narrative logic that conventional apophatic naming engenders and does not unfold through any perpetual play of contradiction and negation. Rather, it fixates and

pushes toward the zero of immanence which is always, unexperienced and only called "death." Hence, against contradiction and ceaseless dialectical non-closure, with Bataille, writing the impossible is an enterprise of obsessed suspension and torrential inertia. He thus outbids negative theology by refusing metaphor, while nonetheless constructing a discursive field upon which the negative can be mobilized in order to swallow the signifier itself in the immanent substrate that looms underneath the work. Reproducing the repetitive explosion of aggregates that characterizes Thanatos, the language simply indexes the instant and never denotes:

Frozen tears
Equivocations of eyelashes
Lips of death
Inexpiable teeth
Absence of life
Nudity of death. (Bataille 1962:154)

Poetry must be hated because it is not driven by hatred itself, because it flees finitude and cowers before the realities of the world transformed into war machine. The age of beauty had officially ended and if there would be poetry it would lament in silence. The impossible is humanity on trial before its Other. And while not a site of artistic work, the discursive markers used by Bataille constitute nodal points for a kind of psychic-work in the present, a means of securing a certain type of courageous remembering of the existence of the immanent world underneath, and the vectors of contemporary violence that are denied in the name of humanity's will to progress. Guilty before the void, the impossible is a common point, a shared space where annihilated, sovereign humanity can emerge without a why and what for. Writing here serves to then transform the now-abandoned subject into a wounded bacchant whose fusion with others is contingent upon the collective apprehension of impossibility, and the excessive overflowing of the anxieties of finitude: "I throw myself among the dead" (Bataille 1962:167).

Origins and ends

Against the backdrop of Josephine Baker, the birth of French ethnology, Surrealism, jazz, and the new found obsession with Oceania, the majority of inter-war artists and intellectuals, from the Surrealists to Lévy-Bruhl, were part of a new French bourgeoisie who lauded primitivism, but kept a safe and specular distance from it. This primitivism emerged not from a desire to universalize, but rather to affirm and define the bourgeois as a class of new moderns whose modernism was dependent upon their sustained gaze on the Other, who was fetishized and specularly colonized.

Bataille was certainly not immune to such tendencies. However, his embrace of the primitive did move beyond the colonial and the orientalist and, by virtue of his desire to collapse the distance of the avant-garde gaze and *épater le bourgeois,* he also collapsed the distance between the primitive and the modern *tout court.* In other words, unlike Durkheim, Bataille was not content to simply identify the elementary form as a key to scientifically understanding the morphology of contemporary societies, but rather sought to avenge contemporary society through a heuristic of primitive alterity that could function as a critical aesthetic tool. The question for Bataille was not to examine the evolution of social formations from their archaic origins to the present, but rather to affirm the existence of an archaic substrate within the present and hence not preclude the possibility of a modern anti-modernism that would be naked and fiery. He opposed the primitive to the modern in order to crush the absolutes of nationalism, progress, utility, race, and religion, upon which societies erected themselves. In an early 1930 review of G.H. Luquet's *L'Art Primitif* for *Documents*, he thus praised the primitive's capacity to destroy the objects of objective reality through a progressive aesthetic alteration that lodged the object into the world of the non-human; art was not only a violation, but that which moved by the successive destruction of the universe, engendering the most sadistic of libidinal instincts; art harnesses nothing, but rather gives free reign to the instincts which propel man into immanent flow through decomposition of the real (Bataille 1970:353). However, the paroxysm of Bataille's primitive aesthetic would come with the opening in 1948 of the Caves of Lascaux, containing more than two thousand paleolithic signs, among which the most celebrated were found in the "Hall of Bulls."[10] For Bataille, the caves were an imagined locus for the lost site of immanence where the "new man" (who was of another time), the sovereign man of art, committed the first artistic act. And, in his own anthropo-archaeology, the signs were inscriptions telling of the agonizing transition from animal to man. In *Lascaux ou la naissance de l'art*, he thus argues:

> Two decisive events mark the beginning of the course of the world; the first is the birth of the tool (of work); the second is the birth of art (of play). The tool is of *homo faber* who, no longer being an animal, is not quite a man either . . . the birth of art emerges with the existence of the tool. Not only does art assume the existence of tools and the know-how to make them and wield them, but there is also, in relationship to utility, the value of opposition: it is a protest against the world that once existed, but without which the protest would have no force. (Bataille 1955a:27)

The origins of art are found in the traumatic transition from a pure space of immanence and non-utility to one constituted by the introduction of the tool, which is also the introduction of time, death, finitude, and taboo.[11] Art is, from its earliest inception, pure agon and precisely the confrontation with a new human world organized upon the instantiation

of the taboo, which bars the possibility of free "communication with the spirits"; whence the strained images of hybrid man-animals who become cognizant of the new division of the universe between the worlds of work and play, and enter into new modes of "primitive classification" that create a series of interdictions between the universes. The birth of art is also the birth of the transgression and de facto, the birth of the sacred and the profane. The first paintings are ritualizations of immanent being overcome by the transcendent, where far from being an animal among other animals, man becomes he who transgresses the animal domain in the hunt, breaking the newly established taboo on murder, a transgression that is expiated in the birth of art. Paleolithic expiation, on the level of the representation, meant dissolving the human figure before the animal and entering into the infinite symphony of animals, confirming that "man's superiority is only technical," an affair of the tool; but not completely absorbed by the world of the tool and human project, Paleolithic man also recognized that the animal "was graced with a force that was not his," that the animal was in fact "superior to man in a multitude of ways . . . in direct contact with the forces of divinity, closer to the forces of nature, which he freely incarnates . . . it is above all a fact of civilization that the *éleveur* is himself inferior" (Bataille 1955a:126). In the drawings, humans sought to partake in the prestige of the animal in an attempt to rally against the imposed distinction between the two orders while lamenting the inevitable adieu to the animal and, perhaps, registering an intuition of the future loss that would follow. The entrance into symbolic and properly aesthetic life, a source of deep anguish, is exemplified by the infamous *homme du puits*, a bird-headed ithyphallic body standing before a wounded bison, forming a *dispositif* of human sexuality, reproduction, death, and religious, agricultural, and economic life. Perhaps he is a shaman in a trance, perhaps a wounded hunter, but what is striking for Bataille is the difference in the representation of the animal and the man, one which signals the separation of two aesthetic economies; the bison is depicted with "intellectual realism," appearing "naturalist" before the human figure (ibid.:117).

Bataille's second monograph on art for Albert Skira concerned not the origins of art, but rather the origins of modern art. In *Critique*, he had already examined the suspended time that impressionist painting often evoked and the definitively modern anxieties that resonated under its play of points and color (Bataille 2008:375). Manet's silences and his own sovereign-silent subversion in art were not only the origin of a modern ethos, but also the foundation of the modern apophatic aesthetic which was the completion of the process initiated at Lascaux. Art would no longer represent sovereignty in exaggerated symbols of divinity, royalty; but rather pervert these codes by setting them in relationship with indiscussable realities, and a silence that evades utility in its fatigue with civilization. In Manet's toreadors, barmaids, bourgeois couples at the park,

and *Olympia*, a looming ugliness is introduced onto the painterly surface which outs the abject horror at the core of the contemporary middle class and the fallen aristocracy. It is precisely in Manet's will to truth that his painting becomes sovereign and naturalistically embraces the obscenity of human nature; the dirty little secret that is locked away in all bourgeois life is always evoked. But the result is not a dramatic reckoning with the negative, but rather the apophatic "play of indifference" on the level of the painterly. For instance, Manet's *Olympia* places in relief the "internal conflict of the bourgeois. The aristocratic world has lost its vigor for life and bourgeois conformism can only maintain it in empty forms" (Bataille 1955b:60). The "scandal of *Olympia*" was the acting out of this conflict which simultaneously mocked modes of classical beauty" while announcing a rupture with the aesthetic norms of the past. Glacial, Manet's *Olympia* is the "secret, the silence of the bedroom," where one gleans the "flatness of violence," and, although "almost a crime or the spectacle of death," everything "slips into the indifference of beauty" (ibid.:74). The scandal of *Olympia*, a simple nude "goddess" being attended to by her Black servant, is the scandal of bourgeois reality itself. Manet's characters are not only indifferent, but also resigned to a world that goes nowhere, inhabited by the last men who frolic indifferently and simply await the catastrophe. Severed from immanence, they cannot communicate at all; their silences, far from being erotic, are truly empty or defined by the ultimate absence of the sacred. The force of Manet's work lies in the despair of this silent indifference, its capacity to be natural and reveal the malaise of impossibility through simply depicting, not deforming, the nudity of the bourgeois at the twilight hour of the world. Moreover, for Bataille, Manet's own indifference toward bourgeois mores is the condition of his own sovereignty, which, characterized by a "sober elegance" which can be cultivated in a "new region where only a deep silence reigns, where art is the supreme value . . . art, in general, this is to individual, autonomous man, detached of all enterprise, of all given systems and of individualism itself" (ibid.:64). In confounding Manet with his pictorial universe of "supreme indifference," Bataille was also arguing for the total denuding of bourgeois civilization which could potentially lead to the point of sovereign detachment, a detachment that can come only out of the disenchantment that flows through Parisian parks and brasseries as a silent energy, buzzing under the din. Manet's sovereign gesture was to be of this world, which he represented, but in thorough disregard of its values and constraints. The dialectic of history is then one where Paleolithic man severs himself from the animal to become civilized only to force civilized man to leave civilization for another sovereign site which is neither animal nor human, but simply enveloped in silence. Sovereignty for the last man may not be Dionysian or Acephalic, but simply a question of evaporating into indifference or cultivating a solitude which can be the only protest against modern decadence.

Tears

The Bataillean aesthetic develops along a gradient from the hotness of the sun to the coldness of *Olympia*. In synchrony with this shift in aesthetic climate is also the movement from the effusion of the orgy to solitude, from the vulcanism of the *Acéphale* to silence. The aesthetic achieves its most powerful apophatic (in)completion in eroticism precisely where the work of philosophy is overturned by a somber transgressive play wherein "silent contemplation would have to be substituted for language. This is the contemplation of being at the pinnacle of being" (Bataille 1987:275). In the thick silence of eroticism, subjectivity removes itself from the world of things through a rising sensual immediacy that reveals a kind of inner truth. Breaking down totalities through the inner movement of transgression, it shatters logos in order to approximate a silence that is not an interval between signification, but the obverse of all "work" done in language, philosophy, and art—"the supreme moment is a silent one, and in the silence our consciousness fails us . . . in the hushed silence of that moment, the moment of death" (ibid.:276). Born in the dialectic of the ithyphallic man in the caves of Lascaux, within erotic silence, be it tortured or torturing, the world of play triumphs over the world of work just as death triumphs over the tool. Erotic apophasis melds into the passing away of the universe, affirming in a definitive manner that being is arbitrary and that inner truth is not of this world, a truth that opens only in the space where "language goes to the end of eroticism, and eroticism goes to the end of language" (Bataille 2008:324).

Bataille's uncompleted *History of Eroticism*, begun in 1951 and labored on until his death, is, in many ways, the culmination of his aesthetic theory and the journey begun at the razed church of Reims. It is also the culmination of the Bataillean imagoes and a placing in relief of the anguished silence that churns under those many photos of flagellation: the flayed body, obscene graffiti, the phallus of Delos, the images of the execution, the mad dance of voodoo rites, the *supplice chinois*, and, of course, the slain bull (Bataille 1971:25–44). The final sigh at the end of life's exasperated movement, *contra* Freud, Eros does not preserve, but is rather typified by a dissolving movement where the world is exasperated in the face of the consciousness of death. Eros and Thanatos thus form an aggregate, one where the force of the death drive violates the will to conservation in an incessant dynamism for which *la petite mort* is but one actualization. The erotic moment is the summit of such exasperated desire or, in the famous Bataillean dictum, the "assenting of life up to the point of death" (Bataille 1987:11), a movement driven by the tragic *jouissance* wherein laughter and tears burst forth simultaneously. The erotic thus should not be confounded with pleasure. The dialectic of transgression/law/*jouissance* actually breaks down in the erotic aesthetic where the subversion not only breaches the taboo while sustaining it, but

where *jouissance* is embodied as a "calling into play" that hovers between the temporal ebullience of having surpassed the taboo and the anguish of experiencing the taboo as the center of all existence. *Jouissance* then is being ruined, or rather where "man achieves his inner experience at the instant when bursting out of the chrysalis, he feels he is tearing himself, not tearing something outside that resists him" (ibid.:39). The tear, the locus of art, is the point from which nude subjectivity speaks silence. And torn erotic man resurrects the tragic unconscious of historical being, one which began in the Dionysian mysteries, only to be rolled back by the era of high Christianity and modernity. In the instant, eroticism plunges one back into pre-history where cathartic sublimation reigned over time, space, labor, and desublimation. The erotic is then also a current that connects modern being with his ancestors, be they the men of the cave or the maenads of the Dionysian. Eros—and here one evinces a "calling into play" that transforms all involved into martyrs of the internal, cosmic, and terrestrial war between the forces of life and those of death. Art and poetry, which have for too long only produced simulacra of such sovereign existence, are thus implored to participate in the instant. Beyond the metaphor and the simulacra that refuses nudity, is the violence of the image and an aesthetic reproduction that is the reproduction of death. Art must approximate the contagious left-*mana* exuded by the corpse.

Assenting to death is a state of negative grace, where one abnegates the world and succumbs to the violence that secretly animates inner life. Aesthetic experience in eroticism is characterized by the onset of a "dizzying effect," then "nausea," then "heady vertigo," and finally the "paradoxical dance ordained by religious attitudes" (1987:69), which shares nothing with Durkheimian effusion. Eroticism, a movement without an end or ends, could never use ecstatic frenzy as a means of creating the autonomous and indeed subservient citizen who was simply better prepared to perform his duties "after the orgy." Paradoxically then, solidarity is a flight away from Bataillean immanent continuity and communication.

The sovereign man of eroticism, freed from duty, lives while ceasing to live, and challenges civilization with the authority of erotic sexuality to which he is wholly subservient. That is, he submits only to the torrents of his own ecstasies which, as in the aesthetics of medieval mysticism, "swoon" and push experience and representation to the threshold of finitude where visions of things are replaced by visions of nothing. The mystic's art is a challenge not only to the "church" and the Durkheimian church, but also to the hegemonies of artistic language that refuse the immediacy of the swoon, which constructs its own metalanguage of death/ecstasy from which it negotiates the alienation of this world. "Going to the end" in eroticism, he gives in to the "desire to fall headlong," to which he yields in spite of himself (Bataille 1987:243). A drunken saint, the man of eroticism is sovereign in his obscenity—the erotic degrades.

But for all of its inner violence, the erotic is constituted by both sanctity and solitude, and although the experiences of eroticism and sanctity are not necessarily identical, they are animated by the same intensity which de-centers in a heroic descent where one becomes the ravished saint who no longer speaks, no longer knows, and has parted with a civilization that was always far too gregarious. Stationary, the aesthetics of excess is also asceticism pushed to its extreme, and quietude is Eros' paroxysm, precisely there where anguish and ecstasy collide in an aesthetic that is neither melancholic nor pathos-ridden. Eros is "unreservedly open and dying, painful and happy ... the cry that being—vainly?—tries to utter from a twisted mouth is an immense *alleluia*, lost in endless silence" (ibid.:271).

The ethico-aesthetic

Bataille's ethics finds its articulation in his de-ontic vision of the aesthetic. If, following Bataille, one accepts that humans are animals constituted by a severed relationship to a pure aesthetic of the low, a new horizon of inquiry opens up which asks what kind of animals they really are and how their aesthetic life reflects this animality. It is precisely this question that opens up a domain of important ethical reflection.

The intrinsic linkage between the good, the fine, and the beautiful, has been a hallmark of philosophical thought from Aristotle to Durkheim to Wittgenstein, exemplified by the latter's celebrated pronouncement that ethics and aesthetics are one. Insofar as ethics is an affair of shared principles, thinking the ethical through the aesthetic necessarily requires that we, on one hand, ask how such principles are incarnated in aesthetic representation and the aesthetic, and, on the other hand, how the aesthetic becomes a site where values are forged resulting in the construction of communal life. But with Bataille, as with other precursors of the postmodern death of the subject, the common, and the possibility of truth, is rooted in the experience of radical heterological difference. As Seyla Benhabib remarks, "the aesthetic intimates a new mode of being, a new mode of relating to nature and to otherness in general ... the aesthetic negation of identity logic also implies an ethical and political project" (1989–90:1443). However, while the principle of non-identity has become *de rigueur* among those who continue to rally to the call of deconstructionism, Bataille, a far more dramatic thinker than Derrida, did not content himself to trace the play of difference on the level of the signifier, but rather radicalized difference to cut through all human ontologies revealing the voided space of apophasis where communities impossibly struggle to construct themselves in a zone devoid of "language."

The impossible, as precisely the non-discursive moment of truth, functions as the point around which such communities of death, spectators

to their own sacrifice, emerge. The self's relationship to its own death in the general economy of nature, is precisely where it engages others and otherness, and becomes ethical. And it is in the aesthetics of excess where the immanent gradient of loss overwhelms and overcomes the human, that the possibility of communicating presents itself. In the excess of the non-discursive, ethical life constructs itself anew without any recourse to outmoded paradigms of normativity. Philosophy, art, and aesthetics stop at the impossible, and with them the history of morality as well. If there will be a moral imperative, it will be articulated, as Jean-Michel Heimonet (1987:15) suggests, as an imperative to heterogenous reality which remains undecided on the level of language, but decisive on the level of the act or *vécu*. In other words, the apophatic representation or enunciation is precisely that which "presences" the traumatic trace of finitude and the alterity to which we are all ultimately responsible and perpetually in debt.

And the balance-sheets of being in common never "break even," insofar as my debt to the *abîme* and to the Other who interpolates me with finitude can never be fulfilled or made positive. If immanence is impossible, so is the community to come that is formed in relation to it. Society is an apophatic construct itself, speaking itself as its absence and untenability, always to come. The aesthetic, as intrinsically bound to the ethical, is thus also the experience and apophatic intimation of such incompleteness and indeed homelessness. Aesthetic life does not foster solidarity as in the Durkheimian paradigm, but rather proves how we can never be reconciled to one another. The neo-Durkheimian critique of the death of the community becomes a mythic and discursive means of retaining the communal in its absence, but as something of the imaginary, something that has actually never taken place. As Jean-Luc Nancy (1981:15) rightly claims, what this community has "lost"—the "immanence and the intimacy of a communion"—is lost only in the sense that such a loss is constitutive of "community" itself. And just as society, and the great projects of modernity, implode because of their failure to reckon with such loss, preferring to erect social ontologies of essence and transcendence, art fails when it serves the former projects.

However, the catastrophe and the negativity of the other are also very natural and alterity consists equally of the agon between the human animal and the explosiveness of the anthropocene. Confronting finitude necessitates that we equally engage the catastrophic ferocity of the general economy of nature, and privilege its torrents and (re)presentation as the locus of aesthetic–ethical life. Bataille neither recognized the transcendence of nature nor configured it as raw matter to be mastered by human project. He refused, to take up Timothy Morton's dark ecological thesis, that nature was ever something "over-there," but knew that it was in us and of us as a nature which is our nature. Or, one could argue, that in between this world and the other, there lies a "second nature" that forms the space of Bataille's inexorable and immediate *entre-deux*. The

construction of the new man is also the ethical and aesthetic construction of the new Earth. Rethinking the human animal as embedded within an immanent socio-eco system would then create the epistemological grounds from which responsibility would no longer be responsibility to oneself as the self would be marked by the principle of insufficiency, but responsibility to negativity itself. And in foregrounding the codependency of the human animal and milieu, a holistic approach to responsibility could be born wherein flows circulating from one entity would enter into assemblage with others creating a series of fluxes and refluxes that would oblige the human animal to act ethically in the face of the catastrophe. The very possibility of an ethics rests upon imagining the unimaginable, in projecting the catastrophe, and herein lies the social function of the Bataillean aesthetic. Hence, as Kathryn Yusoff argues, "For Bataille ... how the world is ordered through archival principles acts on the possibilities of experience and ethics. Thus Bataille's aesthetic engagement with the forms of experience and spaces of action in multispecies living suggests a radical departure from the careful conservational approaches that define our current response of accounting for biological life and the loss of the world" (Yusoff 2010:88). The "conservational approach" which characterizes the human enterprise in all of its domains, most importantly the ethical and the aesthetic, actually forecloses the possibility of such an experiential ethics of the anthropocene. Bataille's aesthetic and ethics, in foregoing "conservationism" and its falsehoods, thus posit a communal possibility that is neither weighed down by moral anachronisms, nor a postmodern nihilism. Bataille's apophatic aesthetic cuts through the fantasies of the conservationist and the conservative, by demanding that the anthropocene confront the traumatic kernel with a certain will to truth—to no longer fortify an already fragile civilizational ego by bringing it to cope, but rather incorporate the trauma to come as the horizon of being. And here one glimpses the politics of Bataille's apophasis which does not imagine, but rather practices a continual unworking of the world.

Notes

1. For instance; immanence/transcendence, negativity/neo-Kantianism, transgression/ morality, the pre-social community/the social, expenditure/utility, revolt/reform, the orgiastic/the effervescent, and decomposition/coherence etc.
2. Like Leiris, Bataille too understood creation to be synonymous with the ambiance and violent undulations of the *corrida*, a place of Mithraic sacrifice and bloody eroticism; tauromachy was a "tragic art" where everything rested on the possibility of a series of wounds. An approximation of aesthetic negativity, it was itself a "sphere" where *tout se jouerait*, a *nowhere*, constituted by a blindness in the face of beastly nature, under an unforgiving sun.
3. For Descartes, the pineal eye, later scientifically called the pituitary gland, was the mover of the soul. Referred to as the "third eye" in Indo-European religions, it was

also associated with ambrosia or the magical elixir *amrta* which upon being secreted from the gland and entering the thought, provide a glimpse of the eternal. In New-Age traditions and Western Yoga, it is moreover dubbed the sixth Chakra or the organ of telepathy.

4. The structural opposition that constitutes Bataille's architectural un-doing is also "geo-philosophical." In other words, long before Deleuze and Guattari coined the term, Bataille was affirming the rhizome as the reality of being and the locus of all de-ontology. However, unlike Deleuze and Guattari whose affirmations were always too joyous, Bataille saw only "muck" and earthly bile.

5. The text was hailed by Hollier, as Bataille's "Don Juan," but it should be empha-sized that Troppmann is a "negative Don Juan" who does not affirm his being as a pure immanence and the incapacity to recognize the law, but rather one who, suffocated by political, sexual, and historical law, continued drinking as though he wanted to die; one whose women were not serialized figures who belonged to the equally immanent Cosmic Feminine, but "loathsome prostitutes" who could help him, an unhappy man with an abnormal sex life. See Bataille, *The Blue of Noon*, trans. Harry Matthews (London/New York, 2002), 52–53. And previous to meeting the "Commander," Troppmann worries that he might die "in disgraceful circumstances," but remains "overjoyed at being the object of horror and repugnance to whom I am bound too—*trop d'humanité.*"

6. Cited in Zenkine (2003:63).

7. Cited in *L'Apprenti Sorcier (textes, lettres et documents): 1932–1939*. Ed. Marina Galletti (Paris, 1999), 339.

8. It is not without coincidence that Van Gogh's paintings leading up to the auto-mutilation were obsessed by solar bursts, the faded sunflower, and the malady-stricken solar principle which would become the wound. The paroxysm of Van Gogh's solar period is the sacrifice—the making sacred of the ear which is placed in circulation as a cursed gift.

9. Photos of Leng Tch'e, where Chinese prisoners had their skin and limbs slowly flayed with or without a mild dose of opium, circulated among the bourgeois Parisians as collectors items in the early twentieth century. Moreover, many a French soldier or emissary would often take credit for the photography while at most times never having visited China. Bataille's psychoanalyst Adrien Borel and fellow psychiatrist Georges Dumas snapped the photo while in China in 1905. Borel would pass on the photo to Bataille. who would insatiably obsess over it daily, falling in love with the victim and using it as a criterion for "ravishing" and "ecstasy."

10. Upon initial discovery, archaeologists rushed to interpret the signs, finding elaborate astrological patterns, depictions of Paleolithic ritual-life, or, as the famous thesis of André Leroi-Gourhan (a student of Mauss himself) argues, a religious sanctuary that was typified by its grappling with sexual difference.

11. The fall into the human, the profane, lodges one in the interstices of an untenable dualism. The world of immanence is antithetical to the real just as excess is to asceti-cism, intoxication to lucidity, violence to repression, and death to life. The entrance into the real, for Bataille, signals the penultimate loss of the sacred. This entrance com-mences with the introduction of labor, the work day, time, the tool, accumulation and the corollary realization of scarcity (physical, economic, emotive). The introduction of "ends" into activity and the naissance of finitude, severs humanity from intimacy and itself; we are, henceforth, alienated in objecthood and utility. Vocation, the threat of the incompletion of a task, and the finality of the work-day all delimit one's capacity to coextend into the universe. Our capacity to be useful and prodigious is a fundamental enslavement, enslavement to ourselves and to others.

References

Bass, Alan. 2000. *Difference and Disavowal: The Trauma of Eros*. Stanford: Stanford University Press.
Bataille, Georges. 1951. *L'expérience intérieure*. Paris: Gallimard.
———. 1955a. *Lascaux ou la naissance de l'art*. Geneva: Skira.
———. 1955b. *Manet*. Geneva: Skira.
———. 1961. *Le Coupable* suivi de *L'Alleluiah (Somme Athéologique, II)*. Paris: Gallimard.
———. 1962. *L'Impossible*. Paris: Editions de Minuit.
———. 1968. *Documents*. Paris: Gallimard.
———. 1970a. *Oeuvres complètes 1: Premiers écrits – 1922–1940*. Paris: Gallimard.
———. 1970b. *Oeuvres complètes 2 : Ecrits Posthume*. Paris: Gallimard.
———. 1971. *Les Larmes d'Eros*. Paris: Pauvert.
———. 1976. *Oeuvres complètes 8 : L'Histoire de l'érotisme*. Paris: Gallimard.
———. 1985. *Visions of Excess: Selected Writings, 1927–1939*. Minneapolis: University of Minnesota Press.
———. 1987. *Erotism*. Trans. Mary Dalwood. San Francisco: City Lights Books.
———. 1988. *Oeuvres complètes 11: Articles I 1944–1949*. Paris: Gallimard.
———. 1989. *Theory of Religion*. Trans. Robert Hurley. New York: Vintage Books.
———. 1995a. "La Conjuration Sacrée." In *Acéphale: réédition des numéros publiés et du numéro final non publié*. Ed. Jean-Michel Place, June 1936.
———. 1995b. "Chronique Nietzschéenne I." In *Acéphale: réédition des numéros publiés et du numéro final non publié*. Ed. Jean-Michel Place, January 1937, 18.
———. 1995c. "Propositions." In *Acéphale: réédition des numéros publiés et du numéro final non publié*. Ed. Jean-Michel Place. July 1937, 15–23.
———. 2002. *The Blue of Noon*. Trans. Harry Matthews. London/New York: Marion Boyars Publishers.
———. 2008. *Oeuvres complètes 12: Articles*. Paris: Gallimard.
Benhabib, Seyla. 1989–90. "Critical Theory and Postmodernism: On the Interplay of Ethics, Aesthetics, and Utopia in Critical Theory." *Cardozo Law Review*, 11: 1435–48.
Bois, Yve-Alain, and Rosalind Kraus. 2000. *Formless: A User's Guide*. Cambridge: Zone Books.
Clair, Jean. 2010. "Naissance de l'Acéphale." In *Crime et châtiment*. Ed. Jean Clair. Paris: Gallimard.
Coole, Diana. 2000. *Negativity and Politics: Dionysus and Dialectics from Kant to Post Structuralism*. London/New York: Routledge.
Gemerchak, Christopher M. 2003. *The Sunday of the Negative: Reading Bataille Reading Hegel (Suny Series in Hegelian Studies)*. Albany: State University of New York Press.
Heimonet, Jean-Michel. 1987. *Le mal à l'oeuvre: Georges Bataille et l'écriture du sacrifice*. Marseille: Parenthèses.
Hollier, Denis. 1988. *The College of Sociology: 1937–1939*. Minneapolis: University of Minnesota Press.
———. 1992. *Against Architecture: The Writings of Georges Bataille*. Cambridge: Cambridge University Press.
———. 1997. "The Dualist Materialism of Georges Bataille." In *Bataille: A Critical Reader*. Eds. Fred Botting and Scott Wilson. Oxford: Oxford University Press.
Hollywood, Amy. 2002. *Sensible Ecstasy: Mysticism, Sexual Difference, and the Demands of History*. Chicago: University of Chicago Press.
Lala, Marie-Christine. 1995. "The Hatred of Poetry." In *Bataille: Writing the Sacred*. Ed. Carolyn Bailey Gill. London: Routledge.
Léonard-Roques, Véronique, and Jean-Cristophe Valtal. 2003. *Les mythes des avant-gardes*. Clermont-Ferrand: PUF Blaise Pascal.
Lévy, Bernard-Henri. 1991. *Les aventures de la liberté*. Paris: Grasset.

Nancy, Jean-Luc. 1981. *The Inoperable Community*. Trans. Peter Connor, Lisa Garbus, Michael Holland, and Simon Sawhney. Minneapolis: University of Minnesota Press.

Nikolopoulou, Kalliopi. 2009. "Elements of Experience: Bataille's Drama." In *The Obsessions of Georges Bataille: Community and Communication*. Eds. Andrew J. Mitchell and Jason Kemp Winfree. Albany: State University of New York Press.

Pickering, W.S.F. 2000. "What Do Representations Represent." In *Durkheim and Representations*. Ed. W.S.F. Pickering. London/New York: Routledge.

Richman, Michèle. 1982. *Reading Georges Bataille: Beyond the Gift*. Baltimore: The John Hopkins University Press.

———. 1990. "Bataille Moralist?: Critique and the Postwar Writings." *Yale French Studies* 78, On Bataille: 143–68.

Sells, Michael A. 1994. *Mystical Languages of Unsaying*. Chicago: University of Chicago Press.

Surya, Michel. 2002. *Georges Bataille: An Intellectual Biography*. Trans. Kryztof Fijalkowski and Michael Richardson. New York: Verso.

Teixeira, Vincent. 1997. *Georges Bataille: La part de l'art – La peinture du non-savoir*. Paris: L'Harmattan.

Yusoff, Kathryn. 2010. "Biopolitical Economies and the Political Aesthetic of Climate Change." *Theory Culture Society*, 27(2–3): 73–99.

Zenkine, Serge. 2003. "Construire un manque: le mythe d'Acéphale." In *Le mythes des avant-gardes*. Eds. Véronique Léonard-Roques and Jean-Cristophe Valtal. Clermont-Ferrand: PUF Blaise Pascal.

Chapter 12

Acéphale/Parsifal
Georges Bataille *contra* Wagner

Claudine Frank

Street singer–popular songs: principles: the world of reason, communication is facile and void, the world of the gift, communication is difficult and full, it's almost impossible to speak, you have to sing. (Bataille 1976a:518)[1]

The French avant-garde secret society Acéphale (1936–39) created by George Bataille, André Masson, and Pierre Klossowski together with friends and outside "consultants" such as Michel Leiris and Roger Caillois, sought to become, according to its founder, "the sole negation that does not simply consist in words, of that principle of necessity in the name of which all contemporary mankind collaborates to waste existence" (Hollier 1988:155). A truly radical negation indeed given the group's (unfulfilled) project of human sacrifice, which presents an extreme variant or appropriation of what Alexander Riley calls "renegade Durkheimianism," namely, the works of Marcel Mauss, Henri Hubert, and Robert Hertz marked by an "engagement with the impure/left sacred" privileging "emotional force" and "transgression."[2] Riley extends this category to include the Collège de Sociologie, contemporaneous with *Acéphale*, where Bataille, Caillois, and Leiris publicly debated their views of "sacred sociology." The Collège combined "a Durkheimian recognition of the place of the sacred in collective life and in the perpetual renewal of the community through collective effervescence in ritualistic ecstasy," Riley explains, with a "Nietzschean tweaking of the entire edifice so as to turn the ritualistic idea of the sacred into a celebration of the transgressive moment per se" (2005:281, 290). Even more renegade, of course, was the mysterious "renegade Durkheimianism" of Acéphale.

The following critical rêverie seeks to clarify the group's mythological *bricolage* and political stance at a time when, "in the face of our impotent remonstrations," as Bataille told the Collège, "the military spirit *alone*

dictates the fate of hypnotized human masses, some overwrought, the others appalled" (Hollier 1988:147). In the wake of landmark research by Denis Hollier and Marina Galletti, new archival material suggests that Bataille's post-Surrealist movement was more akin than previously believed to the genital Freudo-Marxist engagement of Wilhelm Reich's *Die Massenpsychologie des Faschismus (The Mass Psychology of Fascism)* (1933)—a work Caillois included in the Collège bibliography rubric "Sacred Sociology of Modern Forms" (2003:153–54).[3] Difficult though it is to make claims about a protean, metaphorical thinker, and about fragmentary evidence culled from varied avant-garde sources, Bataille's secret society may have been largely conceived as a form of subliminal mass propaganda, drawing upon mystical experiences he shared with André Masson at the Catalan Montserrat holy shrine (1934–35). We shall see that Bataille reconfigured these in 1936 into a Nietzschean, Durkheimian, and psychoanalytic counter-assault on—or mimetic recuperation of—Nazi and fascist cultural myth. One major target, I propose, was the Bayreuth Festival and its yearly-performed *Parsifal* or "Bühnenweihfestspiel" (Festival Play for the Consecration of the Stage) that Wagner specifically created for his vast opera-house, which during the Third Reich would provide National Socialism with "its most distinguished aesthetic cover" (Spotts 1994:188).

A few words about the new archive: in 1991, I happened to interview a former member of Acéphale, now deceased, who requested anonymity. I shall call him: [X]. Without giving any details, he explained: "The fundamental thing is that there was going to be a victim, killed, by one of the members of the group, who would have volunteered to do so." There was even a volunteer victim it appears, but "it was not possible to find a volunteer to carry out the . . ." (we return to this later). In 1998, I discussed the interview with another former member, Jacques Chavy (1912–2000), who revealed he had produced several hundred artworks on paper and canvas, all relating in various ways to Acéphale. He had also saved documents and letters from other key Acéphale members— Georges Ambrosino, René Chenon, Henri Dussat, Pierre Andler, Imre Kélémen, and Patrick Waldberg.[4] These students and aspiring writers or artists had socialized in a Rosa Luxemburg-style study group[5] before meeting Bataille—roughly twenty years older—at Boris Souvarine's Cercle Communiste Démocratique; they followed him to Contre-Attaque and then to Acéphale. Waldberg was the only one with sociological expertise; both before and during Acéphale, he attended the Ecole Pratique des Hautes Etudes en Sciences Religieuses, and he studied with Mauss, who taught at the Collège de France after 1931. "Waldberg would tell us about Mauss, and then we would read *The Gift*," recalled Chavy, who "saw Bataille three times a week from 1936 to 1940."

Because the official *Acéphale* artist, André Masson, never frequented the Parisian group, Chavy may have hoped to make his mark either by

inclusion in the public *Acéphale* journal or in the group's private *journal intérieur* (internal journal) (Bataille 1999:336). Ambrosino sponsored a May 1936 showing of Chavy's artwork in his own apartment, which I can only partially reconstruct; Bataille, Klossowski, and Alfred Métraux briefly dropped by.[6] In November 1937, Chavy took sketches of Dionysus, Uranus, Cronus, and Zeus (see later) to Bataille and Colette Peignot: "He was not terribly excited about them, but she was very favorable."[7] This eclectic Acéphale *oeuvre* seems a sort of private diary, wide-ranging in style, form and scope. (Chavy kept a written diary 1931–34.) The most "secret" mystical sketches he made on scraps of paper at work (as a draftsman); he also crafted large public illustrations of literary texts, in particular Jean Paul Richter's *Hesperus* (1794), which had some relation— at least in his mind—to Acéphale. Most drawings stand somewhere between these two extremes, with stylistic or iconographic clusters suggesting *Acéphale* imagery, Bataille texts or sociological, mythological, and psychoanalytic references. Chavy was very helpful but refused to break his vow of silence and disliked being cast as an "illustrator" of Bataille; moreover, it was not clear just what he had read: "Bataille did not say to us, 'I published such and such an article in such and such a journal.'"

<p style="text-align:center">* * *</p>

Before reaching back to the Montserrat "religious ecstasy" (Bataille 1973a:438), we must first consider the intervening revolutionary political movement Contre-Attaque against (or out of) which Acéphale's sociologically religious project would arise (Surya 2002:221–34). Reuniting Bataille with his erstwhile enemies the Surrealists, and attentive to Italian fascism and the Nazis, Contre-Attaque (1935–36) hoped to deliver avant-garde representations to the masses, thereby freeing them from a French enemy defined as fascism and capitalist nationalism. Here, Bataille made instrumental use of renegade Durkheimianism in the sense that he sought to recuperate various forms of collective effervescence. His "question," writes Hollier, and this to some degree ever since the Paris riots of February 1934, was "not how to prevent the triumph of fascism but what to do in a world in which fascism has triumphed" (1997:59). Indeed, his (then unpublished) 1935 novel, *Blue of Noon* (*Le bleu du ciel*) closes with a Hitler Youth marching band portending strife and bloodshed while the heavens, despite a brief downpour, and as in Baudelaire's "Le Cygne," stay silent (Bataille 2001:126).

The enemy, he told Contre-Attaque, had co-opted Bolshevik strategies predicated upon "violent emotion" and "dramatic historical situations" rather than class interests (against a disintegrating state). "We, in turn, now plan to use the weapons created by fascism, which has known how to use the fundamental yearning of men for affective exaltation and fanaticism," announced the first manifesto (Bataille 1970a:422, 423, 382). For example, Bataille spoke of displacing the passion invested in nationalist Nazi

themes or affective "platforms," such as land or country, onto the revelation of a universal "human community" (1999:237, 263). He believed the spectacular use of collective emotion would reorient French crowds who were easy prey for "the semblance of an escape from boredom," namely "badly formed political conceptions" lacking real passion (1985:162, 165). He voiced the famous "Popular Front in the Street": "What drives crowds to the street is the emotion directly aroused by striking events, in the atmosphere of a storm, it is the contagious emotion that, from house to house, from suburb to suburb, suddenly transforms a hesitating man into a frenzied being (hors de soi)" (ibid.:162).

Recuperation also meant reviving collective memory: the French Revolution. All men were "avid for values," for "reasons to act and live" that they could find in the "disinterested excitement" of revolution (Bataille 1970a:373). But in democracies, revolution was doomed "so long as the memory of the earlier struggles against the royal authority [had] been attenuated" (Bataille 1985:159). For Durkheim, the revolutionary events of 1789 inspired passages in *The Elementary Forms* that commentators such as Michel Menger and Edward Tyriakian cite among his most favorable remarks about art and aesthetics: they "enhanc[e] the moral efficacy of the group. It is in the collective assembly and its rituals generative of enthusiasm that societal ideals are (re)generated, that is, in collective acts of imagination which transvalue the worth of objects" (Tiryakian 2009:175). By contrast, Contre-Attaque's ritual and carnivalesque imagination (Hollier 1995:537) focused on 1793, on the "atheist, regicide and terrorist revolution" of Marat and Sade, writes Galletti (Bataille 1999:207), a collective memory Bataille sought to reignite with heterogeneous energy (1970a:344) defined in terms loosely drawn from Freud, phenomenology and the renegade Durkheimians.[8]

"Sacrificial Mutilation and the Severed Ear of Vincent Van Gogh" (1930) had explored *Sacrifice its Nature and Functions*, the study by Hubert and Mauss, with its famous depiction of the victim as vehicle within the space of the sacred for "all the forces" linking the participants. Bataille focused on the "irrevocable" sacrifice of the god, an act collapsing all roles: "The god, who is at the same time the sacrifier [sic], is one with the victim and sometimes even with the sacrificer" (Hubert and Mauss 1964:44, 101). Adding "automutilation" to this category (Bataille 1985:70), he theorized an ecstatic *"hors de soi"* experience Michèle Richman describes as "the painful transmutation of a certain construct—or more accurately, economy—of the self" (2002:173). In 1933, with "The Notion of Expenditure" and "The Psychological Structure of Fascism," Bataille then worked out radical appropriations of magic, potlatch, *mana, taboo,* and the impure or left sacred. Mauss and Hubert refused to censor from their analyses of religion "ideas and practices" that could defy "moral categories" or threaten the social productivity and its order, such as magic and potlatch—this last conceived as "a form of virtual warfare," explains

Riley (2005:280). *The Gift* hence became a blueprint for Bataille's sacrificial *expenditure* enacted, among other things, by "festivals, spectacles and games" (Bataille 1985:123); and *A General Theory of Magic* may have had more impact than Durkheim's *The Elementary Forms*. "There are almost no religious rites which lack their magical equivalent. Magic has even developed the idea of orthodoxy," wrote Mauss, despite magic's "incoherence" and "the important role played by pure fancy [fantaisie]" (2001:107). It was to include magic that Hubert and Mauss used the category of *mana* (Riley 2005:278); Bataille likewise defined the heterogeneous "sacred," which subsumes magic and religion, in terms of *mana* and *taboo* (1985:141). The experiential reality of this "energetic and desubstantialized" sacred (Gauthier 2010:9) "is one of a force or shock" (Bataille 1985:143). In fact, it is always transgressive, breaching a taboo, and in this sense close to magic defined by Hubert as "willful sacrilege" (qtd. in Riley 2005:279). As exposure to "the violent and excessive nature of a decomposing body" (Bataille 1985:142), it can also comprise an impure/left sacred that Hertz's "The Collective Representation of Death" (1928) defined as a destructive *"néant actif."*[9]

Bataille combined this approach with a psycho-political view of Mussolini's Italy and Hitler's Germany as *fatherlands*, explains Carlo Pasi, who recalls Antonin Artaud's 1936 lecture in Mexico about "the Surrealist movement, which he extended to include Contre-Attaque, as a form of revolt against the father" (1985:212, 213). In one of its rare ritual events, the group commemorated the execution of Louis XVI at the Luxor obelisk— former site of the guillotine—on the Place de la Concorde, followed by a revolutionary dinner (Hollier 1995:537). Perhaps to cultivate the group's anti-fascist paranoia (Stuart Short 1968:157), a wall hanging by Chavy and others showed a black map of France covered by a death's head spider web; representing the Croix-de-Feu far right leagues, it echoed an image in the Croix-de-Feu journal, *Le Flambeau* (The Torch) (Bataille 1999:199). (Underscoring their recuperative mimicry, another Contre-Attaque painter, Marcel Jean, signed his book to "Jacques Chavy, painter of torches, so that we may extinguish them together."[10]) The public side to this event Bataille recounted years later: Together with two friends, he had planned to deposit next to the obelisk a pool of (their own) blood and a note by Sade about the "buried victim"; in the city outskirts, they were also going to plant—and "discover"—a human skull with Louis XVI documentation. This skull would have been macerated, so as to make its "consistency closer to sponges than to bones" (1973a:503). Presumably, these fantastic installations would combine black magic with revolutionary expenditure, and the impure/left sacred, to bring heterogeneous shock to the masses, while symbolically assailing an obelisk—"without a doubt the purest image of the head and of the heavens," as Bataille wrote in 1938 (1985:215). Next to Luxor, furthermore, Louis XVI would merge with Osiris whose sacrificial *sparagmos* antedated Dionysus, and which Sir

James Frazer's *The Golden Bough* analyzed in terms that later became key to Acéphale.[11]

Bataille had been amazed in 1934 by the Exhibition of the Fascist Revolution in Rome (La Mostra della Rivoluzione Fascista) (see Gentile 1996:102–32): especially by the Chapel of the Martyrs, and the black flags with skulls or skull-and-crossbones, some clenching daggers—even "dripping blood"—in their jaws (1999:114).[12] Writing, then, about "radically irrational, religious" fascist society, he denounced the "totalitarian" militarized state and the "hardly believable, archaic presence of the head-gods: dead Lenin, Mussolini, Hitler, Stalin"—here he crossed out: "the hallucinatory ghosts, solemn phantoms of fascism" (Bataille 1970b:210, 207, 436). One 1935 Contre-Attaque sketch by Chavy depicts a ghoul or vampire rising from his skull and bones; the finished version, etched onto blue-painted cardboard, suggests he could take flight. This recalls Hertz's impure/left sacred but also Rudolf Otto's *The Idea of the Holy* as cited by Bataille's "L'art primitif" (Primitive art) (1930): "The term *alteration* . . . conveys a process of partial decomposition similar to that of corpses and also the shift to a perfectly heterogeneous state corresponding to what the Protestant pastor Otto calls the wholly other, the sacred, as realized, for example, in a ghost" (1970a:251).[13] Another blue etching by Chavy shows a nude woman dancing orgiastically, her mask adorned with a double-pipe flute, or *aulos*, that Nietzsche's friend Rohde (in a work read by Bataille) linked to the sacrificial Thracian cult of Dionysus, as "an invitation to madness" (270). Perhaps Contre-Attaque hoped to unleash some numinous vampire, reawakening memories of the Terror, and imperatively driving crowds to revolt against the father/fascist leader in sacrificial ecstasy.

Contre-Attaque did envision "pushing action toward terror in response to the provocations of the legal world," recalled Waldberg (Bataille 1999:591). Behind Bataille's back, in early 1936, his young followers began to create a conspiratorial secret society. Doing his military service far from Paris, Dussat wrote to Chavy on February 26: "I find the society based on blood bonds taking shape to be very compelling"; he then surmised on March 29, "there must have been a reunion one or two days ago where Bataille was probably informed about our clandestine activity" (Chavy Archives). On April 2, Bataille resigned as secretary-general of Contre-Attaque and soon sent out a "Program" for Acéphale: "To form a community that creates values, values that create cohesion" (1999:281).

Unlike Contre-Attaque, Acéphale sought to create values by dint of its own collective existence. Existential society and tragedy were key concepts for its pursuit of "the total world of myth, the world of *being*" (Bataille 1985:233). However, the context here and at the "non-conformist" Collège was still politically engaged: Bataille and Caillois evoked sacred orthodoxy or doctrine that would galvanize and revirilize an atomized, pacifist society in Nietzschean, anti-nationalist, and anti-racist terms

(Caillois 2003:20–24). Furthermore, the Collège's stated quest to reconcile "individual psychology" with "social organization" (Hollier 1988:5) implicitly countered the fascist misappropriation of Durkheim to "abolish the individual," to quote a work read by Bataille (Trentin 1931:56, 112–13). In 1938, at Acéphale, Bataille defined the enemy as Christianity, socialism, and fascism deploying their "trenchant judgement and propaganda (with the result that the masses are put into play like forces)"; his group's real "force" could "only be those sharp words that propagate themselves. We can only fight like an infection, that is, we must take the fight to the terrain where the monster already stands" (1999:517). Two interrelated streams of myth and fantasy, public and private, gave rise to the public journal *Acéphale* and to the secret society launched in early 1936, which went underground with ritual ceremonies in 1937.

<p style="text-align:center">* * *</p>

On blue office paper, in 1938 or 1939, Chavy quickly sketched a woman-tree gazing toward a monumental lance whose tip was shedding droplets of blood. Here may be the Lance of Longinus with which the Romans probed Christ's crucified flank: the miraculous outpouring of blood and water proved his early death. Through a fusion of Celtic and Christian culture, this Lance became the Bleeding Spear featured in the Grail legends (Loomis 1991:79, *passim*). Chrétien de Troyes's Perceval espied it at the Fisher King's castle in a mysterious procession that included the Grail vessel and a candelabra; the Spear appeared in Wolfram von Eschenbach's thirteenth century *Parzival* and then took center stage in Wagner's *Parsifal*. Exploring chivalric motifs in Acéphale, Francis Gandon notes the movement was partly conceived at—and in relation to—the Catalan holy site, Montserrat, where "Wagner is said to have composed the overture to *Parsifal*" (1984:107–10). It is sometimes deemed the abode for the Grail of Eschenbach's *Parzival*.[14] In a June 1936 letter to Bataille, Masson mentions Klossowski's "book about the Grail" (Bataille 1999:303).

Montserrat and the "death of God" are at the mystical heart of Acéphale. In *Minotaure* 8 (1936a),[15] Bataille published his August 1934 article "Le bleu du ciel" alongside two 1935 Montserrat paintings, and Masson's Nietzschean poem "Du haut de Montserrat" (From the Heights of Montserrat) (Masson 1976:217, 237).[16] In November 1934, the painter and his wife had spent the night lost and trapped on the peak where Masson experienced an emotional "maëlstrom" followed by a "sublime" experience at dawn. The couple then clambered down to the Basilica:

> The hotel was not yet open, but we could hear music, the children's choir, exactly as in *Parsifal*, the priests were celebrating mass. Even though we were numb, it was extraordinary. It was one of my most thrilling moments. The cosmic and the religious suddenly linked together through some adventure: travelers who get lost in the mountain; who witness the death of the

solar star and its rebirth; who descend into a religious site that seems to be celebrating this event and not at all the death of Christ. (Bataille 1973a:439)

At Montserrat with Bataille the next summer, Masson kept recounting his night–"[t]he fear of falling into the sky" (Bataille 1970b:267)—in terms of the same celestial vertigo Bataille uses elsewhere to describe Nietzsche's death of God (1970b:391). Most importantly, lines crossed out in a manuscript of Bataille's 1936 frame for the *Minotaure* essay move beyond shared "religious ecstasy" to suggest that the expression of such an experience should be "'preaching' . . . that demands the clear recognition of a reality incommensurate with what common consent admits as such; it is life transformed, 'conversion' and incandescent love" (1936b). In 1945, he would evoke his existential quest for the Grail defined as "chance"— which "responds more accurately than does power to Nietzsche's intentions" (1973b:17; see also 1985:37, 241). Chance and play were recurrent themes in Acéphale. In effect, Bataille's preaching of this Nietzschean Grail fueled his sociological "sacred conspiracy," or Acéphale's impure/ left sacred counter-attack on Hitler's *Parsifal*.

Bataille's (lost) lecture to the Collège on "Hitler and the Teutonic Order" hints at this acephalic response to Wagner. At the time, notes Hollier, there was talk in France about "reawakening the Templar Order as a French (or Celtic) counterweight to the Germanicism of the Knights" (1995:499). From a synopsis sent to Caillois, it seems Bataille planned to reject any such distinction drawn by "occultists" between the French Knights Templar and the Teutonic Order. While noting that "Hitler's affiliation with the Teutonic Order [was] probably a 'myth,'" he wished to discuss "the institution of the Ordensburgen, schools for führers built and instituted in a spirit akin to that of the military orders [Knights Templar]." Indeed, "the Ordensburgen demand a response from those who do not wish to be dominated by a power they do not recognize" (Le Bouler 1988:93). Hollier cites André Thirion's autobiographical account: "Bataille was hypnotized by the military spirit[17] . . . The demoniacal Nazi prestige, their militia with helmets and boots, their savagery, their monstruous assemblies, opening with sound of the Valkyrie cavalcades—this fascinated Bataille while frightening him as well. He claimed he would counter these frightful apparitions by means of an obscure myth, centered on *tragic man*" (1995:500). Bataille never mentions *Parsifal* but describes Wagner in *Acéphale* as part of that "profound 'self-admiration' practiced by the Germany of the Third Reich" (1985:187). In 1944, after promoting Nietzsche's "total" man, "who would not flee a tragic fate but rather love and incarnate it willingly," Bataille cites Wagner along with Paul de Lagarde as "official precursors to National Socialism" whom Nazi propaganda later took as "doctrinal guides." He adds: "Nietzsche was the friend of Richard Wagner but distanced himself, sickened by his Gallophobic and anti-semitic chauvinism" (1973b:186, 187).

Acéphale was a secret knighthood that paradoxically defied the military spirit in the cultural and sociological imagination (see Caillois 2003:209–10). Paraphrasing Nietzsche, Bataille wrote about modernity "where religious sacrifice appears to have lost all value," that "wars and revolutions seem to be the only immense *wounds* to inflict that still have a devastatingly seductive force" (1970b:392). The thesis he wrote on l'*Ordre de chevalerie* is lost (1970a:101), but after the war he described chivalry's passionate "sacred horror," its savage and violent Germanic origins——"a quite primitive kind of secret society" (1987:302)—which vestigially persisted in the Middle Ages, granting knights more "poetic" than "real prestige." For example, in Chrétien de Troye's *Perceval*, the naive youth first misconstrues visiting knights as a god and angels, and Bataille mentions "the inhuman, *sacred* impression that the young initiates of the German tribes could—and would have to ritually—produce" (1988a:508, 503, 504). In his account, sexuality is what distinguished Germanic from Christian knights: the Germans were pure warriors whose drinking and sexuality were mere "excesses"—often "homosexual" (1987:303)—whereas the European Christian knights "breaking with a German tradition, combined erotic passion with that of war" (1988a:505). If the "romances of the Round Table" hence introduced "what we call humanity into chivalric savagery" this was driven "more by eroticism than by piety," wrote Bataille (1988a:510). "Sacred horror" and eroticism were weapons in Acéphale's secret arsenal or subliminal preaching.[18]

Given Masson's ecstatic allusion to *Parsifal*, perhaps Leiris was the one who made it a target for strategic recuperation. Favoring opera above "all other forms of theater" in his youth (1939:48), he would attack Wagner's "messianic aspect" in a postwar essay that decried:

> the affirmation of the supremacy of passion in *Tristan*, . . . the apology of purity in *Parsifal* (despicable aspects of this work, which casts stones at all who are not 'pure people': Kundry dying like a dog on the altar steps; Amfortas punished for having fornicated and roundly snubbed when he complains in front of his father's coffin about the suffering caused by his wound; *Parsifal, 'a simple, pure youth, instructed by his heart,' who can be likened to the SS raised in the Ordensburgen of the Hitlerian period*). (1992b:47, emphasis added)

Leiris also described *Parsifal* as failed "total theater" or sacred performance: "one cannot be caught up in the reality of a ritual if the very framework makes its status as spectacle obviously clear." Where Wagner fails, though, Mozart succeeds: "While *The Magic Flute*, like *Parsifal*, is an initiatory opera, at least it presents itself as a simple *féérie* (magic tale). Can myths be staged any way but ironically these days? In *The Magic Flute*—and also in *Don Giovanni*—the comic element, (which conveys this irony) allows us to believe in the myth" (1992b:51, 52).

Don Giovanni's overture played an important supporting role in the very creation of the Acéphale figure or myth as recounted by Bataille's first *Acéphale* essay "The Sacred Conspiracy" (1985:178). Moreover, "Le bleu du ciel" hailed Don Giovanni's exulting defiance "against all reason": he was "drunk with happy insolence when being swallowed up by the Earth" (1936a:52). Quite publicly, here is the "tragic" erotic hero of the Collège and *Acéphale*.[19] Mozart's opera expresses the Nietzschean "fantasy constellation that informs Acéphale," suggests Carlo Pasi, who evokes a mode of "anti-Oedipal" bliss[20] challenging two features of social formations around the fascist leader, as derived from Freud's *Group Psychology and the Analysis of the Ego* (a work that influenced Bataille): "inhibited sexual drives, thereby favoring an identification with the authoritarian paternal model (expressing the ego ideal) and the absence of woman as object of desire" (Pasi 1987:162, 158; see also Hollier 1997:46–68).

Other hints about Acéphale's anti-*Parsifal* project may be gleaned from Bataille's Collège talk on "Power" which explored the cyclical, ritual killing of the taboo priest-king, the *rex nemorensis*, of Frazer's *Golden Bough* in terms of expenditure, or what Hollier calls "negative sovereignty."[21] Ever renewed "crime" is the impure/left sacred energy the West has recast as the crucified Christ, a "killing of the king" that associates priests with their victims; such religious energy has historically been yoked to military might to create power. However, the crucifix and the tortured king are now supplanted by the fascist axe that kills its subjects. In fact, the king is "no longer put to death but rather is disguised as a wretched lord and, moreover, is personally deprived of force." So the dominant class—whose wealth hinges on royal power—takes up violence with a new "military" formation "that it links to whatever remains of the sacred forces . . . such as the fatherland." As a remedy, Bataille suggests "reactivating the social tragedy" through "secret societies . . . [or] elective communities," and by means of Nietzschean rather than Christian "crime" (Hollier 1988:135, 136).

He had elsewhere discussed Italy's "reduced" monarchy (Bataille 1985:158), but *Parsifal* may be relevant as well. King Amfortas, a "Fisher King," is keeper of the Holy Grail but cannot show it to his Grail Knights because of his wound (impotence). The young hero must recover the Bleeding Spear whose tip first caused the wound after the king's sexual encounter with Kundry; yet it will ultimately heal Amfortas in the concluding apotheosis evoked by Masson, mystically reuniting the Spear with the Holy Grail as a dove flies on high. In short, the "fascist" king is not killed, but remains a humiliated figure; and though Parsifal becomes the new Grail king, Alfred Rosenberg's fascist *Myth of the Twentieth Century* termed the opera "a church-influenced enfeeblement in favor of the value of renunciation" (qtd. in Kinderman and Syer 2005:174). Indeed, the real power rests with the Order of Knights and, in this sense, *Parsifal* was "the gospel of National Socialism," argues Robert Gutman (1990:431) consistent with Leiris's perception of Aryans fighting to save their "pure" blood

and race, against the female Kundry, and the outcast Klingsor's Garden of Desire. (Klingsor's magic powers come from self-castration: a misguided act of purification that has led the Grail Knights to reject him [Kinderman and Syer 2005:50].[22])

The key to Bataille's counter-attack against *Parsifal* may be the following myth formation he briefly notes in his talk:

> In actual fact, the crippled king–or, as they said in the Middle Ages the *roi méhaigné*–is a toned-down version of the king who is put to death. And the toning down is emphasized even more because in the latter case there is no question of real actions or events. *The impersonal and unconscious desire of the subjects–the desire for the castration and impotence of the king–seems to have been expressed only in the form of purely symbolic rituals and especially in the form of myths*, legends–such as the myth of the castrated Uranus or the legend of the mutilated king, the *roi méhaigné* of the Breton romances. (Hollier 1988:131; emphasis added)

Reaching back to his early work on chivalry and medieval satirical *fatrasies*, Bataille here links Dumézil's *Ouranos-Varuna* (1934) with the romances of Chrétien de Troyes and Jean de Boron that grew from the "Matter of Britain" and its Arthurian legends (see Loomis: *passim*). Chrétien's unfinished cycle is the first in a long line of Grail legends where Perceval seeks to restore virility to the Fisher King and life to the wasteland. "Amfortas's wound—his wound in the side made by the sacred spear after he broke his oath of chastity—troubled me and his lamentations had a strange impact on me," is how a very psychoanalytically alert Leiris in *L'Age d'homme* described his first exposure to *Parsifal* (45). Publicly launched to the tragicomic strains of *Don Giovanni* and driven by Bataille's Oedipal theory of "castrational pleasure" (Hollier 1997:67), his crusade, his secret Klingsorian knighthood may have sought to preach in a socially subliminal way the mythical death of the king— but also his rousing *castration*.

* * *

In 1937, the secret society's *journal intérieur* listed as foundational texts—"a state of mind we all share"—"The Notion of Expenditure" and "Sacrifices" (Bataille 1999:341). (The latter was a phenomenology of death illustrated by Masson's dying gods: the Minotaur, Osiris, Orpheus, Mithra, the Crucified [Masson 1963:704].) No mention, then, of the Montserrat essay "Le bleu du ciel" with its metaphor of expenditure or wounds expressing ecstatic and transgressive Nietzschean *being* (1973a:95). Yet wounds and self-wounding are the obsessional theme of Chavy's Sketchbook (A) marked "March 3–April 13 1936," thus highlighting Acéphale's very early rêveries.[23]

In Sketchbook (A) Chavy traced his left hand, breaking the taboo defined in Hertz's *Death and the Right Hand* (1909), and introducing

Figure 12.1. [Untitled]; unsigned; gouache on paper; 21×27 cm; painted in Feb.–Apr. 1936; Sketchbook (A). Reproduced with permission.

an impure/left sacred that would rarely shed its "ambiguity" (Hollier 1995:364–402). He also drew violent human "tragedy" (see Fig. 12.1).

"It's perhaps the sacrifice with the willing victim, I don't know," he (surprisingly) said. These sexualized bodies recall the fused sacrificial roles in Bataille's appropriation of Hubert and Mauss. Chavy also depicts *hors de soi* "automutilation." One such scene involves impure/left sacred Grail imagery: an ecstatic, androgynous dancing man holds a chalice with his left hand to catch blood from his chest, while his right hand holds his own severed, ejaculating organ (see Fig. 12.2).

Near another chalice (see Fig. 12.3), a donkey head recalls Bataille's "Base Materialism and Gnosticism" (1930), where its braying signals a "sect of *licentious gnostics*" (1985:48). However, former member [X] had never heard the term "base materialism": Acéphale was not *Documents*.

Chavy's torrents of bodily fluids reflect a "flow" theme Bataille partly derived from the German anthropologist Konrad Theodor Preuss—*Der Ursprung der Religion und der Kunst* (The Origins of Religion and Art) (1904–5)—whose "direction" he claimed to pursue at the Collège in defining "sacred things" as "essentially discharges emitted by the human body, and in some manner spent forces" (Hollier 1988:122).[24]

Figure 12.2. [Untitled]; unsigned; gouache on paper; 21×27 cm; painted in Feb.–Apr. 1936; Sketchbook (A). Reproduced with permission.

By their sheer volume and intensity, Chavy's drawings show his excitement at this new myth or "religion." There is black humor. "[F]un is the most blatant and, of course, the most terrifying need of human nature," Bataille wrote about a French comic strip in 1930 (1970a: 235). But most striking is the detached, self-conscious representation of violence, perhaps influenced by "Sacrifices," which Bataille reformulated in *L'Expérience intérieure*: "Tragedy" is the human apprehension of death distinct from that of animals; neither mystical knowledge nor revelation, it is inevitably a form of fiction or art. Yet even as self-conscious artifice,

Figure 12.3. [Untitled]; unsigned; ink on paper; 21×27 cm; painted in Feb.–Apr. 1936; Sketchbook (A). Reproduced with permission.

"tragedy" can provoke ecstatic passion: "This object, chaos of light and shadow, is *catastrophe*. I perceive it as an object; however my thought shapes it in its own image, even though it is also a reflection. Perceiving it, my thought sinks into nothingness as if falling and crying out" (1973a:88). Chavy liked to use the term "catastrophe."

Sketchbook (A) also begins to portray the "pineal eye" or vertical vision that had set the stage for Bataille's Montserrat meditation (1973a:92). "[I]t becomes possible to attribute an exceptional value to the violent revelation represented in such a way," Bataille wrote of this expenditure through the top of the skull (1970b:44). Part of his lifelong obsession with "the theme of the blinding sun associated with that of sacrifice as projection outside of the self in ecstasy or in death," according to Leiris (1963:692) a pineal experience recalls that of Icarus: "like a thunder-bolt tearing a clear, invisible sky from top to bottom, [which] occurs precisely because [a human being] was yielding to its most radiant and celestial aspiration" (Bataille 1970b:46, 44). Note the vertical

Figure 12.4. [Untitled]; signed J. Chavy (lower right); gouache and ink on paper; 23×31.5 cm; painted in 1936. Reproduced with permission.

streaks from the head of the crucified, masked figure. The above early sketch (not from Sketchbook [A]) may suggest the recoil of the pineal gaze (see Fig. 12.4).

* * *

One variant of the crucified figure has deer legs and hooves; it is a recurrent motif. As a secret, internal counterpart to Don Giovanni, Acéphale may have deployed the Greco-Roman Actaeon. This young (erotic) hunter observed the appearance or theophany of the divine Artemis/Diana at her bath; she then punished her admirer by transforming him into a stag, and he was devoured by his own dogs. Like Don Giovanni, he is the hero of tragic eroticism but in a visual rather than musical key, which may correspond to the pineal gaze. Both heroes are the Dionysian "superman" as defined by Bataille's "[t]wenty propositions on the death of god," partly published in *Acéphale*: He pursues "insubordination" and an "exalted acceptance of tragic destruction"; he is a "possible mode of being for man (for the subject)" (1999:476). Both heroes could be anti-*Parsifal* role models as well. Parsifal's ascension to "pure" knighthood is a *buildungsroman* teaching, among other things, the virtues of asceticism and restraint (he must not hunt a sacred swan). Actaeon's pagan myth flies in the face of abstinence and idealized passion; he is the quintessential hunter who is hunted, in turn, without any spiritual evolution. After the war, Bataille wrote about transgression: "Due to the act of murder, the hunter or the murderous warrior were *sacred*" (1987:76).

Diana at Her Bath (1956) may contain veiled allusions to Acéphale, in which Klossowski played a founding role before breaking with the group in September 1937.[25] Hardly real evidence, this lyrical essay does mention secret societies: "Having soon decided to found a sect on the *lunatic* temperament, ... [Actaeon] had discerned in a phrase as banal as: *dogs howl at the moon* something like the vestige of a secret truth." Klossowski describes rituals as well: "Actaeon masks his face with a stag head and, thinking himself very clever with his 'larvatus pro Dea' (masked for the goddess), proceeds to the spring and goes to hide in the cave. He waits *for her to come*" (1980:19, 41) (see Bataille 1999:487). At the Collège, Klossowski belonged to the Kierkegaardian "anti-ethnological nucleus" (Hollier 1995:254). However, he later recalled sharing with Bataille a passion for Roman and Roman Catholic culture: "the same certainty evoked by the Kierkegaard of *Either/Or*, that Christianity advocates the assumption of sensuality, the kingdom of the flesh through the Incarnation and the Resurrection. When Bataille asserted eroticism as the source of religious experience, I could not fail to follow him, even though my starting points were very different from his" (Monnoyer 1985:176). If Actaeon countered a Nazi Parsifal, did he also challenge the fascist "cult of Romanity" (Gentile 1996:76)?

Despite much talk of the ritually-sacrificed "king of the wood" (Hollier 1988:130), it would seem that Bataille (prior to 1957)[26] never mentioned Actaeon, hallowed victim of Diana, goddess of the moon and of the hunt, whose ritual and nocturnal cult was ablaze in torches and bonfires. Nor did Actaeon imagery appear in the journal *Acéphale*. Yet we can find a few traces. In May 1935, while together with Bataille in Spain, Masson

Figure 12.5. "Je t'étrangle"; signed J. Chavy; charcoal and pencil on paper; 40.5×26 cm; painted on Nov. 14, 1937. Reproduced with permission.

sketched not only Montserrat but also Actaeon (Bataille 1970b:269). In 1936, two Actaeons by this painter share the same ecstatic pose: "Mort d'Actéon" (Death of Actaeon) shows three attacking dogs (Moutel 2009:53); the second "Actéon" turns his single eye toward the sun, next to bulls and a tunic-clad figure with white pants, bird feet and a ceremonial mask: Quetzalcoatl?[27]

Chavy's Sketchbook (B)—from the same period as Sketchbook (A)—displays deer and stags.[28] He reworked one image into a larger stag with horns held high, near a lake and a tree in the form of a cross; on the stag's back, one human eye staring out at the viewer appears to be part of a dog's head. Chavy said: "That's a stag that—I don't know what it is." In 1937, he drew the above figure, or goddess, surrounded by dying men. Its current title is "I'm strangling you" (see Fig. 12.5).

Among small 1970s sketches that could be reminiscences of Acéphale, here is an unusually explicit sketch. The stag has a humanoid form; the masked or hooded figures have non-human hands (for Chavy) and female traits (see Fig. 12.6).

The symbolic Actaeon, besides suggesting the stag of Christ, was a vital figure for mythology and sociology. *La Religion des Tupinamba* by Bataille's close friend Alfred Métraux told of cannibalistic Tupi tribesman who induced their sacrificial captive to run away, and then chased him "like dogs running after a stag to catch him again" (1928:143). Dumézil's *Le problème des centaures* (The Problem of the Centaurs) linked the dog of

Figure 12.6. [Untitled]; signed; ink on paper; 22×16 cm; n.d. [ca 1970/1980].
Reproduced with permission.

the "Savage Hunter" Actaeon to man-eating monsters of some Dionysian
mysteries (1929:164). Salomon Reinach's *Cults, Myths and Religions* dis-
missed Actaeon's erotic plot as a narrative construct built up over cen-
turies to mask the totemic sacrifice of a deer (1996:855–75). To which
Hubert and Mauss objected that the Dreyfusard archaeologist and
historian of religion, in the lineage of Robertson Smith, "wishes to see
totems in all the sacrificed gods of the Greco-Roman world: Orpheus,
Hippolytus, Actaeon, Phaeton, etc." (1909:xi). Hubert's essay about the
mythical "hero" (to which we return) then inquired: "[F]or how many
gods who die do we know the ritual sacrifice wherein the myth of his
death would be periodically realized? We know well that of Osiris; we do
not know those of Orpheus, Hippolytus, Marsyas, and Actaeon. . . . Yet
these individuals whose sacrifices are conjectural are all precisely heroes"
(2009:56). Transposing Nietzsche's Dionysianism onto the heroic *sparag-
mos* of Actaeon, Acéphale may have venerated the avid hunt and erotic
expenditure of this legendary death (see Bataille 1970b:395–98).

* * *

The wounded king of Dumézil's *Ouranos-Varuna*—whom Bataille cor-
related with the Breton Fisher King—was another initial, perhaps inter-
linked theme. This stark mythology of castration and death gave cultural

weight to Freud's Oedipal plot by painting "a transmission of power that was both dynastic and revolutionary, bloody in its form and regular, even fatal, in its principle" (1934:54).[29] Dumézil here imagined ritual successions in which "the Heir" damaged the King "when he became old or 'reigned badly': perhaps killing him, or at the very least giving back to nature the tokens of a virility that was henceforth useless or dangerous." Hesiod's *Theogony* recounted this "domestic and political *drama*": the earth goddess Gaia hated her son Uranus—god of the sky and tyrannical father to her other sons—so she gave a scythe to her son Cronus who castrated Uranos; and from blood drops in the sea emerged Aphrodite (1934:87, 21). (In 1936, Chavy vividly sketched these Hesiod scenes.) Publicly at stake for Bataille was the project of wresting Nietzsche's "thought from the Uranic dimension and [restoring it] to the chthonic dimension of the Earth-mother," explains Galletti (Bataille 1999:362). Indeed, the Nazi neo-paganism of Rosenberg's *The Myth of the Twentieth Century* had "introduced the legend of a poetic National Socialism," a psychology and mythology of fascism most characterized by its hostility to the chthonic gods, the earth-gods and Dionysus god of the dead, wrote Bataille (1985:188, 189).

Incest unleashed, Bataille's "Le bleu du ciel" celebrated man's bond with the "Earth-mother who gave birth to him" (1973a:94) and his secret society called for ritual sulfur: "matter that stems from inside the earth and only emerges through the mouths of volcanoes" (Bataille 1999:360). Chavy painted many volcanoes. "What is born of the earth, as from a mother blindly assuming her maternity, is the forest," wrote Dussat (Bataille 1999:310); in an undated Acéphale poem, [X] concludes: "Earth, I will love you—one must love you/and I will kiss the mouth of death" (Ambrosino Archives).

Of course, castrating or killing the father/king was key. "We, ourselves, took on the task of giving a figure to the world, as murderous sons," stated an internal text (by Andler) in 1938 (Bataille 1999:459). Such was the dream for this Cronus knighthood of carnival-kings (Dumézil 1944:44), who imbibed an unholy brew of *Ouranos-Varuna* mixed with *Totem and Taboo*: "One day the expelled brothers joined forces, slew and ate the father . . . " (Freud 1946:183).[30] Several Dionysian "Totemic Feasts" (Chavy's title) show bovines being devoured raw (see Fig. 12.7). They all take place at *Round Tables*.[31]

Yet castration could be turned inward as well as outward. Actaeon's secret "'brother" Cronus confirmed the Oedipal threat, namely "[c]astration and its substitute through blinding" (Freud 1946:168), which Bataille dramatically explored in the pineal-eye essays, where castration is "ecstatically experienced," writes Allan Stoekl, "as the father's actual castration of the son as a response to the son's total defiance" (Bataille 1985: xiii).[32] In unpublished notes, Klossowski surmised that Nietzsche moved away "from psychology" because the "metaphysical elaboration" of the Dionysian focused on the "horror" of the "principle of individuation";

Figure 12.7. "Festin totémique"; unsigned; brown ink on paper; 38×27 cm; painted in 1937. Reproduced with permission.

yet Freudian research into "regression," into "the realm of the terrifying as it presents itself in children" should "open new horizons" (ca. 1936:6). Theodor Reik's psychoanalytic anthropology of a universal Oedipal drama—"rebellion, based on incestuous impulses" and its "tragic expiation" (163)—may be reflected in Klossowski's notes, particularly Reik's correlation of Dionysian tragedy and puberty circumcision rituals.[33] More tentatively still, insofar as Freud and Wilhelm Reich often linked castration anxiety to masturbation, we could ponder the relevance of Leiris's youthful onanistic "sacrifice" at the Temple of Zeus, a ritual practice stemming from his boyhood pagan secret society (1939:58).

* * *

The journal *Acéphale* addressed an élite avant-garde audience, such as the public for the Collège. In its pages, Bataille openly declared that "'dionysian' truth [could] not be the topic of propaganda" but might slowly counter the "disaggregation" of the "human masses" by dint of a movement that "gravitated around profound mysteries" involving "figures of death" (1970a:489). He clearly hoped to draw fellow travelers from the post-Surrealist Republic of Letters into tighter, and far from cynical, orbit by means of this conceptually dense yet aesthetic publication, infused with Zarathustra and *Don Giovanni*. If Bataille defined the mythical Acéphale figure—in contrast to the heroic "superman" (or role

model)—as an "object of [the subject's] affective existence" (1999:476–78), such was its logical status for *Acéphale* readers as well. In fact, because beheading is the same as castration for Freudian dreamwork (1953:357), the journal may have been preaching the "castrated king" myth in a tragi-comic, subliminal way. The initial cover presented Masson's Acéphale figure with a skull masking his phallus; yet on the next page, Acéphale reveals a crude, partial phallus which then vanishes forever beneath a skull . . . or a Medusa's head in the July 1937 double-issue.[34] Was this an intentional tease?

In any event, to fully foster such a myth, and thereby fight the terrifying Hitler Youth of *Blue of Noon*, called for a much more dramatic installation than Contre-Attaque's rotten skull, and Acéphale may have countered fascism's mystical appeal with the Dionysian "spirit of music." Its forest activities "bring to mind Stravinsky's *Rite of Spring*—albeit without any women,"[35] said [X], a great lover of music. These "mirrored what young Germans were doing at the time, with the return to primitivism and paganism. One had to know his enemy, in a way. That's why some people could indeed consider us fascists; there was a correspondence, even though they were Enemy Number One!" he added. Publicly known was the secret society's existence, but not its inner workings. Through the well-established lure of secret knowledge, Bataille perhaps sought, among other things, to rival Wagner's phenomenology of initiation, or its subliminal by-product effects. "Especially with regard to *Parsifal*," wrote Leiris in *L'Age d'homme*, "I wondered a lot, knowing there was some-thing 'to understand,' because people around me would allude to those who 'understand' Wagner and those who do not" (45). Considering his view of this opera as staged aesthetic myth, Acéphale may have aspired to be secret sociological ritual whose rumored performance and crime would all the more forcefully ignite the collective mythical imagination (see Galletti 1999:134).

In renegade Durkheimian terms, attributing to secret societies the "function" of social renewal (Hollier 1988:153),[36] Bataille turned inwards the impure/left sacred and numinous emotional energy that Contre-Attaque had once instrumentally thought to deploy. At the Collège, he spoke of recuperating heroic "tragedy" from nationalism and militarism: "It is the blazing coal furnace of sacrifice, not the animality of war that gave rise to men, paradoxical beings, heightened by terrors that captivate them and which they master" (Hollier 1995:734). In *Acéphale*, he mourned the historical demise of any sense of communal life sparked by "the sharing of nocturnal terrors and . . . the kind of ecstatic tension spread by death" (1985:208). Just as important as contagious effervescence, in this regard, was Durkheim's theory of the sacred as "society hypostasized and transfigured" (see Pickering 1984:230).[37] "The exigency that is made apparent among us through the rigor of my language demands that *being* arise from our cohesion," Bataille sternly but vaguely declared to his

adepts in 1938, confirming that collective self-consciousness should be both social and existential (1999:446). At the Collège, he pointed to the perilous "sociological sphinx" that has made "the science of the sacred" a revelation "depriv[ing] human beings of the means they possess to evade what they are" (Hollier 1988:340, 334). Such was "drama" as he defined it to Caillois: "I am searching for a domination of whatever is monstrous, . . . of what precisely is acknowledged as oneself, and set free in festivals" (Hollier 1988:357). Like the revelation of death or "catastrophe," this pre-supposed theatricality or fiction.[38] "The scene is now set. The actors are ready," Hubert and Mauss wrote about sacrifice (1964:28). Magic affects voice, language, and tone, requiring "like sacrifice . . . an alteration, a modification in one's state of mind," explained Mauss: "negative ritual forms a kind of threshold, where a person is stripped of his individuality and becomes an actor" (2001:157). Needless to say, Acéphale's renegade Durkheimian performance was transgressive. Bataille's prewar essay "The Mask" speaks of "chaos incarnate" (1970b:404), thus undermining Mauss's theory about "the origin of the notion of the person" (2007:78, 79). Quite possibly inspired, though, by Hubert's theory of "festival drama," whose "characters . . . are heroes rather than gods" (2009:64), Acéphale's unmistakable intent was to harness the dynamogenic force of the Durkheimian sacred: as a collective phenomenon, Bataille told the Collège, "myth" becomes "vital human reality" and "living *truth*" (Hollier 1988:22).

Let us focus on the forest rituals, which respected a strict calendar (see Mauss 2007:176) and sanctuaries in the Marly forest—former hunting ground of Louis XIV and other French kings—involving three major sites. First, there was the "Etoile parfaite" (Perfect Star), as [X] recalled, one of the crossroads or "stars" of intersecting hunting paths etched into the wooded domain. In the star's center, surrounded by other trees, stood an oak tree struck by lightning.[39] Gatherings "took place every month at the new moon, in wind or rain," and entailed a "small set of symbolic gestures" recalled Waldberg (Bataille 1999:595, 580). "We stayed together all night without saying anything. . . . Then, we also returned to Paris without acknowledging or speaking to each other," recounted [X]. (At the Collège, Bataille invoked a sacred "region of silence" [Hollier 1988:112].) Their initiations took place at the ruins of the Montjoie fortress (Bataille 1999:58–60). Finally, there was the Désert de Retz: a vast garden of fake ruins built in 1774 by an aristocrat with alleged Freemasonic ties; the Surrealists loved this site.[40] [X] briefly reminisced about "a tower in the shape of a truncated column, a pyramid, and a small temple. And *that* is where Bataille would take Laure [Colette Peignot], who was already very ill, to spend the night, in the Ruined Tower [the *Colonne détruite*]. It's almost unspeakable."[41]

The group held two "Pledge" ceremonies in 1937. Only the second, in October, took place at the Montjoie, which [X] identified as the site of

Figure 12.8. [Untitled]; unsigned; pencil on paper; 21×27 cm; n.d. [ca late 1936]; Sketchbook (C). Reproduced with permission.

the following initiation: a small cut to the left arm, after which members signed a human-sacrifice "compact" in blood: "Within the group one pledged to be the *possible* victim or the *possible* assassin but with no further specifications"; indeed, "everybody who participated in Acéphale *could* be a possible victim," he said.[42] Alliance by blood, as opposed to discrete contractual bonds, was promoted by Georges Davy's Durkheimian study *La Foi jurée* (1922): "I myself . . . as a whole, become other and identify with the nature of another person through blood or alimentary communion" (76). Impure as this was, it lacked expenditure or some "radical alteration of the person" (Bataille 1985:70). Chavy's undated sketch suggests sacrificial flow; and the left hand is missing (see Fig. 12.8).

Citing Marcel Griaule, Bataille's postwar writings on knighthood describe "dubbing" as a vestigial initiation ceremony with "mystical beheading and a changed personality." He also explains that "primitive initiation societies and chivalry" hewed to the "social division of age-classes, sects" or wealth—"owning a horse." However, Acéphale may have modeled itself on Muslim "'secret societies' of fighters" such as the "Assassins (The Old Man of the Mountain)" which were "rather similar to Christian chivalry" but *"elective"* (1988a:503, 515).[43] What kind of symbolic beheading or "sacred horror" did Acéphale's elective knighthood experience with their induction into a virtual community of mutual victims and assassins? (Imagine Frazer's Nemi priest-kings grouped together in space rather than time.) Silence and "anonymity" were essential, Chavy and [X] both said—and these may have been internal rather more than outwardly directed norms.[44] [X] also did confide that "jointly, we came into contact with the sacred," citing bonds forged by "absolutely matrimonial sentiments," "secrecy" and "death."

In the light of Acéphale's anti-Nazi engagement, its human sacrifice plot may have sought, on another level, to recuperate this theme from its anti-Semitic usage. Reinach's 1893 essay, "L'accusation du meurtre rituel" (The Accusation of Ritual Murder) (republished in *Cults, Myths and Religions*) decried the blood-libel accusation against the Jews, who were the first to reject such instincts, he explained, citing Isidore Loeb:

> Today, ethnographers count by the thousands those facts in our countries which show or have shown the obsession with blood. Let us merely recall the meal of Thyeste, the human sacrifices of the Druids, tales of ogres, vampires. The symbol of wine that is blood, the hosts that sweat blood, pacts with the devil signed with blood. People who accuse the Jews are accusing or betraying themselves: the Jew is only here to put into action the dream they carry in themselves; they are assigning him to perform in their place the drama that both attracts and terrifies them. (Reinach 1893:19)

Sulfur flames for the collective meditations or the "drama" by the tree could not be lit unless at least two members—including either Ambrosino or Bataille—were present (Bataille 1999:424; Galletti 2009:71). Klossowski has cryptically mentioned "a spectacle solely viewed by members of our society," whose theme "suggested perhaps not an actual ritual sacrifice but evoked, at the very least, the celebration of such a sacrifice"; and then, Isabelle Waldberg, who attended rituals in 1939, concurred with him that *"contemplation* [was] transformed into action" (qtd. in Bataille 1999:361). This brings to mind the pineal eye, which "appears in a kind of nimbus of tears, like the eye of a tree or, perhaps, like a human tree," wrote Bataille: "At the same time this ocular tree is only a giant (ignoble) pink penis, drunk with the sun and suggesting or soliciting a nauseous malaise" (1985:84; 1971:165). In their sacrificial ecstasy, the meditators aspired to

melt into the trees and into the ground, Chavy's drawings suggest, transgressing natural as well as moral boundaries (see Clébert:75).[45] Among other sources, these night vigils may also have drawn from Pascal's *pensée*, repeated by the Russian existentialist Lev Shestov (Chestov, in French), that "the agony of Jesus will last until the end of the world—and therefore one must not sleep during that whole time" (Chestov 1923:12).[46]

Here is one rare sketch of a ritual—or imagined—experience. Smoke may perhaps be swirling below the male figure with open eyes and suffering face, who is crucified to a tree/cross with which his body has fused. He displays non-human hands (in a variant there are hooves); he is crowned and not phallic. Several masked, or depersonalized, figures fall back in collective ecstasy after thrusting lances into him (see Fig. 12.9).

Several other Chavy crucifixions (1936–37) display Lances of Longinus that, instead of probing death, are actually torturing a live body. In this sketch, the lances appear to cause and enlarge the wounds, which may then kill—like the stag—this Christ/"king of the wood" figure.

Unique for Chavy, the horsehead looks like a chivalric motif. Balzac's preface to *History of the Thirteen* was an important reference for Acéphale (Bataille 1999:580), and horses symbolized war, Chavy said. Bataille's 1947 article "Sur le cheval" (About the Horse) defined it as potential frenzy or "unleashed being," whose "essence is to be *sacred*" within the workaday world: "Only the majesty of thunder and the absolute frenzy of the horse have this power to go to the end of light, of brilliant limitless loss" (1988a:168). This animal's "friendship with man is not sealed by labor but by war alone," he wrote in a line he then crossed out (Bataille [n.d.]:139). According to Isabelle Waldberg, as part of his "private ritual," he "would perform sorts of sacrifices" in the forest, such as placing a "horse skull" in a "very deep gallery" (qtd. in Bataille 1999:362). In fact, daily lunch for Acéphale members was "ritually composed of minced horsemeat washed down with water (wine was forbidden at noon)," records Michel Surya (2002:252). Pagan horse sacrifices and ceremonial skulls were banned by Christianity, explained Reinach, arguing that the sacred status of pagan horses was borne out by the persistent taboo status of horse flesh in the modern world "among all populations of Aryan language" (1996:295–97, 292). Acéphale's anti-*Parsifal* warrior lunch was not only pagan, it was transgressively so.

Turning to the broader Aryan sphere, "horse sacrifice (*açvamedha*), is one of the greatest ceremonies of the Brahmanic ritual" (1898:137), according to Sylvain Lévi, whose work inspired Hubert and Mauss, their "impure sacred" orientation reflecting a deep "immersion" in Brahmanic religion, according to Riley (2005:277). That this also interested Bataille in the 1930s may elucidate the sacrifice shown below.[47] Indeed, his postwar theory of the sacred helps one grasp Indian sacrifice, which involves physical destruction in the form of consummation that occurs in "offerings to the fire, oblation and killing," suggests François Gauthier, citing the "use and

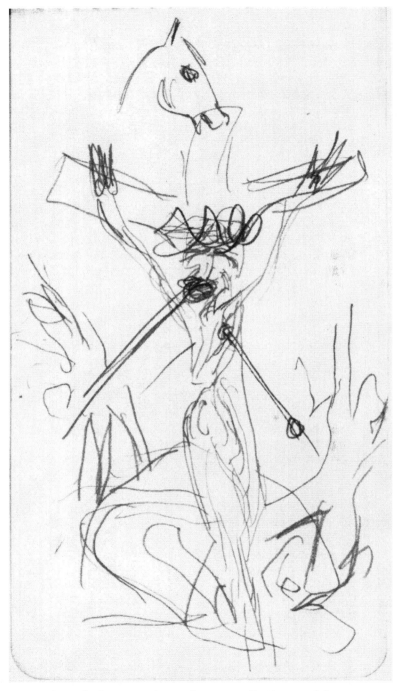

Figure 12.9. [Untitled]; unsigned; pencil on paper; 7×13 cm; n.d. [ca summer 1937]; Small Sketchbook (E). Reproduced with permission.

symbolism of fire into which offerings are poured or thrown" (2001:249, 251). Bataille's *Théorie de la religion* (1948) does use fire to define the "consuming" space of the sacred: "To sacrifice is to give as one gives coal to a furnace" (1976a:311). In October 1938, Acéphale members were told to "proceed alone toward the burning flame, put their hand in this flame (or as close as possible) and come back to the others" (Bataille 1999:498). Durkheim described "pain" as a negative ritual (1965:303) but the avant-garde exercise may have sought subjective "communication" with the sacred space itself.[48]

The Hindu, Chinese and Western rites and mysteries that Bataille surveyed in his 1930s readings shared the same spiritual sacred journey of mock-death and rebirth. Commonly associated with Schopenhauerian Buddhism, Wagner's intricate opera allows for myriad interpretations, but Parsifal's temptations and adventures map out his spiritual purification, or resurrection, as Grail knight and king. Did Bataille and his knights pursue an opposite course? Thinking perhaps of Actaeon (and Don Giovanni), Bataille told the Collège: "dominion [l'empire] will belong to those whose life is such an outpouring that they come to love death" (Hollier 1988:156). Or, writing a few days before the death of Colette Peignot, "I increasingly believe that the will to festival is a profound will to death . . . [T]he only festivals are those of heroes, that is to say, those who triumphed before tragically dying" (Bataille 1999:515).

* * *

One large, mysterious drawing brings into focus the "tragic" chivalric Order and its opposition to *Parsifal*. Chavy proudly kept this on life-long display in his family's dining room although nobody knew what it represented, recounts his son, Jean-Marc (see Fig. 12.10).[49]

Chavy showed me "Hercules" in the foreground, then a "vaguely human guy" on the cross, and "it's possible that those are music-hall singers in the background. It's an operetta next to a tragic scene." The interconnection of background and foreground, though, was "much too complicated" for him to explain. I now interpret the "operetta" as *Parsifal* (Act II, scene 2). There stands Kundry—"She's *singing*!"—enraged at Parsifal's "pure" rejection of her kiss, with her left arm raised in a transgressive, perhaps left-sacred Nazi salute. Parsifal looks dazed and confused. Yet at this very moment he should be overwhelmed by mystical revelation, by the literal pain and, hence, compassion for Amfortas's wound; at this very moment, he should be transformed into the Christian holy "fool made wise through pity" (Kinderman and Syer 2005:49). Instead, he is fusing into the ground like a tree, or like the neopagan Acéphale meditators Chavy depicts elsewhere. At this very moment Parsifal should be magically retrieving from the air the spear with its prominent tip that Chavy has placed in the lower left-hand corner, far out of his reach. In the foreground, the "tragic scene" may derive from the mythological

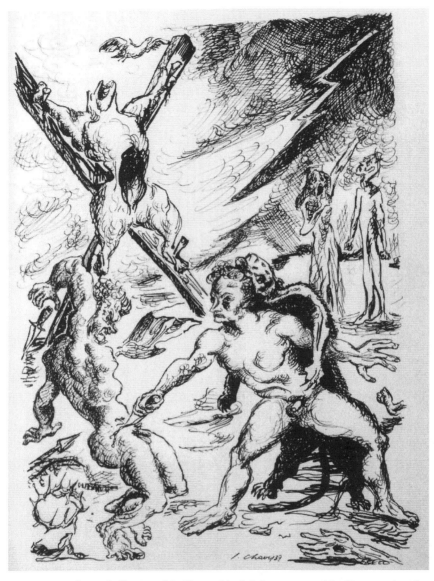

Figure 12.10. [Untitled]; signed J. Chavy; black ink on paper; 28×38 cm; painted in 1937. Reproduced with permission.

sacrifice recounted by Hubert and Mauss in which "three divine person-ages are killed in turn": King Busiris who sacrifices his visitors (at the site of Osiris's cult), and is then killed by Hercules, who "will commit suicide later" (1964:153). However, Chavy's Hercules is literally castrat-ing King Busiris: creating a Fisher King (Amfortas) or Uranus (note the

age difference between the two men); and this occurs by the sea (where Chavy situates another Fisher King sketch). The scene is graced by the dove present when Wagner's Parsifal heals Amfortas but here, there is a tragic lightning strike as well. In short, Parsifal will never reach the Spear; King Busiris/Amfortas/Uranus will be castrated rather than healed; and then death will ensue at the hands of a doomed Hercules. Yet his leopard cloak denotes Acéphale's tragic Dionysus! Whom is the god fighting? The "fascist" kingdom, which slays its own subjects? If so, such death seems recuperated, here, as a sacred *corrida* whose silent scream may echo the closing cry in *Blue of Noon*, while announcing the 1956 Preface to *Madame Edwarda*: "an immense alleluia, flung into endless silence, and lost there" (Bataille 1989:144).

Like the renegade Durkheimians, the universalist Acéphale ranged far and wide in its search of sacred form. The sideways sacrificial cross, or saltire, could possibly refer to the Exhibition of the Fascist Revolution,[50] and/or to the Cross of Saint Patrick, as might befit this Arthurian Fisher King.[51] In 1929, "Le Cheval académique" (The Academic Horse) had evinced Bataille's great passion for the ancient Gauls whose bizarre beasts stamped on their coins gave a "dreadful and burlesque" answer "to idealist platitudes and arrogance." He loved Gallic civilization which, prior to the Roman conquest, was similar to "current Central African tribes and thus embodied, in a social sense, the very antithesis of classical civilization." He loved the Gauls for their "incoherent and useless forays," "hopeless instability and excitement," and lack of "calculation" or interest in "progress of any kind" (Bataille 1970a:162, 160). Yet in the postwar period, he attributed the "cruelty and juvenile debauchery" of the ancient Germans to their "lack of a religious order setting out knowledge and measure against drunkenness, wild temper and violence"— this, in contrast to "the Romans and the Gauls" (1987:302). Rather than launch Celto-French Knights Templars against Hitler's Ordensburgen, Bataille may have imagined an unholy but sacred knightly order infused with "the free religious solemnity of paganism" (Hollier 1995:190). Celtic paganism?

Challenging the "fascist" "lictor's ax" (Hollier 1988:135), the dagger brandished by Masson's Acéphale may have been Celtic because "Roman swords were in fact Celtic swords: the best blacksmiths in Rome were Celts," Mauss taught his students (2007:38). In Saint-Germain-En-Laye, Bataille lived a short stroll away from the Musée des Antiquités Nationales where Gallic and Celtic treasures were on display. Here, Henri Hubert played a key role until his death in 1927, alongside Saloman Reinach. Mauss edited and published Hubert's two major posthumous works on the Celts (1932a; 1932b; 1952) which followed upon his "Preface to *Saint Patrick and the Cult of the Hero*" (1919) by Stefan Czarnowski, who had studied with both of them. *Patrick* Waldberg (whose mother was Irish) recalled having "read or reread" in 1936 (while living abroad) "Durkheim,

Mauss, Hubert, Hertz, Czarnowski, and Granet, those pillars of the French School of Sociology" (Bataille 1999:592).[52] It is very likely that Hubert's Celtic sociology, and perhaps that of Czarnowski, offered crucial renegade Durkheimian content and form to Bataille's "sacred conspiracy."[53]

Several Chavy drawings display Celtic warrior iconography: their nudity in combat and elongated shields (Hubert 1932b:113, 115). Moreover, the very impure/left sacred landscape of Celtic culture with its venerable oaks was the ritual décor of Acéphale. "Druids are attached to these trees as the totemic clans are to their totems," wrote Hubert (1932a:276). Czarnowski added that "the sacred trees representing the mythical Tree of Life are devoted to the dead" (1919: 211). Celtic divinities live in "real megalithic tombs. . . . The Celts enjoyed these funereal representations: one could say that their pantheon is a cemetery," wrote Hubert (1932a:290). On festival nights, when the *sidh*, or underground spirit dwellings open up, they "escape in droves," often as stags (Czarnowski 1919:149, 134). Celtic "forts, which are rallying places for tribes and families, are built on heights that are tombs" (Hubert 1932a:291). Acéphale may have viewed the Montjoie fortress with its "platform" and "excavation" (Bataille 1999:491) as a tumulus; in the 1970s, Chavy sketched men clustering in the forest next to large boulders.

In all fairness, Bataille should have thanked the Celts for the sacred and tragic "community of heart" he hailed in *Acéphale* as an exemplary means of combating fascism: those leaderless Numantians who "killed each other instead of surrendering" to the Roman general Scipio in Cervantes's *Numantia*—the play directed in 1937 by Jean-Louis Barrault with Masson's stage sets (1985:207–10). As did several reviewers at the time,[54] Bataille and Masson probably knew that this siege marked the end of the *Celtiberian* wars chronicled by Appian, and that the Numantians spoke a Celtic tongue. Beyond that, the cult of heroic death was a common theme in Celtic studies. Reinach had defended the Celts against Julius Caesar's allegations of executions performed to redeem important lives threatened by illness or battle; these were sacrifices more akin to generous suicide, he argued (1996:276). Albert Bayet's *Le suicide et la morale* (1922) hailed "Celtic morality" driven by a "suicide craze" in the Gallic wars as aristocratic "generosity," which undermined Durkheim's argument in *Le suicide* that altruistic suicide occurred only where individualism was not yet developed. "The [Celtic] individual was very free and wanted to be so," he announced (Bayet 1922:268, 270, 269). Mauss responded that with Celtic civilization, ritual potlatch reached its "paroxysm" or most "extreme" form: gift recipients would lie back on their shields and "an assistant would come to slit their throats with a sword" (1981:53, 56, 54). Such was Celtic repayment, a *"total prestation with agonistic form."* It was altruistic suicide because it was social sacrifice—"the suicide of a soldier and nobleman." Citing African Ashanti rituals as well, Mauss added that "the creditor" would sometimes "through his suicide, drag his

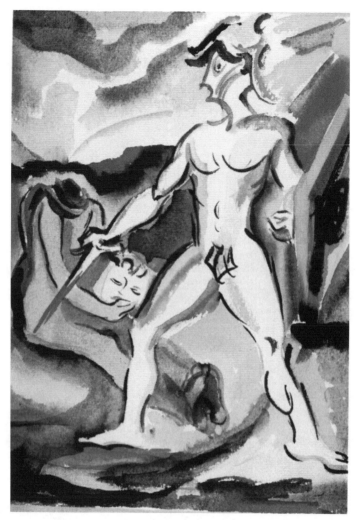

Figure 12.11. [Untitled]; unsigned; gouache on paper; 25×33 cm; n.d. [ca 1937]. Reproduced with permission.

debitor into the other world and insist upon repayment" (1981:54, 56). An unusual sketch by Chavy shows a Celtic warrior slicing the head off an Acéphale whose severed head might be a mask (see Fig. 12.11).

Celto-African or not, the expenditure of suicide, and mutual suicide, were common themes for Bataille's sacrificial community.[55] Chavy produced variations on an Acéphale who had just chopped off his own head. During the summer of *Numantia*, he received a postcard titled "Stags Caught Together in a Fight" (Cerfs pris ensemble dans un combat) cosigned by Ambrosino, Andler, Dussat and Kélémen. This photograph of two stag trophies contiguous on the wall, antlers locked in combat,

seems to symbolize, with echoes of Actaeon, the group's decapitated, hunting and hunted "community of heart" in the (Gallic) Marly woods.

Did renegade Durkheimian Celtic studies give Bataille an ideologically acceptable way of using national history? Ivan Strenski notes that Hubert "developed early Durkheimian critiques of racial sciences such as anthroposociology . . . His major works on the 'primitive' Celts and Germans continued these critiques of racism" (1987:353). One contemporary reviewer agreed it was unwise to associate "peoples" with "race," and "ethnic groups" with "skulls," because the Celts had been "brown-haired dolichocephalics, blond dolichocephalics, and blond brachycephalics" (Demangeon 1933:636). Lacking his skull or "encéphale," Masson's Acéphale figure defied any such racial or ethnic categorizations, and may thus have symbolized the group's utter rejection of cephalic science. Strenski then rightly observes that Hubert nevertheless "engaged in the political mythologizing of French national identity by trading in the republican myth of 'celtisme'" (1987:353). Perhaps this was obscured for Bataille and Acéphale by the scope of his argument. Indeed, together with Mauss and Dumézil (in *Flamen-Brahman* [1935]), Hubert used the category of "society of men" to outline the ancient Indo-European commonality of Indian, Roman and Celtic culture and its universal, prehistoric roots. The Druids, the Brahmans, the Iran Magus, and the Roman Flamen were all very similar, he wrote, as "identical priesthoods" involving religion, magic and human sacrifice at the far reaches of the Indo-European sphere; and he discerned non Indo-European corollaries for such society of men in "the so-called secret societies of British Colombia and Melanesia which are actually brotherhoods." Here, Hubert directly attacked Frazer's emblematic Nemi priest: "One must try to trace this all back to a type of collectivity and not to a category of individuals." That this "took over functions dormant in societies where totemism was becoming disorganized" may have informed the Collège theory of secret societies and social regeneration (Hubert 1932a:229, 284).

Generally speaking, his work, which displays an "aptitude for the imagination [that] was special among the Durkheimians" (Strenski 1987:364), could illuminate Acéphale's blend of literature and sociology. To the extent that Bataille hoped to "preach" sacred Durkheimian and anti-Wagnerian order by dint of an avant-garde *ordre* (and not just a lunatic knighthood), then Hubert's Celts—perhaps more than Caillois's "Society of Jesus or the Ku Klux Klan" (2003:164)—might have seemed a good place to start. The Druid "seers and soothsayers," educators and civilizers literally created their own society, Hubert wrote: this panceltic "religious association made a coherent people out of the various Celtic peoples" (1932a:277, 281). Thereupon, the *filid* fraternities arising after the Druids had been decimated by Christianity became the moral guides of Ireland and Gaul, "who sang the stories of the heroes during festivals" (Hubert 2009:45) and syncretically forged Saint Patrick out of pagan

forms (see Czarnowski 1919). Drawing on Greek drama and Irish cults to explore a "process" that "begins as religion and ends as aesthetics," Hubert described the "excessive"—indeed, potentially parodic—hero as "[a] temporal form of god and a secular and political form of saint" (2009:67, 53).

"In Celtic societies, instead of the clan totem," he explained, "we find the hero of the clan, tribe and nation" (1932a:288). This fused the social order with the religious cult and the festivals, which represented heroes "triumphing and dying in turn." Symbolizing "the fundamental social value," less "religious" than gods or saints, and "closer to men and to the age," these familiar figures inspired affection but were rarely "exemplary"—except for Saint Patrick. "Their catastrophe completes their type and . . . [adds] the myth of death to the myths of life," he wrote, for "it is myth, and not death, that makes the hero" (Hubert 2009:44, 2, 53, 76). At the outset of their project, Masson wrote to Bataille about the "series of sketches" that "in my mind, as well, would be something like the adventures of Acéphale" (Bataille 1999:302). (Chavy imagined the Acéphale as a friend, skeleton, matador, minotaur, dandy, orgiastic hero, female romantic partner, Nietzsche, and Christ in Majesty.) "The dead man is a *socius*," publicly explained Bataille in 1938, using the category of psychologist Pierre Janet: "he is not easy to distinguish from oneself" (1970b:287).

Did Acéphale seek to fulfill Hubert's academic dream that "[w]e will perhaps one day speak of the heroic clan as we speak of the totemic clan" (2009: 79)? Or could it have been James Joyce, apparently quite enthralled by Czarnowski's study (O'Dwyer 1980)? After the war in 1946, referring to *Finnegan's Wake* (1939), Bataille wrote that the traditional Irish and Welsh "wake," fully festive with dance and drink, was a "naive attitude" that in some ways offered a more *"absolute"* consciousness of Negativity—death—than could Kojève's Hegel in all his *"absolute* Wisdom." The Welsh "coffin was placed open, standing at the place of honor of the house. The dead man would be dressed in his finest suit and top hat," Bataille explained: "It is the death of an *other*, but in such instances, the death of the other is always the image of one's own death" (1990:24). Had he not been headless, in a gesture targeting "head-gods" and possibly Wagner as well, the Acéphale figure might have worn a top hat.

Notes

I would like to thank Anne Peyrelevade, and Jean-Marc and Barbara Chavy for their kind help, and for allowing me to publish my photographs of Jacques Chavy's drawings; thanks as well to Olga Tabakman for access to the Ambrosino archives, and to Guillaume Fau at the Bibliothèque Nationale, and to my father, Joseph Frank.
 1. Unless otherwise noted, all translations are mine.

2. Riley also notes a diminished "line separating scientific knowledge and politics," and the "importance" of the theorist's "existential situation" (2005:281).
3. See Wilhelm Reich, *Die Massenpsychologie des Faschismus*, 1st ed. (Copenhagen, Prague, Zurich: Verlag für Sexualpolitik, 1933); *Psychologie de masse du fascisme*, 1st ed., French trans. [anon.] (Paris: La Pensée Molle, 1970). Reich's *La Crise sexuelle (critique de la réforme sexuelle bourgeoise)* (trans. 1934) was listed in 'upcoming reviews' by the last issue of *La Critique Sociale* (March 1934); see also Surya 2002:180. Calling for demystification through political pedagogy and natural sexuality, Reich argued that bourgeois patriarchy caused submissive mysticism, and that "Hitler offered his subjects substitute gratifications for their repressed sexual enthusiasm in the frenzy of Nazi spectacle" (Turner 2011:147).
4. I am preparing an archival study for the Editions de la Différence. In the 1930s, Chavy attended the Ecole des Arts Décoratifs, and worked sporadically in urban sanitation architectural firms; on Ambrosino, Andler, Chenon, Dussat, Kélémen and Waldberg, see Bataille 1999:113, 131, 132, 172, 193, 226, 457.
5. René Lefeuvre ran a group ancillary to the journal *Monde*, called "Amis de *Monde.*"
6. This was reported by Ambrosino's sister-in-law, Olga Tabakman, who was 20 years old at the time (private conversation, March 2012).
7. Bataille unsuccessfully tried to get Chavy hired at *Le journal de Mickey* (Mickey Mouse magazine) published by the Opéra Mundi press agency where Peignot worked, as did Andler and Kélémen.
8. In 1946, Bataille recalled the prewar avant-garde appeal of Durkheim "defining myth and religious activities as a manifestation of the collective being . . . that is society"— "greater than the sum of its parts" and constituted by "religion, or more precisely [by] the sacred" (1988a:58, 65). Undated early 1930s notes, though, "excluded" the "Durkheimian solution," which did not account for "the identity between sacred social, magical and erotic elements" (Bataille 1970b:171).
9. Riley argues that even though Hertz refers to the sacred versus the profane, his language "indicates clearly that he is discussing the distinction between impure and pure sacred statuses" (2005:281).
10. This was *Mourir pour la patrie* (Dec. 15, 1935).
11. See also Moret 1927: *passim*. This work appears on the list of books Bataille borrowed at the Bibliothèque Nationale (Bataille 1988b:553–621).
12. When first exploring Chavy's drawings, I noticed a bloody dagger; it then vanished for good, as did a vivid, spiraling sun likely related to "The Practice of Joy Before Death" (Bataille 1985:235–39).
13. "[T]he so-called 'religion of primitive man'" vestigially survived in "uncanny" form as "the element of horror and 'shudder' in ghost stories" claimed Otto (15, 16). His "sacred" appealed to Durkheimians and Maussians, such as Bataille and Caillois, who felt that "an enchanted world of formidable and creative forces stood against the bourgeois world of daily banality" (Borgeaud: 413). Bataille elsewhere wrote that Durkheim "settled for characterizing the sacred world negatively as being absolutely heterogeneous compared to the profane" (1985:142).
14. See "Extended Definition: Holy Grail," *Webster's Online Dictionary*, at http://www.websters-online-dictionary.org.
15. "Le bleu du ciel," slightly revised, was integrated into *L'Expérience intérieure* (1973a:92–95).
16. Galletti's cover reproduces Masson's 1935 painting "Aube à Montserrat" (Bataille 1999).
17. See the rediscovered Collège lecture: Georges Bataille, *La sociologie sacrée du monde contemporain*, intro. Simonetta Falasca-Zamponi (Paris: Lignes-manifestes, 2004).
18. Bataille's 1949 review of Gustave Cohen's *Histoire de la chevalerie en France au Moyen Age* notes the possible use of such poems by preachers (1988a:513); on Nietzsche's 'preaching' see Bataille 1973b:107.

19. *L'Expérience intérieure* cites Kierkegaard's celebratory essay about *Don Giovanni*, "The Immediate Erotic Stages or the Musical Erotic" (Bataille 1973a:92).
20. Pasi refers to ecstatic dissolution, and "impenitent desire" sinking into "the maternal sex" as its "native land and tomb" (1987:162).
21. "Sovereignty only exists to spend itself. Whence the exemplary value of *potlatch*: the only thing that a power can do is lose itself. The dying-kings of Frazer and Dumézil have their double in the self-that-dies Bataille evoked in *Sacrifices* (1936)" (Hollier 1995:174).
22. A contemporary poster shows "Hitler, portrayed as a kind of neo-Parsifal" (see http://www.wagneroperas.com/indexwagnerbayreuthreich.html).
23. Besides war and mutilation, Bataille's "wounds" involved "unemployed negativity" at the Collège and, increasingly, communication (Hollier 1988:90, 337). One aphorism reads: "The idea of sexual function as wound in Nietzsche—Nietzsche and Freud—People join together and fuse through the wounding of their organs" (Bataille 1970b:391).
24. Did Bataille note Preuss's argument, endorsed by *L'Année Sociologique*, and bolstered by graphic analyses of Aztec bloodshed, that preanimist magic spawned both religion and art (Mauss 1904–05:239)?
25. Stating that Actaeon "presciently projects his own legend as his vocation," the Gallimard cover recalls Klossowski's Collège talk about the "modern" tragic hero (Hollier 1988: 171).
26. He then penned these erotic lines: "C'est la foudre qui te baise/ un fou brame dans la nuit/ qui bande comme un cerf / O mort je suis ce cerf / que dévorent les chiens / La mort éjacule en sang" (1971:36) (It's lighting that fucks you/a madman bells in the night/with a hard-on like a stag/Oh death I am this stag/that the dogs are devouring/ Death ejaculates in blood).
27. Sold on May 7, 2009, this grayscale work is visible online at www.christies.com. *The Plumed Serpent* (D.H. Lawrence) was an Acéphale reference (see Bataille 1999:580; Caillois 2003:168).
28. Dianas and likely Actaeons, including one 1936 figure who seems assailed by a castrating dog, persist throughout his Acéphale oeuvre.
29. Dumézil associated the prehistoric Uranus with the Hindu Vedic god through Frazer's pattern of royal sacrifice tied to social fecundity. But Varuna's myth was then gradually "subjugated to ritual" and "as in a novel, *had to have a happy ending*," while the Uranus myth stayed unbound (1934:54).
30. "The totem feast . . . would be the . . . commemoration of this memorable, criminal act with which so many things began, social organization, moral restrictions and religion" (Freud 1946:183).
31. Another "Totemic feast" sketch has black-and-white floor tiles, as in a Knights Templar castle.
32. "[T]he child who is terrified of being sliced through and seeks to provoke the bloody outcome, does not show lack of virility: on the contrary, excess strength and an attack of horror project him blindly toward what is sharpest in the world, that is to say, toward solar radiance" (Bataille 1970b:46).
33. Both initiation masks and Greek dramatic disguises "served . . . [as] a magic identification with the father (primitive god) whose removal was originally desired and accomplished" wrote Reik (162), whom Bataille read in 1931 and 1932 (1988b:580, 585). Klossowski noted about Nietzsche's Dionysus that he "seems to play the role of pubescent novices [subject to ritual mutilation] ritually punished by death and resurrected, and also to symbolize, at the same time, the totemic father torn apart and eaten by the members of his community" (ca. 1936:3).
34. Freud's 1922 article on Medusa and castration, *Das Medusenhaupt*, was only published in 1940.

35. [X] was not always in Paris; Isabelle Waldberg, for one, participated in 1939. On Stravinsky, jazz, and Maussian ethnomusicology, see the prewar studies by André Schaeffner—a close interlocutor of Leiris and Bataille.

36. In this respect, Bataille hailed "dynamic" and "strange" "Russian sects" (Hollier 1988:154), perhaps thinking of Karl Konrad Grass's *Die Russischen Sekten* (Russian sects) reviewed by Hertz: "Australian religion, then primitive Christianity, and the Russian sects . . . all stem from 'collective effervescence'." In Russia, Hertz discerned an 'internal relationship' between orgiastic ecstasy and asceticism (which may have influenced Acéphale's overall structure [Bataille 1999:580, 595]), also noting that the bloody Skoptzy "castration ritual" reduced their festivities to "rants about the merits of castration" (1928:248, 239, 247).

37. Lukes describes the duality of "interpretation" and "expression" (1973:465); W. Watts Miller refers to "'mythological truths'—beliefs not just rooted in, but constitutive and creative of, a social reality," arguing that for Durkheim, "symbolism does not just express or reinforce already existing beliefs. It helps to create and constitute them" (1996:16).

38. In 1951, Bataille described a (1920s?) lecture by Artaud who decided "to make us feel the soul of Thyestes understanding that he is digesting his own children. . . . [He] uttered the most inhuman cry that ever emerged from a human throat. . . . It was dreadful (perhaps even more dreadful because it was merely *performed*)" (1976b:180). Artaud's Theater of Cruelty inspired by ritual possessions influenced Leiris (see Armel:528, *passim*).

39. Galletti discusses Acéphale's "cult of the oak-tree, the tree of the god of thunder, which was once guarded–risking his own life—by Dianus, the mythical king-priest of Nemi who, having obtained his current rank by murder, kept it until he was deposed and killed, in turn, by the next king of the woods" (2009: 71).

40. See Ketcham (1994). See also http://desertderetz.info.

41. Waldberg mentions a "big abandoned park in whose recesses one could make out a few fake ruins buried in ivy" (Bataille 1999:578); neither he nor Bataille mention the park's 'ancient' sacrificial altar. Peignot died of tuberculosis in November, 1938.

42. This second pledge eventually became the criterion separating new recruits, or "participants," from full-fledged "adepts" (Bataille 1999:424). Bataille volunteered as victim in late October 1939, and the other members refused to 'sacrifice' him–a crisis that brought Acéphale to an end (1999:562–70, 597). Caillois wrote that Bataille asked him to perform a sacrifice (2003:30). Leiris may have volunteered at an earlier date (Galletti 1999:133), writing in his private journal: "Impossibility of ever signing the 'pledge,' because I retreat in the face of commitment" (1997:45); see Bataille and Leiris (2004:117).

43. Bataille suggests this influenced the Freemasons (1988a:515).

44. See Simmel (1950).

45. "What holds for the tree holds for man. The more it rises up in the sky and the light, all the more deeply do its roots plunge into the earth, in the darkness and depth–into evil," states a Nietzsche fragment favored by Acéphale (Bataille 1973b:264).

46. On Shestov and Bataille, see Surya 2002:58–63.

47. In 1936, Bataille read Arthur Miles's *Le culte de Civa* (The Land of Lingam) (1933) about India's extant, impure horror—i.e. human sacrifice to the "goddess earth" (18). In 1948, he called Lévi's *La Doctrine du sacrifice dans les brâhmanas* "one of the essential pieces" of the "interpretation of sacrifice," which is the "foundation of 'self-consciousness'" (1976a:359).

48. Hindu fire transmits the "divine" to "the place of sacrifice and consecrates it"; in this context, Acéphale's oaktree might connote the "yûpa" sacrificial stake, site of "that communication, that fusion of the gods and the sacrifier [sic], which will become even more marked in the victim" (Hubert and Mauss 1964:27, 28).

49. It was paired with a similarly-styled scene of Dionysus fending off the pirates.

50. The Roman numeral X was the "emblem" of Mussolini's decennial monument (Gentile 1996:112).
51. Artaud took a month-long 1937 trip to Ireland seeking occult revelation—as in his 1936 Mexican trip. He also hoped to restore to Ireland a cane of Saint Patrick. The actor's madness and internment upon returning to France "had to do with Saint Patrick," Bataille wrote in 1951: "I had the feeling that someone was striking or crushing my shadow" (1976b:180).
52. In 1943, he wrote to his wife about "miraculously" finding in Algeria a copy of Czarnowski's study "that Mauss had praised so very highly" (Waldberg 1992:75).
53. Bruce Lincoln explains that Dumézil's *Mythes et dieux des germains* (1939) set "militarized" German myths apart from Greek, Roman and Celtic myths, "which—having been entrusted to priests–gave way to the Christian conversion. [In contrast,] Germanic stories survived in a host of heroic legends that were ready to be reactivated by Wagner, the Romantics, and others" (202).
54. Jean Prudhomme's review for *Le Matin* (April 23, 1937) evokes "Gallic settlers"; E.H.G. refers in *Dionysos* (April 1937) to "Celts." I cannot explore here certain Celtic motifs that do appear in Masson's sets and in several paintings at the time.
55. Bataille did extensively read Charles Blondel, whose writing on collective psychology Maurice Halbwachs cited when linking ritual sacrifice to individual suicide: "'consciousness is aware of a system of all sorts of collective imperatives, to which our behavior has to justify itself, even if it does not conform to them.' . . . Let us apply this idea to the explanation of suicide" (166).

References

[Anon.] "Extended Definition: Holy Grail." *Webster's Online Dictionary*. http://www.web sters-online-dictionary.org.

Armel, Aliette.1997. *Michel Leiris*. Paris: Librairie Arthème Fayard.

Bataille, Georges. 1936a. "Le bleu du ciel." *Minotaure* 8 (June): 50–52.

———. 1936b. "Montserrat par André Masson et Georges Bataille: handwritten manuscript, 1 pg." Bibliothèque Nationale de France. Fonds Bataille, NAF 28606: Box VI E, 1.

———. 1990[1946]. "Hegel, Death and Sacrifice." *Yale French Studies*, 78: 9–28.

———. 1970a. *Oeuvres complètes*. Vol. 1. Paris: Gallimard.

———. 1970b. *Oeuvres complètes*. Vol. 2. Paris: Gallimard.

———. 1971. *Oeuvres complètes*. Vol. 4. Paris: Gallimard.

———. 1973a. *Oeuvres complètes*. Vol. 5. Paris: Gallimard.

———. 1973b. *Oeuvres complètes*. Vol. 6. Paris: Gallimard.

———. 1976a. *Oeuvres complètes*. Vol. 7. Paris: Gallimard.

———. 1976b. *Oeuvres complètes*. Vol. 8. Paris: Gallimard.

———. 1985. *Visions of Excess: Selected Writings, 1927–1939*. Ed. and intro. Allan Stoekl. Minneapolis: University of Minnesota Press.

———. 1987. *Oeuvres complètes*. Vol. 10. Paris: Gallimard.

———. 1988a. *Oeuvres complètes*. Vol. 11. Paris: Gallimard.

———. 1988b. *Oeuvres complètes*. Vol. 12. Paris: Gallimard.

———. 1989. *My Mother; Madame Edwarda; The Dead Man*. Trans. Austryn Wainhouse. London: Marion Boyars.

———. 1999. *L'apprenti sorcier: textes, lettres et documents (1932–1939)*. Ed. Marina Galletti. Paris: Editions de la Différence.

———. 2001. *Blue of Noon*. Trans. Harry Mathews, int. Will Self. London: Penguin Books.

———. 2004. *Acéphale n° 1 à 5, 1936–1939*. Paris: Jean-Michel Place.

———. [n.d.]. "Sur le cheval; handwritten manuscript, 15 pgs." Bibliothèque Nationale de France. Fonds Bataille, NAF 28606: Box XIII, 130–44.

Bataille, Georges, and Michel Leiris. 2004. *Echanges et correspondances*. Ed. Louis Yvert. Paris: Gallimard.

Bayet, Albert. 1922. *Le suicide et la morale*. Paris: Félix Alcan.

Borgeaud, Philippe. 1994. "Le couple sacré/profane. Genèse et fortune d'un concept 'opératoire' en histoire des religions." *Revue de l'histoire des religions* , 211(211–14): 387–418.

Caillois, Roger. 2001. *Man and the Sacred*. Trans. Meyer Barash. Urbana and Chicago: University of Illinois Press.

———. 2003. *The Edge of Surrealism; a Roger Caillois Reader*. Ed. Claudine Frank, trans. Claudine Frank and Camille Naish. Durham: Duke University Press.

Chestov, Léon. 1923. *La nuit de Gethsémani; essai sur la philosophie de Pascal*. Paris: Bernard Grasset.

Clébert, Jean-Paul. 1971. "Georges Bataille et André Masson." *Les Lettres Nouvelles* (May): 57–80.

Czarnowski, Stefan Zygmunt. 1919. *Le Culte des héros et ses conditions sociales. Saint Patrick, héros national de l'Irlande*. Intro. Henri Hubert. Paris: Félix Alcan.

Davy, Georges. 1922. *La Foi jurée. Etude sociologique du problème du contrat*. Paris: Félix Alcan.

Demangeon, A. 1933. "Les Celtes, d'après Henri Hubert," *Annales de Géographie*, 42(240): 636–42.

Dumézil, Georges. 1929. *Le problème des centaures: étude de mythologie comparée indo-européenne*. Paris: Paul Geuthner.

———. 1934. *Ouranós-Váruna: étude de mythologie comparée indo-européenne*. Paris: Adrien-Maisonneuve.

———. 1935. *Flamen-Brahman*. Paris: Paul Geuthner.

Durkheim, Emile. 1965[1913]. *The Elementary Forms of the Religious Life*. Trans. Joseph Ward Swain. New York: The Free Press.

Frank, Claudine. "Interview with [X], May 1992." Unpublished manuscript.

Freud, Sigmund. 1946. *Totem and Taboo*. Trans. A.A. Brill. New York: Vintage Books.

———. 1953. *The Interpretation of Dreams*. In *The Standard Edition of the Complete Psychological Works*. Vol. 5. London: Hogarth Press.

Galletti, Marina. 1999. "Secret et sacré chez Leiris et Bataille." In *Bataille-Leiris; L'intenable assentiment au monde*. Ed. Francis Marmande. Paris: Belin.

———. 2009. "Histoire d'une société secrète (Le chapitre biffé de la Somme athéologique)." In *Writing in Context: French Literature, Theory and the Avant-Gardes Studies across Disciplines in the Humanities and Social Sciences* 5. Helsinki: Helsinki Collegium for Advanced Studies, 61–77.

Gandon, Francis. 1984. "Les guenilles de l'histoire sur un inédit de G. Bataille." *Revue Romane*, 19(1): 98–116.

Gauthier, François. 2001. "La finitude consomée. Le sacrifice dans l'Inde ancienne." *Religiologiques*, 23 (Spring): 247–76.

———. 2010. "L'héritage de Mauss chez Lévi-Strauss et Bataille (et leur dépassement par Mauss)." *Revue du MAUSS*, 36(2): 111–23.

Gentile, Emilio. 1996. *The Sacralization of Politics in Fascist Italy*. Trans. Keith Botsford. Cambridge, MA: Harvard University Press.

Gutman, Robert W. 1990. *Richard Wagner: The Man, His Mind, and His Music*. New York: Mariner Books.

Halbwachs, Maurice. 1930. *Les Causes du suicide*. Intro. Marcel Mauss. Paris: Félix Alcan.

Hertz, Robert. 1928. *Mélanges de sociologie religieuse et Folklore: Représentation collective de la mort. Prééminence de la main droite. Saint Besse. Contes et Dictons recueillis sur le front. Sectes russes*. Paris: Félix Alcan.

Hollier, Denis. 1997. *Absent Without Leave: French Literature under the Threat of War*. Trans. Catherine Anne Porter. Cambridge, MA: Harvard University Press.
———, ed. 1988. *The College of Sociology (Theory and History of Literature)*. Trans. Betsy Wing. Minneapolis: University of Minnesota Press.
———, ed. 1995. *Le Collège de Sociologie 1937–1939*. Paris: Gallimard.
Hubert, Henri. 2009[1919]. "Preface to *Saint Patrick and the Cult of the Hero*." In *Saints, Heroes, Myths, and Rites: Classical Durkheimian Studies of Religion and Society*. Ed. and trans. Alexander Riley, Sarah Daynes, Cyril Isnart. Boulder, CO: Paradigm Press.
———. 1932a. *Les Celtes depuis l'époque de la Tène et la civilisation celtique*. Paris: La Renaissance du livre.
———. 1932b. *Les Celtes et l'Expansion celtique jusqu'à l'époque de La Tène*. Paris: La Renaissance du livre.
———. 1952. *Les Germains: cours professé à l'École du Louvre en 1924-1925*. Paris: A. Michel.
Hubert, Henri, and Marcel Mauss. 1909. "Introduction à l'analyse de quelques phénomènes religieux"[1906]. In *Mélanges d'histoire des religions*. Paris: F. Alcan.
———. 1964. *Sacrifice Its Nature and Functions*. Trans. W.D. Halls. Chicago: University of Chicago Press.
Ketcham, Diana. 1994. *Le Désert de Retz: A Late Eighteenth-Century French Folly Garden, the Artful Landscape of Monsieur de Monville*. Cambridge, MA; London: The MIT Press.
Kinderman, William, and Katherine Rae Syer. 2005. *A Companion to Wagner's Parsifal*. Rochester, NY and Woodbridge: Camden House.
Klossowski, Pierre. Ca. 1936. "Notes sur Nietzsche (dont certaines de la main de Klossowski): Encore que l'origine. De la Tragédie; handwritten manuscript, 5 pgs." Bibliothèque Nationale de France. Fonds Bataille, NAF 28086: Box VI D, "Notes diverses pour Nietzsche et Acephale," 2–6.
———. 1980. *Le Bain de Diane*. Paris: Gallimard.
Le Bouler, Jean-Pierre, ed. 1988. *Georges Bataille; lettres à Roger Caillois 4 août 1935–4 février 1959*. Paris: Folle Avoine.
Leiris, Michel. 1939. *L'Age d'homme*. Paris: Gallimard.
———. 1963."De Bataille l'impossible à l'impossible *Documents*." *Critique*, 195–96 (Aug.–Sept.): 685–93.
———. 1988. *A propos de Georges Bataille*. Paris: Fourbis.
———. 1992a. *Journal 1922–1989*. Paris: Gallimard.
———. 1992b. *Operratiques*. Ed. Jean Jamin. Paris: POL.
———. 1997. *L'homme sans Honneur*. Paris: Jean-Michel Place.
Lévi, Sylvain. 1898. *La Doctrine du sacrifice dans les Brâhmanas*. Paris: E. Leroux.
Lincoln, Bruce. 1998. "Rewriting the German War God: Georges Dumézil, Politics and Scholarship in the Late 1930s." *History of Religions*, 37(3): 187–208.
Loomis, Roger Sherman. 1991. *The Grail: From Celtic Myth to Christian Symbol*. Princeton: Princeton University Press.
Lukes, Stephen. 1973. *Emile Durkheim, his Life and Work*. London: The Penguin Press.
Masson, André. 1963. "Le soc de la charrue." *Critique* 195–96 (Aug.–Sept.): 701–5.
———. 1976. *Le Rebelle du surréalisme: écrits*. Ed. Françoise Levaillant. Paris: Hermann.
Mauss, Marcel. 1904–05. "Review of Konrad Theodor Preuss ("Der Ursprung der religion und der Kunst", *Globus*, 86, 1904 and 87, 1905), *L'Année sociologique*, 9: 239–40.
———. 1954. *The Gift: Forms and Functions of Exchange in Archaic Societies*. Trans. Ian Cunnison. Glencoe, IL: The Free Press.
———. 1981. "Sur un texte de Posidonius. Le suicide, contre prestation suprême" [1925]. In *Oeuvres* by Marcel Mauss, 3 vols. Ed. Victor Karady. Paris: Ed. de Minuit. Vol. 3, 52–57.
———. 2001. *A General Theory of Magic*. Trans. Robert Brain. London: Routledge.
———. 2007. *Manual of Ethnography*. Trans. N.J. Allen. New York: Berghahn Books/The Durkheim Press.

Métraux, A. 1928. *La Religion des Tupinamba et ses rapports avec celle des autres tribus Tupi-Guarani*. Paris: E. Leroux.

Miles, Arthur. 1951[1935]. *Le culte de Civa. Superstition, perversions et horreurs de l'hindouisme*. Trans. Marc Logé. Paris: Payot.

Monnoyer, Jean-Maurice. 1985. *Le Peintre et son démon: entretiens avec Pierre Klossowski*. Paris: Flammarion.

Moret, Alexandre. 1927. *La Mise à mort du dieu en Égypte*. Paris: P. Geuthner.

Moutel, Christiane. 2009. *Le Bestiaire d'André Masson (1896–1987): Exposition du 6 avril au 5 septembre 2009 Musée de la Poste*. Paris: Ecole Nationale Supérieure des Beaux-Arts.

O'Dwyer, Riana. 1980. "Czarnowski and 'Finnegans Wake': A Study of the Cult of the Hero." *James Joyce Quarterly*, 17(3): 281–91.

Otto, Rudolf. 1958. *The Idea of the Holy: an Inquiry into the Non-Rational Factor in the Idea of the Divine and its Relation to the Rational*. Trans. John W. Harvey. London, Oxford, New York: Oxford University Press.

Pasi, Carlo. 1985. "*Acéphale* ou la mise à mort du chef/du père." In *Des années trente: groupes et ruptures*. Ed. Anne Roche and Christian Tarting. Paris: Ed. du CNRS, 207–24.

———. 1987. "L'Hétérologie et '*Acéphale*': du fantasme au mythe." *Revue des Sciences humaines*, 76(206): 143–62.

Pickering, W.S.F. 1984. *Durkheim's Sociology of Religion: Themes and Theories*. New York: Routledge Kegan & Paul.

Reik, Theodor. 1973[1919]. *Dogma and Compulsion: Psychoanalytic Studies of Religion and Myths]*. Westport, CT: Greenwood Press.

Reinach, Salomon. 1893. "L'accusation du meurtre rituel." Paris: Librarie Léopold Cerf.

———. 1996. *Cultes, mythes et religions*. Ed. Hervé Duchêne. Paris: Robert Laffont.

Riley, Alexander. 2005. "'Renegade Durkheimianism' and the Transgressive/Left Sacred." In *The Cambridge Companion to Durkheim*. Ed. Jeffrey Alexander and Philip Smith. Cambridge: Cambridge University Press.

Richman, Michèle. 2002. *Sacred Revolutions: Durkheim and the Collège de Sociologie*. Minneapolis: University of Minnesota Press.

Rohde, Erwin. 1928. *Psyché, le culte de l'âme chez les grecs et leur croyance à l'immortalité*. Trans. Auguste Reymond. Paris: Payot.

Simmel, Georg. 1950. *The Sociology of Georg Simmel*. Trans. and ed. Kurt H. Wolff. Glencoe, IL: Free Press.

Spotts, Frederic. 1994. *Bayreuth: A History of the Bayreuth Festival*. New Haven: Yale University Press.

Strenski, Ivan. 1987. "Henri Hubert, racial science and political myth." *Journal of the History of Behavioral Sciences*, 23(4): 353–67.

Stuart Short, Robert. 1968. "Contre-Attaque." In *Le surréalisme*. Ed. Ferdinand Alquié. Paris-La Haye: Mouton.

Surya, Michel. 2002. *Georges Bataille: An Intellectual Biography*. Trans. Michael Richardson and Krzystof Fijalkowski. New York: Verso Books.

Tiryakian, Edward. 2009. *For Durkheim: Essays in Cultural and Historical Sociology*. Aldershot: Ashgate Publishing.

Trentin, Silvio. 1931. *Aux sources du fascisme*. Paris: Marcel Rivière.

Turner, Christopher. 2011. *Adventures in the Orgasmatron; How the Sexual Revolution Came to America*. New York: Farrar, Straus and Giroux.

Waldberg, Patrick. 1992. *Un amour acéphale: correspondance 1940–1949 / Patrick Waldberg, Isabelle Waldberg*. Ed. and intro. Michel Waldberg. Paris: Ed. de la Différence.

Watts Miller, W. 1996. *Durkheim, Morals and Modernity*. Montreal, Kingston: McGill-Queen's University Press.

Contributors

Sarah Daynes is an Assistant Professor of Sociology at the University of North Carolina Greensboro. Her publications include *Desire for Race* (Cambridge University Press 2008) and *Time and Memory in Reggae Music* (Manchester University Press 2010). In collaboration with Alexander Riley and Cyril Isnart, she also published a volume of translations of texts by early Durkheimian scholars entitled *Saints, Heroes, Myths and Rites: Classical Durkheimian Studies of Religion and Society* (Paradigm Press 2009). Her current research is on innovation and the value of work in winemaking.

Jean-Louis Fabiani is Professor of Sociology and Social Anthropology at the Central European University in Budapest and directeur d'études at the Ecole des hautes études en sciences sociales in Paris. He received his Phd from the EHESS in 1980. He is the author of *Les Philosophes de la République* (1988), *Lire en prison* (1995), *Beautés du Sud* (2005), *l'Education populaire et le théâtre. Le festival d'Avignon en action* (2008) and *Qu'est-ce qu'un philosophe francais?* (2010). He has edited four other books, including *La Société vulnérable* (1987) and *Le Goût de l'enquête* (2001).

Marcel Fournier has a PhD in sociology (Sorbonne-EPHE). He is Full Professor in the Department of Sociology at the Université de Montréal. His main interests are the history of sociology, social theory, sociology of science and higher education, and sociology of culture. His books include *Cultivating Differences, Symbolic Boundaries and the making of Inequalities* (University of Chicago Press 1992, with Michéle Lamont, ed.); *Marcel Mauss* (Fayard, 1994, translated into English by Princeton University Press); *Knowledge Society, Creativity and Communication* (Sage 2007, with Arnaud Sales, ed.); and *Émile Durkheim* (Seuil 2008, translated into English by Polity Press).

Claudine Frank is living in Paris, where she is pursuing independent research on Georges Bataille's secret society, Acéphale; Roger Caillois, whose work she edited and translated in *The Edge of Surrealism: A Roger Caillois Reader* (Duke University Press 2003); and French pedagogical

fiction. With a doctorate in Comparative Literature from Harvard University, and a Journalism M.S. from Columbia University, she has taught at Harvard, the University of Chicago and Barnard College, and has published in journals such as *Modernism/Modernity, Europe* and *Comparative Literature Studies*.

Pierre-Michel Menger earned his Ph.D. at the Ecole des Hautes Etudes en Sciences Sociales in Paris in 1980. He is senior researcher at the Centre National de la Recherche Scientifique and professor at the Ecole des Hautes Etudes en Sciences Sociales. He is the author or coauthor of fourteen books, and has published articles in such journals as *Revue française de sociologie, L'Année sociologique,* and *Annales*. He is currently joint editor of the *Revue française de sociologie*. His latest book, *The Economics of Creativity,* will be published by Harvard University Press in 2013.

Stephan Moebius is professor of sociological theory and the history of sociology at the University of Graz. He is president of the Section on Cultural Sociology of the German Sociological Association, and president of the Section on Sociological Theory of the Austrian Sociological Association. Between 2005 and 2009, he led a research project on Marcel Mauss funded by the German Research Foundation (DFG). He is coeditor of the German translation of Marcel Mauss's studies in the sociology of religion and of the German translation of Denis Hollier's book on the Collège de Sociologie.

S. Romi Mukherjee is *maître de conférences* in Political Theory and the History of Religions at l'Institut d'Etudes Politiques de Paris. He is also secretary general of the French Society of Durkheimian Studies and contributing editor for the *International Social Science Journal*. He is the editor of *Durkheim and Violence* (Blackwell 2010) and *Henri Hubert: Archéologie et Histoire* (with Laurent Olivier, forthcoming 2013, *La revue d'histoire des sciences humaines*/Septentrion). He has published widely, primarily on the history of religions, contemporary political theory, and critical global studies. He is currently working on a manuscript on "Cosmopolitan Republicanism: Ethics, Governance, Ecology."

Donald A. Nielsen received his doctorate in Sociology from the New School for Social Research in New York City. He has taught at the State University of New York-Oneonta and the University of Wisconsin-Eau Claire, and published two books, *Three Faces of God: Society, Religion and the Categories of Totality in the Philosophy of Emile Durkheim* (SUNY Press 1999) and *Horrible Workers: Max Stirner, Arthur Rimbaud, Robert Johnson and the Charles Manson Circle—Studies in Moral Experience and Cultural Expression* (Lexington Books 2005). He is currently Adjunct Instructor at the College of Charleston in South Carolina.

Frithjof Nungesser is lecturer at the University of Graz. Between 2008 and 2009, he was member of a research project on Marcel Mauss's influence on the social sciences in France headed by Stephan Moebius and funded by the German Research Foundation (DFG). Together with Stephan Moebius and Christian Papilloud, he is coeditor of the German edition of Marcel Mauss's studies in the sociology of religion (*Schriften zur Religionssoziologie*; published by Suhrkamp in 2012).

W.S.F. (Bill) Pickering studied at Kings College London. He taught sociology in Canada from 1958 to 1966 and then at Newcastle upon Tyne until he retired in 1987. Although his original interest was in the sociology of religion, he later turned to the work of Durkheim. In 1975 he published *Durkheim on Religion* (1975) and then *Durkheim's Sociology of Religion: Themes and Theories* (1984). In 1991 he helped to found the British Centre of Durkheimian Studies in Oxford, based in the Institute of Social and Cultural Anthropology, of which he is the General Secretary.

Michèle Richman is Full Professor of French Studies at the University of Pennsylvania. Her interdisciplinary work focuses primarily on the connections between literature, anthropology and social criticism, especially in the twentieth century. Her publications include *Reading Georges Bataille: Beyond the Gift, Sacred Revolutions: Durkheim and the College de Sociologie*, as well as articles devoted to Marcel Mauss, Michel Leiris, Roland Barthes, Georges Bataille and the sociology of Bernard Lahire. Her current research project is entitled "The Prehistoric Detour of French Modernism."

Alexander Riley completed a PhD. at the University of California at San Diego. While in graduate school, he spent several years in Paris sifting through archival materials from the *Année sociologique* team. With the aid of the late Philippe Besnard, he edited the war correspondence of Robert Hertz, *Un ethnologue dans les tranchées*. He is the author of *Godless Intellectuals?: The Intellectual Pursuit of the Sacred Reinvented*, and he is currently working on a book on literary autobiography, cultural sociology, and the writing of Michel Leiris.

William Watts Miller is editor of *Durkheimian Studies/Etudes durkheimiennes* and a member of the board, British Centre for Durkheimian Studies, Institute of Social and Cultural Anthropology, University of Oxford. He has published extensively in the field, collaborated in translations, and is a member of the team producing a new critical edition of Durkheim's *Complete Works*. His most recent book is entitled *A Durkheimian Quest: Solidarity and the Sacred*.

Index